Ancient Art to Post-Impressionism

Masterpieces from the Ny Carlsberg Glyptotek, Copenhagen

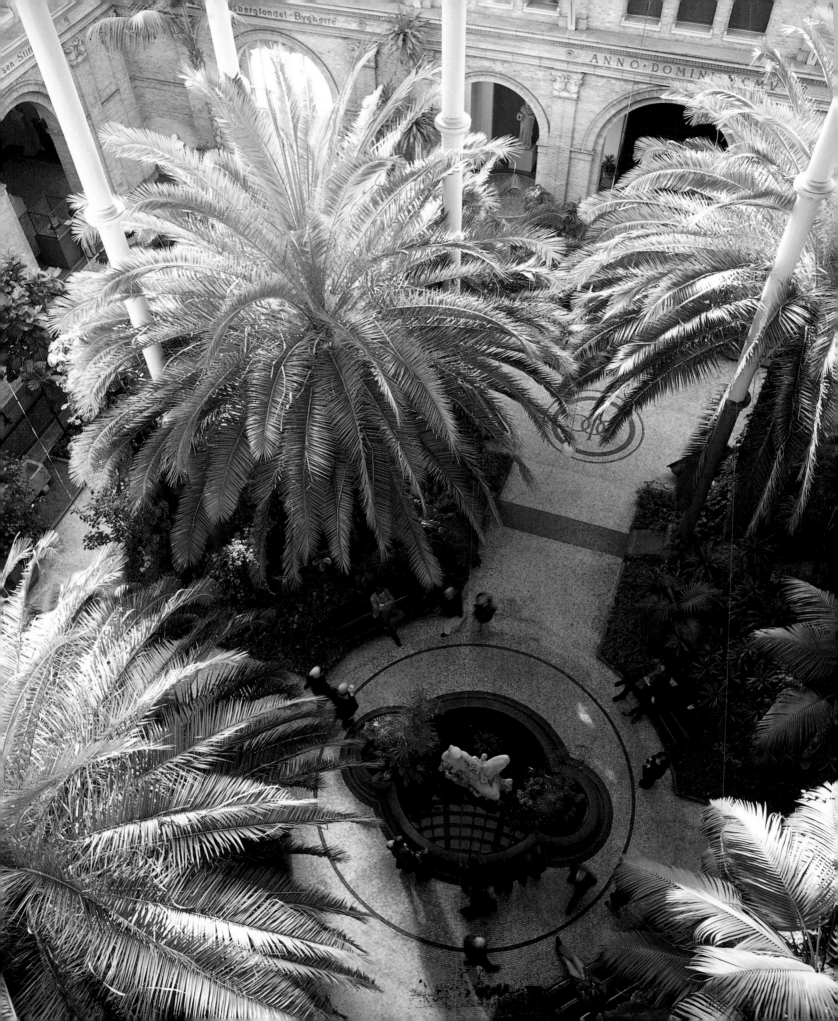

Ancient Art to Post-Impressionism

Masterpieces from the Ny Carlsberg Glyptotek, Copenhagen

Royal Academy of Arts

First published on the occasion of the exhibition
Ancient Art to Post-Impressionism: Masterpieces from the Ny Carlsberg Glyptotek, Copenhagen
Royal Academy of Arts, London
18 September – 10 December 2004

Sponsored by

Supported by Novo Nordisk

The Royal Academy of Arts is grateful to Her Majesty's Government for agreeing to indemnify this exhibition under the National Heritage Act 1980, and to the Museums, Libraries and Archives Council for its help in arranging the indemnity.

EXHIBITION CURATORS
Flemming Friborg
MaryAnne Stevens
with
Mary Beard
Ann Dumas
Norman Rosenthal

EXHIBITION ORGANISERS
Hillary Taylor
with
Emeline Winston

PHOTOGRAPHIC AND COPYRIGHT COORDINATION
Andreja Brulc

CATALOGUE
Royal Academy Publications
David Breuer
Harry Burden
Claire Callow
Carola Krueger
Peter Sawbridge
Nick Tite

Copy-editor: Christine Davis
Design: Esterson Associates
Colour origination: DawkinsColour
Printed in Italy by Graphicom

British Library Cataloguing-in-Publication Data

A catalogue record for this book is available from the British Library

ISBN 1-903973-63-5 (paperback)
ISBN 1-903973-50-3 (hardback)

Distributed outside the United States and Canada by Thames & Hudson Ltd, London
Distributed in the United States and Canada by Harry N. Abrams, Inc., New York

EDITORIAL NOTE
Measurements are given in centimetres, height before width before depth

CAPTIONS
Frontispiece: Interior, Winter Garden
Detail images: Page 6: detail of cat. 51; page 8: detail of cat. 193; pages 26–7: detail of cat. 11; pages 48–9: detail of cat. 27; pages 56–7: detail of cat. 37; pages 68–9: detail of cat. 99; pages 122–3: detail of cat. 130; pages 151–2: detail of cat. 202

Contents

Sponsors' Preface

Danske Bank is honoured to help sponsor the exhibition of one of the great Danish art collections for the first time outside its homeland.

As Denmark's largest bank, we take pride in sharing our country's treasures with an international audience. The dedication that brought about the beauty and grace of these works inspires us to pursue our own core values – commitment, integrity, expertise, accessibility and value creation – in nurturing our client relationships every day.

A strong commitment to cultural activities benefits our customers, our employees and our country as a whole. Denmark is a country of only five million people, but modern Danish design is world-famous for its sleek line, utility and relentless creativity. What's true in the art world is just as true in the banking world. Many banks offer similar services, but what makes a bank stand out is its ability to offer creative solutions and a thoughtfully designed approach. At Danske Bank we learn from those around us, and by being involved with the community we are able to maintain our edge.

Long-term relationships with customers are also very important to us, and few of our relationships are broader or deeper than that which we have with Carlsberg. The makers of Denmark's finest beverages and Danske Bank have an active relationship in the full range of banking products and services, ranging from bespoke complex solutions to daily account management. We take great pride in being Carlsberg's bank because – as the millions who have enjoyed its products will testify – Carlsberg knows there is no substitute for quality.

Quality is something Carl and Helge Jacobsen recognised instinctively when they began collecting art more than 125 years ago. We trust that many people will enjoy and find inspiration in this unique exhibition.

Angus MacLennan
Associate Member of the Executive Committee, Danske Bank

It is a great pleasure for Carlsberg UK to be involved in supporting this superb exhibition. One of its many charms lies in the links that we at Carlsberg have with the creation of the original collection. The first pieces were bought by the brewer Carl Jacobsen, the son of Carlsberg's founder, J. C. Jacobsen.

After building a new brewery on a hill outside the walled city of Copenhagen, J. C. Jacobsen took his son's name, Carl, and joined it to the Danish word 'berg', meaning hill. Thus the name Carlsberg was born.

Carl Jacobsen went on to found his own brewery next door to his father's, calling it Ny Carlsberg, or 'New' Carlsberg. Having created a very successful brewing company in his own right, Carl was able to acquire an outstanding collection of antiquities and nineteenth-century French art. Carl's son Helge followed his father's footsteps into the brewing business and also expanded the family's art collection.

Carl Jacobsen founded the Ny Carlsberg Foundation to ensure that his great collection would be suitably endowed for the continuing pleasure of the Danish public. The completion of the Ny Carlsberg Glyptotek was the first of its many great works. In this, Carl was following the philanthropic example of his father, J. C. Jacobsen, who had created the Carlsberg Foundation to endow scientific and medical research from the proceeds of his brewing empire.

We are proud of our Danish brewing heritage and the achievements of its founder and his descendants. Sponsorship of the arts is part of the fabric of our company's history, and sponsorship of this exhibition is a natural continuation of that story.

I am thrilled that art lovers in the UK will have access to this fine collection at the Royal Academy's beautifully and creatively curated exhibition. I have no doubt that you will discover some new delights hidden among works by familiar artists, and I wish you a very enjoyable visit.

Lars Fellman
Chairman, Carlsberg UK

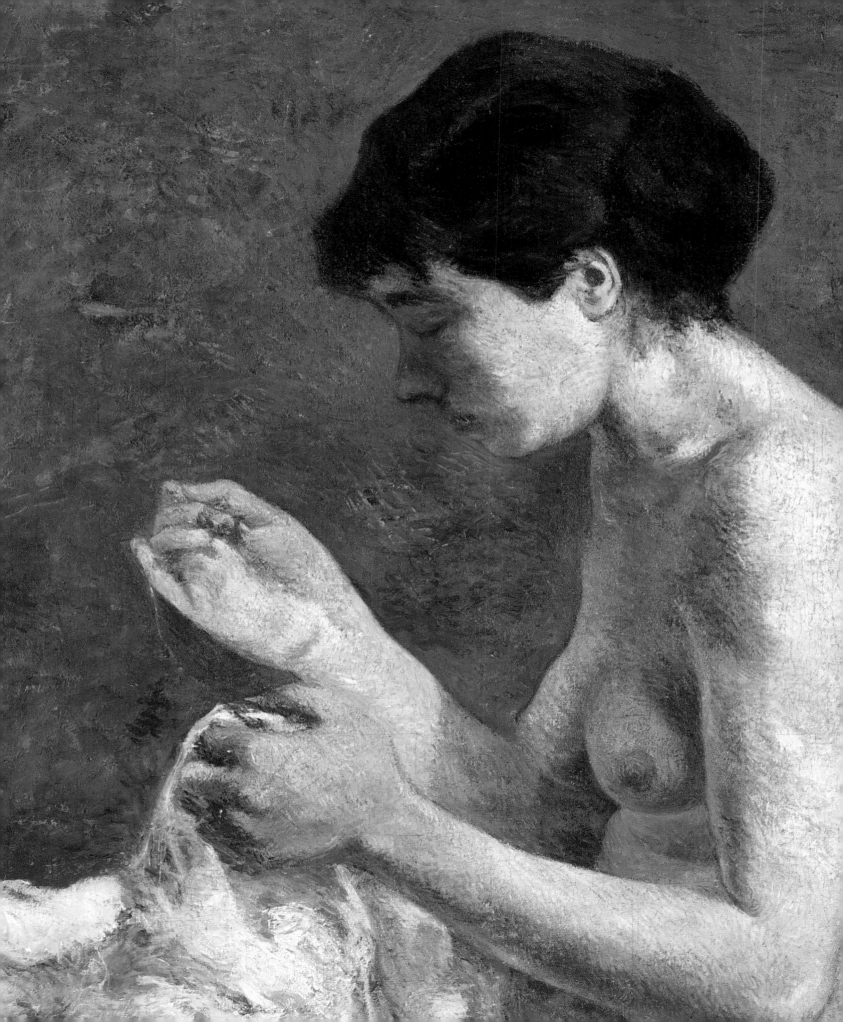

President's Foreword

Ancient Art to Post-Impressionism: Masterpieces from the Ny Carlsberg Glyptotek, Copenhagen is the result of a unique opportunity. The closure of the Ny Carlsberg Glyptotek's galleries for essential refurbishment and modernisation has made it possible for a large number of the museum's finest works to travel abroad, many of them for the first time since their acquisition. Thus this exceptional collection can become more widely known on an international stage.

The Ny Carlsberg Glyptotek stands witness to the remarkable achievement of two Danish collectors: Carl Jacobsen and his son, Helge. Their accumulation of works of art, made possible through a fortune built on the family brewery, was fired by Carl Jacobsen's passion for sculpture and his interest in Classical antiquities, and by Helge's commitment to extend his father's collection into the realms of Impressionism and Post-Impressionism, informed by distinguished scholars and advisors. Father and son were driven by patriotic and philanthropic principles to bring examples of the Golden Age of Danish art to the Danish people, and to provide solace, aesthetic pleasure and enlightenment to the public. Carl Jacobsen's original collection of Danish Golden Age art and his nineteenth-century French paintings and sculptures were given to the Danish state in 1888. Nine years later the first part of his collection of antiquities – which was to grow until his death in 1914 – followed. Funded now by the Ny Carlsberg Foundation, Helge both purchased for the Glyptotek and donated works from his own private collection. All were housed in the building designed by the distinguished architects Vilhelm Dahlerup and Hack Kampmann, to which Henning Larsen added an exceptional wing in 1996.

Many people have contributed to the selection and realisation of this exhibition. Ann Dumas initiated our discussions with the Ny Carlsberg Glyptotek, which led to their acceptance of the idea of such an ambitious project. Without the unconditional enthusiasm and involvement of the Glyptotek's director, Flemming Friborg, and his staff – notably the curators Mette Moltesen, Anne Marie Nielsen, Mogens Jørgensen and Tine Blicher-Moritz, and the head of conservation, Lars Henningsen – the exhibition and its accompanying catalogue would not have materialised. At the Royal Academy, selection and an invaluable editorial contribution to the catalogue for Greek, Roman and Etruscan antiquities was expertly handled by Mary Beard of the University of Cambridge, and for the Danish Golden Age and the French nineteenth- and early twentieth-century painting and sculpture by MaryAnne Stevens, with Ann Dumas; the Egyptian selection has benefited from the contribution of Tom Phillips RA and Norman Rosenthal. The exhibition's beautiful installation is due to the designs of Ivor Heal, and its organisation has been meticulously delivered by Hillary Taylor.

It is especially pleasing for the Royal Academy that the financial support without which this exhibition could not have been realised should have come from three leading Danish enterprises: Carlsberg, Danske Bank and Novo Nordisk. We thank them most sincerely for their engagement with this exceptional manifestation of Danish collecting and public commitment. Our thanks are also due to His Excellency the Danish Ambassador to the Court of St James, Tom Risdahl Jensen; Søren Dyssegaard, Minister-Counsellor, Press, Cultural Relations, Information, and his assistant Lone Britt Christensen, at the Danish Embassy in London; and Lord Aldington for their advice, support and encouragement at all stages in the planning of the exhibition and its opening events.

Ancient Art to Post-Impressionism: Masterpieces from the Ny Carlsberg Glyptotek, Copenhagen demonstrates two remarkable collectors' personal belief in the power of works of exceptional quality to mark people's lives. It is our hope that this guiding principle has been made manifest in the galleries of the Royal Academy. As they move from outstanding examples of Egyptian, Greek and Roman sculpture to exceptional groupings of paintings and sculpture by Købke and Bissen, Manet and Carpeaux, Monet and Rodin, Degas and Gauguin, we hope that our visitors will not only be the beneficiaries of this belief, but will also be moved to visit the home of these works in Copenhagen when its newly refurbished galleries reopen resplendent in 2006.

Professor Phillip King CBE
President, Royal Academy of Arts

A Dynasty of Brewers and Collectors

HANS EDVARD NØRREGÅRD-NIELSEN

Like many other European countries, Denmark did not come into its own as a nation state until after the Napoleonic Wars. Prior to 1848 Denmark was ruled by an absolute monarch as a hereditary realm that existed for the sole purpose of entertaining the privileged class. But when power in Europe was assumed by democratic authorities, members of a new ruling class began to compete for the honour of being their country's leading citizens.

In Denmark these changes began in Copenhagen, a city which, despite having suffered from a lack of space within its confining ramparts, had nevertheless seen a number of advances in all areas of art and science: the 'Danish Golden Age' of *c.* 1800–50 remains to this day a cultural peak in the Danish national consciousness. But this young spirit of nationalism underwent a change of character in the course of a generation or two, as Denmark was crushed by the ambitious German Confederation in 1864. The significance of Denmark's 1864 defeat cannot be overestimated, and it served to dictate most subsequent Danish events. The fearlessness of the early years was replaced by a whining defeatism which, like a lingering disease, was to prevail for the next century. On top of this the nascent democratic process, which had been simple and dignified, had been virtually abandoned during the years leading up to 1860, after demands made by the Russian tsar. Denmark was humiliated, and now her best sons vied with each other to present her with their finest work.

The idea of Denmark's new liberal democracy was seized on from the outset by J. C. Jacobsen (1813–1887), a young, unscholarly brewer who was running his mother's business in the heart of Copenhagen (fig. 1) while simultaneously trying to improve his education. In his free time he attended lectures given by the Danish scientist H. C. Ørsted at the Technical University of Copenhagen. Jacobsen admired the new democracy's idealistic politicians, headed by the outstanding L. N. Hvidt, and was deeply impressed by the fact that Copenhagen had fostered in its midst the sculptor Bertel Thorvaldsen (1770–1844), who by sheer talent had forged a career in Rome of the type that other artists had formerly enjoyed only through circumstances of birth. Busts of his three Danish role models were to follow J. C. Jacobsen throughout his life as examples of the importance of science, democracy and art to the individual citizen and his development.

J. C. Jacobsen's efficiency and energy resulted in his expanding the Carlsberg business to become one of the leading breweries in Europe (fig. 2). Impressive profits enabled him to shoulder the main financial burden of the rebuilding of Frederiksborg Castle, one of Denmark's finest royal palaces, after it was almost totally destroyed by fire in 1859. The building was subsequently turned into a museum of national history. Jacobsen was also responsible for setting up the Carlsberg Laboratory in Copenhagen as a centre for independent research.

FIGURE 1

FIGURE 2

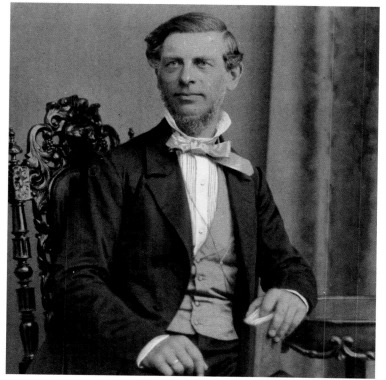

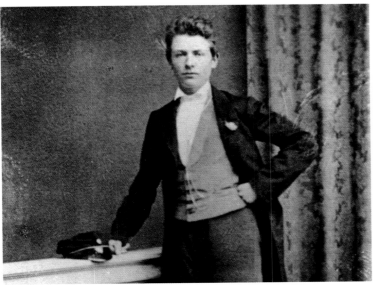

FIGURE 3

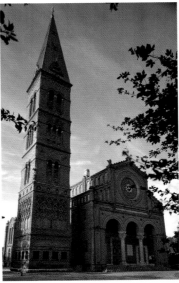

FIGURE 4

FIGURE 5

These acts of philanthropy, together with many others, were made possible only because J. C. Jacobsen – in the course of a long and bitter conflict with his only son, Carl (fig. 3) – set up the Carlsberg Foundation (in 1876) and made it his principal heir. By this time Carl had established himself as a brewer in his own right alongside his father and had become financially independent, but the distressing disagreements between father and son were to cast a tragic shadow over the two men's progress and desire to be an example to others.

Both competed to bestow lavish gifts on their oppressed homeland and its impoverished citizens. An added factor was that as an influential politician J. C. Jacobsen had been among those who had advocated going to war in 1864 in order to uphold Denmark's self-respect. His gifts to the nation were intended as a form of consolation, for he felt partly responsible for its plight. Denmark's recovery was to be promoted by knowledge, an awareness of history and an appreciation of beauty.

Carl more or less agreed with his father on this, but whereas the older man firmly believed in the educational importance of history, his son felt that art was to a far greater extent capable of ennobling and refining people. This had been his own experience from visiting museums in his childhood. As an adult, he was able to add one acquisition after another to his new home. Carl Jacobsen shared his father's deep admiration for the aforementioned Thorvaldsen, whose museum in Copenhagen had become a temple of beauty for them both, and was moreover a pantheon of many of the period's other ideals.

Carl Jacobsen collected works of art from the generation of sculptors that followed the ideals on display in Thorvaldsen's museum. In 1882 Carl Jacobsen opened his home to the public.

Visitors were able to view collections that included paintings as well as sculpture, especially from Denmark's Golden Age. He also added an increasing range of French Salon sculpture: new pieces were acquired in Paris every year. All this collecting necessitated more and more buildings in which to display the works. As far as Carl and his Scottish wife Ottilia's home life was concerned, art had become a cuckoo in the nest. During the early years of her marriage Ottilia liked to describe herself as a 'volunteer' in support of her husband's almost obsessive struggle to acquire and exhibit art. In 1888 the couple decided to make over the more contemporary part of their collection to the public. The first half of the Ny Carlsberg Glyptotek, designed by the architect Vilhelm Dahlerup, was completed by 1897. (Another of Carl Jacobsen's major donations to Copenhagen was Dahlerup's Jesus Church [fig. 4], completed in 1891, which he had determined was to be the most beautiful church in the whole of Copenhagen; the interior is particularly magnificent. The Jacobsen family vault is in the crypt.)

Reference to the more contemporary part of the collection is due to the fact that in 1887 Carl Jacobsen had travelled to Greece and Rome, where he had discovered that works of art dating from Antiquity could be purchased. After a few initial blunders he renewed his efforts, and by dint of endless financial sacrifices (and with the help of sound advice from many quarters) he began to fill the rooms adjoining his private apartments with a steady flow of works from Rome, Greece, Egypt and Etruria (fig. 5). One major acquisition after another stood out from the lesser works, and Carl Jacobsen and his wife decided to add this collection to their previous donation, provided that the major expenses involved in the completion of the Ny Carlsberg Glyptotek would be met by the state. Despite agreement over this, the couple had to put up

Figure 6
The façade of the Ny Carlsberg
Glyptotek's Dahlerup Building, 1911

Figure 7
The opening ceremony of the
Ny Carlsberg Glyptotek, 27 June 1906

considerable sums of their own money to ensure that the building was completed in accordance with Carl's vision. Ottilia had long been concerned on her children's behalf by the way things were developing, and she began to see with increasing clarity how ruthlessly he was prepared to plunder his family's future heritage in order to satisfy his growing passion as the creator of a museum. Tragically she lost confidence in him and his repeated promises to safeguard their children's heritage. Nevertheless, Carl insisted on retaining her as a co-founder, as can be seen in the double portrait from the Ny Carlsberg Glyptotek's vestibule (cat. 138), which was begun by the sculptor Ludvig Brandstrup (1861–1935) shortly after Ottilia's early death in 1904. In contrast to her husband, she is portrayed with eyes that no longer see, yet with a hand on his shoulder that is both protective and slightly restraining, a hand that he was to miss enormously after her death.

Carl acquired large quantities of works of art for all the Ny Carlsberg Glyptotek's departments. His debts to artists such as Rodin ran into millions, and the more strained his family situation became the more he began to fear that in the event of his untimely death, the Glyptotek would not be completed in accordance with his wishes. His continuous overspending brought the brewery to the brink of ruin, and it was therefore a stroke of genius when in 1902, just after the twenty-fifth anniversary of his father's establishment of the Carlsberg Foundation, Carl donated his own brewery to this foundation with the proviso that a *new* Carlsberg Foundation be established to safeguard the interests of art in Denmark. Although partly, perhaps, a late display of filial affection, the donation also enabled Carl to secure a loan with which to complete the building of the Ny Carlsberg Glyptotek and to round off his collecting activities.

The handing over of the brewery and the signing of the Ny Carlsberg Foundation's trust deed were finalised in the summer of 1902, but the size of the debts, together with the fact that the Ny Carlsberg Glyptotek was not completed until 1906 (figs 6, 7), meant that to start with Carl Jacobsen had no appreciable sums of money at his disposal. Although he had demonstrated how he thought his vision should be carried through, he also regarded it as imperative that areas such as landscape gardening and industrial art should be supported.

At his death in 1914 Carl Jacobsen was succeeded as chairman of the Ny Carlsberg Foundation by his son Helge (1882–1946), but it was not until the mid-1920s that funds were sufficient to permit major disbursements beyond the Glyptotek's immediate needs. The close relationship between the Glyptotek and the foundation, based more on tradition than on any specific instruction, has been maintained, so that the Glyptotek's collections are essentially due to Carl Jacobsen and subsequently the Ny Carlsberg Foundation. But over the past 75 years the foundation has been an indispensable partner in the acquisition of works of art that would otherwise be beyond the Glyptotek's means. Increasingly large purchases of Danish art have led to the founding of art museums all over Denmark. The breadth of these activities is indicated, for instance, by the fact that during the depression in the 1930s the Ny Carlsberg Foundation both financed the furnishings of the Royal Chambers in Christiansborg Palace and contributed to the establishment of beautifully designed recreational areas for the large number of unemployed people at the time.

In the course of his travels in southern Europe, Carl Jacobsen was particularly struck by art that was part of everyday life, works of art that required no museum. He found the idea inspiring and

FIGURE 6

FIGURE 7

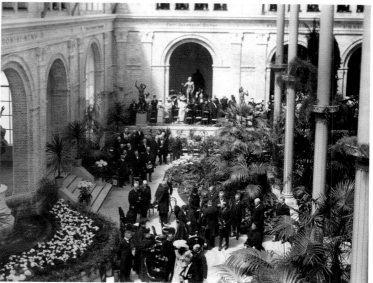

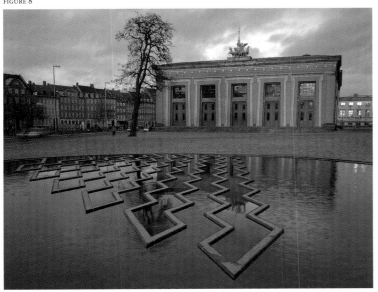

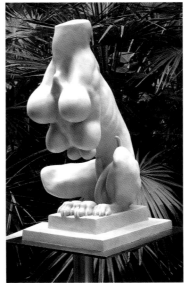

Figure 8
Thorvaldsens Plads, with
Jørn Larsen's fountain in front
of Thorvaldsens Museum

Figure 9
Louise Bourgeois, *Nature Study*, 1984.
Latex, 76.2 × 48.3 × 38.1 cm

elevating, and in 1879, in order to create something similar in Denmark, he set up the Albertina Trust, named after Thorvaldsen's Roman name, Albert. The trust has financed many copies of major works of Antiquity as well as examples of Danish and French sculpture executed during Carl Jacobsen's own lifetime. These have left their mark on many parts of Copenhagen. The Albertina funds were only exhausted in recent years. As its final donation, the Albertina Trust, with the Ny Carlsberg Foundation and other donors, established a more successful arrangement of a hitherto somewhat chaotic area in front of Thorvaldsens Museum (fig. 8). This was executed by the painter Jørn Larsen in 2002 in collaboration with the landscape architect Torben Schönherr.

Carl Jacobsen and his father never missed an opportunity to teach or instruct. For them, the experience of art was not part of an obligatory syllabus, not always dependent on the help of a catalogue, but a tryst with something beautiful when one least expected it. Carl Jacobsen was able to alternate the enjoyment of art with that of a good cigar outdoors, and he sought to perpetuate this by establishing a Winter Garden in his new museum. In his speech at the opening in June 1906, he hoped visitors would 'pause between the two collections', like those 'resting awhile by the fountain' in the Belvedere Court of the Vatican Museums in Rome. A line in one of Goethe's poems reflects the type of encounter with beauty that delighted Jacobsen: 'Und Marmorbilder stehn und sehn mich an'. With the help of Carl Jacobsen's two creations, the Ny Carlsberg Glyptotek and the Ny Carlsberg Foundation, it has been possible for us to continue from where he left off in 1914.

It must be regretfully acknowledged that there could have been many more additions to the Glyptotek's collection had it not been for a long series of currency restrictions during and after the Second World War, and the many forms of taxation on foundation activities subsequently imposed in Denmark. Nevertheless, an attempt has been made to extend the collecting range proposed by the founder himself. In addition it has been our good fortune that, thanks to his large donation of works by Gauguin and others, Carl Jacobsen's son and successor, Helge, contributed to establishing a solid foundation for the collecting of French Impressionist painting – a genre that Carl Jacobsen abhorred. (On the aesthetic disagreements between father and son see Flemming Friborg's essay, 'The Clash of Generations', below.)

The Glyptotek's collections may be well balanced, but there are still gaps to fill. Priorities must be established at a time when more and more people expect to acquire knowledge in a museum without necessarily possessing much art-historical background themselves. As a result the Glyptotek and the Ny Carlsberg Foundation have decided to make the existing collections more accessible, rather than expand them. In 1996 a new wing was added to the museum, and in response to the demand for more and better information about the collections a major rebuilding programme has been instituted; it is this that has made it possible for works from the Ny Carlsberg Glyptotek to visit the Royal Academy of Arts in London. Both phases of development have been completed with financial support from the Carlsberg foundations, and will equip the Ny Carlsberg Glyptotek for the needs of the future. Spiralling price rises in the art market, and our reluctance to acquire antiquities tinged with any sheen of illegality, will make it necessary for us to consider that future very carefully. In the midst of it all, one of our latest acquisitions, Louise Bourgeois's *Nature Study* (fig. 9), sits like a sphinx, watching.

FIGURE 8

FIGURE 9

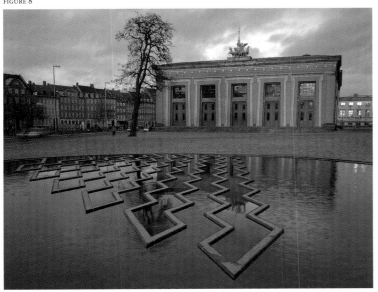

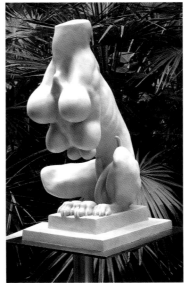

Carl Jacobsen and Wolfgang Helbig: Perfect Partners in Ancient Art

METTE MOLTESEN

The story that lies behind the Ny Carlsberg Glyptotek's collection of antiquities has two main characters: the Danish brewer Carl Jacobsen, and his agent, the German archaeologist Wolfgang Helbig (see cat. 215). The setting for this story is Rome in the years around 1900.

Carl Jacobsen's prime interest was sculpture, but at first his collection developed slowly. He bought his first work of ancient art in 1879: the head of an archaic male statue, from about 520 BC, found in Athens and acquired at an auction of the possessions of the French archaeologist Olivier Rayet. Although today it is regarded as one of the masterpieces of the Ny Carlsberg Glyptotek, it was never a favourite of Jacobsen's; Greek archaic art was not then in vogue. In 1882, when Jacobsen opened his art collection to the Danish public, his holdings still fitted comfortably into one room at the Carlsberg brewery outside Copenhagen. As an early photograph (fig. 10) shows, this was a motley group of sculpture from different periods: as well as the *Rayet Head* it included the so-called Casali Sarcophagus of the second century AD, which he had acquired in 1883 from the Casali Collection in Rome; a clutch of tomb portraits from the desert town of Palmyra; some copies of Roman bronze statuettes; and a plaster cast of the famous fifth-century BC *Discobolos* by Myron.

Jacobsen's meeting with Wolfgang Helbig in 1887 was to have a great impact on his acquisition of sculpture. It came about through the purchase of an Etruscan tufa sarcophagus. Helbig had offered this fine work, depicting a female demon of death on its lid and the entrance of the dead into the afterlife on its front (fig. 11), to the director of the Danish National Museum, who declined the offer; Carl Jacobsen bought it instead. Immediately afterwards, Jacobsen made enquiries with the Danish consul in Rome, Christoffer Myhlenphort, into Helbig's background, but received a disappointingly negative report. Myhlenphort was convinced that Helbig would only offer Jacobsen the objects that were rejected by German museums and probably also at exorbitant prices. Fortunately Jacobsen took no notice. Wolfgang Helbig, a native of Saxony, was in fact no admirer of Prussia and the new German order, and never favoured the German museums over the Glyptotek.

From this point on, until Jacobsen's death in 1914, Helbig was instrumental in acquiring works of ancient art for the Glyptotek. Only a few months after their first encounter Helbig helped Jacobsen to obtain a unique group of Roman portraits of exquisite quality, fifteen of them allegedly found together in a tomb belonging to the Roman aristocratic family of Licinius Crassus, including a now-famous portrait of Pompey the Great (the adversary of Julius Caesar) identified by Helbig himself. When the portraits arrived in Copenhagen, after a brief sojourn in Paris, Jacobsen was delighted: 'It is especially moving to see these important beings in all their earnestness; they stand as if they were wandering right out of the tomb together' (letter to Helbig,

3 October 1887). Portraiture was to remain a major preoccupation. The acquisition of the Licinians was the starting point for one of the largest and finest collections of Roman portraits in the world. The Glyptotek now holds some 350, mostly from Rome.

In all, Jacobsen acquired 955 Greco-Roman and Etruscan works through Helbig. Nearly half of these were placed in the Etruscan collection, which Jacobsen named the Helbig Museum (a view of the collection is shown on pages 210–11). In 1889 Jacobsen offered Helbig 5,000 francs a year and the title of deputy director of the Glyptotek. Helbig declined the title but accepted the annuity, which he received until Jacobsen's death. Although he acted as an intermediary for other museums, Helbig regarded himself so much the representative of the Glyptotek that he demanded the monopoly of acting for Jacobsen in Rome. The collection of ancient sculpture in the Glyptotek is very much the joint creation of the two men.

Wolfgang Helbig (1839–1915)

Helbig was born in Dresden in 1839 and studied Classical philology and archaeology at the University of Göttingen and later in Bonn. He arrived in Rome in 1862 with a scholarship as a 'ragazzo' at the Instituto di Corrispondenza Archaeologica, the precursor of the

FIGURE 10

FIGURE 11

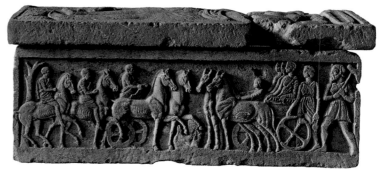

14

present German Archaeological Institute in Rome, which was founded in 1829. In 1865 Helbig was appointed 'second secretary' (zweite Sekretär, equivalent to deputy director) of the institute. One of his main functions was to follow building works in Rome closely and to report on archaeological discoveries in the journals of the institute.

In 1887 Helbig left the institute, partly because of his disappointment at not being asked to become its director, but also as a reaction to the 'Germanisation' that the institute had undergone under Bismarck when it became an institution of the Prussian state. German was to be the only language permitted in lectures and publications, while women were not to be allowed to participate in any of its guided archaeological tours. Unhappy with these developments, Helbig moved from the Capitoline Hill, where the institute was then based, to the Villa Lante on the Janiculan Hill (see fig. 19), a wonderful villa designed by Giulio Romano, which enjoyed a panorama of the entire city. There he stayed until his death, more Roman than the Romans (he was the only German permitted to remain in Rome during the First World War).

His was a privileged and cosmopolitan world. Helbig was married to a Russian noblewoman whose family had until 1905 owned large estates in Russia: Nadina Shakowskoy, a gifted pianist

FIGURE 12

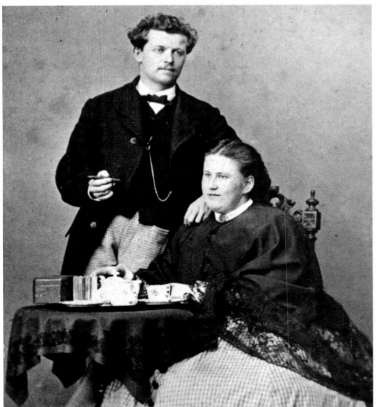

and a pupil of Franz Liszt (fig. 12). The marriage brought Helbig into contact with prominent musicians and artists (they visited Wagner in Bayreuth, and Nadina stayed with Tolstoy in Russia), noble families in Russia and the German states, and the highest aristocracy in Italy, many of whom owned collections of art and antiquities. This gave him an advantage as an agent in ancient sculpture, and he was always careful to cultivate the 'major-domo' of a household, who would be party to his master's financial affairs and therefore aware of the likelihood of his being willing to sell works of art.

Helbig dined frequently with Prince Borghese, owner of one of the greatest collections in Rome. When the prince faced bankruptcy Helbig managed to acquire several of his finest pieces, notably the statues found at the Roman villa on Monte Calvo (cats 91–4). He also bought several masterpieces from the Sciarra family – including the *Sciarra Amazon* (cat. 57) and the statue of a young man now known as the *Sciarra Bronze* (cat. 45) – and attempted to broker a major deal with the Ludovisi family. The Villa Ludovisi was the grandest villa and park on the northern outskirts of Rome. In 1884 it was sold for development as the Quartiere Ludovisi, the area around the present Via Veneto. Helbig knew Prince Ludovisi, who built a new palace to which he moved his large collection of sculpture. In 1892 Jacobsen paid the collection a visit and noted which sculptures he wished to buy. In 1898 he and E. Perry Warren, who bought ancient art for the Museum of Fine Arts in Boston, drew up several plans for acquiring the entire collection and splitting it between them, but they were unsuccessful. The majority of works in the collection were acquired by the Italian state and are now exhibited in the Palazzo Altemps in Rome. Only a few sculptures (including the *'Peplophoros'* [cat. 58]) came to Copenhagen.

Helbig's own work lay between dealing and academic archaeology. As was typical of the period, he had a foot in both camps. He had close connections with other dealers and collectors in Rome, including the charismatic Polish count Michael Tyszkiewicz, through whose hands the Licinian portraits passed, and the Italian senator Giovanni Barracco, whom he also helped to create a major collection of sculpture (which was eventually donated to the city of Rome and is now known as the Museo Barracco). Barracco and Jacobsen had the same taste in sculpture, and Helbig sometimes had difficulty preventing them from bidding for the same works. Another vital associate was Francesco Martinetti, an 'antiquario' who bought and sold antiquities and cleaned and restored bronzes and coins, sometimes even 'improving' them. Martinetti helped to procure export permits for ancient sculptures through his connections with the members of the antiquities commission, sometimes succeeding in getting a very low estimate of a piece's value by taking it apart and sending first the head and later the body. It is difficult to be certain how often outright fraud was involved.

Helbig has himself been accused of faking and forgery, and one or two of the objects he sold to Jacobsen were clearly fakes.

At the same time Helbig had great archaeological knowledge and expert insight into the topography and excavations of Rome. He was also a prolific scholar who wrote on a wide range of subjects, mainly the early cultures of Italy and Greece, but also Roman wall-paintings from Campania and Etruscan artefacts. Best known of all is his *Führer durch die öffentlichen Sammlungen klassischer Alterthümer in Rom*, still the best guide to the collections of the Roman museums.

The correspondence

Much of our information on the collaboration between Jacobsen and Helbig comes from the letters they exchanged throughout their partnership, often several times a week. From them we can reconstruct the day-to-day process of the purchase of individual pieces. The postal service at the time seems to have functioned much better than it does now: it was possible for a sculpture to be offered for sale, purchased and paid for, all in a week. But the correspondence also allows us to follow the formation of the collection more generally and to understand the aims of the two men, as well as offering an insight into their interaction and other more personal issues, such as finding suitable sons-in-law and later the frailty of their old age.

From the letters, it is clear how quickly Carl Jacobsen formed a high opinion of Helbig and his talent for producing attractive works of art. 'I am beginning to wonder', Jacobsen wrote in 1893, 'whether you are a learned scholar or rather a medieval magician who only needs to shake the tree to have golden apples fall in his lap.' To which Helbig answered: 'When I sometimes succeed in making a spectacular acquisition, I owe it solely to an instinct I have for discerning whether people are in need of money or not'– as if to imply that it was to the magician rather than to the scholar that Jacobsen owed his gratitude. It is also clear that Jacobsen's ambitions for his collection grew very soon after the beginning of their collaboration. In July 1887 he formulated his vision to Helbig in these terms: 'My plan is probably the same as my great model, the old king Ludwig, had in Munich: to create a sculpture collection as beautiful, as rich and as educational as possible. Since Copenhagen in that respect is an open book, one can start at will.' And he continues: 'The speciality of the Glyptotek to my mind shall be this: to show my fellow citizens the most beautiful that art can create and has created. And apart from these in the finest sense of the word, "art-works", it would also be interesting to represent the different types of ancient sculpture: emperor statues, priests and Vestal virgins. A series of busts of the Roman emperors would supplement the Licinians.'

Alongside these noble ambitions, there is plenty of evidence of the wheeling and dealing necessary to secure the desired objects. Not all acquisitions were exported in an entirely legal way and a certain amount of secrecy was required. At difficult times Helbig asked that his letters be addressed to Selma, his wife's faithful servant, while statues themselves were given code-names to conceal their identities: the *Sciarra Bronze* was 'Emil the second' (the bronze *Hercules* [cat. 50] had been the first 'Emil'); the *Amazon* masqueraded under the name of Anna or 'Emil's sister'; and the Borghese Poets (see cat. 91) were carefully referred to as 'Dupont' and 'Armstrong'. There was also the problem of delivery and transport. Prince Sciarra was so desperate to get rid of his bronze statue that his secretary offered to take it to Paris himself in a suitcase. Jacobsen was surprised when he received a telegram announcing its arrival, especially as he found it an ugly and primitive work, not Greek by his standards at all. In general this correspondence must count as one of the most important archives in the history of collecting.

Carl Jacobsen, the museum owner

Jacobsen himself was a serious student of ancient art, not merely a rich collector slavishly dependent on the expertise of his archaeological adviser. The two men disagreed on a few major issues. Jacobsen did not share Helbig's very low opinion of sarcophagi (which Helbig regarded as mere picture books) and for years, despite Helbig's lack of enthusiasm, Jacobsen tried to acquire the beautiful examples, now at the Walters Art Museum in Baltimore, that had also come from the Licinian Tomb. Although he spent much of his time developing new kinds of beer, Jacobsen was well read, followed the most recent art-historical literature in English, French and German, and even contributed to that literature himself. In 1903 he wrote his first archaeological article in the French periodical *Revue archéologique*, on a portrait of the Roman emperor Caracalla as a young man. Helbig acknowledged Jacobsen's effort and encouraged him to continue: 'Vivat sequens!'. Jacobsen also wrote a catalogue for his whole collection, adding a supplement, to include new acquisitions, every year.

The art-historical theories of the time were reflected in the layout and organisation of his museum (fig. 13). We know that he discussed Adolph Furtwängler's *Meisterwerke der griechischen Skulptur* with Helbig immediately upon its publication in 1893. This extremely influential work attempted to identify the 'original' Greek masterpieces that supposedly lay behind much Roman sculpture (examples of which were themselves relegated to the status of 'copies'). Although recently challenged, this way of thinking about ancient sculpture has survived into modern times. In the Glyptotek a gallery is still devoted to 'Greek' portraits, in fact Roman copies of Greek portrait sculpture.

Jacobsen's ultimate goal was a display constructed on chronological lines. Not so much interested in the archaeological context of the works in his collection, he preferred to concentrate on the chronological and developmental story of ancient art that they could illustrate. In 1889 he wrote to Helbig: 'In the beginning

Figure 13
The Greek Portrait Gallery at the first
Glyptotek, 1896

FIGURE 13

I placed my sculptures after their artistic value because there
were too few to create a chronology. But now I have begun to plan
a chronological setting. The lantern hall is entirely occupied by
Greek works. This also constitutes a new era for a new principle.
Previously the hallmark of the collection was artistic – to achieve
the most beautiful – now it is also about bringing the historical
side to the fore.' Modern priorities in art history and archaeology
may have changed; and paradoxically for modern scholars the
possibility of reconstructing the original context of several of
the sculptures and sculptural groups has proved one of the most
important aspects of the Ny Carlsberg collection. Nonetheless
in its magnificent setting in Copenhagen, the story of ancient
art selected for us by Jacobsen and Helbig remains an attractive
and powerful one.

Archaeology and Collecting in Late Nineteenth-Century Rome

MARY BEARD

'Never has the Roman soil yielded such a magnificent archaeological harvest as within the last few years.' So in December 1887 Rodolfo Lanciani (fig. 14), Italian engineer, journalist and an archaeologist who had himself witnessed the harvesting of much of this bumper crop, summed up recent discoveries in one of his regular columns for British readers, 'Notes from Rome', published in the *Athenaeum* magazine. He went on to explain that he had recently returned to Rome after a few months' absence to find that 'not fewer than eleven hundred Latin and Greek inscriptions have come to light from our inexhaustible mine of antiquities.' This was in addition to the haul of sculpture, frescoes, silver and jewels whose description was to dominate his 'Notes' for 1888.[1]

This was an archaeological boom that far outstripped the earlier much-heralded discoveries by Renaissance collectors and antiquarians, rivalling even what was later uncovered in Mussolini's aggressive campaigns to bring imperial Rome back to light. Its origins can be traced to the day in September 1870 when the Piedmontese forces finally took Rome from papal control and instantly set about turning it into the capital of the new united Italy. Quite simply, the building operations required to equip the old papal city with the government buildings, residential quarters, transport networks and urban infrastructure necessary for a modern state capital could not help but stumble across the remains of the ancient city under the ground. Archaeological discoveries by the wagonload were the by-product of Roman expansion and modernisation.[2]

The speed of Rome's development through the 1870s and 1880s is without parallel in any modern European city. In 1870 the population was barely more than quarter of a million and large parts of the area within the ancient Aurelian walls were effectively open countryside or farmland. Within twenty years the population had doubled and the urban occupation vastly extended. Lanciani himself, in the preface to his *Ancient Rome in the Light of Recent Discoveries* (a book written in English for the Anglo-American market), details the physical changes in the city with an engineer's precision: 'Between January 1, 1872, and December 31, 1885, 82 miles of new streets have been opened, paved, drained, and built; new quarters have sprung up which cover an area of 1,158 acres; 3,094 houses have been built or enlarged with an addition of 95,260 rooms; 135 million lire (27 million dollars) have been spent in works of public utility and general improvement.' Or, as he put it in another way, '*two hundred and seventy million cubic feet of that land of promise*' had been dug up in the process of improving Rome.[3]

The promise did not disappoint, either in quality or quantity. Some of the most renowned works of Roman sculpture, painting and mosaic emerged from the ground during this period. The building development in the area of the Esquiline Hill, where the great imperial pleasure parks (or *horti*) had once been, produced particularly spectacular finds: the so-called Esquiline Venus (fig. 15), for example, and the famous bust of the emperor Commodus in the guise of Hercules (fig. 16); both are now in the Capitoline Museum. But beneath any blow of spade or pickaxe a masterpiece or some other significant find might lurk: from the extraordinary stuccoes and paintings of the imperial Villa of the Farnesina (now in the National Archaeological Museum at the Palazzo Massimo) discovered during the construction of the Tiber embankment to remains, in the shape of burials and pottery, of the prehistoric phases of the city's development. Literally thousands upon thousands of antiquities found their way into the hands of private

FIGURE 14

FIGURE 15

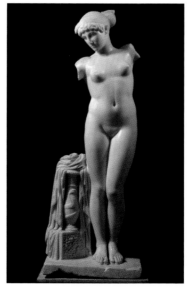

FIGURE 16

Figure 14
Excavation of the Via Nazionale on the Quirinal, showing the remains of buildings of different periods. Photograph from Rodolfo Lanciani, *The Destruction of Ancient Rome*, 1901

Figure 15
The Esquiline Venus. Marble, Roman copy of a Greek original, from the Villa Palombara, first century AD. Museo Capitolino, Rome

Figure 16
Bust of the Emperor Commodus in the guise of Hercules, from the Esquiline. Marble, 190 AD. Museo Capitolino, Rome

Figure 17
Remains of the Portico of Octavia, in the Jewish ghetto, Rome. Engraving from Rodolfo Lanciani, *Ancient Rome in the Light of Recent Discoveries*, 1889

collectors and into public museums in Rome and abroad. Lanciani again added up the number of objects that had come into the collection owned by the city of Rome itself (not including the museum of the church or the new Italian state). Between 1872 and 1887 (the time of writing of his *Ancient Rome*) these acquisitions included: '711 gems, intaglios, cameos ... 152 bas-reliefs; 192 marble statues in a good state of preservation; 21 marble figures of animals; 266 busts and heads; 54 pictures in polychrome mosaic ... 36,679 coins of gold, silver, and bronze.'[4]

Not all contemporary observers were enthusiastic at the speed or the style of the discoveries. In fact, Lanciani's triumphalist rhetoric was in part a reply to the worries of those who were loudly lamenting the destruction of the character of the old city that came with the new developments – including the demolition of some of its most picturesque corners (such as the traditional Jewish ghetto) in the name of hygiene, modern planning and urban services (fig. 17). Among the most eloquent opponents was the German historian Hermann Grimm, whose open letter of 1886, aptly titled 'Vernichtung Roms' (Destruction of Rome), complained that 'this wonderful historical sanctuary ... this sacred ground is abandoned to the hands of speculators'.[5] As early as 1873, his compatriot, the historian Ferdinand Gregorovius, had also lamented the furious pace of the building work: 'Almost every hour witnesses the fall of some portion of ancient Rome.'[6] These criticisms could partly be dismissed as visitors' romantic nostalgia for the superficial charm (to outsiders at least) of old-fashioned living conditions and the lack of modern amenities. Not so the objections of archaeologists in 1883 to the plans for the erection of the vast monument to Victor Emmanuel on the side of the Capitoline Hill (the 'wedding cake' or 'typewriter' as it is often

FIGURE 17

known); they pointed to the destruction of ancient and medieval sites that it would entail.[7]

Recent archaeologists have likewise deplored what was happening in Rome in the late nineteenth century. Even by the standards of the time, there was very little 'excavation' in a scientific sense. Finds were dragged out of the ground as they were spotted in the course of building and other engineering work. There was often little or no care taken to record where they had been unearthed and their context was destroyed as construction pressed on. The frescoes and stuccoes from the Villa of the Farnesina may have been preserved in the National Museum, but the villa itself, along with granaries, tombs and a stretch of the ancient city wall, was completely destroyed by the new Tiber embankment (albeit a necessary project aiming to prevent the terrible floods which regularly afflicted the city). A new road scheme ploughed through one of the most grandiose surviving sections of Nero's Golden House. The construction of the Ministry of Finance involved the demolition of part of the Baths of Diocletian, as well as a section of the Republican city walls, ancient streets and houses on either side, and the water tanks that marked the ends of three of the main aqueducts coming into Rome. In an ironic twist – given the archaeological destruction the building of the ministry had involved – its plan included a brand new bronze statue of the legendary Roman centurion whose words, casually overheard by the senate ('plant the standard, we will do best to remain here'), were taken as an omen, according to Livy, to justify the rebuilding of Rome after its sack by the Gauls in the fourth century BC. He was to stand for (and legitimate) the Italian recovery of their capital in 1870. For us he offers a neat symbol of the complexity of the nineteenth-century city's relations with its ancient past.[8]

The new government was not blind to the need to protect what we would now call the archaeological heritage of the city of Rome. In 1870, less than two months after taking the city, the Soprintendenza per gli scavi e la conservazione dei monumenti della provincia di Rome (the Superintendency of Excavations and Conservation of Monuments in the Province of Rome) was established. Very soon after, the state acquired the sites of Hadrian's Villa at Tivoli and Ostia Antica, which more or less put an end to opportunistic private treasure-hunting, and it sponsored a programme of excavations in the Forum, partly to provide work for the unemployed (it was here in 1898 that Giacomo Boni embarked on the first stratigraphic excavation in Rome). Meanwhile in 1872 the local government of the city (the 'Comune'), which to this day shares the responsibility for the city's archaeology with the 'Soprintendenza' of the Italian state, established an archaeological commission, including Lanciani as one of its members. Yet no new legal framework governing excavation or the sale and dispersal of antiquities was drawn up until 1909. Instead the old rules of the papal government, as

formulated by Cardinal Bartolemeo Pacca in 1820 (in what became known as the 'Editto Pacca'), were restated. Among other things, these rules attempted to regulate the trade in antiquities, restricting and/or taxing exports.[9]

The restated 'Editto' did not in practice do very much to impede the activities of dealers or, in many cases, the flow of ancient works of art abroad. It certainly remained a consideration in the negotiations between suppliers and collectors, but more often as something to be worked around than an insuperable obstacle to the trade. There are many reasons for this. First, the terms as drawn up in the papal state were an antiquated instrument for the regulation of trade in the new national capital. Second, neither the state nor the Comune provided sufficient resources or personnel to police excavations and sales that were strictly illegal. Moreover, the quantity of finds emerging from the ground would probably have defeated even the best-funded modern antiquities service. Material was coming up all over the city, not just from public works but from almost unregulated development on privately owned land sponsored by private, and sometimes fly-by-night, speculators. Add to this one of the other consequences of the building mania at the period, namely the financial crash of the late 1880s which saw over-extended aristocrats such as the Borghese family attempt to realise hard cash through the sale of their ancestral collections of art and antiquities.[10] There could hardly have been a better time than this to acquire a collection (as Carl Jacobsen did) of major sculpture from Rome. It is certainly not difficult to see why the systems of control made little impact. Indeed, even where there was public intervention, the museum structure could barely cope with much of the material that it did take into its care. It was only recently, for example, that the

terracotta fragments from Republican sanctuaries on the Capitol, lost after coming to light in the building of the Victor Emmanuel monument, were 'rediscovered' in the National Museum.[11]

The traditional system of private enterprise that had played such a major part in the dispersal of Roman antiquities since the Renaissance remained in place because there were no other procedures to handle antiquities once they left the ground, certainly not in the bonanza quantities of the late nineteenth century. The reason for the relative lack of conflict between the public authorities and the private dealers was simply that there were more than enough finds to go round, and a lot more than those authorities could on their own have regulated, administered, stored or displayed. The antiquities business, from the original discovery through the series of links on the chain of sale, to the publication, classification and study of the material, involved almost every sector of Roman society. Both Italian and foreign residents played their part: the building workers who pocketed any of the smaller treasures their pickaxes revealed (if it was too big for the pocket, the usual practice was to bury it conveniently on the site and come back to retrieve it by night[12]) no less than the members of the elegant and scholarly antiquarian *soirées* who would gather with the likes of Wolfgang Helbig, one time 'second secretary' (the equivalent of deputy director) of the prestigious German Archaeological Institute at Rome, and his Russian princess wife (fig.18), at his wonderful villa (the Villa Lante) on the Janiculan Hill overlooking the city (fig. 19). There was no clear split, such as we have come to expect, between those working for the public and academic institutions and those who acted as dealers themselves, or at least intermediaries between collector and dealers. Not only Helbig himself, who was agent for

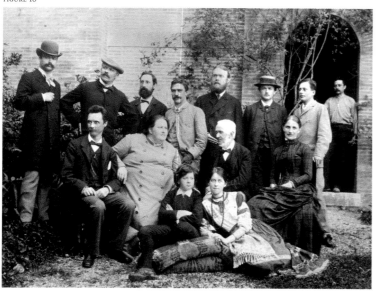

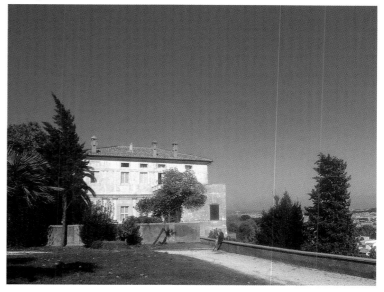

Jacobsen and others, but Augusto Castellani – one of the founding members of the archaeological commission of the Comune and in due course director of the Capitoline Museums – had a foot in both camps, as the brother of the notorious gem dealer Alessandro.[13] Ludwig Pollak, too, bought and sold antiquities, advised the rich collector Giovanni Barracco on his purchases and later became the honorary director of the Museo Barracco, when it was bequeathed to the Comune on Barracco's death.[14]

The memoirs of the Polish count, Michael Tyszkiewicz, one of Jacobsen's suppliers, capture the romantic side of the world of nineteenth-century collecting in Rome. Writing shortly before his death in 1898, Tyszkiewicz reminisces about the Sunday market at the Piazza Montanara (a square long since demolished) where the farmers came, counting on 'finding buyers for the tiniest objects they had come upon during their work in the field' and where 'the cunning peasants' would try to hoodwink the amateur collectors, while employing agents themselves to outsmart the professional dealers. Elsewhere he proudly boasts of the clever profit-sharing schemes he devised to ensure that the workmen on his excavations did not pocket all the best finds, and recounts the intricate trickery he played on others – or they on him – in the interests of securing a bargain.[15]

Yet there are other sides to Roman collecting and dealing during this period which Tyszkiewicz's elegantly ironic (and self-justifying) account does not raise. First, it is clear that some of this activity skirted very close to the law. Although the exact legal requirements could be hazy, although there were plenty of loopholes to exploit, and although the rights and wrongs of any individual case will almost always be debatable (especially at a distance of more than a hundred years), some dealers and their intermediaries went further than even the Roman authorities could tolerate. Lanciani himself, for example, was subject to an enquiry after it was revealed that he had arranged the export of various pieces to museums in Boston and Chicago without an export licence; he was forced to resign from his post in the administration of museums and excavations.[16] Second is the issue of forgery. Puzzling as it is that forgery would seem worthwhile in a period when there was such a surplus of genuine new discoveries, as always the interests of the market (combined occasionally with academic ambition) prompted more or less wilful falsification. Among the series of exceptionally high quality pieces of Roman sculpture that Helbig acquired for Jacobsen, it has been argued (and seems likely to be true) that on a couple of occasions, in collaboration with a dealer, restorer and engraver, Francesco Martinetti, he contrived to pass fakes onto Jacobsen. It is almost certainly the case that, again in collaboration with Martinetti, Helbig went to the extraordinary lengths of forging the inscription on an Etruscan-style brooch which he claimed had been found in a tomb at Palestrina. For many years this inscription was taken to be the earliest surviving Latin text that we have and

took an honoured place in the study of the history of the Latin language. It is now widely accepted to be the work of the skilful engraver Martinetti, writing on a plain Etruscan brooch to the instructions of Helbig.[17]

There is, however, a final twist in the story of Martinetti. For in the 1930s when Mussolini's men were demolishing the houses in the area of the proposed Via del Impero (or 'dei Fori Imperiali' as it is now known), one of them put his pickaxe into what had obviously been a hidden and forgotten strongbox. Inside were a collection of more than 400 antique coins, mostly gold, 200 of them Roman; in addition were more than 2,000 nineteenth-century coins plus some 65 rings, seals and gems, ancient and modern. It turned out that the house, 101 Via Alessandrina, had belonged to Francesco Martinetti; the treasure left hidden at his death and not recovered included his share of a collection of gems acquired in partnership with Tyszkiewicz and described in the count's memoirs. There is a rich irony in this hoard of one of the leading late nineteenth-century dealers finally being unearthed during the next great wave of archaeological and urban schemes – that of the Fascist period.[18]

1. Lanciani 1887.
2. Sartorio and Quilici 1983 (especially the essays of Sartorio, Ramieri and Quilici); Moatti 1993, pp. 121–4.
3. Lanciani 1888, p. ix.
4. Lanciani 1888, p. x.
5. Quoted in Quilici 1983, p. 61.
6. Entry of 12 January 1873, in Gregorovius 1911.
7. Quilici 1983, p. 57.
8. Quilici 1983, pp. 53–7; Livy, *History* V.55.
9. Ramieri 1983, pp. 18–19; Rome 1990, p. 19; the text of the Editto Pacca is given in Emiliani 1996, pp. 100–11.
10. Moltesen 1987B.
11. Di Mino 1981.
12. The hiding place was popularly called a *gatto*: 'a spot where dishonest workmen … put the antiquities or any other treasure they have been able to conceal' (Tyszkiewicz 1898, p. 92).
13. Tyszkiewicz 1898, pp. 32–6, 71–90.
14. Rome 1990, pp. 19–21; Guldan 1988.
15. Tyszkiewicz 1898, pp. 46–51, 58–64.
16. Zevi 1990, p. 8.
17. Tyszkiewicz 1898, pp. 157–69; Guarducci 1980; Guarducci 1984; Rome 1990, p. 25. Guarducci considers that other objects directly or indirectly connected with Helbig are also fakes; though the evidence in these cases is much more open. For a recent discussion of the arguments for and against the so-called 'Boston Throne' being a fake, see Hartswick 2004, pp. 119–30.
18. Rome 1990.

The Clash of Generations: Carl and Helge Jacobsen's Views on Art

FLEMMING FRIBORG

Carl Jacobsen's Glyptotek: sculpture, not painting

As far as Carl Jacobsen was concerned, sculpture was the truest expression of art throughout the ages. As a collector he bought paintings only sporadically – focusing on Italian Renaissance or Dutch and Flemish works by painters of renown – and did so without that great enthusiasm he could muster when it came to sculpture. To be sure, he triumphed when he was able to secure the Millet that marked his first acquisition of 'contemporary' painting, he bought a David portrait and some works by the main Danish Golden Age painters of the school of Eckersberg, but the abiding impression prevails that Jacobsen never developed any deeper understanding of painting as an art form. He simply did not care enough about it. When his museum came into being, it was not surprising that it was a 'Glyptotek', a collection of carved stone, not a 'Pinakothek', a collection of paintings.

Carl Jacobsen published his credo and manifesto in 1878 in the form of a letter from Paris, telling of his encounter with the French sculpture of the Salon. He asserted that France was in the vanguard in this field,[1] and his choice of words is significant:

> For us Danes there is something strange about even the best French sculpture; and, in this matter, our national character is not entirely blameless ... the powerful influence of Thorvaldsen has ... sharpened our critical sense and made sterner demands on the creatures to which sculpture has given life than in other spheres. But perhaps it is precisely this critical sense which is the reason that the great works of foreign art have only imperfectly moved us ... various Frenchmen have been tolerated, but to the point of being practically ignored. The sculpture of France is a vigorous affirmation of life: it can no longer be ignored.[2]

Jacobsen accords full justice to Thorvaldsen, but simultaneously he unhesitatingly declares that his time is past, and will accept no excuse for becoming mired in tradition. There was also an elegant patricide implicit in this reckoning with Thorvaldsen, the artistic hero of J. C. Jacobsen, Carl's father, and the great cultural bastion of his childhood home.

French Salon sculpture had that quality of permanence that to Carl Jacobsen was the very definition of 'classical'. But at the same time it was *modern* art, an art of its own time, and in this respect Denmark was lagging behind. 'Save in our own land, the products of this new breed wander the world over in incarnations of bronze in every conceivable size', as 'witnesses of this new age', he wrote. What did he see in these sculptures? *Music* by Eugène Delaplanche, his favourite, was not an easy work to admire. Jacobsen spoke warmly about its naked limbs rendered in an outstanding (un-Danish) manner, the soulful expression, the originality of the theme, and the 'Raphaelesque' spirit of the work. The young *amateur* was well aware that such spiritual over-indulgence and love of virtuoso statements in art would attract antipathy in Denmark. It was, in fact, this resistance on which his status as a patron became based. Jacobsen realised disappointedly that to install a figure such as *Music* in a Danish public space – namely the Royal Theatre, the Danish answer to Garnier's Opéra in Paris – would be impossible. Denmark was an 'inhospitable shore'. But there still might be a cure for barbarism, and Jacobsen wanted to administer it. His mission was not to turn everything Danish into something rich and French, but to focus on the necessity for self-development; via sculpture, it should be possible to move up a step or two on the ladder of aesthetic taste as well as of human enlightenment (fig. 20).

FIGURE 20

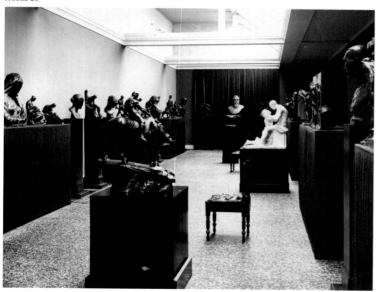

FIGURE 21

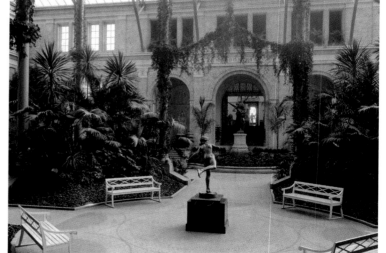

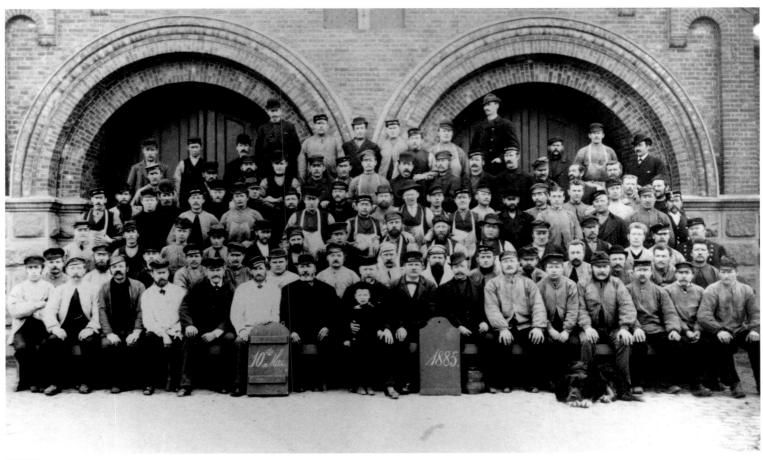

FIGURE 22

Sculpture, to Carl Jacobsen, should elevate the Danish public,
instruct artists and embellish cities – and posthumous
reputations, that of Jacobsen himself as much as that of the entire
nation. 'To have been is nothing. To be is momentary. To become is
of eternity', resounds the Latin motto that Jacobsen had inscribed
in capital letters in the Winter Garden of the Glyptotek (fig. 21).

To be modern is more than momentary:
Helge Jacobsen's sense of painting

Helge Jacobsen (1882–1946) was not the first-born son of the great
Maecenas. Alf, born in 1880, was the first of a total of eight
Jacobsen children, and the centre of Carl's attention. But the
brewer's ambitions on behalf of the dynasty were cut short when
Alf died at the age of ten. He had been his father's best hope,
and there is much evidence that something in Carl died with
the loss of this son. He was not a man to give up easily, however,
and he continued in his set path with determination and energy,
deciding to make the most of Helge and his brother Vagn
(1884–1931) as heirs to the Carlsberg line.

Helge was to be moulded in his father's image as brewer and
businessman. Carl Jacobsen's interest in the arts did not extend to
letting his son pursue a career in art history, even though the boy
showed this inclination from an early age; despite his mother's
pleas, Helge was to receive the training his father had suffered
before him. 'My parents' intention was that Birkerød [to the north-
west of Copenhagen] for me was to be the equivalent of an English
public school: little connection with home, and training in
personal independence and industriousness. Visits to home
automatically restricted themselves to once a week, however –
it was so expensive to go by train.' The immense wealth of the
Jacobsen family considered, Helge's testimony of his early
schooldays betokens an austere view of upbringing and a Spartan
attitude to spending money on themselves. After Birkerød, Helge
was sent to England to study brewing techniques and the state of
modern beer production, just as Carl had been by his father (fig.
22); and like his father, he found a bride in Edinburgh – young
Josephine, the daughter of a Scots banker. Like father, like son,
one might say, and yet changes were already afoot.

23

There is no doubt that it was difficult to be a Jacobsen, under the constant scrutiny of Carl, someone who missed no opportunity to point out the weaknesses of his sons and how they could be remedied. A few days prior to his death in January 1914, Carl Jacobsen wrote in a letter to Helge, who moments before had left his father's deathbed in a private clinic in Copenhagen: 'When from the window I saw you leave ... I noticed that your gait is very lacking in grace ... I, too, walked poorly when I was a boy, my father was always nagging me and making fun of my stoop and craning neck ... but it did not improve until I grew up, became vain and, most of all, evolved my sense of beauty.'

It hardly seems fair to call the 32-year-old Helge a boy, but it was typical of Jacobsen senior to extend the fatherly tone and his permanent, edificatory presence into every area of Helge's life, even on the eve of his own death. But proper posture or not, Helge Jacobsen had definitely developed his own sense of beauty, and in ways radically different from Carl. He managed to free himself significantly from the worst shadows of atavism, not unironically, via the arts – just as Carl Jacobsen had done with his father before him.

Helge Jacobsen, the discreet Maecenas

When Carl Jacobsen was preparing for a huge show of contemporary French art in Copenhagen in 1888, he wrote to his exhibition secretary, who was hoarding together art treasures from Parisian dealers: 'As to the Impressionists, I declare myself a non-voter. I would rather do without that kind of art, which is beyond my understanding and a nuisance. But I shall not go against you, if you want them present.'[3] As opposed to the gradual refinement of his taste for and understanding of antiquities as he went along and

was guided by experts on the subject, Carl Jacobsen's attitude to the Impressionists never changed – even though the new painting rapidly became increasingly established among collectors all over Europe. As late as 1903 he would write on a postcard to Helge from Berlin: 'One of the galleries here has a show of Manet and his like, the Impressionists. Awful, mannered and ghastly I find them.'[4]

But filial rebellion ran in the Jacobsen family, and Helge was no exception to the rule, although by the time Helge departed from his father's views on what to include in the Glyptotek, the old man had in fact died (albeit only just). Carl Jacobsen expired in January 1914, leaving the museum for Helge, already by then a collector of some distinction and the new chairman of the Ny Carlsberg Foundation (fig. 23). Focusing on Impressionism and Post-Impressionism, Helge now undertook a large-scale operation involving a network of agents and dealers. He purged the collection of 'wild oats', among them most of the plaster casts and replicas that Carl Jacobsen had lovingly put in to fill the gaps in his first concept; Rodin remained, as did Maillol, but the Salon became less the focus and heart of the French collection. The 40-odd Meuniers were restricted to a few bronzes appearing along the façade of the museum, and more Modernist works of French art were given pride of place. Helge had his own attitudes, those of a new century, based mostly on an aesthetic viewpoint that no longer believed in a didactic, historical approach, but more in displaying the best of contemporary art: French painting by Monet, the Impressionists and their heirs.

In May 1914 came a stroke of luck for the new director of the Glyptotek: the 'French Exhibition', which had been demanded and expected by Danish artists and art historians for years, was finally realised at the Statens Museum for Kunst (Danish National Gallery), with Helge as one of the main organisers. This was a

FIGURE 23

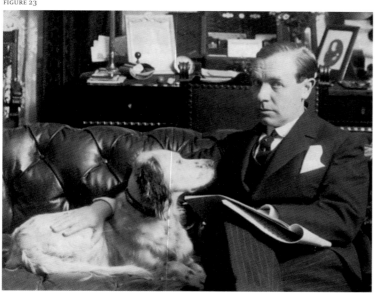

FIGURE 24

survey of nineteenth-century French art, from Delacroix and Manet through early Impressionism to Gauguin and Matisse. Because of the outbreak of the First World War, most of the 356 paintings could not return to Paris when the show closed on 30 June, and it was arranged that they be stored at the Statens Museum for Kunst and at the Glyptotek. Their prolonged stay in Copenhagen was a gift to gallerists and collectors alike: the Parisian art dealers now had a showroom out of harm's way for their wares, which they could not count on selling in war-stricken Paris, and Danish fine-art enthusiasts had plenty of time to consider artworks of a calibre seldom seen in Scandinavia, and hope of maybe making a good deal or two.

They had money aplenty. The war and its aftermath led to financial means of hitherto unknown proportions in Denmark. Whereas Carl had been practically a lone figure, Helge Jacobsen was now one among a number of Danish magnates, industrialists and bankers who competed over fine-art acquisitions. He certainly profited from the French Exhibition, bagging fine pieces such as Monet's *Shadows on the Sea* (1882). By degrees, a worthy representation of modern French masterpieces was forming at the Ny Carlsberg Glyptotek.

Paul Gauguin was one of Helge Jacobsen's favourites (fig. 24). He was represented in the 1914 show with nine paintings, among them *Woman Sewing* (then still in the possession of the painter Theodor Philipsen), a magnificent Breton landscape and several others. All in all, five of these works ended up in the Glyptotek, either in 1914–15 or following the so-called 'equal terms exchange' of 1922 and 1924, whereby a plethora of French nineteenth-century paintings from the Statens Museum were exchanged for all of Carl Jacobsen's Renaissance and Baroque Italian and Flemish masterpieces, among them paintings by Cranach, Mantegna and Titian, and sculptures by Bernini.

But enough was enough, apparently: the Board of Trustees of which Helge was chairman from 1914 to his death in 1946 did not always follow him in his quest for modern art, and when, about the same time as the many acquisitions were made at the French Exhibition, there came an offer of Gauguin's masterwork, the large *What Are We? Where Do We Come From? Where Are We Going?* (1897; Museum of Fine Arts, Boston), it was turned down. The Trustees felt that Manet's *Absinthe Drinker* was a safer bet, and since the two were offered at the same price (around 150,000 francs), the Manet was preferred. But it is a testament to Helge Jacobsen's taste and insight that he promoted Gauguin so fervently at this time.[5]

Helge's most dangerous competitor as a Danish arts magnate was probably Wilhelm Hansen, the director of an insurance firm and the founder of the Ordrupgaard Collection in Charlottenlund, a few miles north of Copenhagen. The numerous Danish dealers and agents who served both masters between 1914 and 1922 knew their trade sufficiently well to overdo the magnificence of each when reporting back to their two customers, probably, as one of

Helge's friends in the art world, Paris-based Tyge Møller, once wrote, to spur Jacobsen in the Danish art race: 'Mr Hansen is received here like a small king, and the Parisian dealers save their best stuff for him.' He was known as *Hansen le terrible* because of his unerring sense of quality. But Helge triumphed in the end, although not in a way that befitted either of the two men's great love of French art: following the bankruptcy of a large investment bank in 1922, Hansen felt compelled to sell off his huge collection. Dividing it with the Swiss insurance magnate Oskar Winterthur and the Japanese millionaire Kojiro Matsukata (son of the future Japanese prime minister, Masayoshi Matsukata) Jacobsen secured nineteen Ordrupgaard paintings for the Glyptotek, from Daumier to Van Gogh.

In 1927, two years after his resignation as director of the Glyptotek, Helge Jacobsen bequeathed his extensive private collection of French nineteenth- and twentieth-century art to the museum, including his valuable Gauguin paintings. From then on he kept himself out of direct involvement in the management of the museum, but remained chairman of the board and a very visible benefactor, often with more Gauguins: in 1938 he donated *Landscape with Tall Trees* (1883), and posthumously he gave the wood-relief *Eve with the Snake and Other Animals* (1889 [?]).

In the 1930s pickings were as meagre as they had been rich in the 1910s and 1920s. The European crisis began to be felt, and restrictions were imposed on the import of 'luxury goods', including fine arts, by the Danish government. Helge Jacobsen was able at least to sustain a limited but constant flow of French paintings from his private collection, now put together over two decades, into the Glyptotek's store, securing a basis for coming generations to build on. It is largely to Helge Jacobsen that today's Ny Carlsberg Glyptotek owes its full representation of French art.

1. Jacobsen was later to take the offensive by combining plaster casts with paintings in the new Statens Museum for Kunst, because painting could function as a lever to aid in the experience of sculpture (Carl Jacobsen, October 1902; see Berner 1980, p. 35).
2. Jacobsen 1878, p. 142 ff.
3. Glamann 1995, p. 124.
4. Letter to Helge, Glyptotek archives.
5. For a full account of the Glyptotek's Gauguin collection, see Friborg 2004.

Ancient Egypt

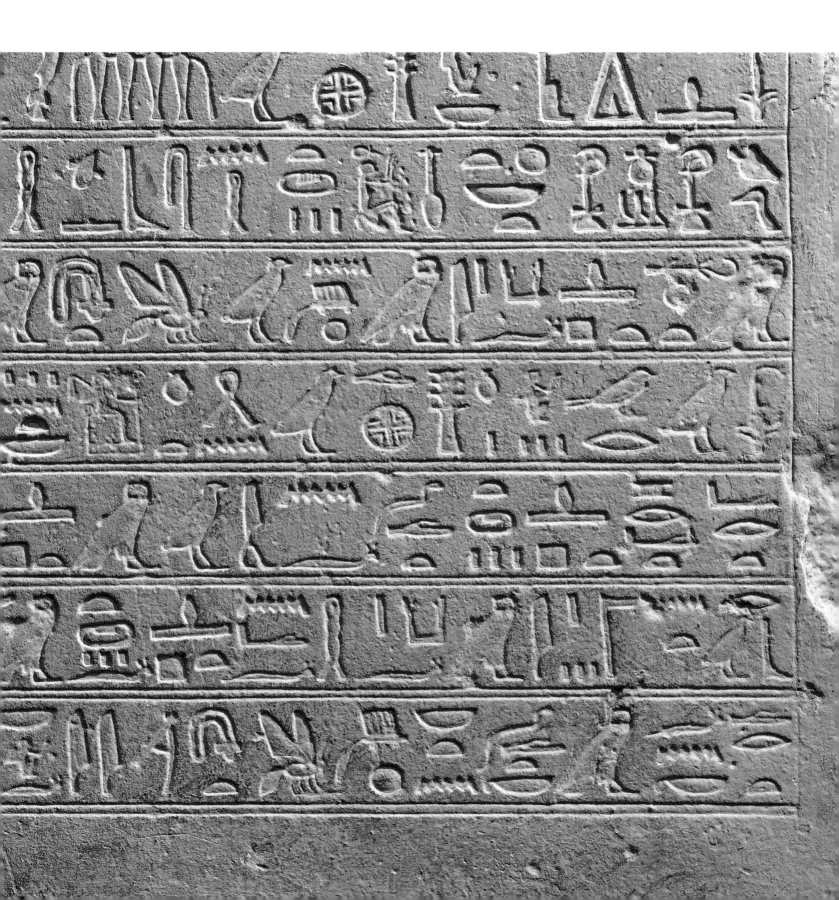

The Ny Carlsberg Glyptotek's Egyptian Collection

MOGENS JØRGENSEN

Before the foundation of the Glyptotek, Denmark had two Egyptian collections: a large one in the National Museum of Denmark, the origins of which dated back to the old royal collections of antiquities; and a smaller one at the Thorvaldsens Museum in Copenhagen, assembled by the Danish sculptor Bertel Thorvaldsen (1770–1844). Carl Jacobsen wished to establish yet another Egyptian collection, however. This was to exhibit impressive works of Egyptian art to catch the interest of the public and to constitute an inspiring introduction to the Glyptotek's other collections.

Today such a project would be an ambitious undertaking, but in Jacobsen's time there were still many significant works of Egyptian art on the market. He acquired his first pieces through the agency of the Danish Consul in Beirut, Julius Løytved (see p. 50), who had connections with Egypt through the German Egyptologist Emile Brugsch. Brugsch sent a series of sculpturally formed and beautifully decorated mummy cases. Ever since their arrival in Copenhagen in 1884 and 1888, these have been among the favourites with the public.

Shortly afterwards, in 1890, Jacobsen succeeded in buying a whole series of masterworks which had belonged to the French diplomat Raymond Sabatier: the statue of the Royal Treasurer Gebu, the group of the Amun Priest Ahmose and his mother, and the statue of the god Anubis (cat. 7). Jacobsen, however, was far from satisfied: 'It was a good beginning, but it was not yet a proper Egyptian collection,' he later wrote.

Fate then dealt Jacobsen another strong card, in the person of the Danish Egyptologist Valdemar Schmidt (1836–1925). He was the man who had the expertise and will to create a 'proper' Egyptian collection for Jacobsen.

A learned academic and the first to teach Egyptology at the University of Copenhagen, Schmidt was a genuine cosmopolitan, to whom travelling around the whole of Europe and Russia and lecturing at the various universities came entirely naturally. In the course of his long life he visited Egypt no fewer than 34 times. As characters the flamboyant Jacobsen and the ascetic Schmidt were diametrically opposed, yet they combined perfectly in their common enthusiasm for Egyptian art.

Jacobsen provided Schmidt with money both for travel expenses and to finance large-scale purchases of art in Egypt. Even on his first journey in 1892 Schmidt acquired several hundred works and the journeys continued, year after year, until 1910, when Schmidt, 74 years old, had brought home half of the Glyptotek's present-day collection. Schmidt's interests ranged from the most perfect works of art to fragmentary inscriptions. He is particularly remembered for one of the museum's greatest treasures, the Head of the Young Amenemhat III (cat. 8), and Jacobsen had no hesitation in referring to Schmidt as the 'creator of the Glyptotek's Egyptian collection'.

With exemplary speed Schmidt published 'his' and Jacobsen's acquisitions in catalogues from 1899 and 1908 as well as writing the Egyptian section in *La Glyptothèque Ny-Carlsberg*, a publication which in the years 1896–1912 became a lavishly produced catalogue of the Glyptotek's Egyptian, Greek, Etruscan and Roman works. He also published a large work on the history of the mummy case. He was a scholar of immense knowledge, and many of his conclusions are still valid.

In only 25 years, from 1884 until 1908, the Glyptotek's Egyptian collection had grown to over 1,000 inventory numbers, the majority of which were published in what, for the time, was exemplary fashion. However, both Jacobsen and Schmidt had even greater ambitions and in 1908 they entered into a collaboration with the great English Egyptologist W.M.F. Petrie, who, from 1880 onwards, undertook countless excavations throughout the whole of Egypt.

Petrie's activities were financed by European and American museums, which received newly excavated antiquities in exchange for their contributions. The Egyptian Antiquities Service exercised careful supervision to ensure that unique finds remained in Egypt while types that were already to be found in the Cairo Museum were sanctioned for export.

From 1908 onwards the Ny Carlsberg Foundation – established by Jacobsen in 1902 – gave Petrie substantial financial assistance, and the Glyptotek received a steady stream of Egyptian finds. These acquisitions were especially valuable as, in contrast to the majority of Jacobsen's and Schmidt's purchases, they had a known provenance. The Glyptotek owns superb works of art from such important sites as Memphis, Medum, Fayum, Abydos and el-Amarna. The colossal granite group of Ramses II and the Creator God Ptah comes from Petrie's excavations at Memphis in 1912.

The Ny Carlsberg Foundation's support for Petrie continued after Jacobsen's death in 1914. When Petrie's activity in Egypt ceased in the 1920s, support was transferred to the Egypt Exploration Society, an English archaeological organisation which undertook – and continues to undertake – excavations in Egypt. The Glyptotek received significant treasures from the society until the 1930s. Finds from its excavations at el-Amarna in 1932–3 are particularly well represented in the collection.

In the 1920s it was becoming increasingly rare for the Egyptian Antiquities Service to grant export licences, and as a result the Glyptotek turned its attention to the European art market. Financed by the Ny Carlsberg Foundation, the museum – now under the direction of Carl Jacobsen's son Helge (1882–1946) – continued to acquire important works of Egyptian art, particularly when two large English private collections, those of Lord Amherst (1835–1909) and William MacGregor (1848–1937), came up for auction in 1921 and 1922 respectively.

Today the collection contains some 2,000 works. Although in terms of size it cannot compare with the Egyptian collections in the large European and American museums, its array of exquisite masterpieces functions precisely as Carl Jacobsen had first envisaged: as an inspiring introduction to the Glyptotek's other art collections.

1
Hippopotamus, late Predynastic –
early Dynastic period, *c.* 3000 BC
Calcite, H. 16.5 cm

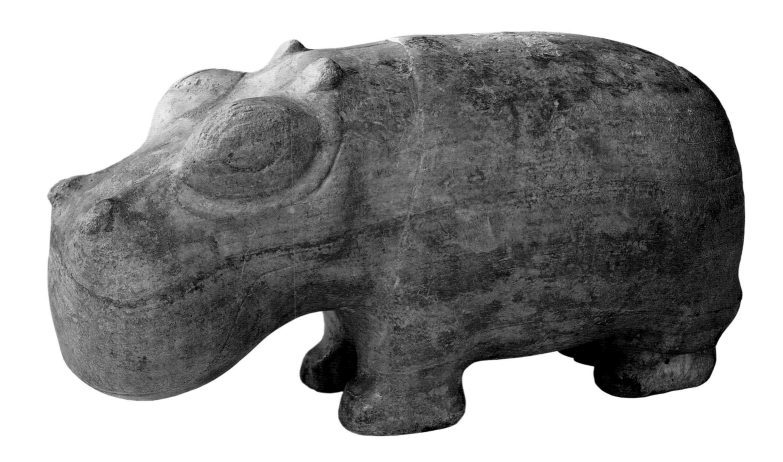

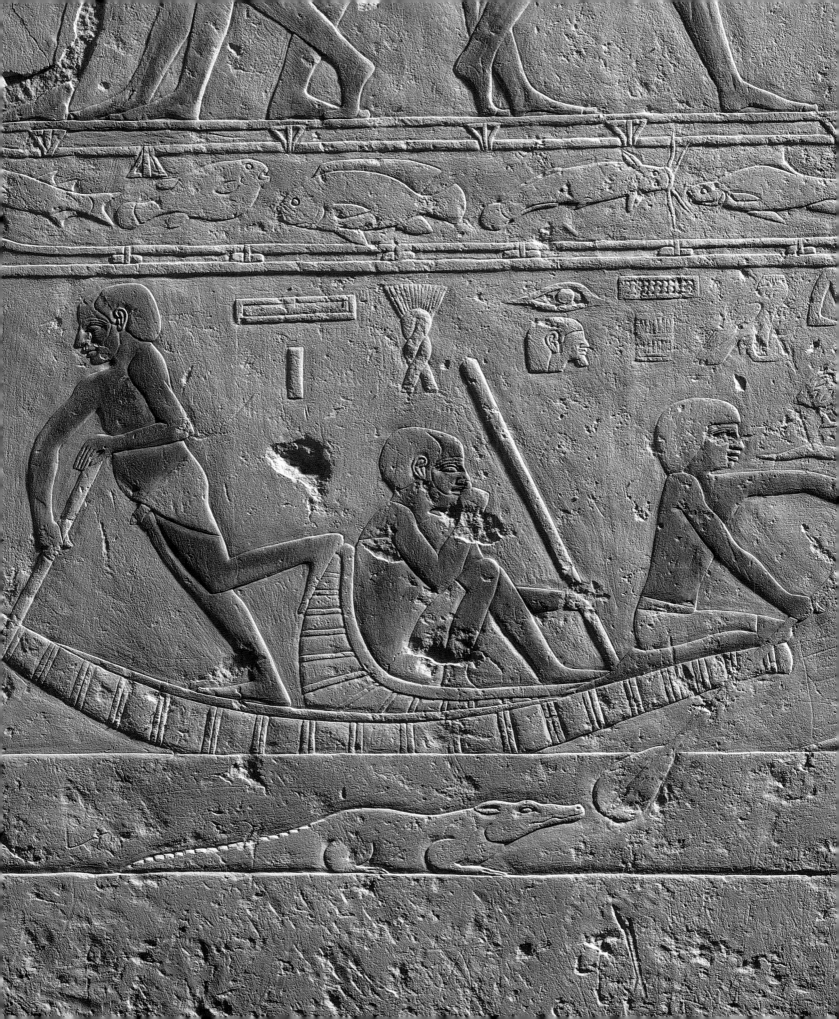

2
Pastoral scene from the mastaba
of Ka-em-rehu at Sakkara,
late 5th Dynasty, *c.* 2300 BC
Limestone, 70 × 141 × 14 cm

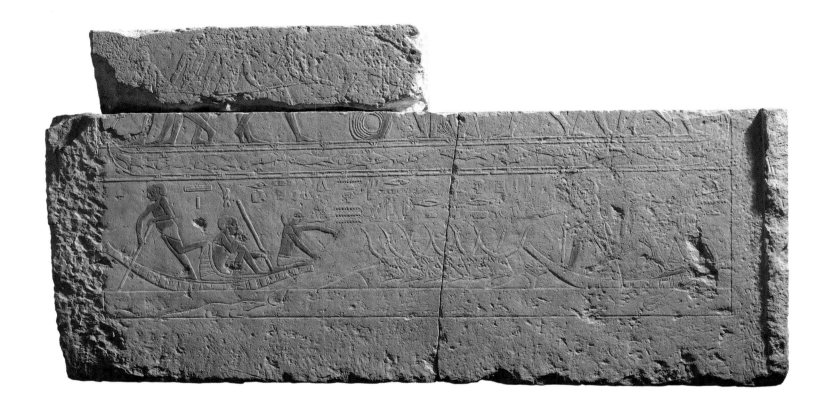

3
Offering bearer,
end of 6th Dynasty, *c.* 2150 BC
Painted wood, H. 40 cm

4
Meri-re-ha-ishtef as a middle-aged man,
late 6th Dynasty, *c.* 2200–2150 BC
Wood, H. 65.5 cm

5
The official Hema,
Transitional period between Old
and Middle Kingdoms, *c.* 2100 BC
Painted wood, H. 112 cm

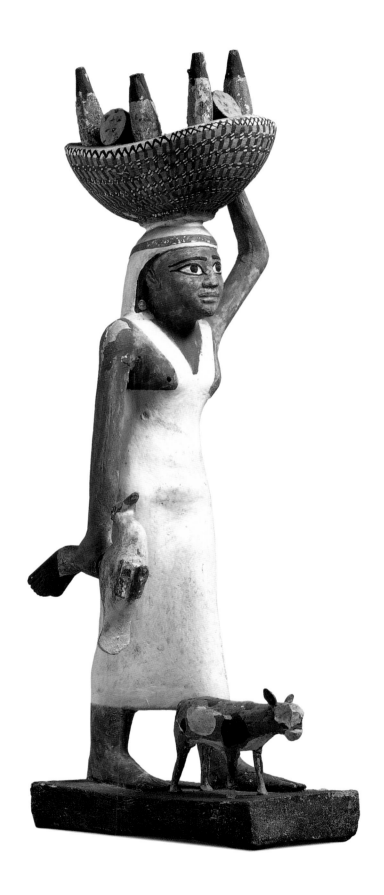

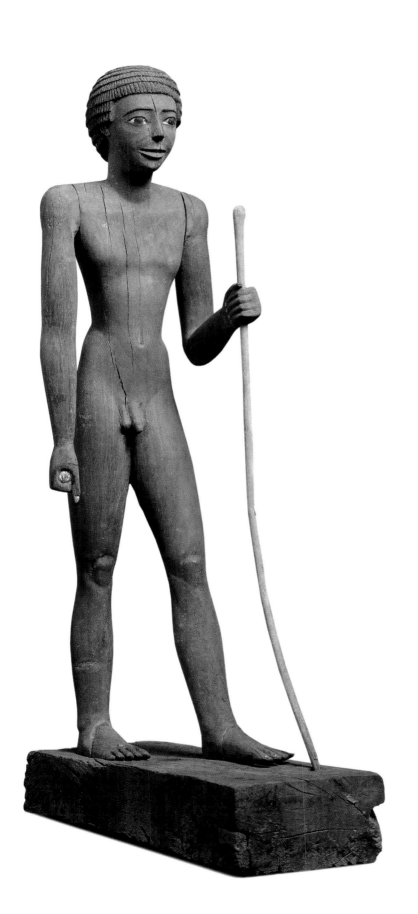
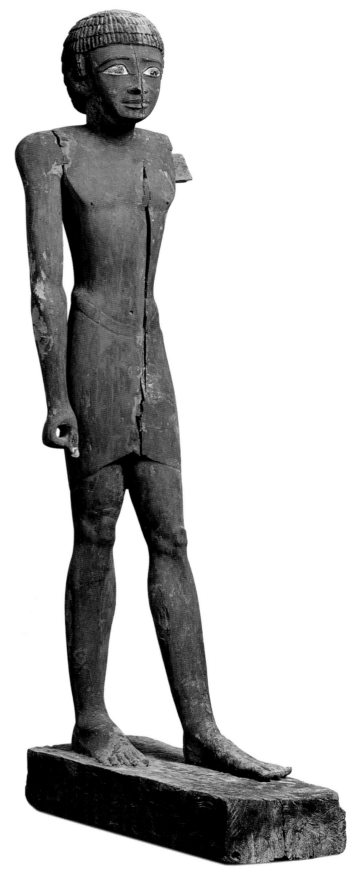

6
Man, probably reign of Sesostris II,
c. 1897–1878 BC
Limestone, H. 22 cm

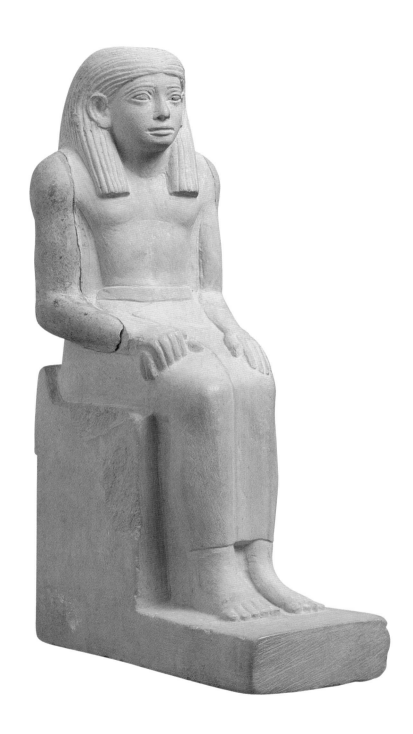

7
The god Anubis,
reign of Amenophis III,
c. 1403–1365 BC
Diorite, H. 158 cm

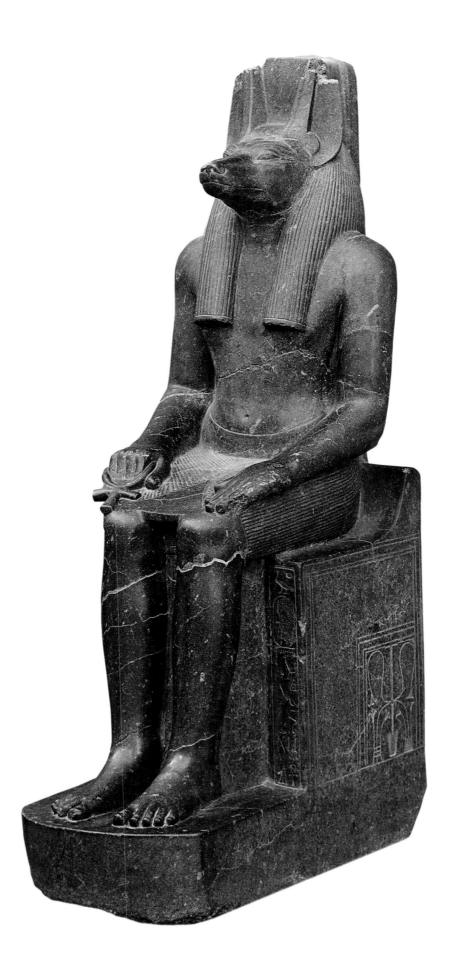

8
Head of the Young Amenemhat III,
12th Dynasty, reign of
Amenemhat III, 1842–1795 BC
Greywacke, H. 46 cm

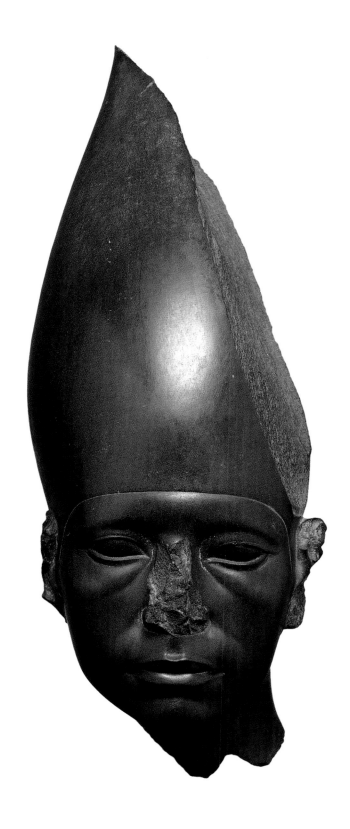

9
King Amenophis II, reign of
Amenophis II, *c.* 1439–1413 BC
Diorite, H. 40 cm

10
Amun, probably from the reign
of Tutankhamun, *c.* 1346–1337 BC
Diorite, H. 54 cm

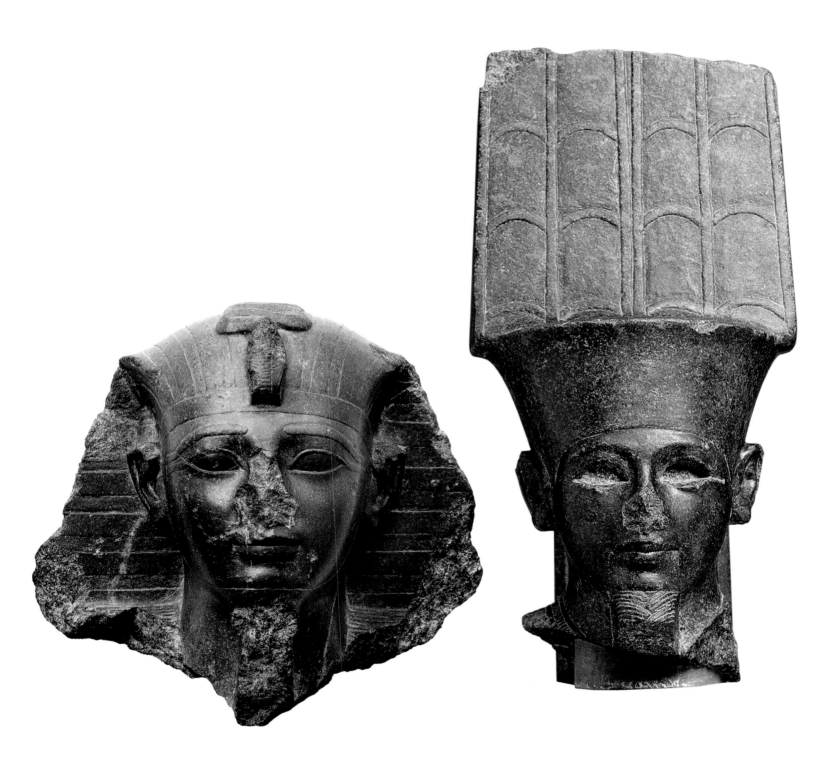

The stela of General Antef,
Transitional period between Old
and Middle Kingdoms, *c.* 2050 BC
Limestone, H. 172 cm

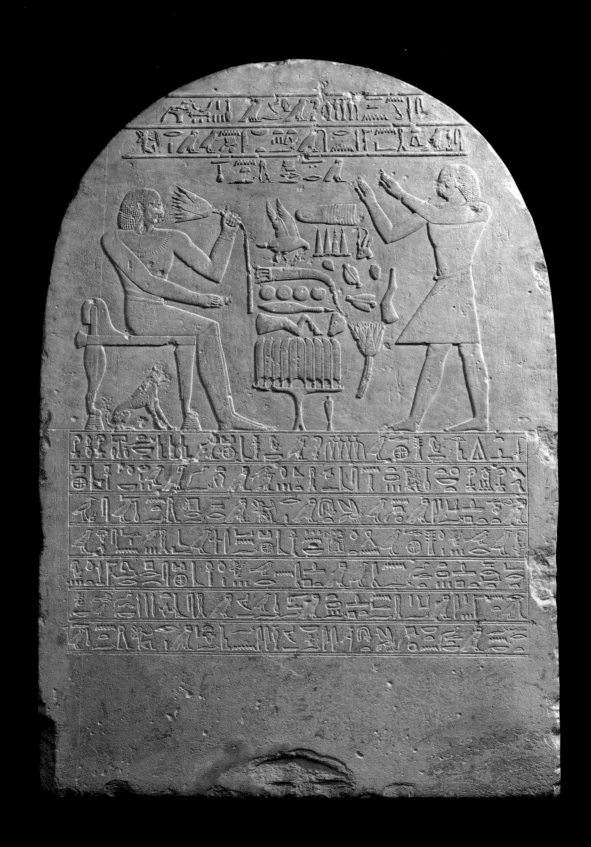

12
The Polio stela, reign of
Amenophis III, *c.* 1403–1365 BC
Limestone with original
paintwork, H. 27 cm

13
Stela dedicated to Min, reign of
Amenophis III, *c.* 1403–1365 BC
Limestone, H. 24 cm

14
Stela dedicated to Mnevis,
19th Dynasty, *c.* 1305–1196 BC
Limestone, H. 36 cm

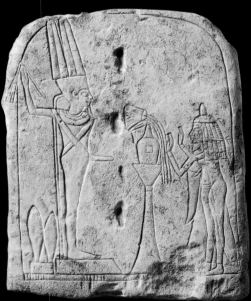
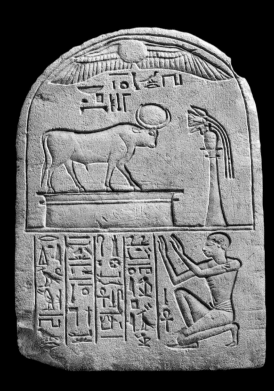

15
Fragment of a relief showing King
Akhenaten, reign of Akhenaten,
c. 1365–1347 BC
Quartzite, H. 15 cm

16
Princess, reign of Akhenaten,
c. 1365–1347 BC
Quartzite, H. 15 cm

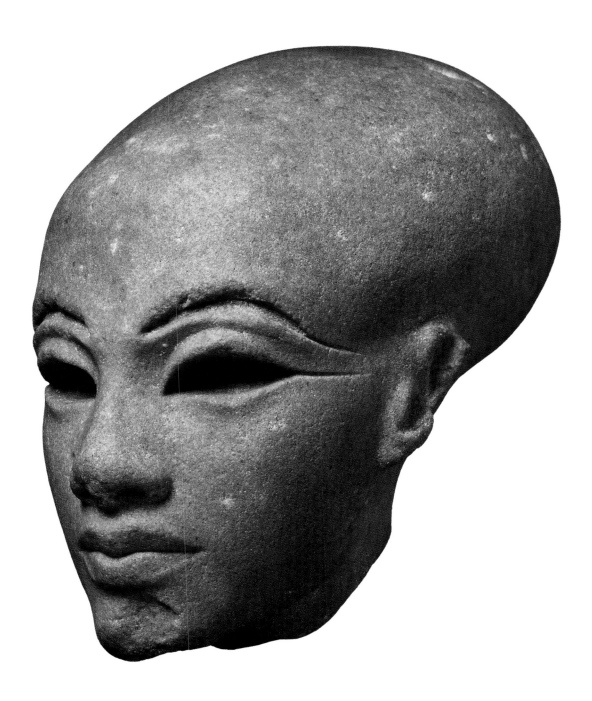

The Coffin of Kep-ha-ese, c. 900–700 BC
Linen, glue and plaster, H. 160 cm

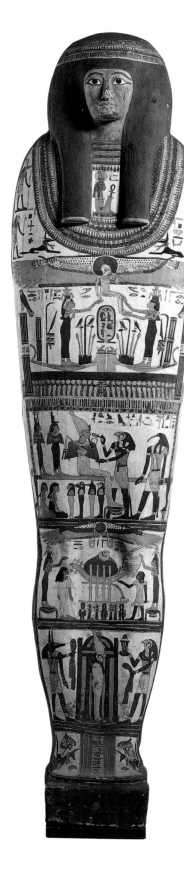
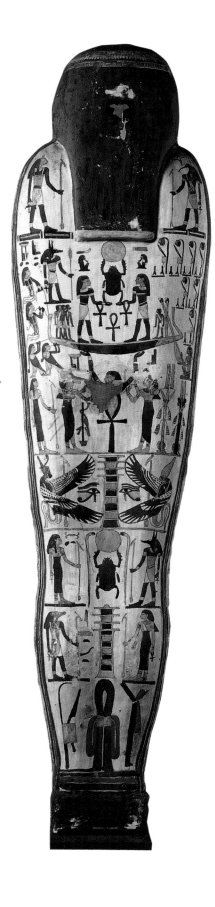

18
Seth, probably Ramesside Period,
c. 1300–1080 BC
Bronze and silver, H. 70 cm

19
Amun, probably 22nd Dynasty,
c. 900 BC
Bronze with silver inlays, H. 21 cm

20
Mongoose, probably 26th Dynasty,
664–525 BC
Bronze, H. 27 cm

21
Ptah, probably 26th Dynasty,
664–525 BC
Egyptian faience, H. 23 cm

22
Bes, probably 26th Dynasty,
664–525 BC
Bronze, H. 14 cm

23
Cat head, probably 26th Dynasty,
664–525 BC
Bronze, H. 13 cm

Man, probably third century BC
Limestone, H. 33 cm

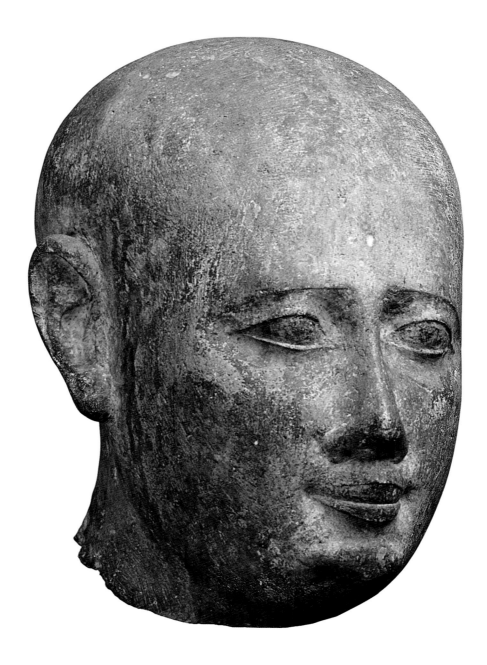

25
Young man, third century BC
Diorite, H. 42 cm

26
Aphrodite, first century AD
Bronze, H. 32 cm

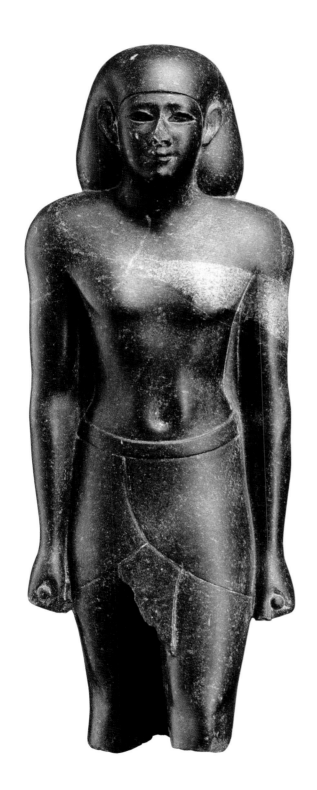

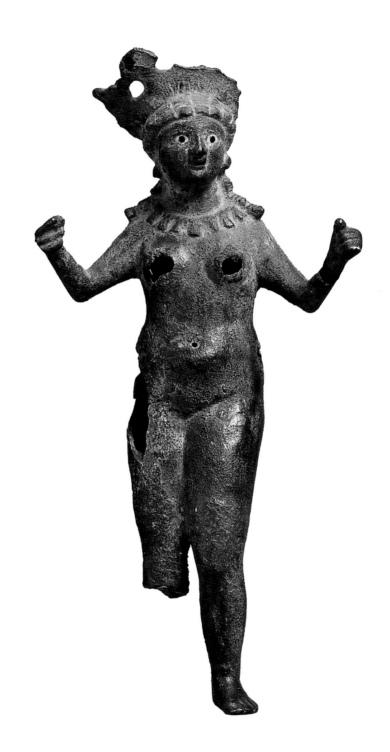

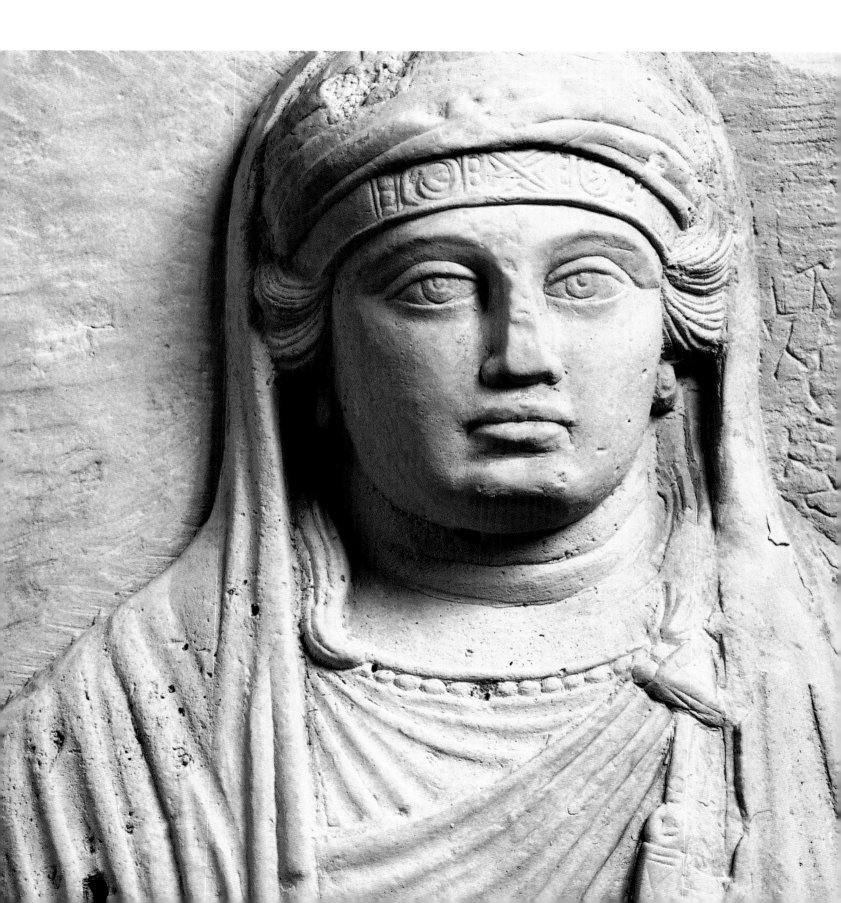

Cypriot and Palmyran Antiquities

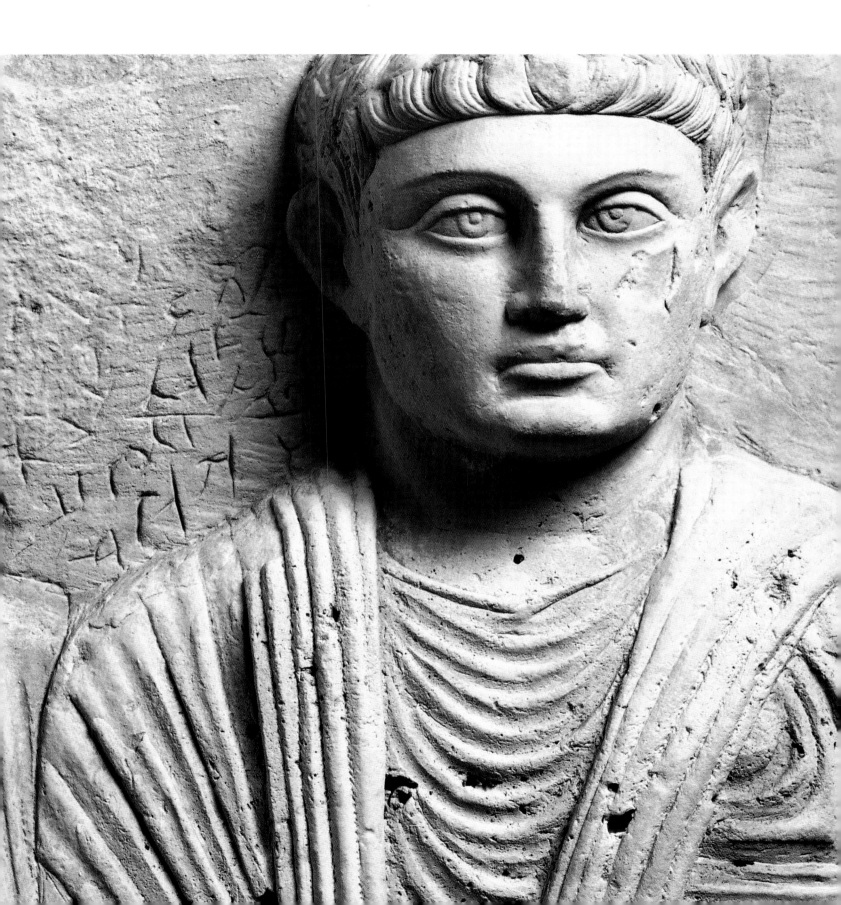

Palmyra and Cyprus

ANNE MARIE NIELSEN

Apart from his acquisition of the spectacular Greek Archaic Rayet Head (cat. 44) in 1879, Carl Jacobsen's first encounter with ancient art was with Cypriot and Palmyran antiquities, and it came about through his contact in the Levant, Julius Løytved (1836–1911), Danish consul to the Sublime Porte. Løytved was based in Beirut, and travelled extensively in the Near East.

Jacobsen was an early collector of Palmyran funerary sculpture, an area of collecting that had only started in Europe around 1850, when two busts were presented to the Louvre. The city of Palmyra, to give it its Roman name, is situated on the fringe of the Syrian desert on the Silk Road. In 64 BC Syria was annexed by the Romans, and Palmyra became the Roman gateway to the Orient. In the third century AD the city reached its zenith under the local queen, Zenobia. Although known through ancient literary sources, it was not visited by Europeans until the early seventeenth century. The English traveller Robert Wood published his *Ruins of Palmyra*, a plan of the site, in 1753. Characteristic sculptures from Palmyra from the first three centuries AD are almost exclusively funerary, and come from tombs outside the city.

Although he travelled extensively all his life, Jacobsen never visited Cyprus himself. He must have known about Cypriot antiquities by 1879, because we know that he saved clippings from the Danish magazine *Ude og Hjemme* (Abroad and at Home) from that year, concerning excavations in Cyprus by Luigi Palma di Cesnola. This Danish account discussed Cyprus, reviewing the island's history and geography in antiquity as well as elaborating on the contemporary situation on the island, as a prelude to reports on Cesnola's excavations. The author's opinion of this faraway place, then recently freed from Turkish rule, was not very high: he describes St Paul's visit to Cyprus, where he was so ill-treated by its inhabitants that he declared them the vilest people on earth. The journalist continues: 'And this is valid until this very day ... Now, however – as we all know – England has stretched her protecting hand towards the island and a new and more brilliant future seems to dawn on Cyprus.'

This conclusion seems to have whetted Carl Jacobsen's appetite for Cypriot antiquities. Løytved offered him a wide selection, but as late as 1894 Jacobsen, having received a large and very disappointing collection of undistinguished Roman glass, still had to stress the fact that he only wanted the very best – and genuine – pieces from Cyprus: 'I am particularly interested in *good pieces of genuine Cypriot art*, and should you ever encounter any I shall thank you if you would think of the Glyptotek.'

The extensive correspondence between the two men shows Løytved to be rather self-righteous, always talking about his fatherland and never about profit. After a visit to the Danish National Museum in Copenhagen, he wrote (on 10 July 1883) that he collects:

... mainly in the hope of doing my fatherland a favour without seeking any material gain, and it hurts me immensely being treated like a dealer ... You know that I love my fatherland and I am interested in its collections, and abroad I am working for it without self-interest, anything that I in my weak condition may do to serve, and I regret that I cannot do more than already done. How often do I not fail my other obligations, again and again maintaining that I cannot part with anything until it has been in Denmark. What a disappointment to be received like this. How grateful our fatherland must be to you, dear Mr Jacobsen, who with God's help is able to do so much.

In addition to such pieties, the two men exchanged family news; we learn about the weather and the threat of cholera in the Levant, and we hear the echoes of contemporary world history; they discuss beer, while Carl Jacobsen places an order with Løytved for some Lebanese cedarwood for an altar in the church that he built just down the hill from the Carlsberg breweries. Løytved presented Ottilia Jacobsen with a necklace made of Alexander tetradrachms.

Just as with the Cypriot antiquities, Jacobsen did not always consider Løytved's Palmyran works to be of a sufficiently high quality; this forced Løytved to offer only the best, with the result that the Glyptotek collection is highly distinguished. Jacobsen was nobody's fool: those dealers who tried to push false antiquities his way were soon forced to apologise profusely. Jacobsen purchased only a very limited number of fakes.

He acquired his Palmyran sculptures in the years 1883–7, mainly through Løytved, from Damascus, Homs and Beirut. Løytved was never specific about his sources, referring vaguely, for instance, to just 'a French Jew in Damascus'. In Jacobsen's later years, when he was well established as a serious museum collector, he bought individual pieces of Cypriot sculpture from various European dealers and auction houses, albeit on a relatively modest scale. E. Puttmann of the German consulate in Damascus was also supplying Jacobsen with Palmyran sculpture, and after Jacobsen's death the Glyptotek acquired a number of sculptures from the Palmyran excavations of the Danish scholar Harald Ingholt in the 1920s and 1930s, as well as through dealers with the mediation of Ingholt.

The Cypriot and Palmyran collections are still cherished in the Glyptotek, the latter being particularly distinguished and one of the most prominent outside Syria, comprising more than 200 items.

27
Bust of a couple, c. 150 AD
Soft white limestone, H. 47 cm

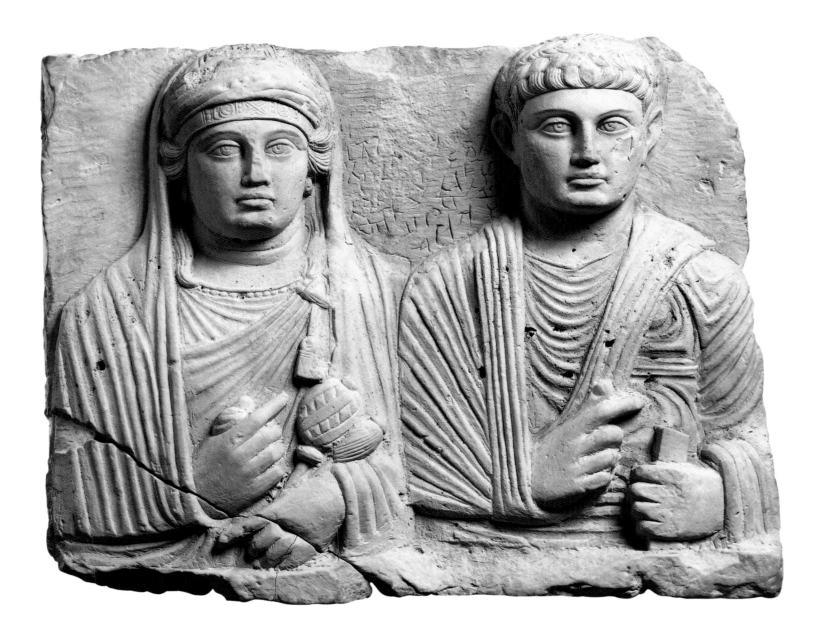

28
Bust of 'The Beauty of Palmyra',
AD 190–210
Hard white limestone with traces
of yellowish, red and black paint,
H. 55 cm

29
Bust of Kaspâ, AD 150–70
Hard white limestone, H. 53 cm

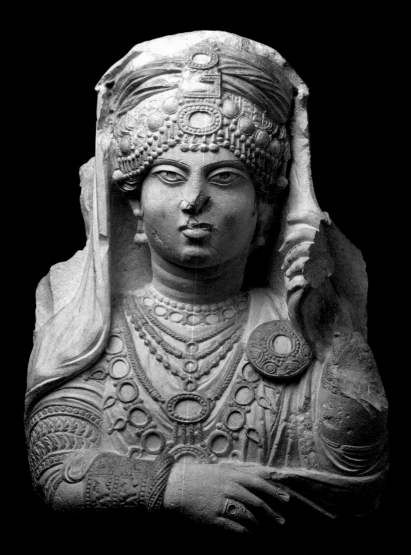

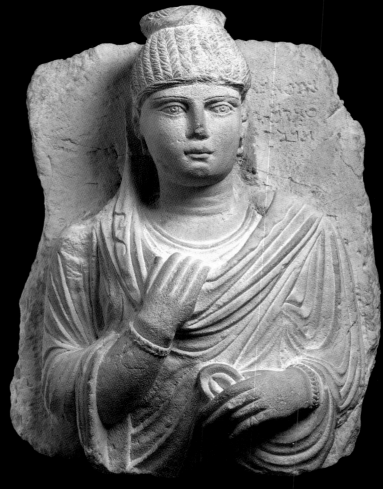

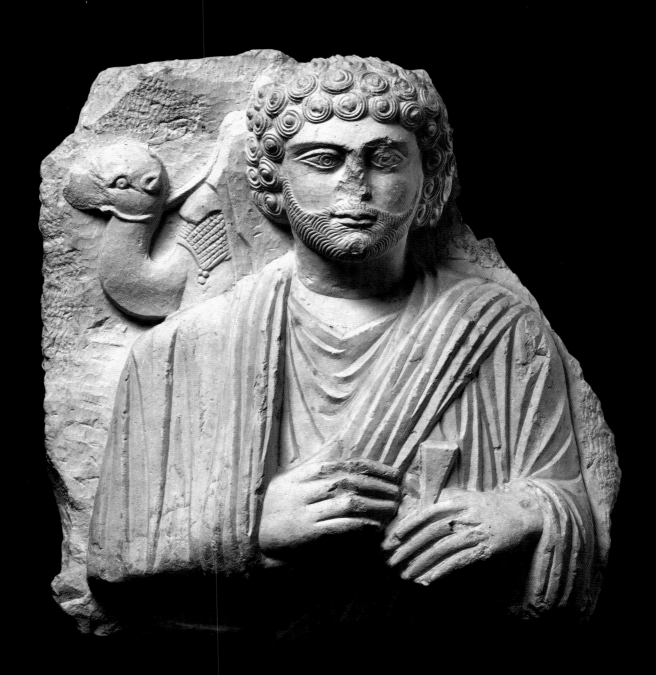

Head of a man, Cypro-Classical,
fifth century BC
Limestone, H. 32 cm

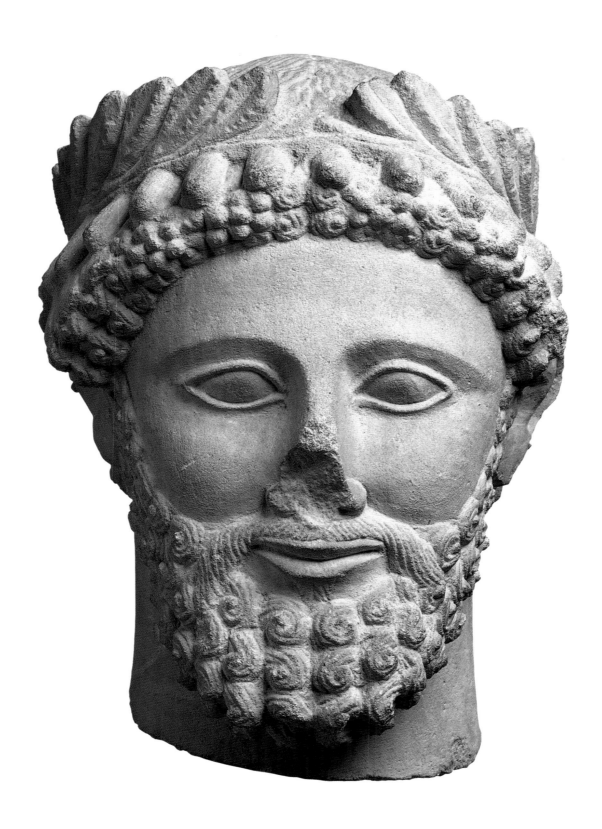

32
Head of a man, Hellenistic-Roman,
second century BC
Limestone, H. 32 cm

Etruria

Carl Jacobsen and His Etruscan Collection

JETTE CHRISTIANSEN

An Etruscan collection was not part of Carl Jacobsen's original plan. But when by chance in 1887 the first work of art he acquired through Wolfgang Helbig was a characteristic Etruscan sarcophagus (see fig. 11), the first step was taken. Roman portraits and sarcophagi remained Jacobsen's first priority. But influenced by Helbig (see fig. 12), one of the outstanding Etruscologists of his time, Jacobsen almost reluctantly began to consider also acquiring Etruscan artefacts. After reading Jules Martha's book *L'Art étrusque* upon its publication in 1889, Jacobsen saw the necessity of an Etruscan department: in his didactic display of ancient art it was to form a link between the sculpture of the Greeks and that of the Romans. Etruscan society – which flourished in Central Italy from the eighth century BC until it succumbed to the Romans after the fourth – had an important influence on Roman culture and as a main early channel through which Greek art and artefacts reached the Italian peninsula.

Nonetheless, necessity rather than enthusiasm for the art itself remained Jacobsen's attitude throughout his years of collecting Etruscan works, as is evident from the comprehensive correspondence between the two protagonists. Jacobsen was not inclined to spend too much on the Etruscans nor to collect, as he put it, 'very expensive objects of bronze such as are very much requested, but rather, more modest and instructive items' (letter from Jacobsen to Helbig, 15 October 1891). In his opinion the Etruscans would never appeal to a wide public, and it was therefore of the utmost importance to present the items as attractively as possible: 'This museum should be *the* collection in the world in which to study Etruscan culture' (letter from Jacobsen to Helbig, 10 September 1892). It was with these ideas in mind that he instructed Helbig to buy objects that were specifically and characteristically Etruscan, such as the early ash urns with lids in the shape of human heads. In fact he encouraged Helbig to buy lids only, not the urns themselves, which he found uninteresting on their own. His reason was that he considered the human-head lid to be the predecessor of the whole genre of Roman portraiture: both were related to the cult of ancestors so important in Etruscan culture, and taken over by the Romans.

From the same didactic point of view Jacobsen also wanted to acquire Etruscan sarcophagi, both the smaller examples that held cremated ash and larger sarcophagi intended for a body. But he insisted that they should have reclining figures on top of the lid and relief decorations in a more or less Greek style on the sides. Again, he was thinking of their role as predecessors of the Roman sarcophagi that he was also constantly urging Helbig to acquire, even though Helbig for his part did not pretend to share his client's passion for this type of funerary monument. Jacobsen also valued the sculpted panels on the sides of the sarcophagi as reflections of contemporary Greek art and saw them as instructive for understanding the development of art in ancient Italy and its dependence on Greek models. This sense of the Etruscans as mediators of Greek art determined Jacobsen's collection of some representative types of Etruscan pottery: black- and red-figured imitations of Greek vases, as well as the specific Etruscan ware named *bucchero*, a black, monochrome earthenware occurring in shapes both copying Greek models and reflecting ancient local traditional vessels.

Surprisingly, though, Jacobsen's most spectacular contribution to our understanding of the Etruscans came not through this collection of original works of art but from his commissioning of a splendid series of facsimiles of Etruscan tomb paintings. Again in close collaboration with Helbig, and at great cost, he underwrote the copying of painted walls and ceilings from 28 Etruscan chamber tombs. These paintings arrived in Copenhagen from 1895 until 1914, and were meant to illustrate the death – and life – of the Etruscans as they were presented in the tomb (cats 38–9). Only a few of this large number of canvases could be included in the display, but they supplied an otherwise rather colourless Etruscan collection with some vivid illustrations of the civilisation and its funeral rites and customs. Because of deterioration in the Etruscan painted tombs themselves, the facsimiles now provide important evidence for the tombs' original appearance.

Despite his distinguished collection, Carl Jacobsen never seriously revised his opinion of the Etruscans. In his catalogue from 1906 he concluded: 'Etruscan art deserves some attention on its own, but its main importance should be found partly as reflecting Hellenic art in its various aspects partly providing a basis for the Roman.' He continued: 'The Etruscans were mere imitators, occasionally adding some peculiar character of their own. They were totally devoid of any talent for invention and their sense of beauty remained oddly imperfect.' Accordingly, Jacobsen made a clear distinction: the items listed in his Etruscan catalogue were referred to as 'objects', while those in the catalogues of the other departments were described as 'works of art'. Nevertheless, and despite this guarded enthusiasm, Carl Jacobsen succeeded in establishing one of the most important Etruscan collections outside Italy.

The five pieces shown here fully match Jacobsen's declared intentions and his view of Etruscan art: the young boy, the female head and the enthroned woman (cats 34–6) reflect Greek art of the severe and Classical style, even if there are characteristic Etruscan aspects of hairstyle, function and material. The cloaked nobleman and the reclining official (cats 33, 37) are more distinctively Etruscan but at the same time prefigure unmistakable Roman types (see cat. 97). Yet together they deserve to be considered on a level with other works of art in the ancient department rather than mere 'objects'.

33
Male votive head, fifth century BC
Terracotta, H. 25 cm

34
Male votive head,
late fourth – early third century BC
Terracotta, H. 29.5 cm

35
Female votive head,
fourth – third centuries BC
Terracotta, H. 23 cm

Enthroned woman, c. 450 BC
Stinkstone with faint traces
of colour, H. 100 cm

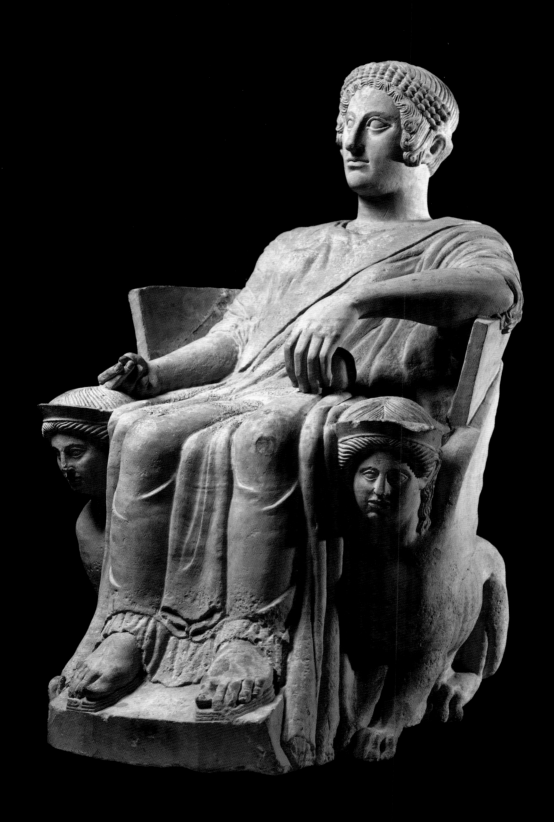

37
Sarcophagus with reclining male on lid,
second century BC
Nenfro (tufa), sarcophagus
76 × 195 × 67 cm, lid H. 74 cm

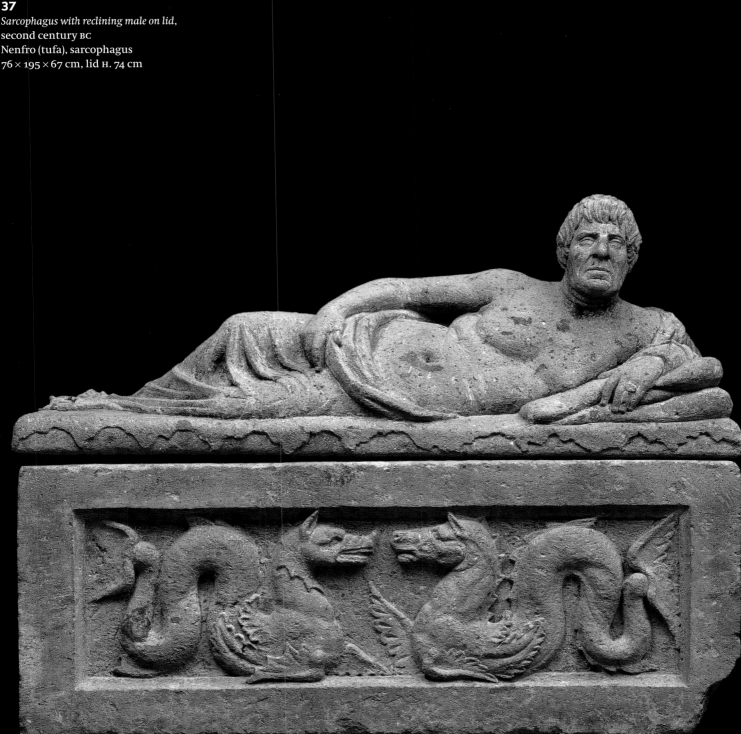

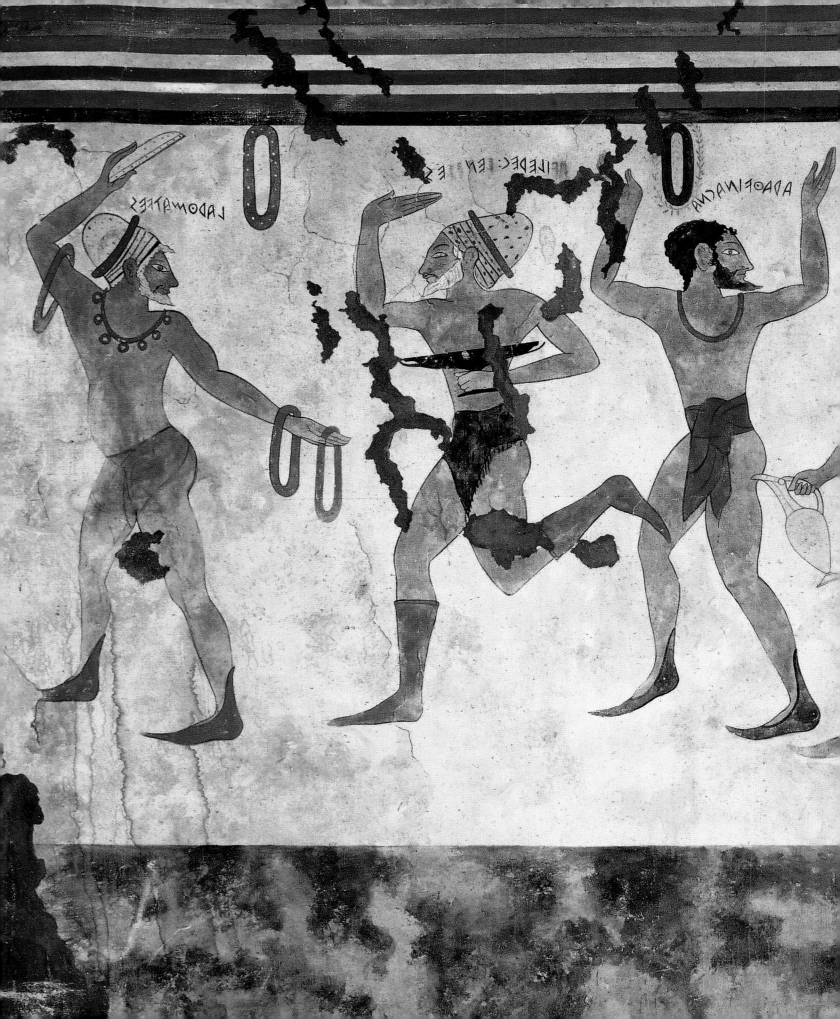

38
Alessandro Colonelli
Facsimile of the left wall of the Tomba
delle Iscrizioni, Tarquinia, 1900
Tempera on canvas, 178 × 477 cm

39
Alessandro Colonelli
Facsimile of the right wall of the Tomba
delle Iscrizioni, Tarquinia, 1900
Tempera on canvas, 174 × 483 cm

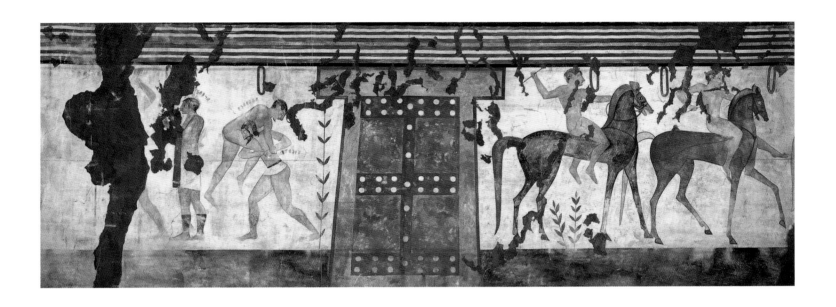

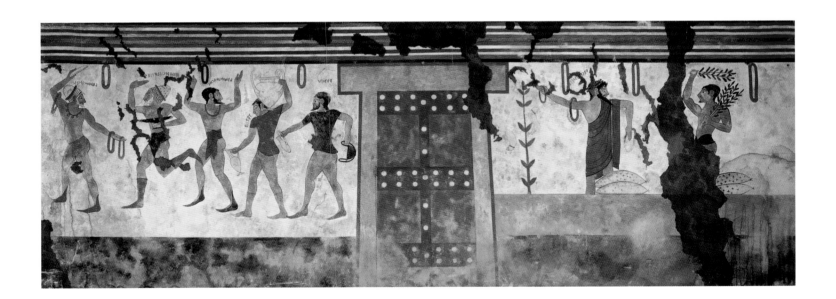

40–43

Four statuettes of mourning women,
early third century BC
Terracotta, H. 92 cm, 92 cm, 89 cm, 92 cm

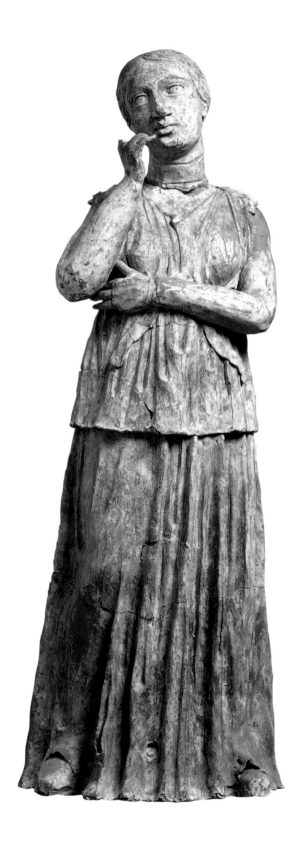
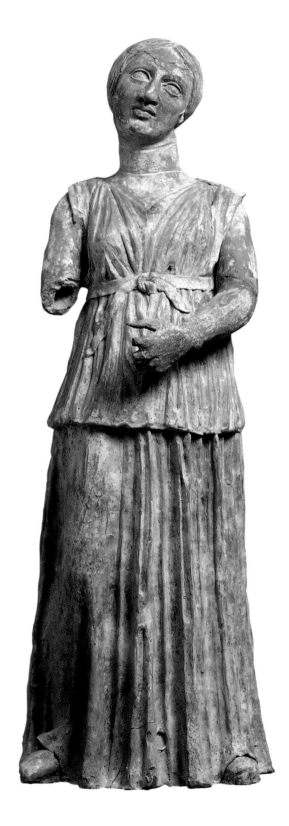

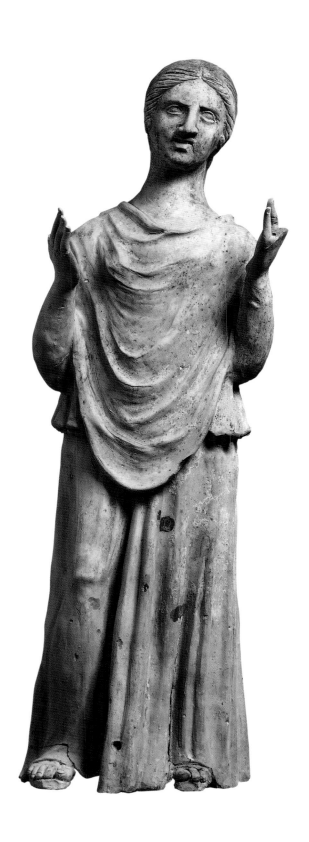
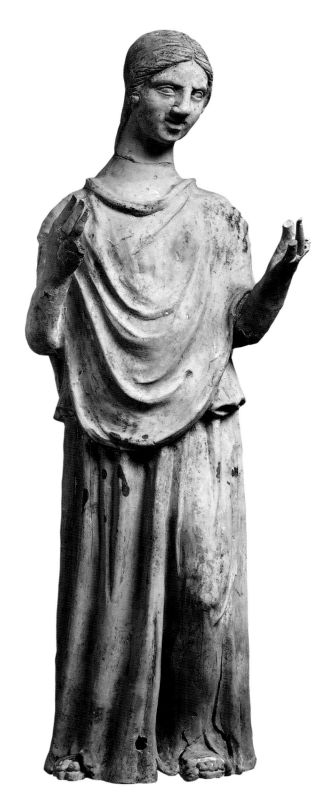

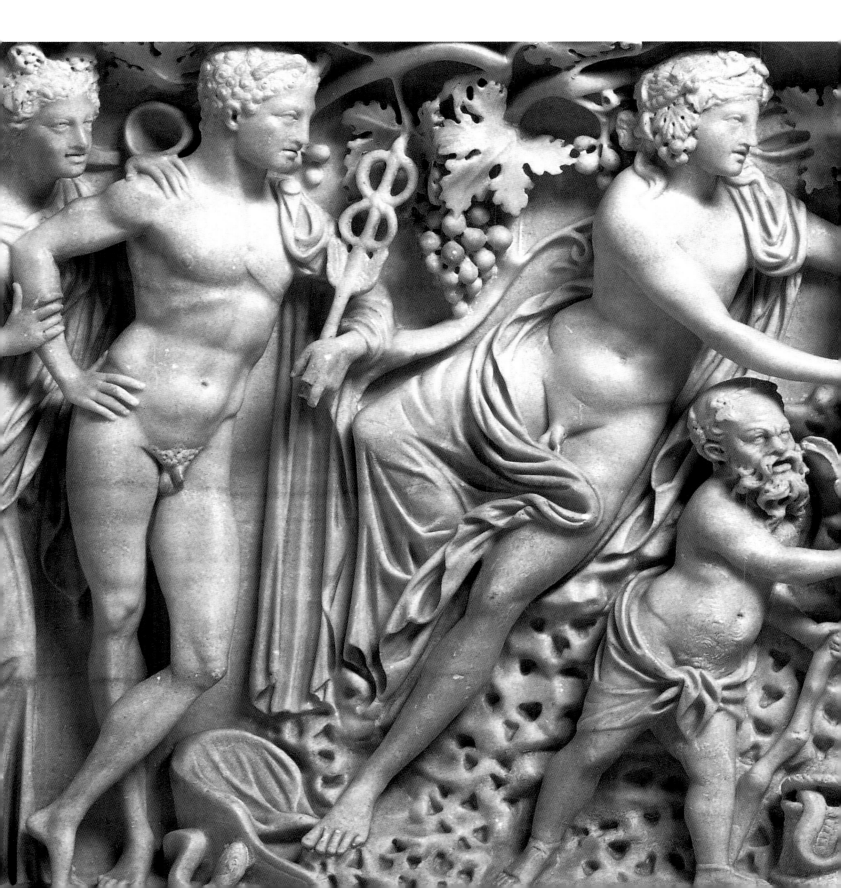

Greco-Roman Sculpture

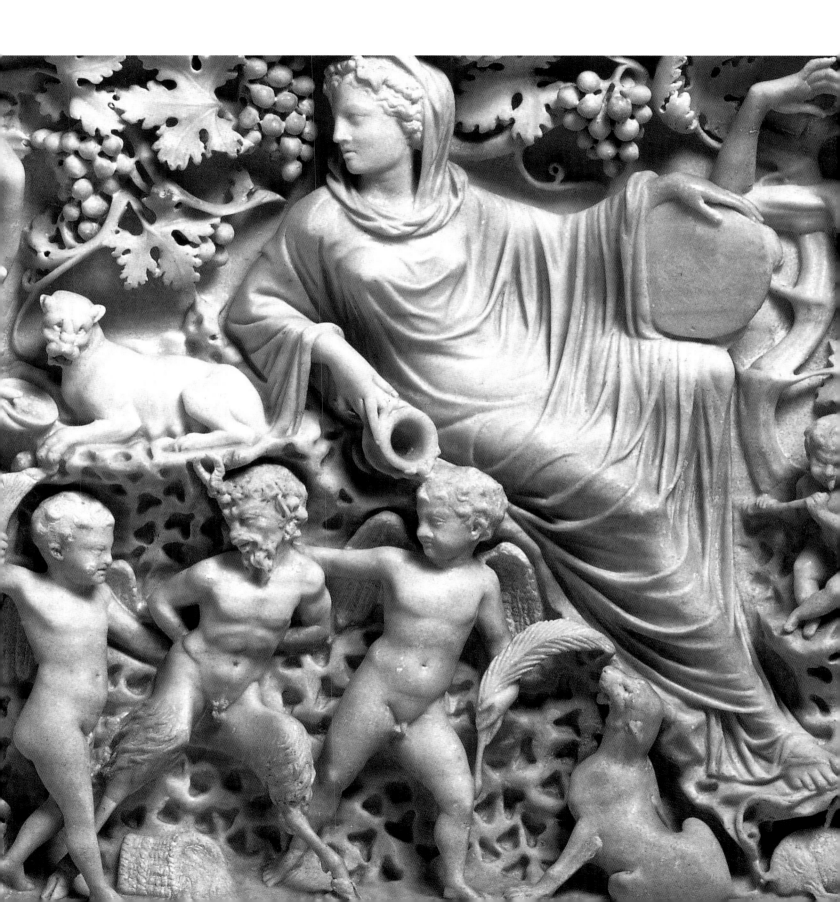

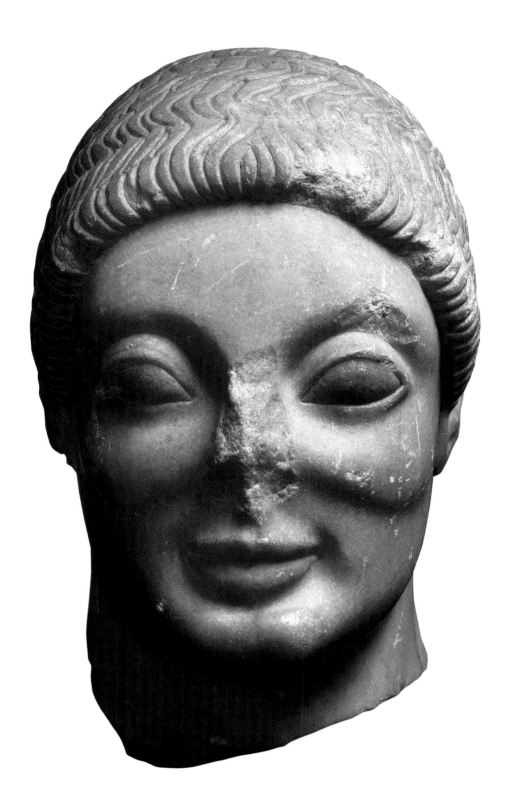

45
The Sciarra Bronze, 470–460 BC
Bronze, H. 102 cm

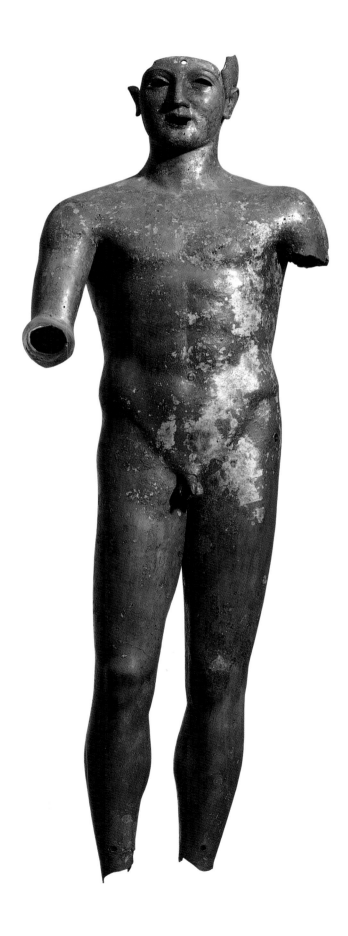

46

Torso of a wind goddess, c. 400 BC
Pentelic marble, H. 98 cm

47
Portrait of Alexander the Great,
third century BC
Marble, H. 34 cm

48
Double herm, first century BC
Marble, H. 17 cm

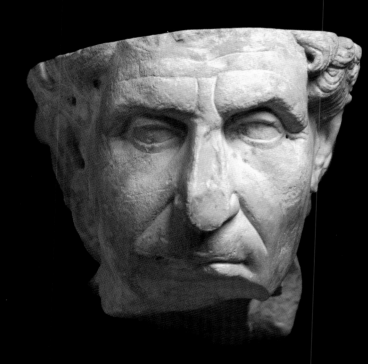

49
Statue of the 'Laurentian Sow',
first – second century AD
Marble, 46 × 75 cm

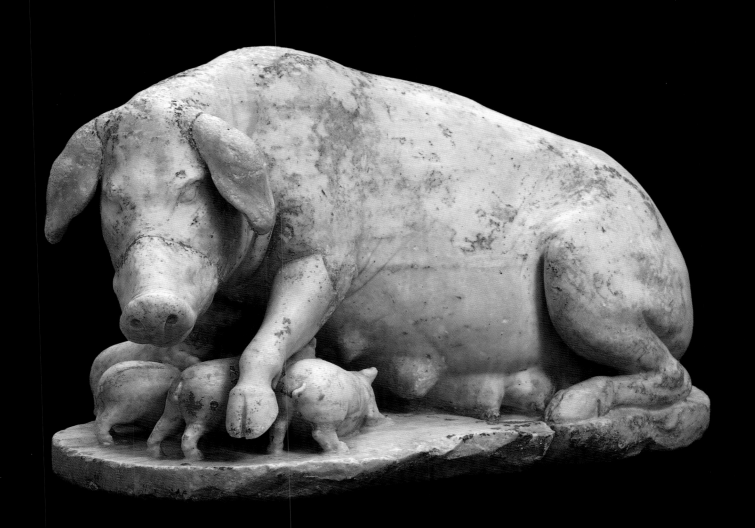

50
Hercules
First century AD
Bronze, H. 125 cm, including plinth

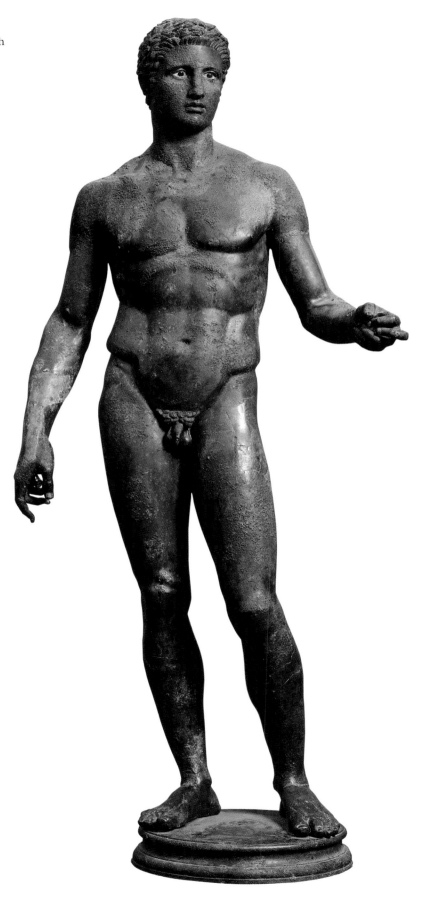

51
Head of Dea Roma, AD 150–200
Carrara marble, H. 66 cm

52
Head of Penelope, c. 460 BC;
copy second century AD
Marble, H. 25 cm

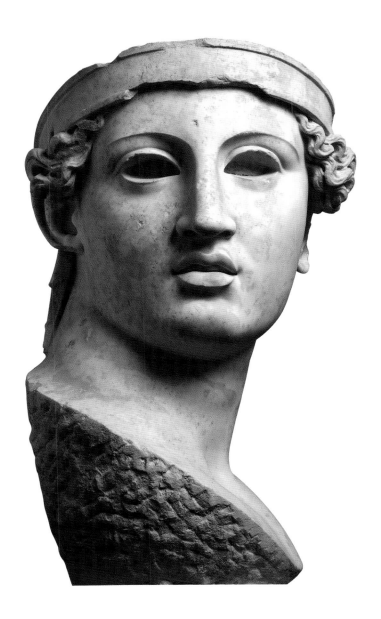

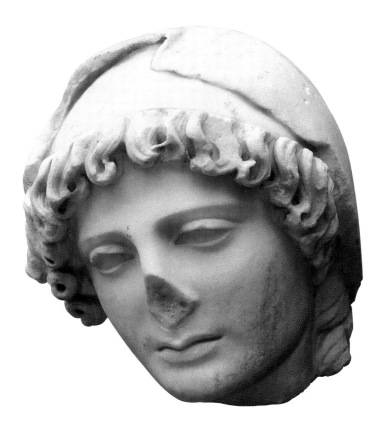

The Gardens of Sallust

ANNE MARIE NIELSEN

In the early Empire the city of Rome was surrounded by *horti*, pleasure gardens, belonging to the imperial house and the ruling classes. Originally the word *hortus* signified a vegetable garden, but in time the term grew to include luxurious parks or realisations of the notions of *paradeisos*, earthly paradise. In Roman ideology gardens were important for the edification of the self; they were taken as images of aristocratic status and state of mind. Gardens were areas for recreation, mediating between city and country life. They were places of retreat and of business. Extensive areas contained *nymphaia* with fountains, rural settings, racecourses, lavish pavilions for feasts, temples, theatres, residential areas and guest houses. Gardens were filled with marble and bronze sculpture, either antiquities acquired in Greece or Egypt, or contemporary creations, often copies of earlier masterpieces. Many of the art works brought to Rome during the late Republic (first century BC) and the ensuing Imperial period probably ended up on display in the *horti*.

The huge and famous Gardens of Sallust were established by the historian C. Sallustius Priscus, a friend of the emperor Augustus, towards the end of the first century BC. They subsequently came into the possession of the Imperial House, no later than the reign of Nero (AD 54–68). They are said to have been especially appreciated by the emperors Vespasian and Nerva in the first century AD and Aurelian in the third century. Situated within the Aurelian Wall, they occupied the former valley between the Pincio and Quirinal hills (in the area of the lavish estate later owned by the Ludovisi family). Sporadic excavations, legal and illegal, took place from at least Renaissance times, resulting in finds of important sculpture and a hall (*aula*) in the present Piazza Sallustio. Drawings of the area from the Middle Ages and onwards exist, and the gardens were mentioned in ancient literary sources. Allegedly the Egyptian obelisk above the Spanish Steps in front of Santa Maria della Trinità dei Monti once adorned the circus of the Gardens of Sallust.

Carl Jacobsen acquired sculpture from the area from various sources, but it is only within the last few decades that the connection between these sculptures – their status as a Roman collection – was realised. Much of the material was found during the hectic building activities that took place in Rome in the 1880s. Vast sums of money changed hands quickly and much shady buying and selling took place, and possibly some outright forgery. An interesting case involves the so-called Ludovisi and Boston thrones. The Ludovisi throne is evidently an original Greek work found in this area, while the Boston throne, allegedly found in the vicinity, might well be a very ingenious forgery. Earlier discoveries from these *horti* include the two famous statues of Gauls, *The Dying Gaul* and the *Gaul Killing Himself and His Wife*, which were both found within the Ludovisi property. The works' subject matter – subjugated barbarians rendered in a well-known Pergamene style – might well have been appropriate in the environment of the pleasure garden: cultivated visitors might have appreciated an admiration for ancient Greek art while at the same time reflecting, through these pieces, on the nature of Roman domination.

The Glyptotek's range of Greco-Roman sculpture thought to be from these gardens covers a wide range of time: early and high Classical of the fifth century BC, late Classical of the fourth, and Hellenistic of the third century BC; presumably partly spoils of war from Greece, partly new works in older styles. The gardens also contained a substantial number of Egyptian works. We do not know how they were exhibited, indoors or out, alone or in groups, but an idea of the works' layout may be given by the most famous of all gardens, those of Hadrian's villa at Tivoli.

Plan of Rome, showing the city's principal landmarks and the locations of the archaeological sites represented in the collections of the Ny Carlsberg Glyptotek

53
Statue group of Artemis and Iphigeneia,
third – first century BC
Marble, H. 170 cm

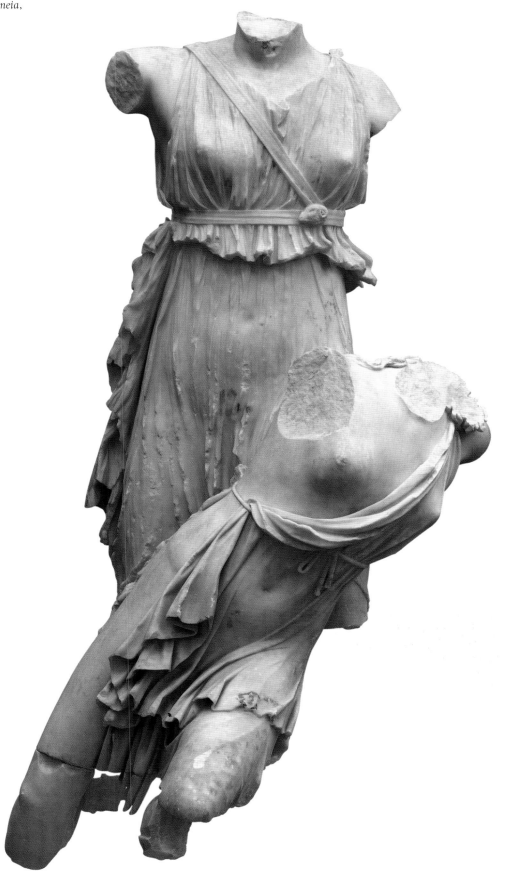

54
Statue of a dying Niobid,
Greek original, 440–430 BC
Parian Lychnites marble, 62 × 165 cm

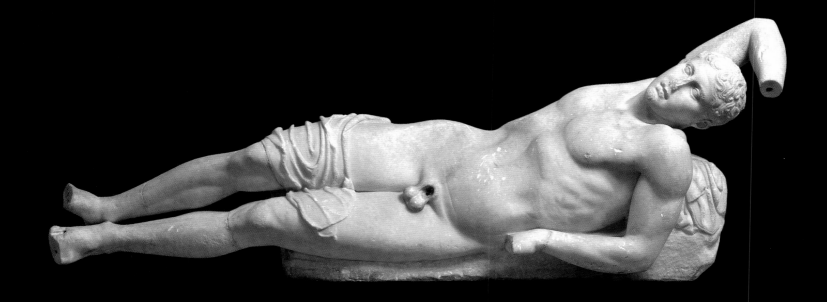

55

Statue of a running Niobid,
Greek original, 440–430 BC
Parian Lychnites marble, H. 140 cm,
not including the modern plinth

56
Statue of a resting satyr,
second-century AD Roman copy
of a Greek original by Praxiteles,
c. 340–330 BC
Marble, H. 180 cm

57
Statue of a wounded Amazon,
Roman copy, *c.* AD 150, of Greek original
Marble, H. 197 cm, including plinth

58
Torso of a 'Peplophoros',
first century BC
Large-grained Greek marble, H. 156 cm

59
Statue of a hippopotamus,
second century AD
Rosso antico marble, H. 77 cm

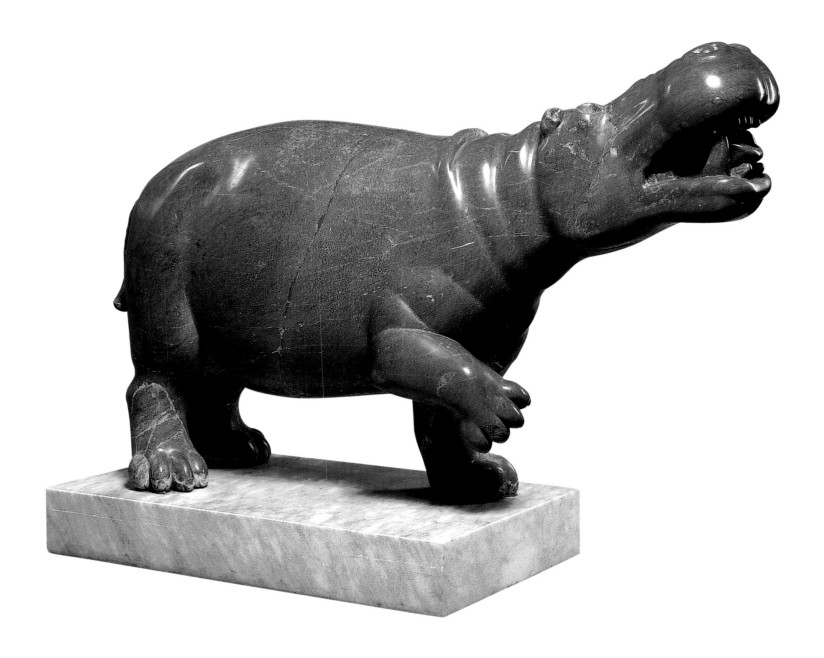

Portraits from the Licinian Tomb in Rome: Fact or Fiction?

METTE MOLTESEN

The first large acquisition that Wolfgang Helbig managed to secure for Carl Jacobsen was a group of sixteen Roman marble portraits belonging to his friend Michael Tyszkiewicz, a Polish count who lived in Rome and Paris. They had been found in Rome some years before, but by 1887 Tyszkiewicz had tired of them, apparently wishing to collect Greek bronzes instead. In all likelihood these works represent the sculptures assembled in an aristocratic tomb of the early Roman empire. They are a unique example of ancestral portraiture connected with a single noble family to have survived from ancient Rome.

The story of their discovery is complicated and far from clear. When in 1884 piles were driven for a new building on the Via Salaria (now Via Piave) in Rome, a small chamber (3.8 × 1.5 m) came to light. In it were found seven marble funerary altars, with inscriptions naming members of the family Licinius Crassus, from the first and second centuries AD. In 1885 another chamber was found nearby with seven marble sarcophagi, and then yet another containing three sarcophagi, all from the second century (most of these are now in the collection of the Walters Art Museum, Baltimore). These discoveries were made by builders and thus there are no excavation reports; we know only that they took place on the same building site. The portraits acquired by Jacobsen in 1887 were said to have been found here: twelve in the first chamber, three in the second. The chambers were later published in the great plan of Rome, *Forma Urbis*, as if they were part of the same grave building. But it is not certain that these chambers were part of a single original tomb. It seems more likely that the small chamber (which contained twelve portraits) was a deposit in which earlier family tomb furniture could, for whatever reason, be hidden. The other two probably were real tomb chambers of the second century AD.

The most notable portrait discovered in this group is one identified as Gnaeus Pompeius Magnus, Pompey the Great (106–48 BC). Pompey was the defeated opponent of Julius Caesar and his defeat was taken to mark the end of the Republic and the beginning of imperial autocracy, first under Julius Caesar and then under the emperor Augustus. Through the female line, Pompey's descendants formed generations of aristocrats who were dangerously close to those in power. One of the altars in the tomb was set up for another Pompeius Magnus. His mother, Scribonia, was the great-great-granddaughter of Pompey the Great and had named her son after him. His father was Marcus Licinius Crassus Frugi, who was consul in AD 27. The emperor Claudius (AD 41–54) took an interest in the young Pompeius and gave him his daughter, Claudia Antonia, in marriage. This was, however, to be a short period of happiness. In AD 47, under the influence of his wife Messalina, the emperor had the whole family murdered: Crassus, Scribonia and young Pompeius. The parents may also be among the portraits in this group. Another altar commemorates Lucius Calpurnius Piso Frugi, who was adopted by the short-lived emperor Galba (AD 68–69) as his heir. But this arrangement lasted only a few days before heir and emperor were murdered. Piso's widow's altar was also found in the tomb. The bust of Pompey within the group represents an important ancestor (albeit a politically dangerous one). It is possible that one of the other busts represents Marcus Licinius Crassus (consul in 70 and 55 BC), a one-time ally of both Pompey and Caesar.

Some scholars have been suspicious of the complicated story of the excavation, difficult as it is to substantiate; they have instead suggested that the portraits were just a random assortment of heads that Wolfgang Helbig had put together with the portrait of Pompey for the benefit of Jacobsen, in order to get a better price. Although this cannot be firmly disproved, given the available documentation, several of the portraits do seem to form a group; they are much alike in style and material, and can be dated to the reign of Claudius. This would fit well with an assemblage first made at the time of the murder of Pompeius Magnus and his parents in AD 47. The portraits are all of very high quality and, apart from that of Pompey, are all in Parian marble. They were probably made in the same workshop and seem to depict both ancestors of the family (such as Pompey, Crassus, the old woman and the two sisters who have the hairstyle of the 40s BC) and contemporaries of the unfortunate young Pompeius Magnus. The three late portraits are contemporary with the sarcophagi. Whatever the truth about their origin, Jacobsen was thrilled with his acquisition and made it the starting point for his collection of more than 300 pieces, one of the most important collections of Roman portraits in the world.

60

Portrait of Pompey the Great,
marble copy from the AD 40s
of a bronze statue of 55 BC
Marble, H. 25 cm

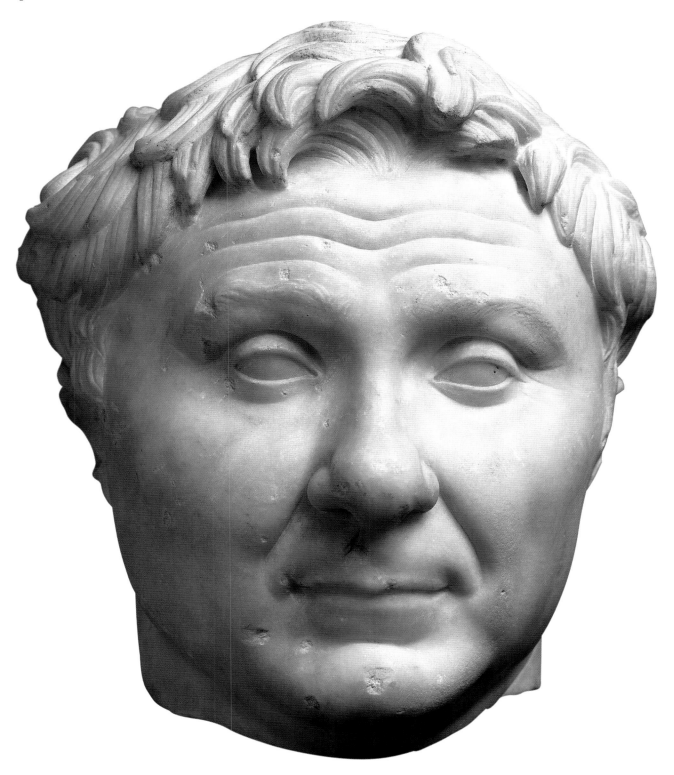

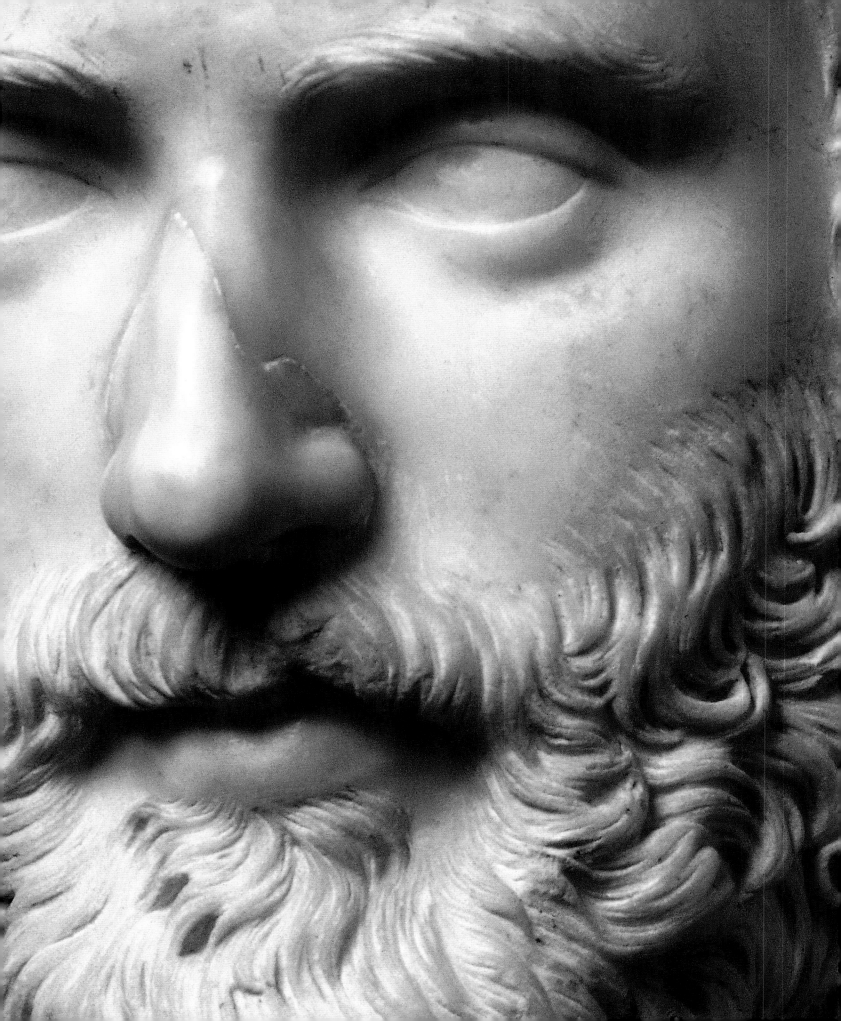

61
Portrait of a man,
c. AD 160
Marble, H. 41 cm

62
Portrait bust of Lucius
Verus as a child,
c. AD 140–150
Marble, H. 47 cm

63
Portrait of a young woman,
late second century AD
Marble, H. 37 cm

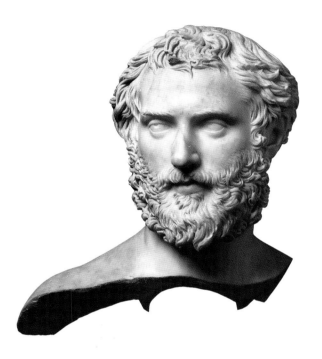
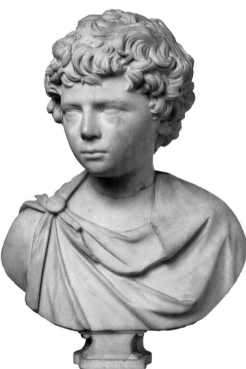
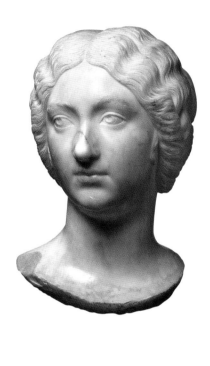

64
Portrait of a small boy,
AD 40s
Marble, н. 24 cm

65
Portrait bust of a young woman,
AD 40s
Parian marble, н. 38 cm

66
Portrait of a woman,
AD 40s
Parian marble, н. 35.5 cm

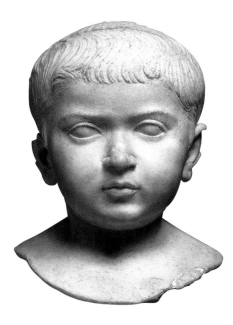
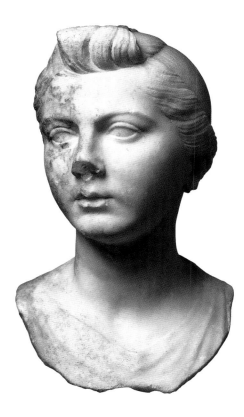
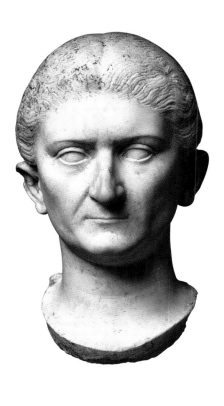

67
Portrait of a woman,
AD 40s
Parian marble, H. 38 cm

68
Portrait of a young woman,
AD 40s
Marble, H. 39 cm

69
Portrait of a young man,
perhaps Pompeius Magnus,
AD 40s
Marble, H. 28 cm

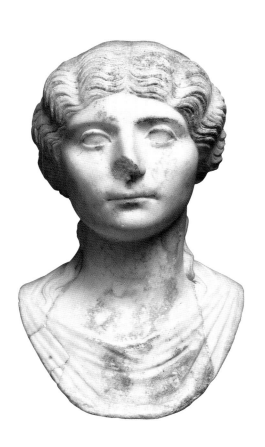

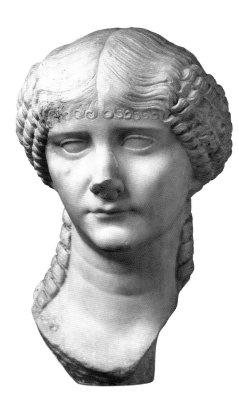

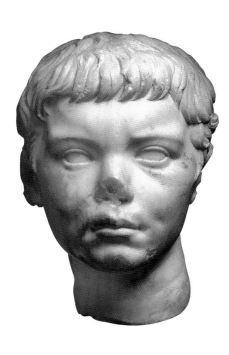

70
Portrait of a young woman,
AD 40S
Parian marble, H. 36 cm

71
Portrait of a woman,
AD 40S
Parian marble, H. 27 cm

72
Portrait bust of an elderly woman,
AD 40S
Parian marble, H. 34 cm

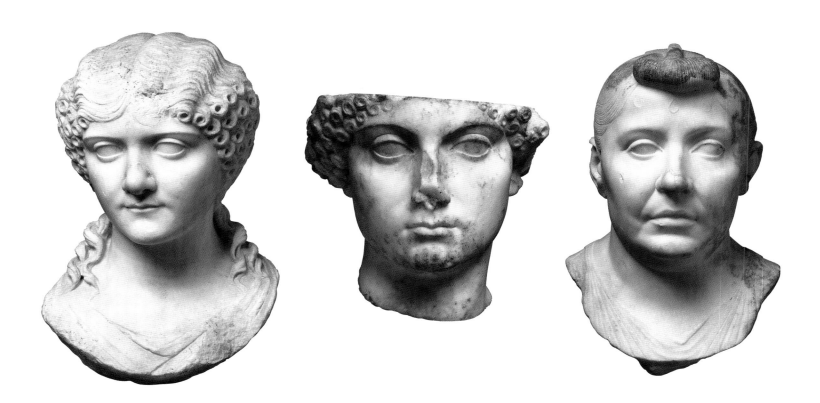

73
Portrait bust of a man,
perhaps Marcus Licinius Crassus,
AD 40s
Parian marble, H. 45 cm

74
Portrait of a man,
AD 40s
Marble, H. 24 cm

75
Portrait bust of a young woman,
AD 40s
Parian marble, H. 44 cm

Finds from the Sanctuary of Diana at Nemi

METTE MOLTESEN

The Ny Carlsberg Glyptotek houses a number of Roman portraits of superb quality that were excavated in the Sanctuary of Diana at Nemi, in the Alban Hills south-east of Rome. They were acquired separately over a number of years, but were found together in the votive rooms (*cellae*) in the central part of the main portico (see plan, right). They represent a rare collection of portraits: not only do we have a good idea of the original context of their display, but also many are clearly named, showing that we are dealing for the most part with a group of wealthy non-aristocrats, actors and former slaves.

The goddess Diana was the sanctuary's main deity and was worshipped together with a consort deity, the Greek hero Hippolytos, who according to one version of the myth had been raised from the dead by Diana and transformed into a minor local god by the name of Virbius. Diana, often seen as the Roman equivalent of the Greek goddess Artemis, had several functions: goddess of the hunt and of wild animals, she was also associated with the moon and the darker side of nature, and with women and childbirth. The sanctuary at Nemi had a highly unusual priesthood, which captured the imagination of ancient and modern observers alike. A runaway slave was permitted to challenge the incumbent priest, the so-called *rex nemorensis* (or king of the grove, after the sacred grove in which the sanctuary was set), to single combat to the death. If the challenger won he became the new priest and watchfully awaited his own fate. It was this strange tradition (which continued until Roman imperial times) that puzzled Sir James Frazer and launched his monumental *Golden Bough*, one of the early classics of British anthropology. The site was the inspiration for paintings by J. M. W. Turner and other nineteenth-century painters.

The earliest sanctuary was a clearing in the dense forest. The first small temple building on the site has been dated from the remains of its terracotta decorations to the third century BC. The monumentalisation of the sanctuary stems from the second half of the second century BC, a time when many of the sites of Central Italy were being spectacularly developed (the best preserved is the Sanctuary of Fortuna Primigenia at Praeneste, modern-day Palestrina). The main terrace at Nemi took up more than 50,000 m² and housed a number of architectural elements, including the small temple designated KKK. The terrace was framed on three sides by a large portico. The most conspicuous features today are the huge vaults in concrete that support the lower and middle terraces. According to plans made in the area by the architect Pietro Rosa in 1856, the main temple is thought to lie centrally on an upper terrace which has not yet been excavated.

Since the eighteenth century excavations had been carried out here in order to find sculpture that could be sold on the

General plan of excavations at the Temple of Diana at Nemi (1885)

antiquities market. In 1885 Sir John Savile Lumley, later Lord Savile, British ambassador to Rome and a passionate amateur archaeologist, excavated in the Sanctuary of Diana. Later excavations were carried out by art dealers such as Luigi Boccanera (from 1886 to 1888) and Eliseo Borghi (in 1895). Lumley uncovered temple KKK and parts of the rooms in the northern wing of the central portico, although the excavations were not carried out in a way we would regard as scientific, and only a very rough plan exists. According to the law of that time the proceeds of the excavations were shared between the excavator and the landowner, Prince Orsini. Lumley's share of the find is now in the Castle Museum, Nottingham. In 1998 the Italian authorities recommenced excavations in the sanctuary.

The majority of the finds were votives, gifts to the goddess, in gratitude for services rendered or in the hope of help. These took the form of small terracotta figurines or anatomical parts such as feet, hands, eyes and wombs. More spectacular gifts were made of marble, such as a group of eight vases, four amphorae and four griffin cauldrons. These bear the inscription CHIO DD (*Chio Dono Dedit*, 'Chio gave this as a gift'), revealing that a single man, Chio, gave the whole series as a very costly gift to the goddess.

The Glyptotek sculptures come from the central portico. The statue of the emperor Tiberius (cat. 77) was found in one of three niches in an apsidal room (see plan, opposite). The portrait head of Germanicus (cat. 85) was found nearby and the arrangement may have represented Tiberius with his two designated heirs Germanicus and Drusus, both of whom died before succeeding him. In a storeroom-type area on the northern corner of the site were discovered a large number of sculptures, among them a head of Diana from a large Hellenistic composite or 'acrolithic' statue (cat. 90), probably the cult statue from *c*. 100 BC. In another room a series of portraits came to light, some still in their original setting (see plan, right). First and foremost are the two full-size statues of Fundilia and her ex-slave Fundilius Doctus, an actor (C, D; cats 78–9). To the sides stood four herms (tall, rectangular blocks) in bluish Carrara marble (*bardiglio*) on which portraits in white marble were set: one of Fundilia (A) and by her side Lucius Aninius Rufus (B; cat. 81); opposite stood a young woman, Staia Quinta (E; cat. 82) and a man named Hostius Capito (F; cat. 83). Three more portraits were found in the room: one of an elderly lady whose herm, naming her Licinia Chrysarion, was found in a room nearby (cat. 80). The portraits are all of very high quality and made mostly of imported marble. They can all be dated to the middle part of the first century AD. Their subjects are local people of the freedmen class from the neighbouring towns, several of whom seem to have been active in the world of the theatre.

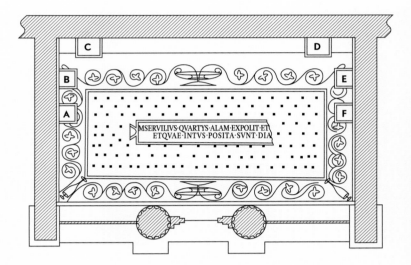

Plan of the Fundilia Room showing mosaic floor and location of some of the portraits

A Original location of portrait herm of Fundilia Rufa (Nottingham Castle Museum and Art Gallery)
B Original location of portrait herm of Aninius Rufus (cat. 81)
C Original location of statue of Fundilia Rufa (cat. 78)
D Original location of statue of Fundilius Doctus (cat. 79)
E Original location of portrait herm of Staia Quinta (cat. 82)
F Original location of portrait herm of Hostius Capito (cat. 83)

76
Torso of Drusus the Younger,
AD 20–50
Parian marble, H. 182 cm

77
Statue of Tiberius, AD 20–50
Torso Carrara marble; lower body
Parian marble, H. 212 cm

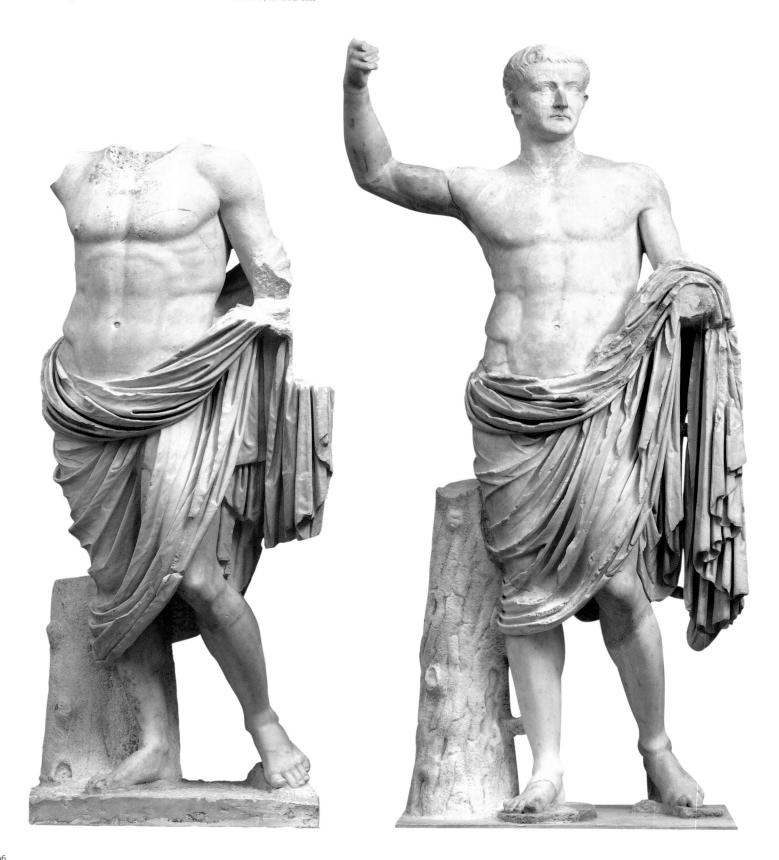

78
Statue of Fundilia Rufa, AD 20–50
Carrara marble, H. 178 cm

79
Statue of Fundilius Doctus, AD 20–50
Dokimian marble, H. 183 cm

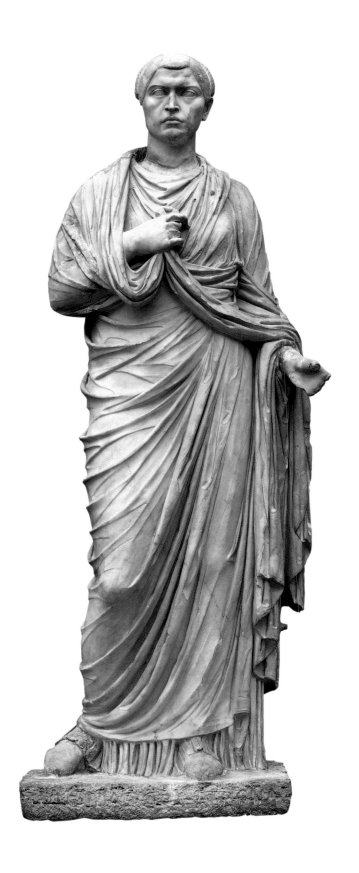

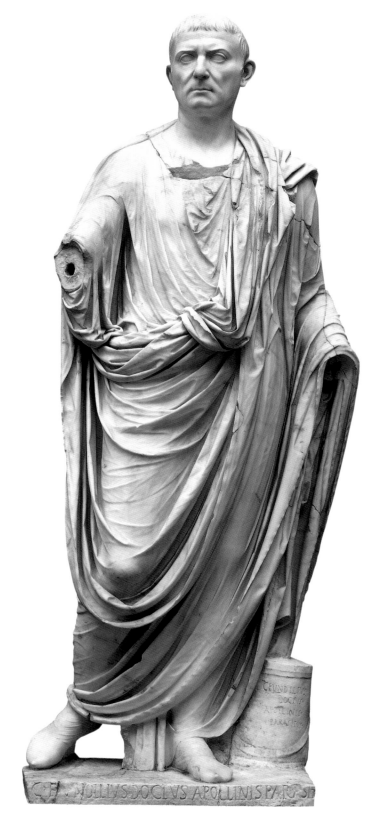

80
Portrait of a mature woman,
AD 20–50
Carrara marble, H. 31 cm

81
Portrait herm of Aninius Rufus,
AD 20–50
Parian marble, H. 40 cm;
herm in *bardiglio*, H. 110 cm

82
Portrait herm of Staia Quinta,
AD 20–50
Parian marble, H. 44 cm;
herm in *bardiglio*, H. 100 cm

83
Portrait herm of Hostius Capito,
AD 20–50
Parian marble, H. 32 cm;
herm in *bardiglio*, H. 112 cm

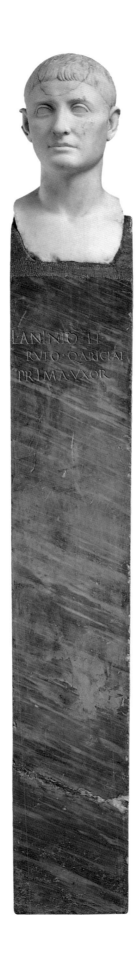

L·ANINIO·LL
RVFO·Q·ARICIAE
PRIMA·VXOR

STATIA·LLQVINTA

Q·HOSTIVS·Q·F·CAPITO
RHETOR

84
Portrait of a young woman, AD 20–50
Parian marble, H. 42 cm

85
Portrait of Germanicus (?), AD 20–50
Dokimian marble, H. 41 cm

86
Portrait of a man wearing a wreath,
AD 20–50
Parian marble, H. 40 cm

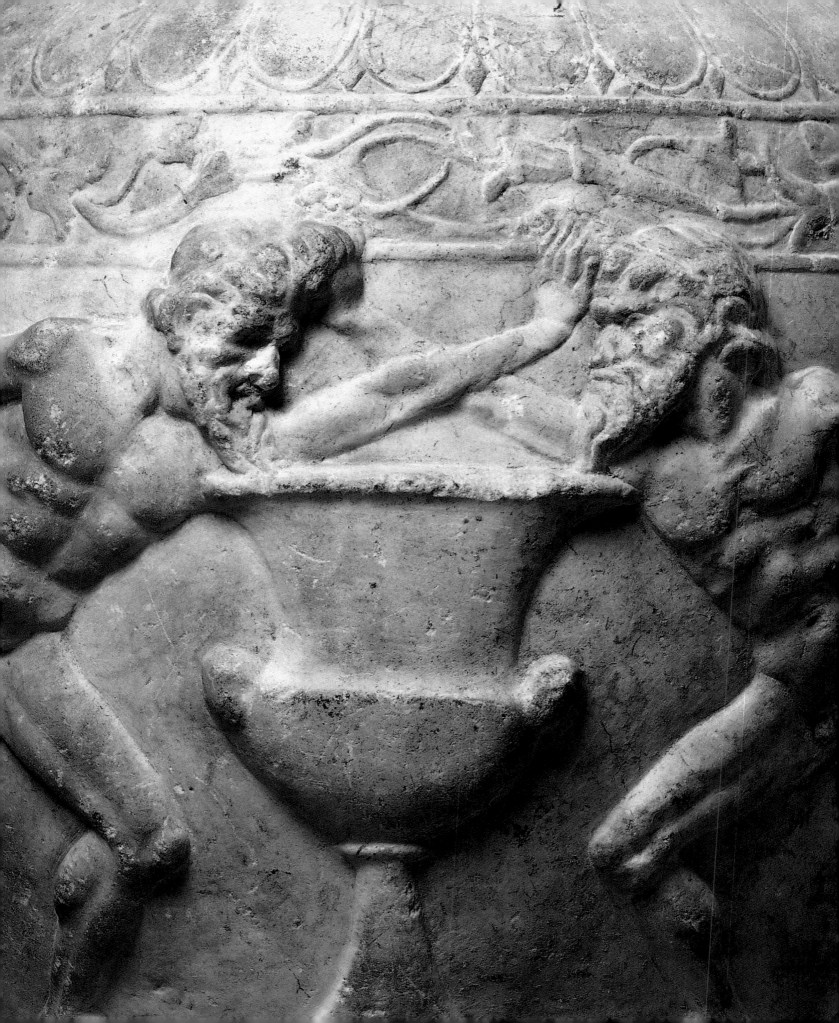

87
Marble vase, first century BC
Marble from Asia Minor, H. 86 cm

88
Marble vase, first century BC
Marble from Asia Minor, H. 94 cm

89
The Ariccia Head, c. 480 BC
Bronze, H. 21.5 cm

104

90
Head of the goddess Diana, c. 100 BC
Parian marble, H. 54 cm

Sculptures from the Villa of Bruttius Praesens in the Sabine Hills

METTE MOLTESEN

In 1807 Prince Camillo Borghese sold his collection of art – regarded as the cream of the world's private collections – to his brother-in-law Napoleon Bonaparte for thirteen million francs. After the fall of Napoleon, a new collection was assembled from finds made on the family's properties, and also by the purchase of statuary from other excavations. When Marcantonio Borghese died in 1886 the family was in debt on account of the recession that had followed the building boom in Rome after its early years as the capital of the newly united Italy. Although Carl Jacobsen managed to buy some of the finest pieces, much of the Borghese collection was entailed, and thus was acquired by the Italian government in 1901; today it can be seen at the Villa Borghese.

The sculptures that came to Jacobsen had been found in an excavation on Monte Calvo, 53 km north of Rome on the Via Salaria, the ancient Roman road that followed the River Tiber into the Sabine Hills. Until recently the remains of a vast and very elegant villa were visible, but deep ploughing in the 1990s destroyed them. New excavations began in 1998.

The nineteenth-century excavations at Monte Calvo were carried out by two Roman art dealers with the sole purpose of finding ancient sculpture, and were never published; no plans or sections have been preserved. The only information we have comprises weekly dispatches to the office of the papal antiquities service; these are mere lists of finds. It appears that 70 marble statues, 200 pounds (90 kg) of lead water-pipes, mosaic floors, fountains and many architectural fragments of various coloured marbles came to light.

Inscriptions on tile stamps and water-pipes show that the villa was built by C. Bruttius Praesens (c. AD 68–140), who was married to Laberia Crispina, the owner of large estates in the vicinity. Praesens was twice consul and had been posted overseas in many parts of the empire, amassing great wealth. Their granddaughter, Bruttia Crispina, married the emperor Commodus (AD 177–192) and the family remained influential well into the fourth century. Praesens was a close friend of the emperor Hadrian (AD 117–138), builder of that largest and most elegant of all villas, the Villa Adriana at Tivoli. A letter to Praesens from Pliny the Younger (Ep. VII, 3) describes villa life. Pliny urges Praesens to return to the city and not pass all his time at leisure in the country, perhaps an indication that Praesens was a follower of Epicurean philosophy.

Statues of the nine muses – goddesses of inspiration and culture – were found in the villa. The statues were first installed at the Villa Borghese. Five were subsequently bought by Carl Jacobsen. The head of Thalia is now in Dresden; the last three have been lost. A recent study of all the material found at the villa has shown that the statue of a goddess, the famous 'Hera Borghese' – in fact a representation of Aphrodite – was found together with the statues of the nine muses. Although Apollo would normally lead them, in this case Bruttius Praesens made Aphrodite their leader. The muses were heavily restored after their discovery, but their individual characters remain clear: Melpomene, muse of tragedy (cat. 92), carries a large mask bearing the likeness of Hercules in her right hand and a sword in her left; Erato, muse of lyric poetry (cat. 94), holds a musical instrument; pretty Polyhymnia was muse of dancing (cat. 93); and Clio, muse of history, sits on a rock, originally holding a scroll in her lap (her head is lost; she was previously restored with the head of the muse of choral dancing, Terpsichore).

The most important sculptures found at the villa are two portrait statues of Greek poets. These would probably have decorated a hall for recitals and concerts. One, a standing figure, represents Anakreon, a sixth-century BC Greek poet best known for his drinking songs celebrating wine and love (cat. 91). The statue from Monte Calvo may be a copy of a bronze statue of the poet set up on the Athenian Acropolis in c. 440 BC; the sculptor of the original is thought to have been Phidias himself. The other, seated, is broad and fleshy, and wears a thick cloak, perhaps an animal skin, around his lower body. He has often been identified as the seventh-century BC Greek poet Archilochus. The style of the statue, however, is Hellenistic of the third to second centuries BC. The two statues are made from the pure white marble of the Greek island of Thasos. They were probably manufactured in the same workshop, which perhaps created statues on demand after models from different periods. They both share a technical characteristic, namely that the crown of the head was made in a separate piece and attached with an iron dowel. Both skull caps are now missing. Jacobsen was particularly keen to acquire these two pieces. Helbig had great difficulty in obtaining an export licence for them, and in their correspondence he and Jacobsen resorted to using the intriguing code-names 'Armstrong' and 'Dupont' if they needed to mention the poets. The seated poet was retained for five years by the Italian authorities before its shipment to Copenhagen.

All this suggests that the owner of the Monte Calvo villa was a man of erudition who had an eclectic taste, choosing sculptures with thematic links, a man of culture who we might imagine decorated his library or concert hall with statues of poets and the choir of muses led by the goddess Aphrodite, in her role as *musagetes* (leader of the muses).

91
Anakreon, second century AD
Thasian marble, H. 206 cm,
including plinth

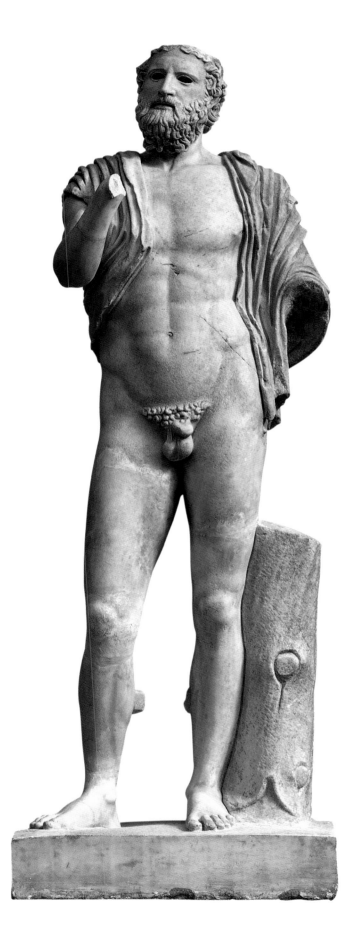

92
Melpomene, muse of tragedy,
second century AD
White marble, H. 178 cm,
including plinth

93
Polyhymnia, muse of dancing,
second century AD
White marble, H. 179 cm,
including plinth

94
Erato, muse of lyric poetry,
second century AD
White marble, H. 182 cm,
including plinth

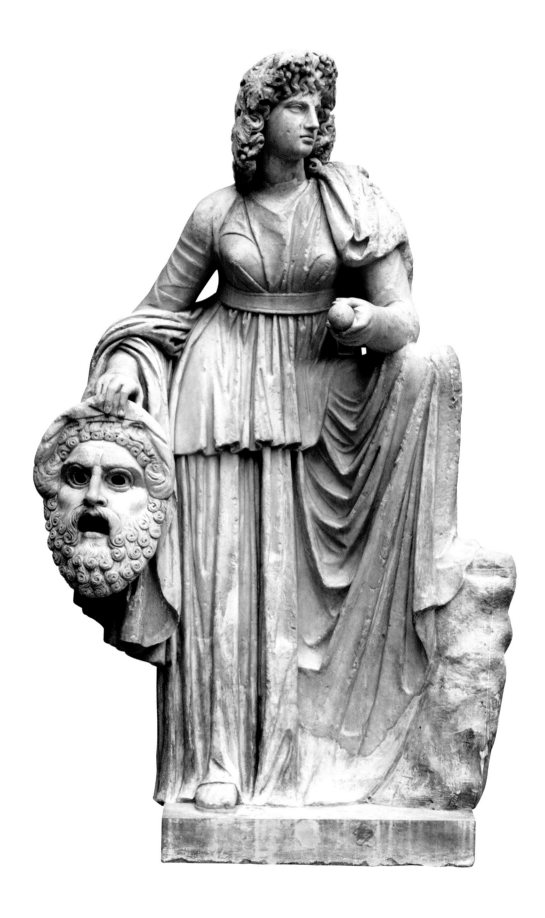

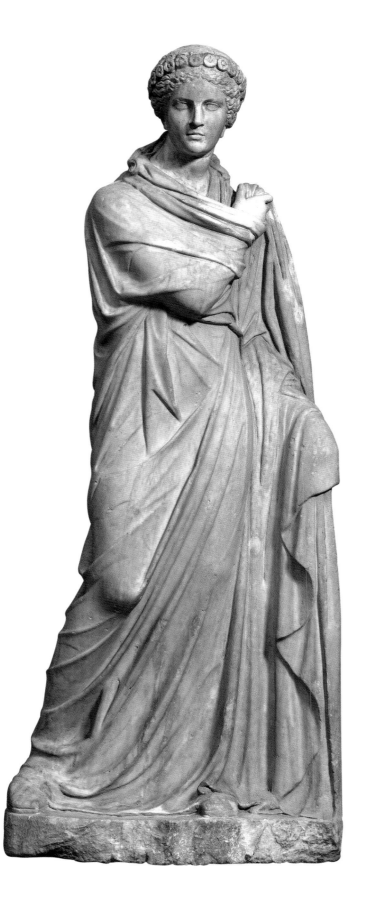
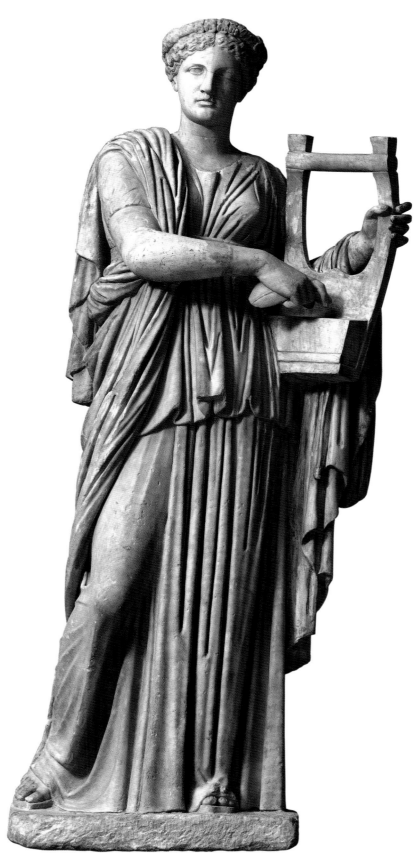

95
Statue of a mature woman as Venus,
AD 90–100
Marble, H. 191 cm

96
Statue of Trajan in armour,
AD 110–17
Marble, H. 200 cm

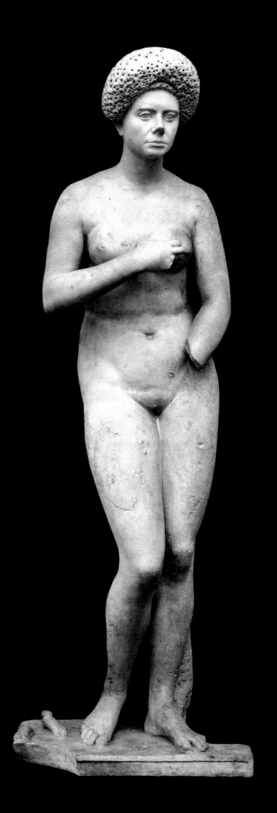

Kline monument: reclining man,
Rome, *c.* AD 100–150
Thasian marble, 63 × 175 × 66 cm

98
Sarcophagus with Roman shipping,
late third century AD
Marble with many traces of red,
blue and green paint,
52 × 178 × 85 cm

99

Sarcophagus with the wedding feast
of Dionysos and Ariadne,
end of the second century AD
Marble, 68 × 222 × 83 cm;
lid relief H. 31 cm

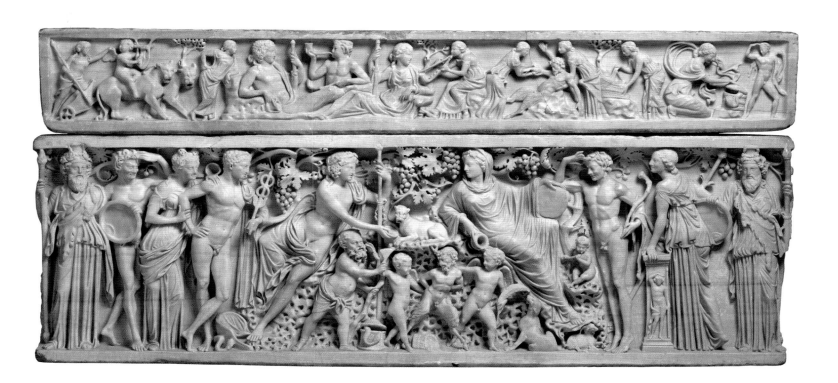

100

*A child's sarcophagus with
the legend of Jonah, c. AD 300*
Marble, 40 × 124 × 42 cm

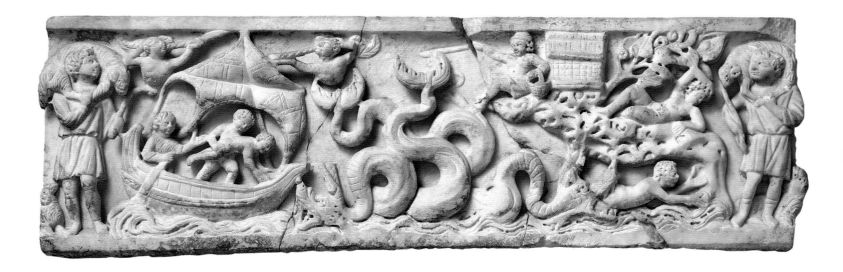

101
Funerary altar, Rome, *c.* AD 130
Marble, 90 × 55 × 43 cm

102
Cinerary altar, AD 100–150
Marble, 105 × 62 × 30 cm

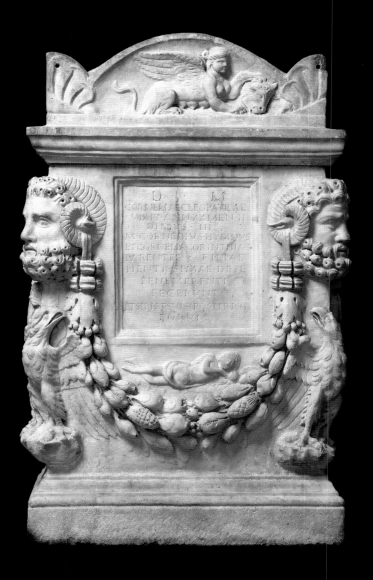

103
Funerary portrait relief,
end of the first century BC
Marble, 63 × 127 × 23 cm

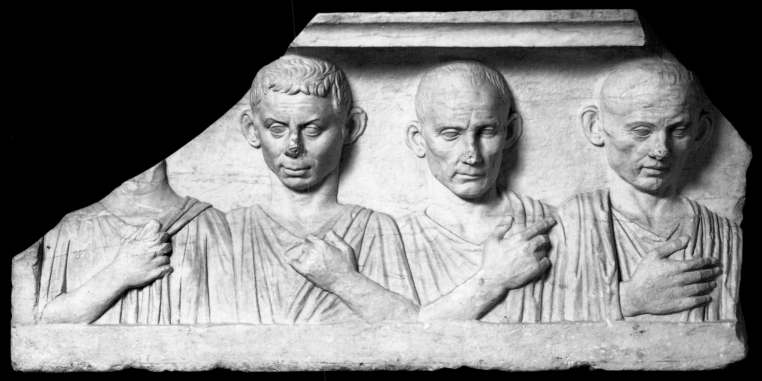

104
Portrait of a Roman lady,
end of the first century BC
Marble, H. 39 cm

105
Portrait of the emperor Caligula,
AD 37–41
Parian marble, H. 51 cm

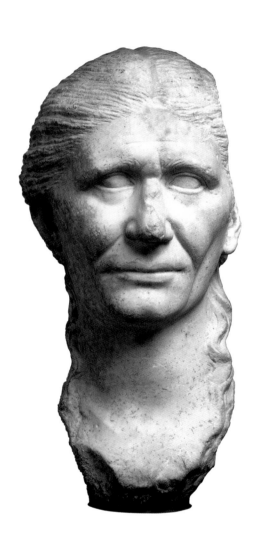

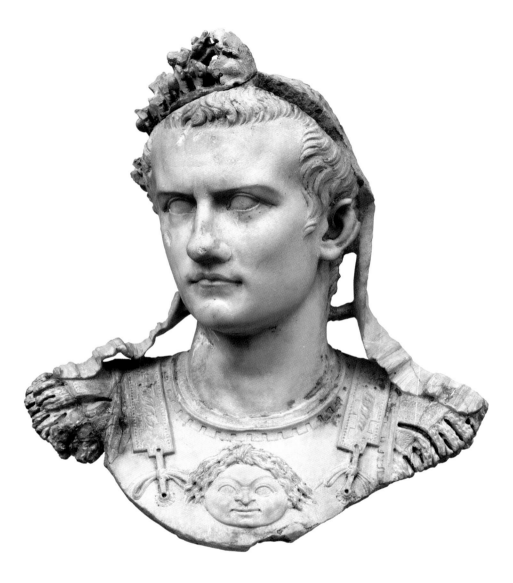

106
Portrait of Agrippina the Younger,
wife of the emperor Claudius,
AD 41–54
Marble, H. 36 cm

107
Portrait of a young man,
AD 160–170
Marble, H. 70 cm

108
Portrait of the emperor Caracalla,
c. 212 AD
Marble, H. 35 cm

109
Portrait of a Roman woman,
c. 220 AD
Marble, H. 45 cm

110
Bust of a Roman lady,
c. 240 AD
Marble, H. 33 cm

111
Portrait of a Roman,
middle of the third century AD
Marble, H. 35 cm

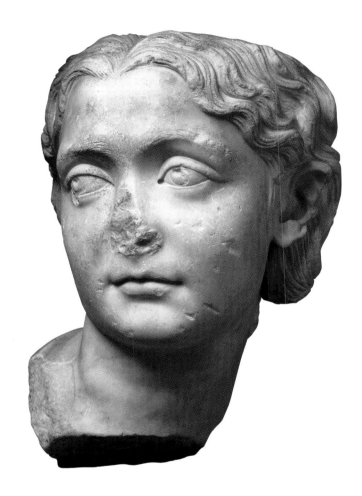

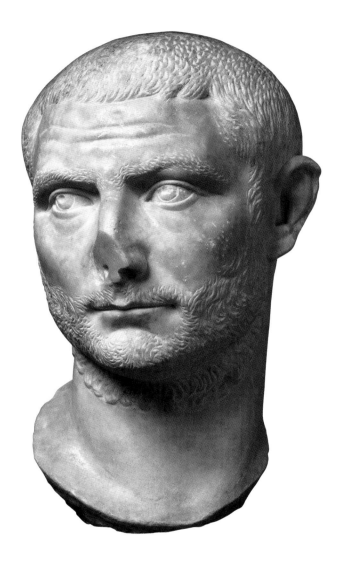

Danish Painting and Sculpture

Carl Jacobsen's Collections of Danish Painting and Sculpture, 1800–1850

TINE BLICHER-MORITZ

Denmark experienced fundamental change in the first half of the nineteenth century. Politically, the country witnessed the demise of its international power with the loss of Norway to Sweden in 1814, and the ceding of the duchies of Schleswig and Holstein to Germany after ignominious military defeat in 1864. The revolutions across Europe in 1848 brought about the replacement of an absolute monarchy with a constitutional monarchy and some limited popular representation. This change in the system of government, enshrined in a new constitution of 1849, also acknowledged the rapid growth of the middle classes, notably in Copenhagen in the decades leading up to that date. Economic prosperity, allied to intellectual and cultural aspirations, gave them an increasingly influential stake in literature, science, painting, sculpture and philosophy.

Both J. C. and Carl Jacobsen played a central role in Danish society in the nineteenth century. They owed their fortune to the introduction of new industrial processes in the making of ales and beer, and hence were able to contribute to the cultural and intellectual life of the nation, both as benefactors and collectors.

Carl Jacobsen's taste for Danish art was shaped by that of his father. As a child Jacobsen had been introduced to the artists of the early nineteenth century. J. C. Jacobsen and his wife collected contemporary painting and sculpture (including works by Bertel Thorvaldsen [1770–1844]), albeit modestly, and a number of the most important figures in Danish cultural circles frequented their home. Carl Jacobsen supplemented this access to Danish art with visits to museums and collections in Denmark and abroad, and established friendships with many of the prominent painters and sculptors of the age.

Although the Glyptotek's collection of Danish painting from the period of the 'Danish Golden Age' (c. 1800–50) was formed by Carl Jacobsen, during his lifetime it was never conceived of as a cornerstone of the museum. Rather, he was inspired by a nationalist zeal to present to the public the achievement of Danish artists through a small but exquisite collection. Paintings tended to be acquired primarily for their individual qualities and only secondarily as exemplars of the history of this specific school. Although many of the pictures had hung in Carl Jacobsen's private home before entering the new Glyptotek, only the best were transferred to the museum. After Carl Jacobsen's death, his son Helge established guidelines for the expansion of the Golden Age collection. Certain works that Carl Jacobsen had deaccessioned were bought back, and gaps were filled. Within the last quarter of a century, a large number of oil sketches have been acquired. As it stands today, the collection makes possible both an appreciation of the achievements of Danish Golden Age art and the study of the relationship between oil sketch and finished work, a process central to Danish Golden Age painting.

The Royal Danish Academy of Fine Arts was founded by King Frederik V in 1754, making it possible for artists both to obtain a professional training at home and to lay the foundations for a national school of art. During the first decades of the nineteenth century the academy trained a number of talented students, most of them taught by the professor of painting, Christoffer Wilhelm Eckersberg (1783–1853). Having completed his studies at the Royal Danish Academy in 1810, Eckersberg commenced a study tour to improve his skills as a history painter, the most elevated genre sanctioned by the academy. In Paris he attended the studio of Jacques-Louis David (1748–1825), studying after the nude. He also copied Antique and Renaissance art in the Louvre, then overflowing with loot taken by Napoleon in the wake of his early military successes. Having improved his painting of the figure, Eckersberg travelled on to Rome in 1813. Disenchanted with the study of the old masters, he turned to making topographical studies of Roman sites, as seen, for example, in his brilliant *View of the Via Sacra, Rome* (cat. 112). These small-scale views record with immediacy the luminosity of the South, and they were to become an important step in the development of a new, national, Danish art. When Eckersberg was appointed professor at the Royal Academy in Copenhagen in 1818 he introduced plein-air painting to his students and, in 1822, classes in the study of the female nude (cat. 122), both new elements in Danish art.

Eckersberg's students – Christen Købke (1810–1848), Martinus Rørbye (1803–1848), Constantin Hansen (1804–1880), Wilhelm Marstrand (1810–1873), Wilhelm Bendz (1804–1832) and Jørgen Roed (1808–1888) – and their fellow Danish Golden Age painters established their reputations through subject matter and treatments gained during their travels abroad, usually in Italy, and notably in Rome, and subsequently applied to Danish motifs made on their return. Their choice of motif bears witness to two concerns: an interest in artistic and cultural heritage, whether ancient, medieval or Renaissance, and a fascination with scenes drawn from contemporary everyday life in Denmark.

Eckersberg's students were shaped by the North's perception of Italy and the Classical past. During the late 1820s and the 1830s, the image of a Classical arcadia derived from Italy was increasingly found in Denmark itself. Influenced by the literature of, among others, Sir Walter Scott, a number of Danish writers published historical novels which informed the emergence of the national Romantic movement's idea of a glorious Danish past. This was reinforced by the lectures and writings of the art historian Niels Lauritz Høyen (1789–1870), delivered at the Royal Academy, in which he equated Danish monuments and ancient remains with those of Italy for the first time. Taken together, a sense of noble, Danish history and culture was established to which artists could readily respond. The paintings of the Golden Age exude Danish national identity. Formed with a specific respect for the detailed study of nature, they are infused with Eckersberg's enthusiasm for Classical art and the art of the High Renaissance. The relative ease of access to Dutch seventeenth-century art in

Copenhagen, both in royal and private collections, also informed the new school of painting, which was further encouraged by artists' travels abroad, notably in Italy, Germany, Switzerland, Norway and, later, Greece. This new painting, which tended to avoid the sentimentality of the contemporary German Biedermeier style, thus acquired a unique timbre that set it apart from other contemporary northern European schools.

The term 'Danish Golden Age' can accommodate literature, science, philosophy and painting, but cannot be so readily applied to sculpture. Carl Jacobsen's interest in sculpture inevitably overshadowed his interest in Danish Golden Age painting. A guiding principle in his purchases of Danish sculpture was his wish to raise public awareness of the quality of the works and to extend appreciation of the art of the neoclassical sculptor Thorvaldsen.

Thorvaldsen practised in Rome from 1797. His success abroad was renowned as a credit to his nation. Such was his standing that tradition has it that young artists would follow him through the streets of Rome; his studio became a focus for visitors. Hermann Ernst Freund (1786–1840) and Herman Wilhelm Bissen (1798–1868) completed their apprenticeships in Rome under Thorvaldsen; both are strongly represented in the Glyptotek. Bissen became Denmark's leading sculptor after Thorvaldsen's death, providing the basis for the collection of Danish art in the museum.

Although Jens Adolph Jerichau (1816–1883) was a student of Freund, his debt to his master's master remained central to his art: 'I think I understand the Greeks, and perhaps better than Thorvaldsen did; but without him I would not have understood them so well.' Jerichau's *Penelope* (cat. 121) draws upon both Classical art and Thorvaldsen. But Thorvaldsen's art posed a dilemma for his pupils: not only did his exceptional talent present a challenge to those struggling to find their own artistic voice, but his devotion to the Classical idiom sat uncomfortably beside the growing taste for the contemporaneous – for realism both in sculpture and in painting. Eventually, both Bissen and Jerichau succeeded in finding a style of their own. Bissen introduced contemporary dress and a growing naturalism into his works, and Jerichau developed a particular form of psychologically charged classicism. These two manifestations of Thorvaldsen's heritage must have appealed to Carl Jacobsen, who was set upon supporting a sculpture that was essentially more *modern* than that of Thorvaldsen. Carl's purpose was made clear in the deed-of-gift he wrote with his wife Ottilia in 1888, which passed their private collection of contemporary art to the state: 'Since the Glyptotek contains precisely the most and the best of what our nation's sculptural art has produced following Thorvaldsen's example and thus represents a period when our country assumed a prominent role in the history of European sculpture, especially with the works of Bissen and Jerichau ... we could only wish that this work would obtain its final place in the capital of Denmark, and we hereby offer it as a gift to our fatherland.'

112
Christoffer Wilhelm Eckersberg (1783–1853)
View of the Via Sacra, Rome, 1814
Oil on canvas, 28 × 33 cm

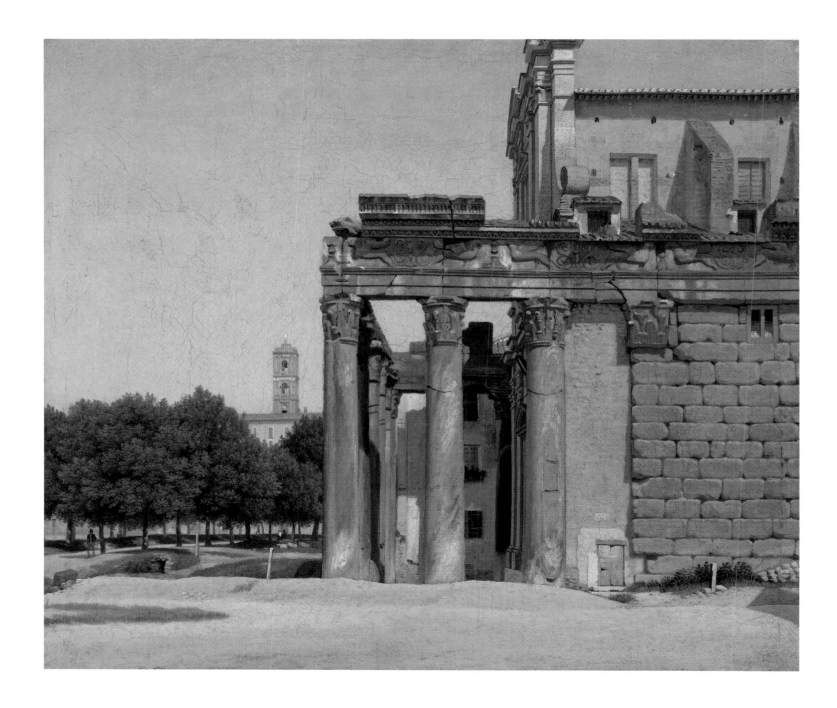

113
Constantin Hansen (1804–1880)
View of the Forum Romanum in Rome, 1837
Oil on canvas, 34 × 46 cm

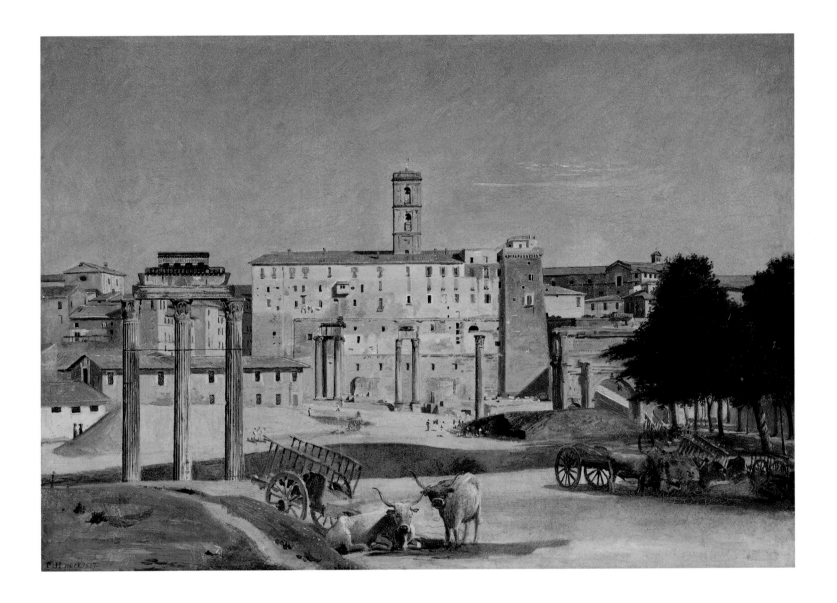

114
Jørgen Roed (1808–1888)
Casa Cenci, presumably 1840
Oil on canvas, 29 × 37 cm

115
Fritz Petzholdt (1805–1838)
The Campagna Outside Rome, c. 1832
Oil on paper on canvas, 23 × 27 cm

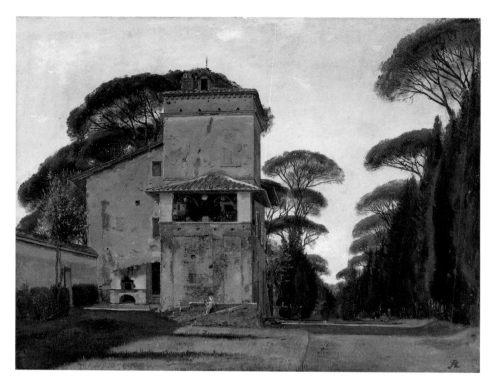

116
Martinus Rørbye (1803–1848)
Michelangelo's Cypresses in the Monastery
in the Baths of Diocletian, 1841
Oil on canvas, 55 × 37 cm

117
Constantin Hansen (1804–1880)
The Bay of Naples with Vesuvius in the Background, 1839/40
Oil on paper on canvas, 20 × 28 cm

118
Christen Købke (1810–1848)
Path Leading Up from the Marina Piccola on the Island of Capri, c. 1839
Oil on paper, 23 × 24 cm

Martinus Rørbye (1803–1848)
*Greeks Fetching Water from the Well at
the Tower of the Winds in Athens*, 1836
Oil on canvas, 30 × 41.5 cm

120
H. W. Bissen (1798–1868)
Flower Girl, 1828–9; carved 1829–31
Marble, H. 120 cm

121
Jens Adolph Jerichau (1816–1883)
Penelope, 1843
Marble, H. 182 cm

122
Christoffer Wilhelm Eckersberg
(1783–1853)
Nude Study, 1833
Oil on zinc, 34.5 × 24.5 cm

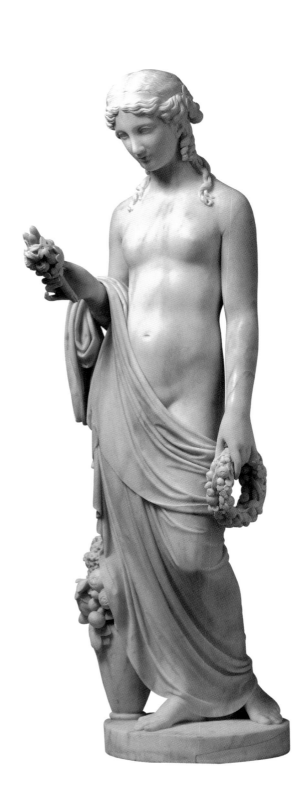

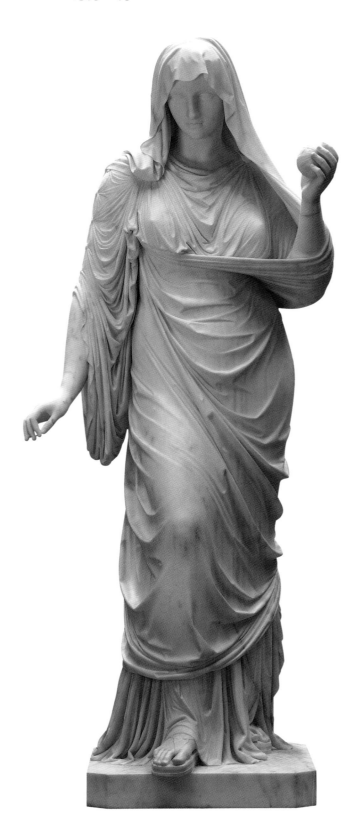

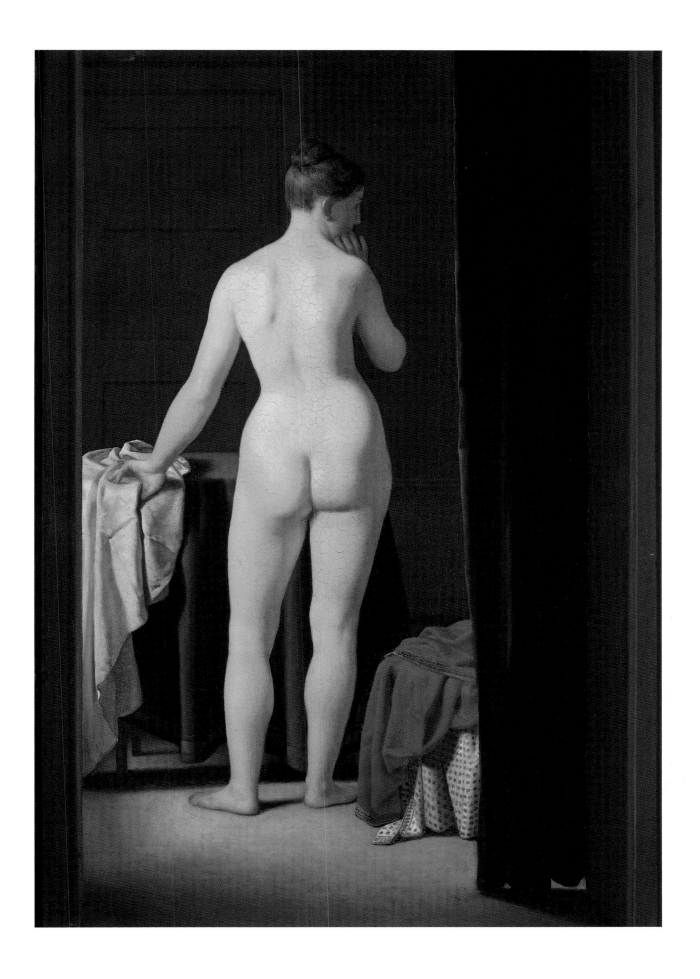

123
Constantin Hansen (1804–1880)
Resting Model, 1839
Oil on canvas, 40 × 55 cm

124
Christoffer Wilhelm Eckersberg
(1783–1853)
*Naked Woman Putting on
Her Slippers*, 1843
Oil on canvas, 65.5 × 46 cm

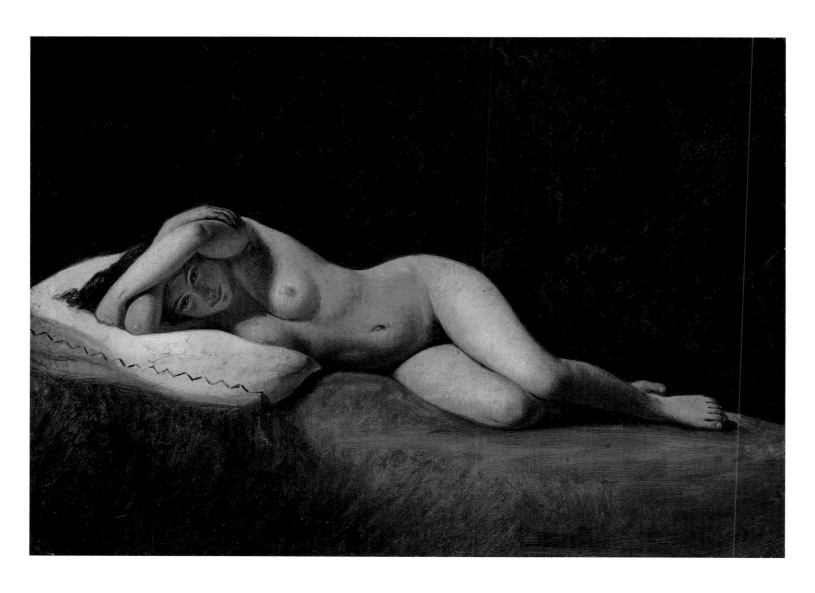

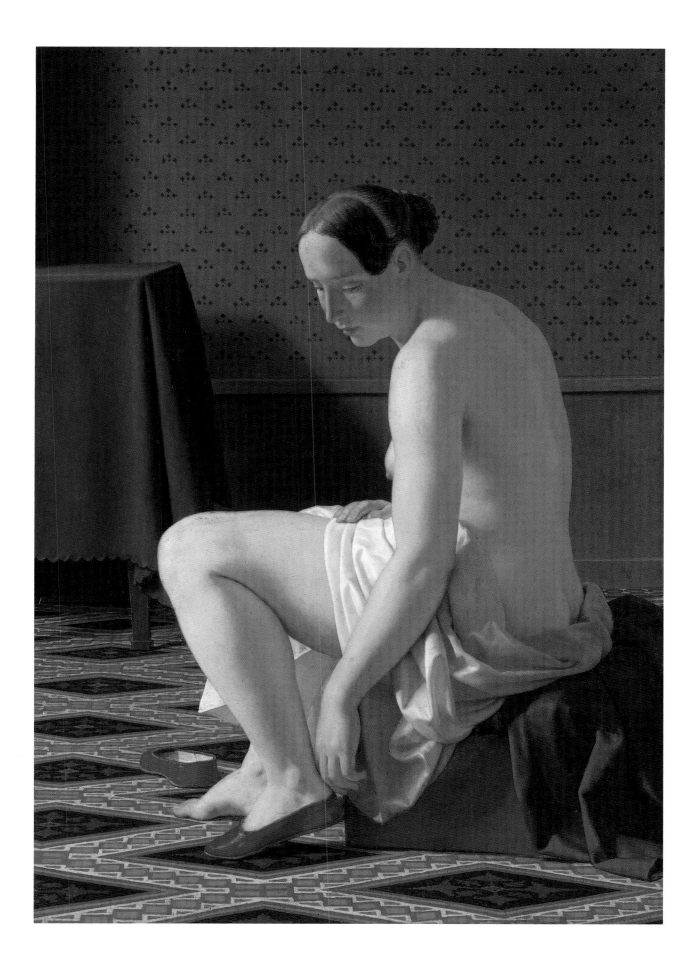

125
Wilhelm Marstrand (1810–1873)
*Study of an Italian Woman
and a Sleeping Child*, 1841
Oil on paper, 29 × 44 cm

126
Jens Juel (1745–1802)
*Elisabeth Henriette Bruun de
Neergaard and Her Eldest Son, Henrik,*
possibly 1799 or 1800
Oil on canvas, 63.5 × 48.5 cm

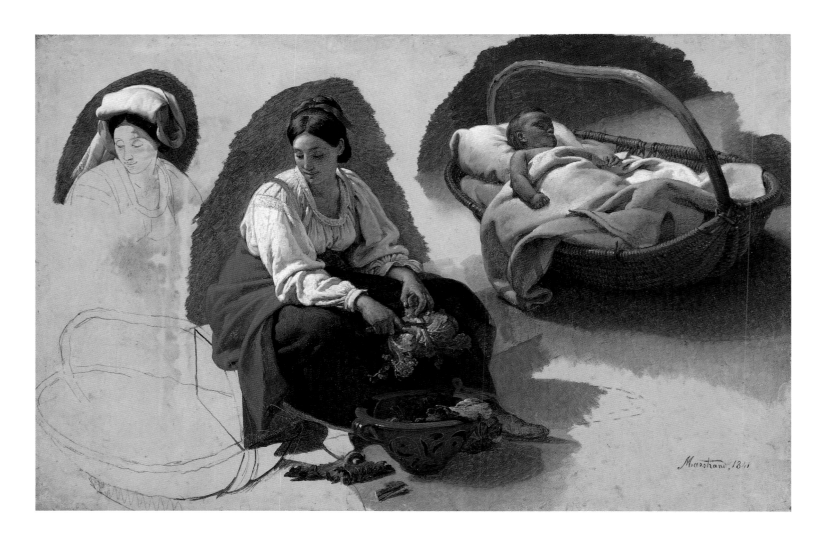

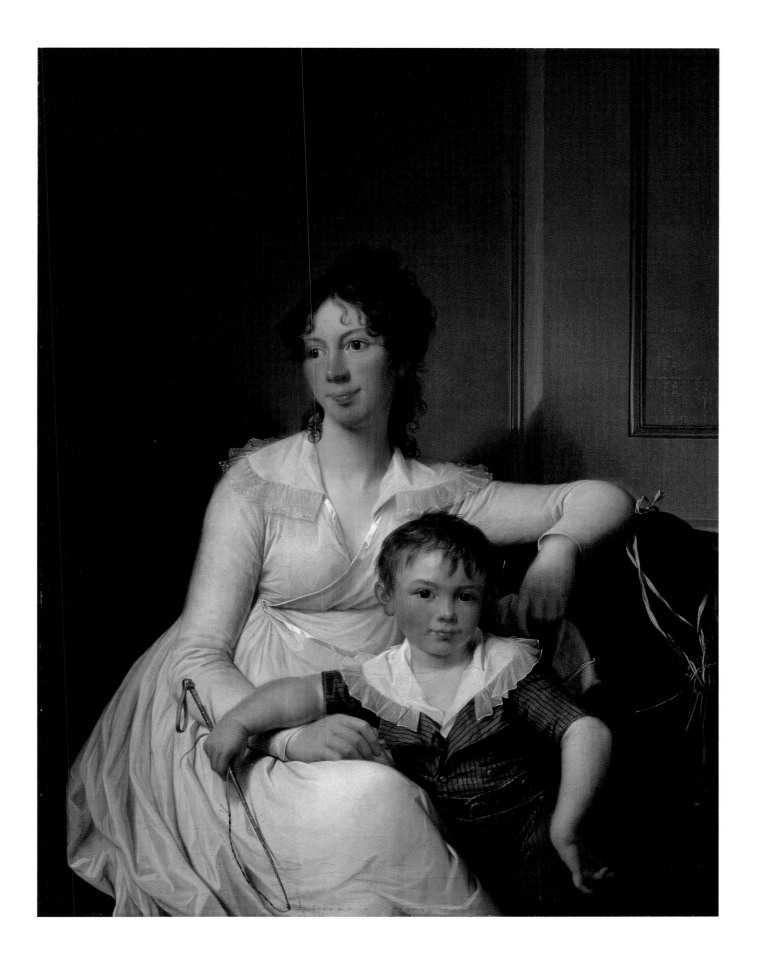

127
Constantin Hansen (1804–1880)
A Hunter Shows a Little Girl
His Bag, 1832
Oil on canvas, 44.5 × 34 cm

128
Wilhelm Bendz (1804–1832)
A Smoking Party, 1827–8
Oil on canvas, 98.5 × 85 cm

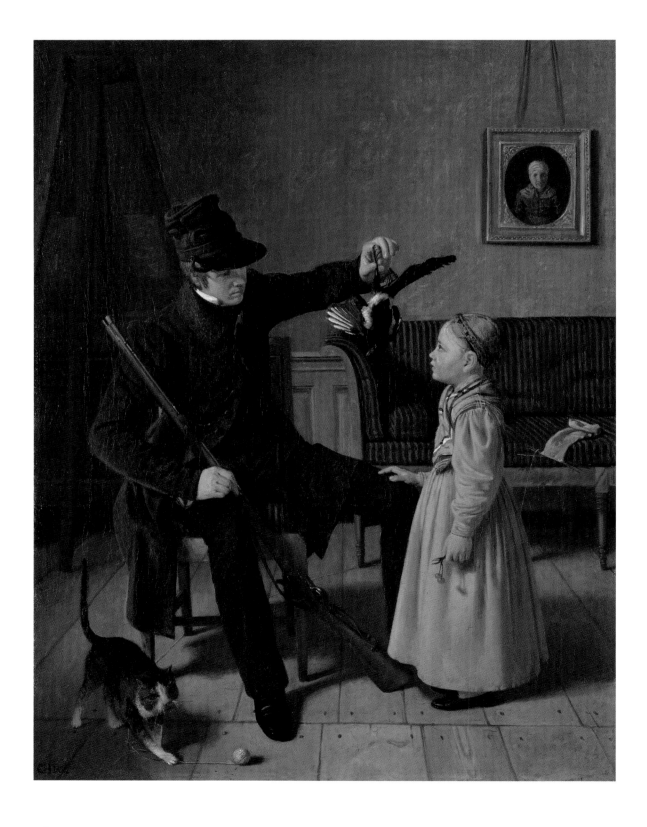

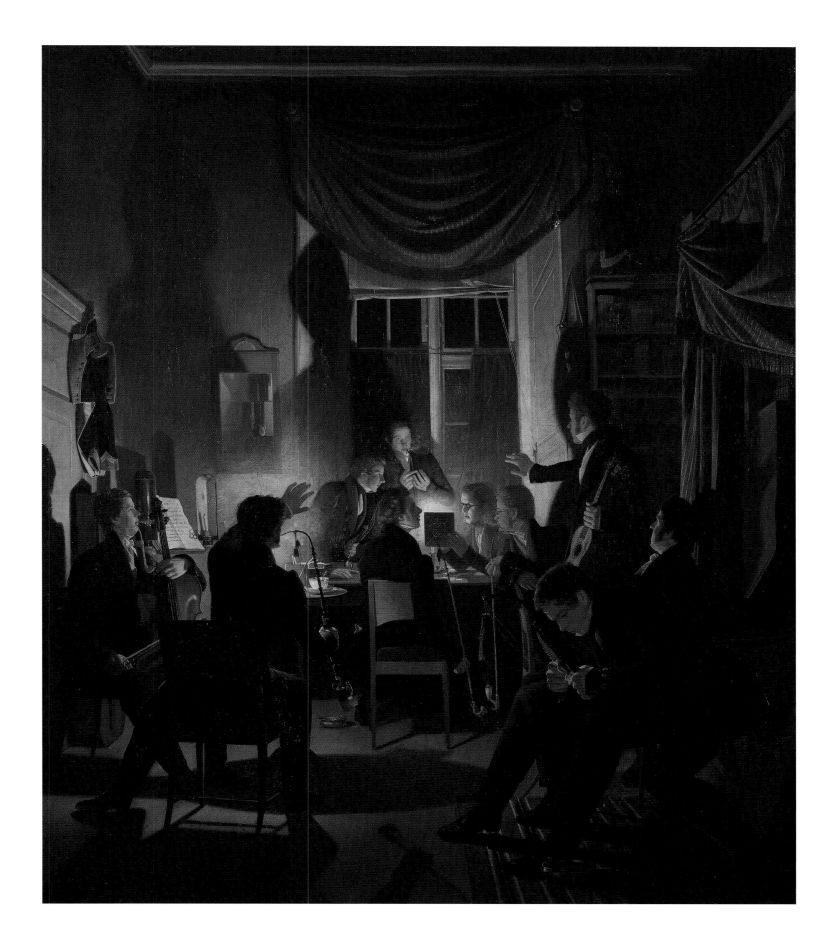

129
Jens Juel (1745–1802)
Landscape with Aurora Borealis, with Middelfart Church
in the Background: 'Attempt to Paint the Aurora Borealis',
possibly 1790s
Oil on canvas, 31.2 × 39.5 cm

130
Christen Købke (1810–1848)
The North Gate of the Citadel, 1834
Oil on canvas, 79 × 93 cm

131
Christen Købke (1810–1848)
Two Tall Poplars, c. 1836
Oil on paper, 29 × 15.5 cm

132
Christen Købke (1810–1848)
*View of the Yard Beside the
Bakery in the Citadel*, c. 1832
Oil on canvas, 33 × 24 cm

133
Johan Thomas Lundbye (1818–1848)
Zealand Landscape, 1840
Oil on canvas, 61 × 124 cm

134
Christen Købke (1810–1848)
Autumn Landscape. Frederiksborg
Castle in the Middle Distance, 1837–8
Oil on canvas, 25.5 × 35.5 cm

135
Johan Thomas Lundbye
(1818–1848)
Landscape at Arresø [Lake Arre], 1838
Oil on canvas, 64 × 86.5 cm

136

Peter Christian Skovgaard
(1817–1875)
View from Frederiksborg Castle, 1842
Oil on canvas, 34 × 59 cm

137

Martinus Rørbye (1803–1848)
*Vester Egede Church with Gisselfelt
Monastery in the Background*, 1832
Oil on canvas, 23.7 × 34.2 cm

138
Ludvig Brandstrup (1861–1935)
Carl and Ottilia Jacobsen
('The Double Bust'), carved 1906
Marble, H. 76 cm

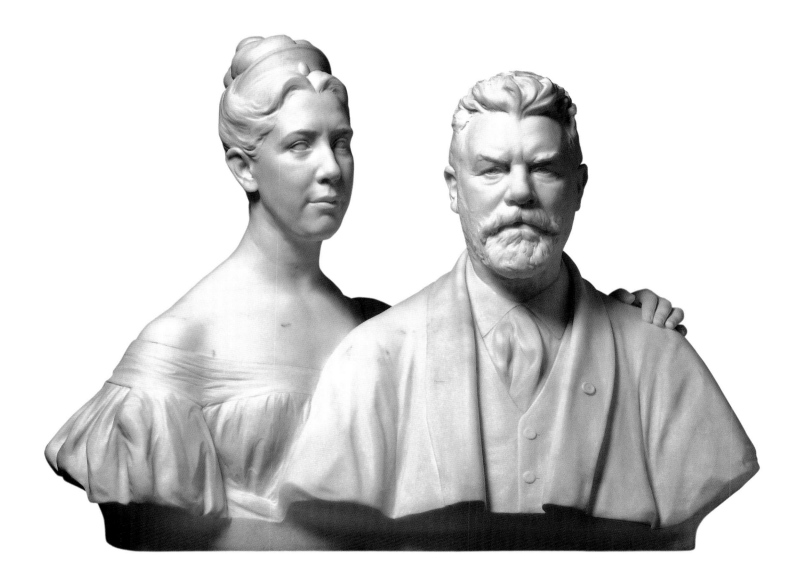

139
Peder Severin Krøyer (1851–1909)
An Evening at the Ny Carlsberg, 1888
Oil on canvas, 145 × 174 cm

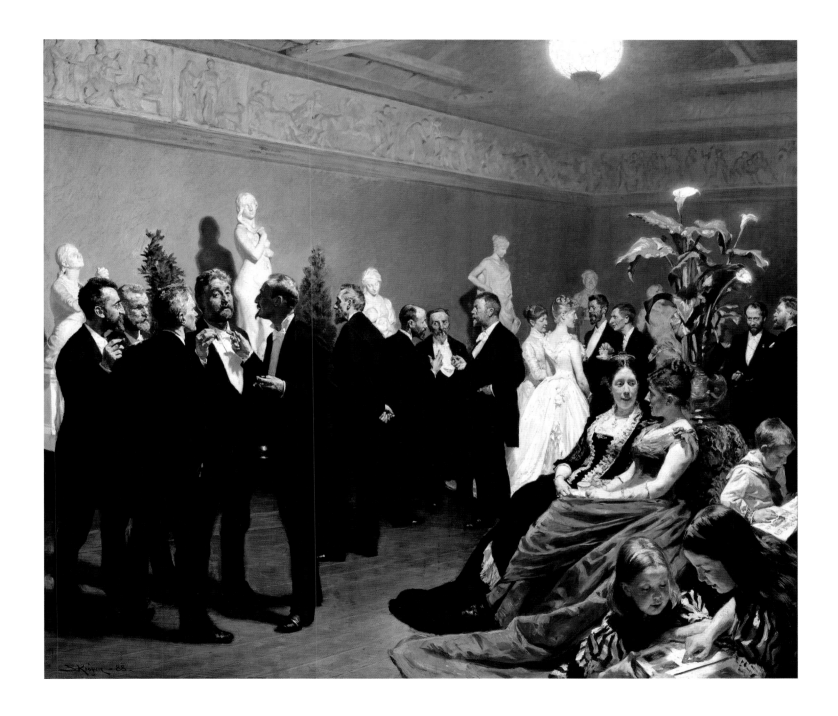

French Painting and Sculpture

The Collection of French Nineteenth-century Art in the Ny Carlsberg Glyptotek

TINE BLICHER-MORITZ

By the middle of the nineteenth century, the reputation of contemporary French art was well established in Copenhagen. In 1878 it was sufficient to encourage Carl Jacobsen to visit the Parisian Salon. There he made his first two purchases of contemporary French art: Jean-François Millet's *Death and the Wood Cutter* (cat. 156), and Eugène Delaplanche's *Music* (cat. 147), which was initially modelled for Charles Garnier's Opéra in Paris in 1877. Thus Jacobsen founded a collection of contemporary French art that was to become one of the finest outside France.

Initially, Jacobsen's taste concentrated upon the art of the French Salon in general, and on sculpture in particular. The collection developed at great speed, with Jacobsen both buying and commissioning exceptional pieces. In 1887, in one of the first guides to his then still private, but publicly accessible, collection, he wrote: 'Never since antiquity has the art of sculpture flourished in any land so abundantly – indeed, it is truly overwhelming – as in the last decade in France. Each year the Salon brings forth young names while the older ones are still in the full flower of their manhood.'

Sculpture shown at the Paris Salon during much of the nineteenth century tended to reflect the dominant teaching of the Ecole des Beaux-Arts: classically inspired treatments of grand subjects drawn from Classical mythology and ancient history served to communicate high-minded, moralising subjects that were intended to educate and inspire the spectator. Given his concern for sculpture to play an educational role for the public, Carl Jacobsen naturally gravitated towards such works. Thus Antonin Mercié's *Gloria Victis* (cat. 148), a monument intended to elevate French soldiers to the status of heroes after their defeat at the hands of the Prussians in 1870–1, could be read as a hymn to individual sacrifice for the defence of the fatherland.

The didactic potential of academic sculpture guided Carl Jacobsen's eye as he attended the annual Salons in Paris. From 1880 until the 1900s he acquired Salon sculpture every year for his collection. He envisaged making a collection that would provide an overview of the development of French sculpture in his own century. Although the original of a sculpture was preferable, the creation of a comprehensive and pedagogical collection was his overriding concern: 'As far as possible, works of art should be original. Exceptionally, however, casts have been included, partly to represent works that especially belong here in the collection, the originals of which could not be acquired, and partly by comparison to serve a fuller understanding of what establishes the true content of the Glyptotek.' In his later years, Carl Jacobsen also sought to develop the idea of stylistic comparison within the Glyptotek collections. As a result, he began to acquire works ranging from Javanese carving to Spanish medieval sculpture. This was to remain a minor aspect of his collection, however, and today these pieces are no longer on display.

It has only been in the last twenty years that Jacobsen's nineteenth-century Salon sculpture has been re-evaluated in the wake of a more tolerant attitude to studies of the development of nineteenth-century art in general. In the late 1980s, after about 60 years 'off stage', these sculptures were brought out of store. They are now understood and appreciated within the context of their own time, as statements of the search for timeless values in a period of rapid modernisation and change.

As for the way he formed his collection, Carl Jacobsen's tendency was to develop specific areas of great strength, both in terms of number and quality. He possessed so many works by certain sculptors that each group tended to represent a discrete monographic collection. Significant within this pattern were Carpeaux, Meunier and Rodin.

A highly gifted sculptor, Jean-Baptiste Carpeaux (1827–1875) is represented by as many as 54 works. Drawing upon such fine examples as the Hellenistic sculptors, Michelangelo and the French Rococo masters, he created an eclectic sculptural language that made him the sculptor *par excellence* during the Second Empire (1852–70). Carl Jacobsen started collecting works by Carpeaux in 1886. He expanded the collection significantly by purchasing original plaster casts from Carpeaux's widow in 1907, and from her estate the following year. Jacobsen's collection therefore includes both major works in the sculptor's oeuvre and comprehensive groups of work, such as portrait busts. His *Dance*, commissioned to decorate the façade of Garnier's Opéra in Paris, exists in a terracotta version in the collection (acquired 1913). Together with versions of his other major works, such as *Ugolino* (1861, acquired 1913) and *The Triumph of Flora* (1870/3, acquired 1907), Jacobsen purchased an important group of portrait busts by Carpeaux of distinguished men and women of the Second Empire (see cat. 145).

The Belgian Constantin Meunier (1831–1905) was a painter and sculptor who overtly championed the working class, which in a letter to Carl Jacobsen he described as 'that most interesting class in our modern society'. Meunier's sculptures, cast in bronze, whether three-dimensional or in relief, show the human struggle to survive in an industrialised world: its impact on society, often negative, was recorded through portraits of miners, blacksmiths, iron-workers and fishermen at the turn of the nineteenth century. Carl Jacobsen admired Meunier's works deeply, and acquired a large number for the Glyptotek. The first shipment arrived in Copenhagen in 1902 (see cat. 208) and was presented to the brewery workers. Jacobsen organised an exhibition of Meunier's work in Copenhagen in 1908, from which he purchased a significant number of pieces (see cat. 207).

Possibly the most important innovator in nineteenth-century sculpture was Auguste Rodin (1840–1917). Jacobsen was deeply impressed by Rodin's work, preferring the most direct, figurative works to the seemingly less detailed, symbolist ones which often bore ambiguous meanings. The two men developed a close relationship, well documented in numerous letters from the 1900s, but this foundered in 1912 with the delivery of the marble version of the strikingly symbolist work *The Blessings* (cat. 191).

In 1900 Carl Jacobsen ordered a number of works from Rodin, among them *The Burghers of Calais*, *The Age of Bronze*, *The Kiss* and *The Thinker* (cat. 192), after visiting the sculptor's major one-man exhibition held at the Pavillon de l'Alma in Paris as part of the Exposition Universelle. Over the following twelve years the Rodin collection gradually grew to 33 works, arranged in their own 'Rodin Room'.

In contrast to his enthusiastic collection of sculpture, Carl Jacobsen did not show much interest in French nineteenth-century painting. Apart from his acquisition of Millet's *Death and the Wood Cutter* in 1878, his purchases were sparse, with a tendency to favour paintings in an academic style that had usually been exhibited at the Salon. Hence he acquired works by the neoclassical artist Jacques-Louis David (1748–1825) and the Salon painters Adolphe-William Bouguereau (1825–1905) and Jules-Elie Delaunay (1828–1891). He did, however, also include landscape painting by Camille Corot (1796–1875) and members of the Barbizon School.

The strength of the French nineteenth-century painting collection in the Glyptotek can be ascribed to Carl's son, Helge (1882–1946). Helge took over the direction of the Glyptotek in 1915, after his father's death. He changed the acquisitions policy, substituting Carl Jacobsen's emphasis upon the mainstream French painters and sculptors for one which incorporated the Impressionists and the younger avant-garde generations whose work Carl had known but disliked. This brought artists such as Manet, Monet and Gauguin into the collection. When taking over, Helge stated: 'What particularly interest me are recent French paintings, the real Impressionists after Manet.'

Despite a fairly conventional academic training, a devotion to the old masters (notably the Venetians and Spanish masters of the seventeenth century) and a determination to gain official acceptance within the Salon, Edouard Manet (1832–1883) was set apart as a radical by his choice of subject matter and his bold painterly style; both also made him a model for the younger generation of artists and writers. The Ny Carlsberg Glyptotek owns three outstanding works by Manet: *The Absinthe Drinker* (cat. 161) focuses on the contemporary subject of the person marginalised but enabled by modern society; *The Execution of the Emperor Maximilian* (cat. 162) engages in a critique of contemporary politics mediated through references to Goya; and *Mademoiselle Isabelle Lemonnier* (cat. 163) demonstrates Manet's engagement with Impressionism during the 1880s.

Helge's realignment of the Glyptotek's French nineteenth-century holdings was confirmed in his commitment to Gauguin (see below) and continued after his death, most specifically in the acquisition in 1949 of a major collection of sculptures by Degas. Generously donated by the Ny Carlsberg Foundation, a complete series of Degas bronze sculptures consisting of 72 pieces entered the collection. This series, one of four sets still intact, was cast in 1919–22. A few years later a newly found work, *The Schoolgirl*

(cat. 164), was added, making the Glyptotek's holdings truly outstanding. The highlight of Degas's series is, of course, the *Little Ballet Dancer Aged Fourteen Years* (see cat. 165) a work that shocked the critics and public when it was shown at the sixth Impressionist exhibition in 1881. The harsh realism of the vulnerable yet defiant girl made of wax, her hair made out of human hair and her tutu out of actual fabric, stands at the opposite pole to Carl Jacobsen's snow-white, sensual Salon beauties.

Paul Gauguin (1848–1903) has a special place within the Glyptotek, which with 45 works possesses one of the most important collections of his output in the world. Gauguin was initially drawn to Impressionism, with its use of rapid brushwork to create scenes from contemporary life caught at fleeting moments in time. The collection includes several works from this phase in his career, including those made during his short stay in Denmark in 1884–5 (see cats 194, 195) during which he tried to re-establish a happy and financially viable family life with his Danish wife Mette and their children.

Over the course of the succeeding three years, an increasing disillusionment with naturalism led him to a new style of non-naturalist, or symbolist, painting, in which subject and technique seem to convey great ideas and profound emotions. His search for new subjects took him to increasingly 'primitive' societies, from Brittany (cats 196, 197) to Tahiti (cats 199, 200), in his quest to create a completely new type of art. An inveterate explorer of visual imagery and techniques, Gauguin worked in a range of media, from carved wooden reliefs (cats 201, 202) to highly original ceramic works (cats 204, 206). Helge Jacobsen's private collection was generously donated to the museum during the 1920s, 1930s and 1940s. Several near-contemporaries of Gauguin – among them Pierre Bonnard (1867–1947), Edouard Vuillard (1868–1940), Emile Bernard (1868–1941) and Maurice Denis (1870–1943) – are also represented.

Together with that of Paul Cézanne, Gauguin's influence on subsequent generations in the first part of the twentieth century was pre-eminent, and the acquisitions policy of later museum directors and of the Ny Carlsberg Foundation has been primarily to follow the artistic ideas of the collections formed by Carl and Helge and extend them further into the twentieth century. Works by, for example, Pablo Picasso (1881–1973), Henri Matisse (1869–1954), Alberto Giacometti (1901–1966) and Aristide Maillol (1861–1944) have been added (Maillol was in fact a favourite of Carl Jacobsen's). The most recent purchase is *Nature Study* (fig. 9), a sculpture in latex, by the French-American sculptor Louise Bourgeois (b. 1911).

A collection formed by personal tastes, the Ny Carlsberg Glyptotek offers an aesthetic experience of exceptional value rather than an encyclopaedic introduction to French art of the nineteenth and early twentieth centuries. It thus mirrors the different choices and preferences of father and son, as well as the various ideas and currents of their centuries. Today's Glyptotek manoeuvres in between their aesthetic differences while continuing the visions of both.

140
Jean-Baptiste Carpeaux (1827–1875)
Negress, modelled 1868, carved 1869
Marble, H. 67 cm

141
Jean-Baptiste Carpeaux (1827–1875)
Neapolitan Fisher Lad, modelled 1856
(signed 1857), reproduced 1873
Terracotta, H. 84 cm,
including socle

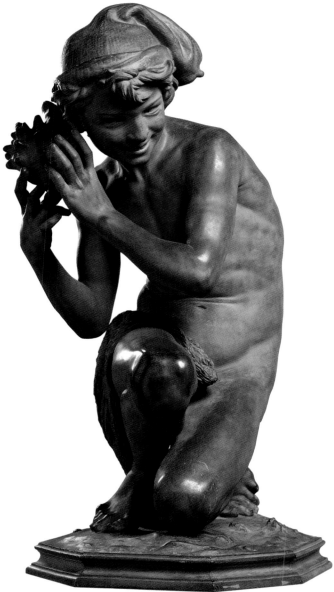

142
Jean-Baptiste Carpeaux (1827–1875)
Laughing Boy with Vines in His Hair, 1860s
Patinated plaster, original model,
H. 56 cm, including socle

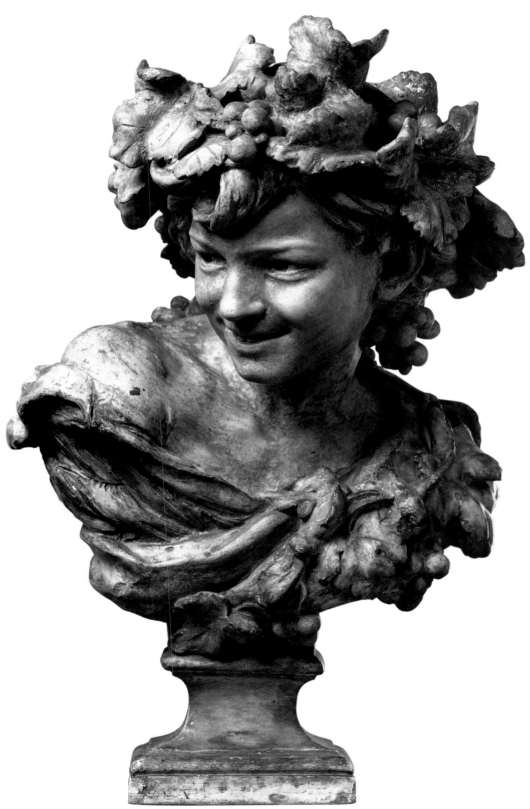

143
Jean-Baptiste Carpeaux (1827–1875)
Bacchante with Roses, c. 1872
Patinated plaster, original model,
H. 63 cm, including socle

144
Jean-Baptiste Carpeaux (1827–1875)
Spring, c. 1870
Patinated plaster, original model,
H. 59 cm, including socle

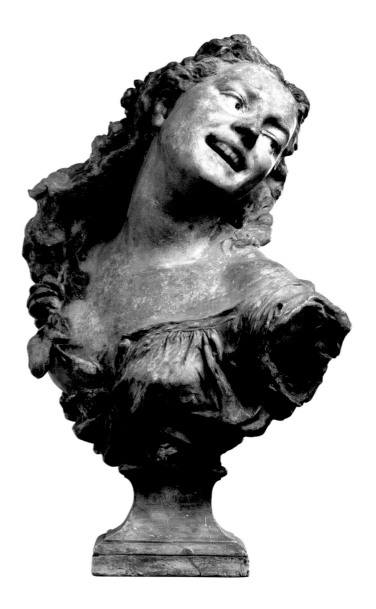

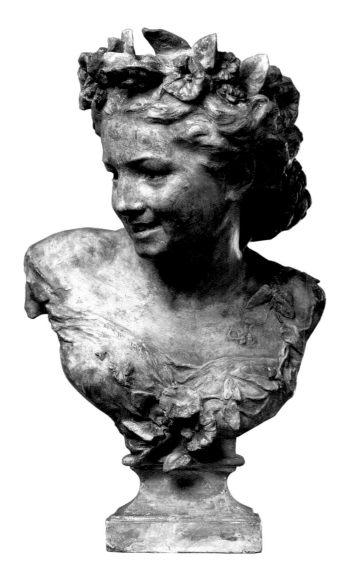

145
Jean-Baptiste Carpeaux (1827–1875)
Portrait Bust of Charles Garnier, 1869
Patinated plaster, original model,
H. 68 cm, including socle

146
Jean-Baptiste Carpeaux (1827–1875)
Portrait Bust of Mrs Turner, 1871
Patinated plaster, original model,
H. 85 cm, including socle

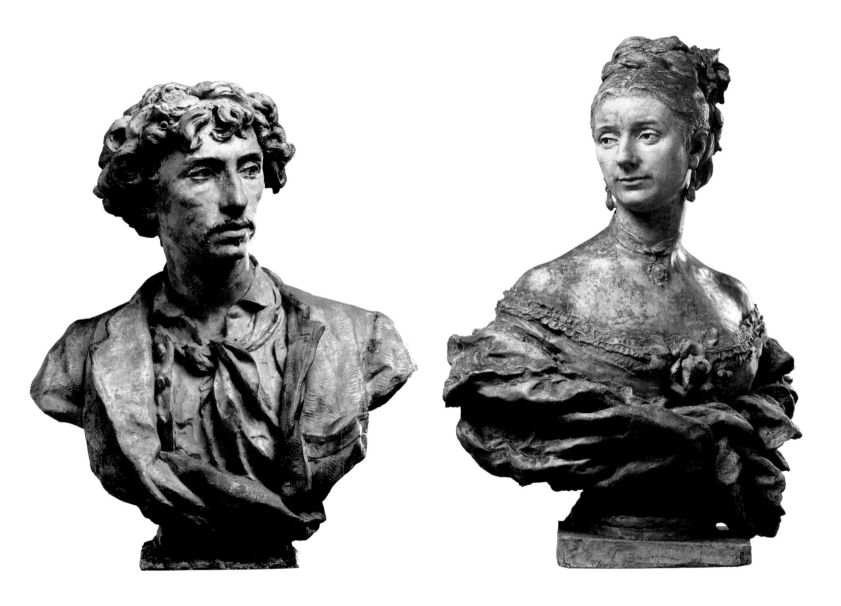

147
Eugène Delaplanche (1836–1891)
Music, modelled 1877, carved 1878
Marble, ivory, horsehair and gut,
H. 174 cm

148
Antonin Mercié (1845–1916)
Gloria Victis (Honour to the Vanquished),
modelled 1874, cast 1905
Bronze, H. 309 cm

149

Jacques-Louis David (1748–1825)
Portrait of the Comte de Turenne, 1816
Oil on canvas, 112 × 87 cm

150

Paul Delaroche (1797–1856)
*The Statesman and Historian
Guizot, c.* 1839
Oil on canvas, 53 × 45 cm

151

Emile-Auguste Carolus-Duran
(1837–1917)
*Portrait of a Little Girl in Spanish
Costume*, 1870
Oil on canvas, 41 × 39 cm

152
Jean-Baptiste-Camille Corot (1796–1875)
Landscape from the Region around Civita
Castellana with a View towards Monte Soratte, 1827
Oil on paper on canvas, 22.5 × 34.5 cm

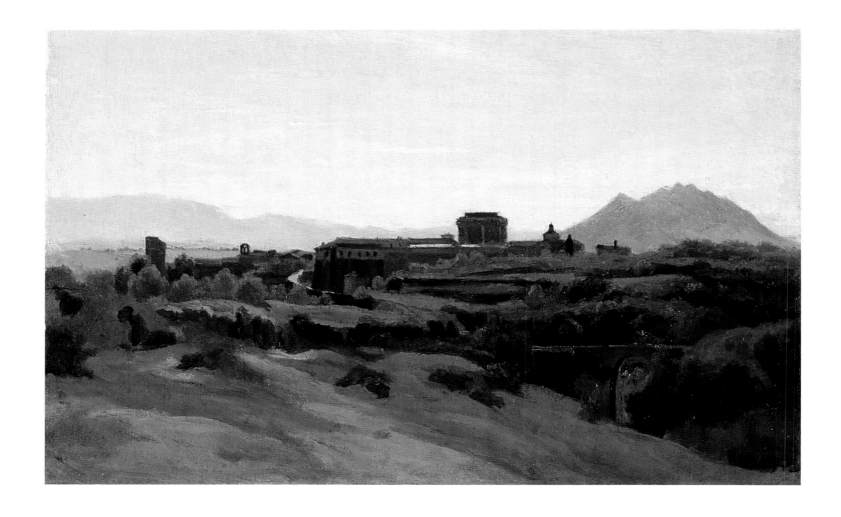

153

Théodore Rousseau (1812–1867)
Landscape from the Auvergne /
Landscape from the Region of Lake
Geneva, 1829/30
Oil on paper, 27 × 42.2 cm

154

Jean-Baptiste-Camille Corot
(1796–1875)
Wooded Landscape from Mas-Bilier
near Limoges, possibly around 1850
Oil on canvas, 34 × 52 cm

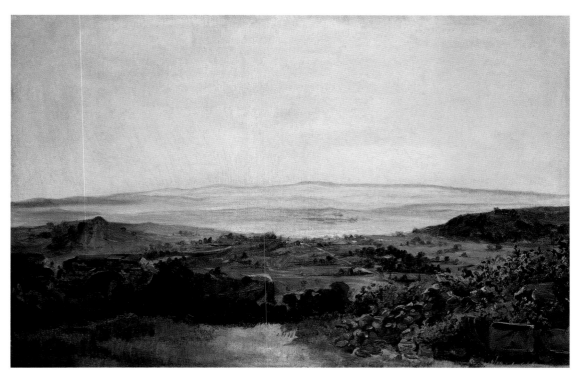

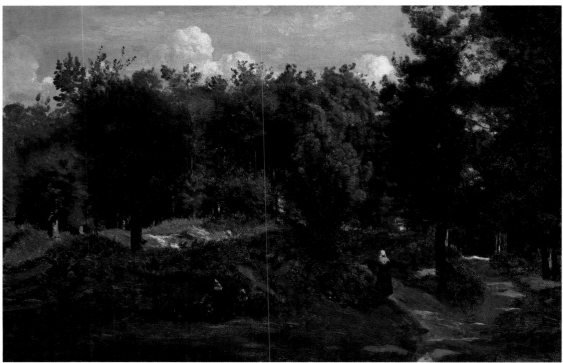

155
Jean-Baptiste-Camille Corot (1796–1875)
Landscape with Harvesters, c. 1850
Oil on canvas, 34 × 47 cm

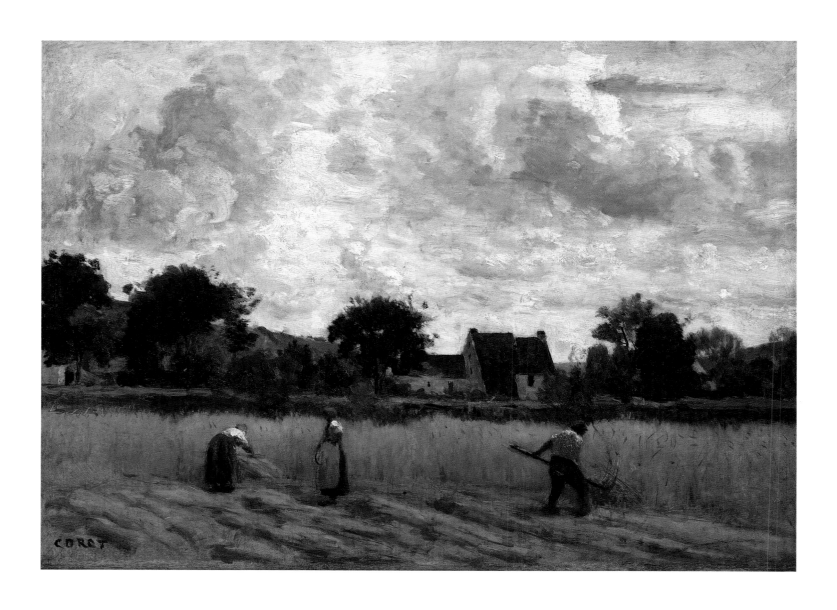

156
Jean-François Millet (1814–1875)
Death and the Wood Cutter, 1858–9
Oil on canvas, 77.5 × 98.5 cm

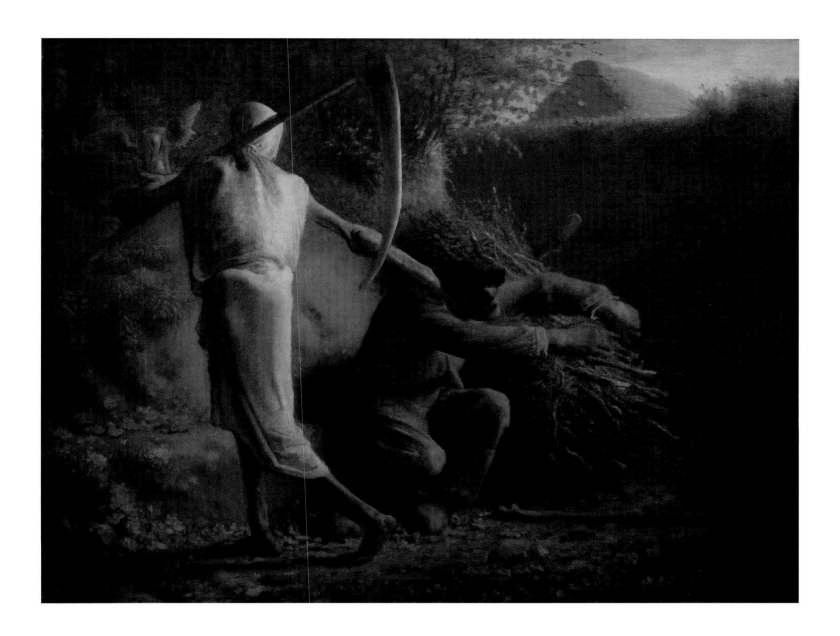

157
Théodore Rousseau (1812–1867)
Thunderstorm over Mont Blanc, 1834, 1863–7
Oil on canvas, 143 × 240 cm

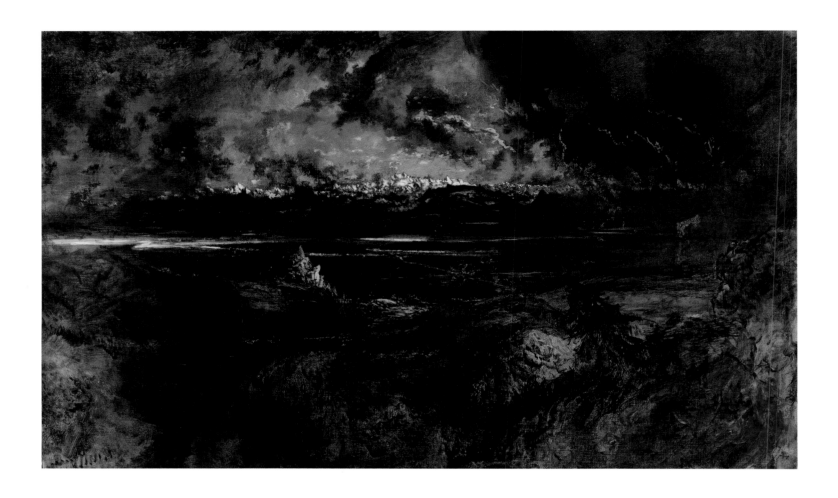

158
Gustave Courbet (1819–1877)
Landscape with Trees, c. 1856
Oil on canvas, 88 × 115 cm

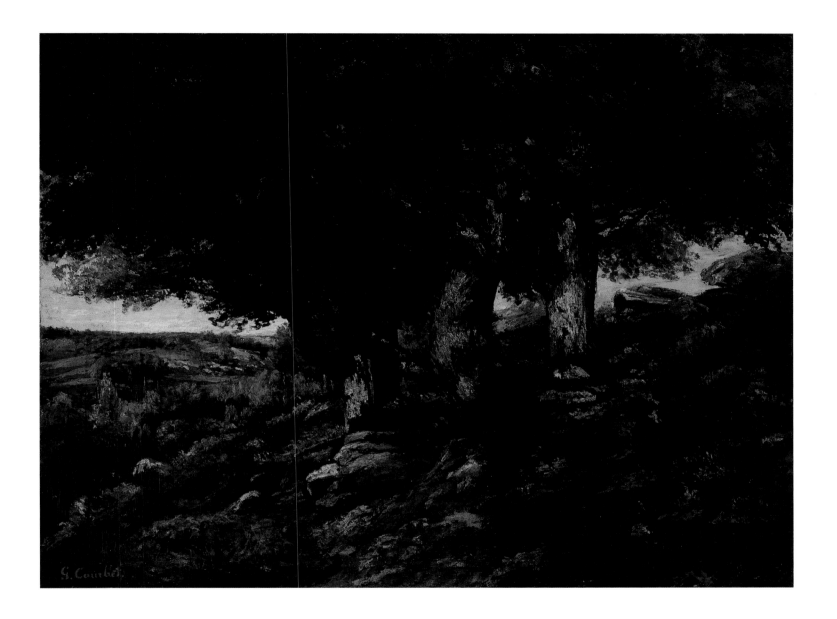

159
Gustave Courbet (1819–1877)
Self-portrait, 1850–3
Oil on canvas, 71.5 × 59 cm

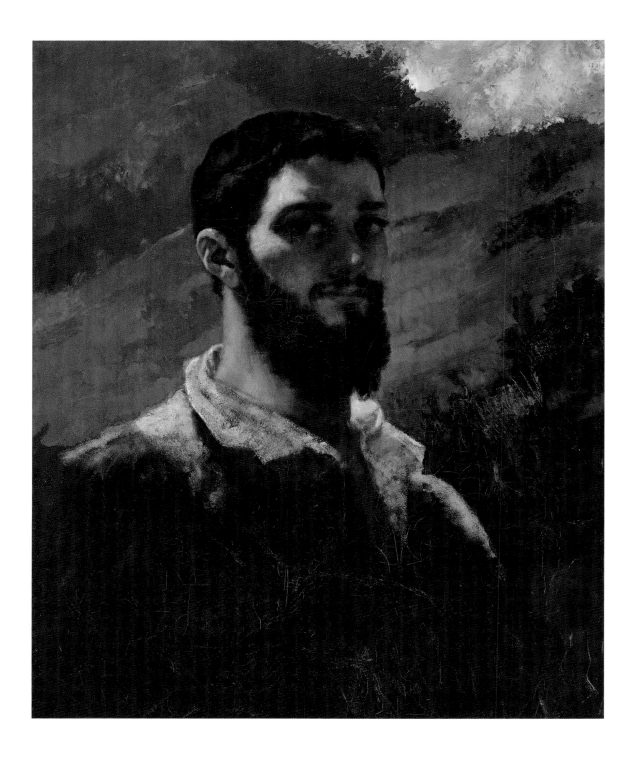

160
Gustave Courbet (1819–1877)
*Three Young Englishwomen
by a Window*, 1865
Oil on canvas, 92.2 × 72.5 cm

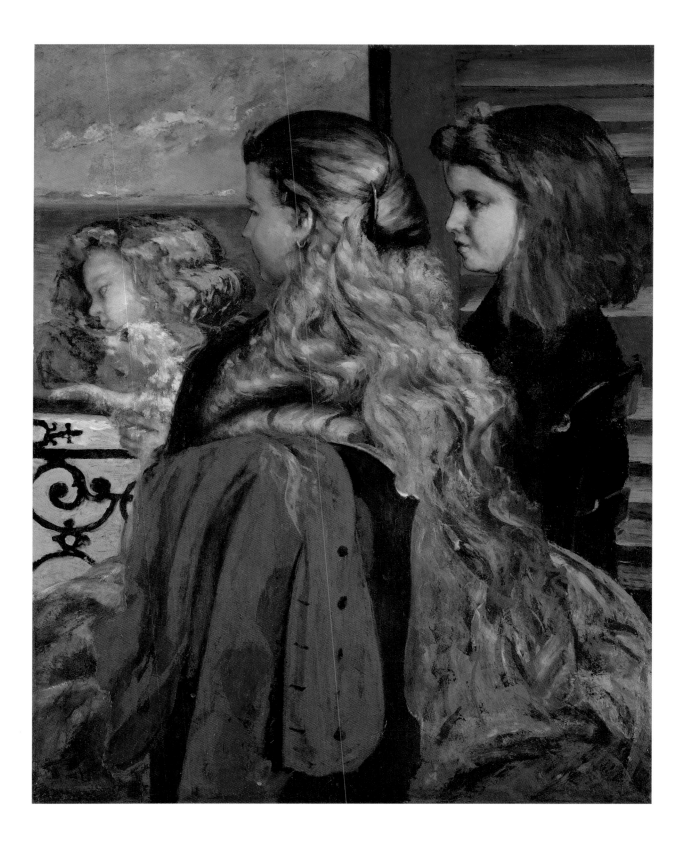

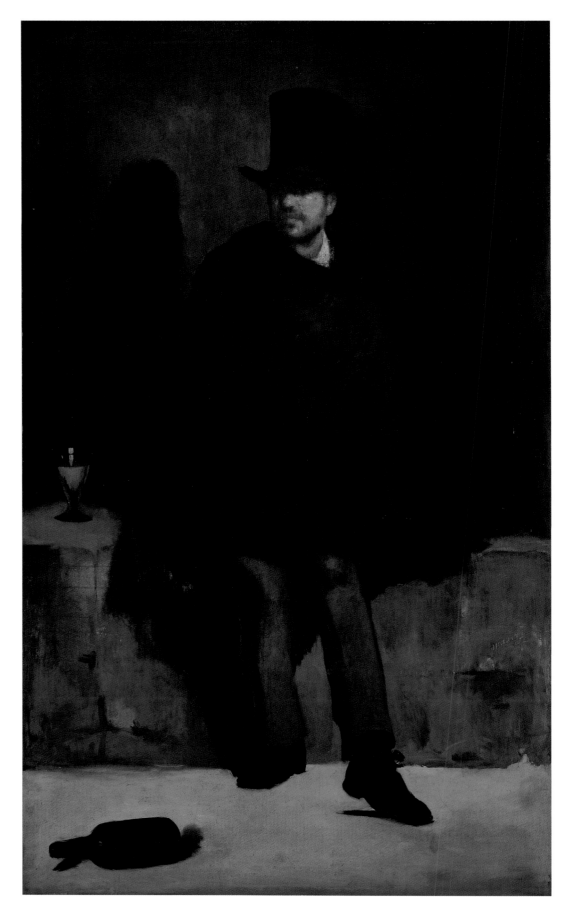

161
Edouard Manet (1832–1883)
The Absinthe Drinker, 1859
Oil on canvas, 180.5 × 105.6 cm

162
Edouard Manet (1832–1883)
*The Execution of the Emperor
Maximilian*, 1867
Oil on canvas, 48 × 58 cm

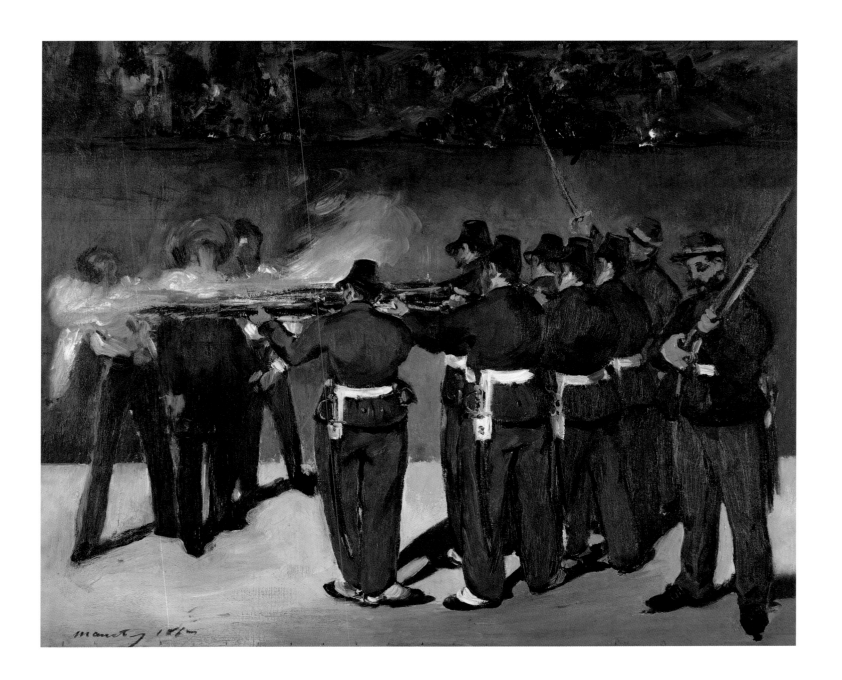

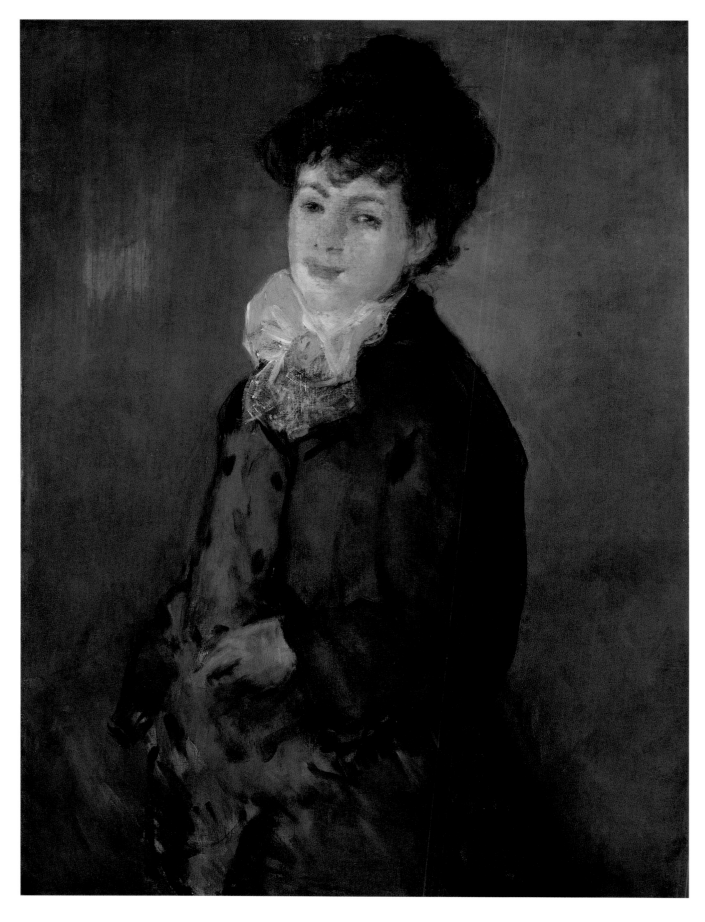

163
Edouard Manet (1832–1883)
Mademoiselle Isabelle Lemonnier,
c. 1879–82
Oil on canvas, 86.5 × 63.5 cm

164
Edgar Degas (1834–1917)
The Schoolgirl, 1879
Bronze, 27.5 × 12 × 15 cm

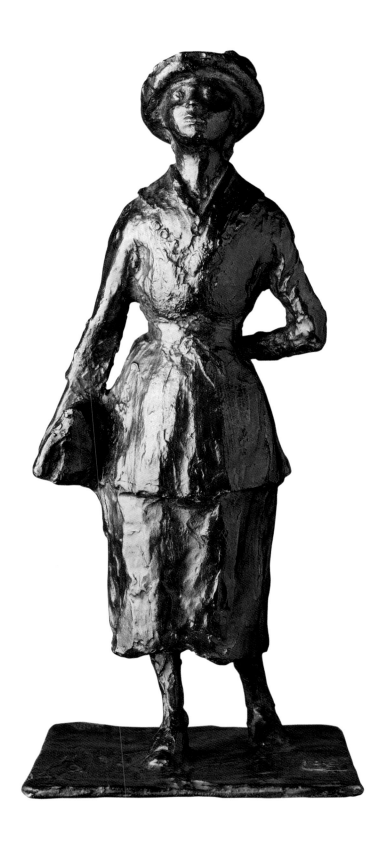

165
Edgar Degas (1834–1917)
Nude Study for the Little Ballet Dancer
Aged Fourteen Years, c. 1878–80
Bronze, 72 × 34 × 28 cm

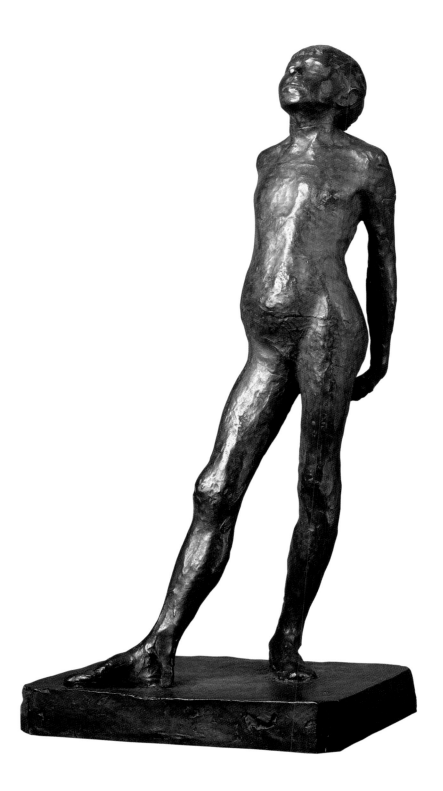

166
Edgar Degas (1834–1917)
Dancers Practising in the Foyer,
c. 1875–1900
Oil on canvas, 71 × 88 cm

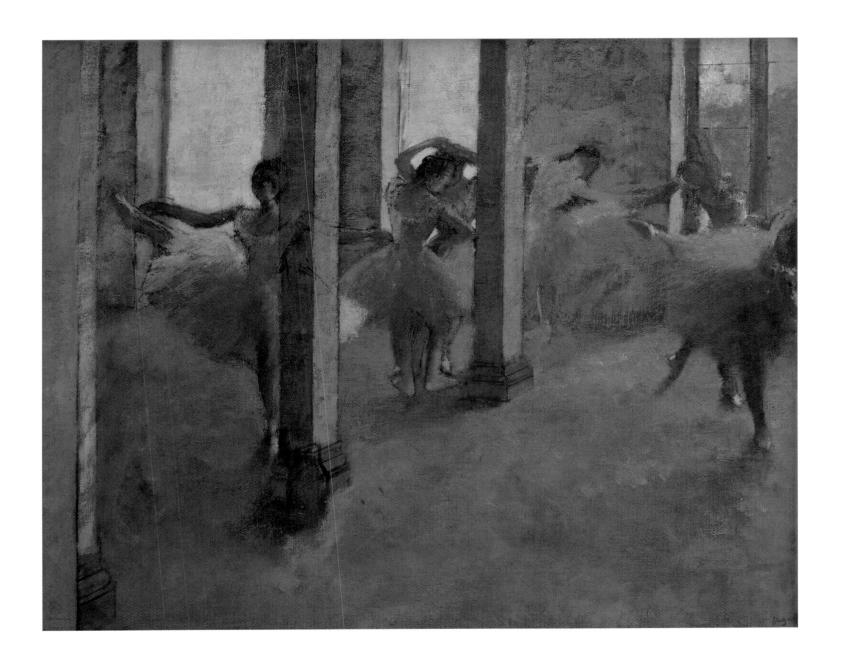

Edgar Degas (1834–1917)
Dancer Putting on Her Stocking,
1896–1911
Bronze, 46 × 19 × 33 cm

Edgar Degas (1834–1917)
Grande Arabesque, 1882–95 / 1885–90
Bronze, 45 × 28 × 54 cm

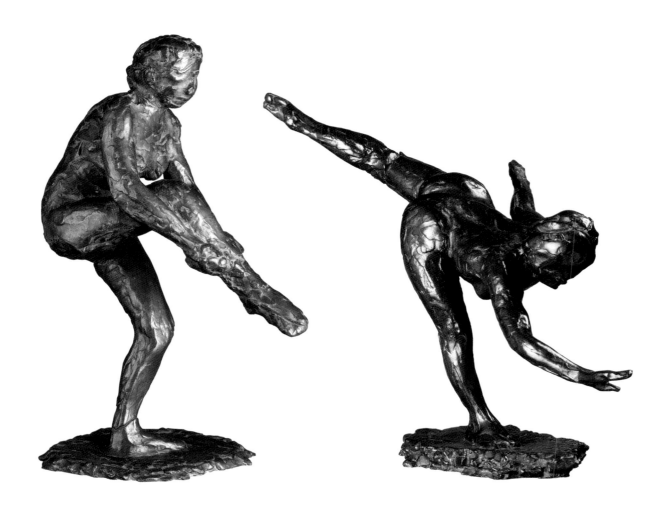

169
Edgar Degas (1834–1917)
Dancer Fastening the String of Her Tights, 1882–95 / 1885–90
Bronze, 42.5 × 21.5 × 15 cm

170
Edgar Degas (1834–1917)
Dancer at Rest, Hands Behind Her Back, Right Leg Forward, 1882–95 / 1881–5
Bronze, 44.5 × 14 × 25.5 cm

171
Edgar Degas (1834–1917)
Fourth Position Front, on the Left Leg, 1883–8 / 1896–1911
Bronze, 40.5 × 28 × 25 cm

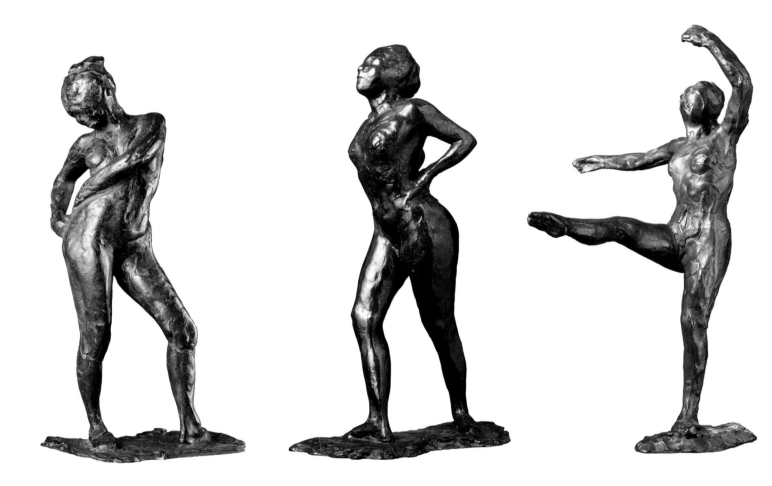

172
Edgar Degas (1834–1917)
Woman Taken Unawares, 1896–1911
Bronze, 40.3 × 28 × 19 cm

173
Edgar Degas (1834–1917)
The Tub, 1888–9
Bronze, 24 × 42 × 47 cm

174
Edgar Degas (1834–1917)
Seated Woman Wiping Her Left Side,
1896–1911 / 1900–10
Bronze, 35 × 24 × 35 cm

175
Edgar Degas (1834–1917)
Toilette after the Bath, 1888–9
Pastel on paper, 77.5 × 53.5 cm

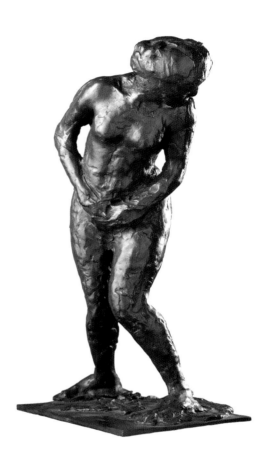

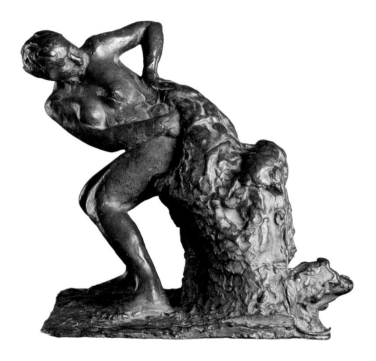

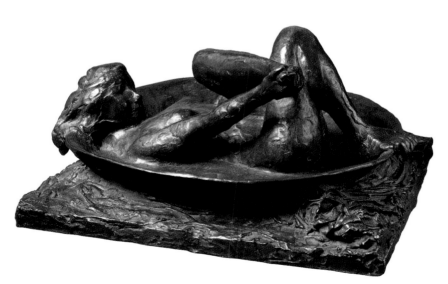

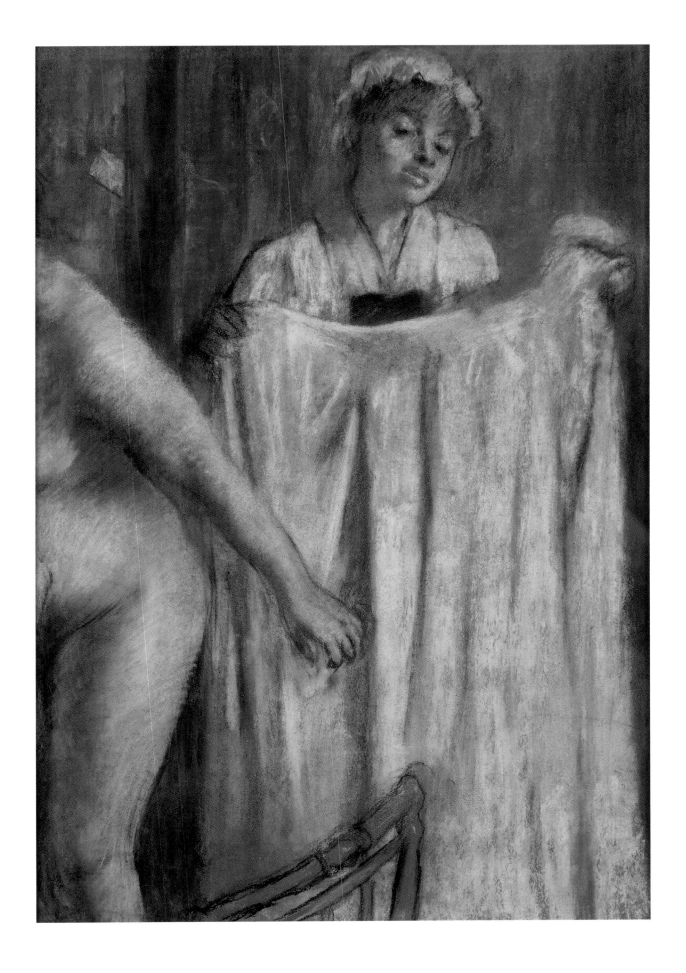

176
Edgar Degas (1834–1917)
Rearing Horse, 1865–81 / end 1880s / 1888–90
Bronze, 30.5 × 19.5 × 24 cm

177
Edgar Degas (1834–1917)
Horse Galloping with the Off Fore Leading, 1865–81 / 1881–90
Bronze, 30 × 21 × 44 cm

178
Edgar Degas (1834–1917)
Horse with Head Lowered, 1865–90
Bronze, 19 × 8 × 28 cm

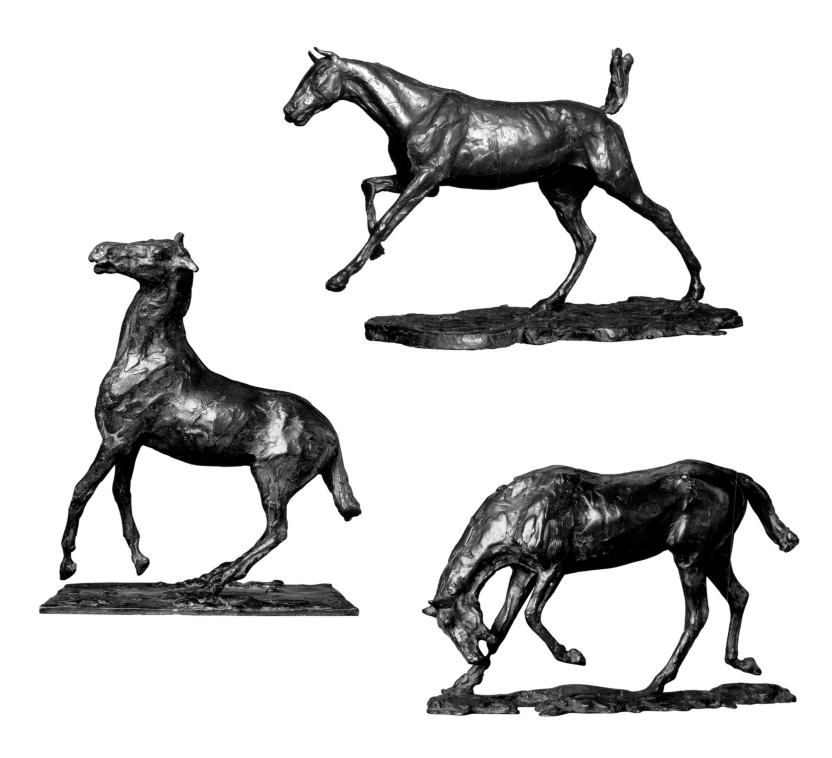

179
Edgar Degas (1834–1917)
Village Street, Saint-Valéry-sur-Somme, c. 1896–8
Oil on canvas, 67.5 × 81 cm

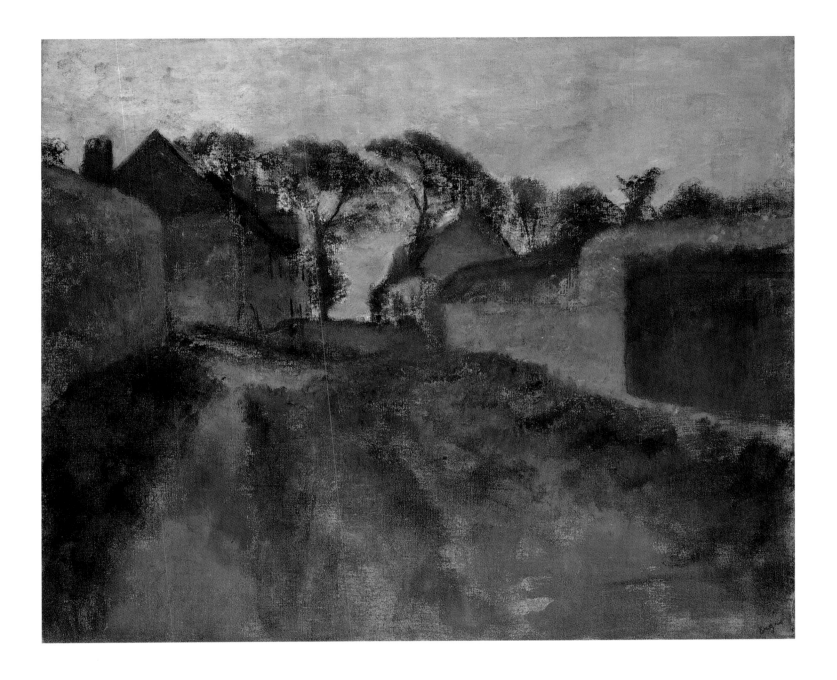

180
Claude Monet (1840–1926)
Windmill and Boats near
Zaandam, Holland, 1871
Oil on canvas, 48 × 73.5 cm

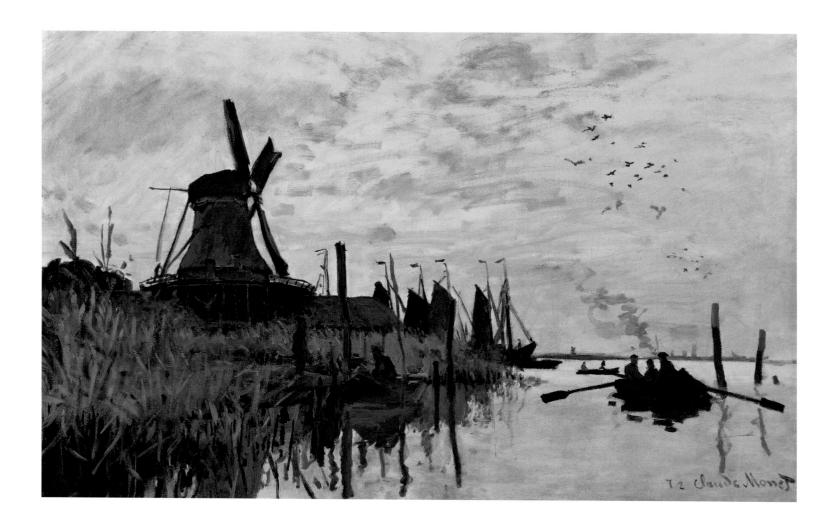

181
Alfred Sisley (1839–1899)
Inundation: The Ferry of the Île du Bac, 1872
Oil on canvas, 45 × 60 cm

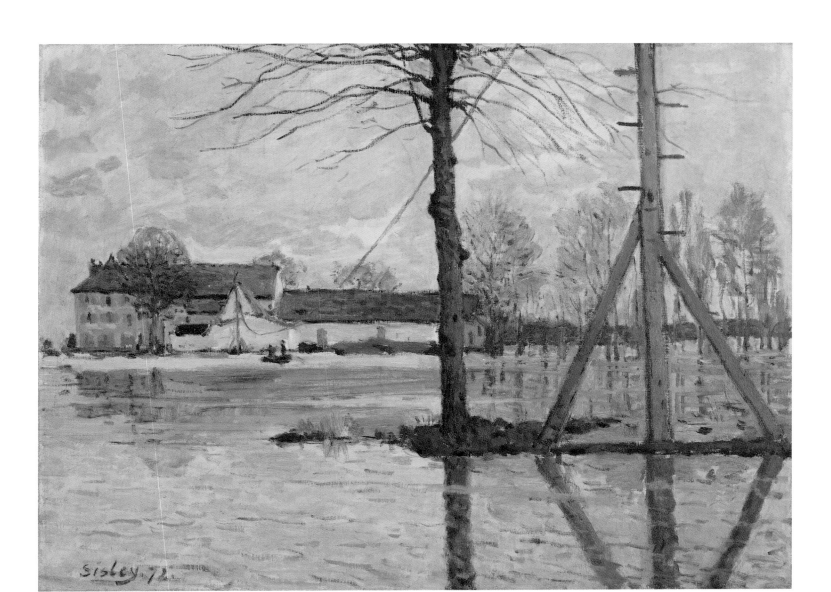

182
Alfred Sisley (1839–1899)
The Furrows, 1873
Oil on canvas, 45.5 × 64.5 cm

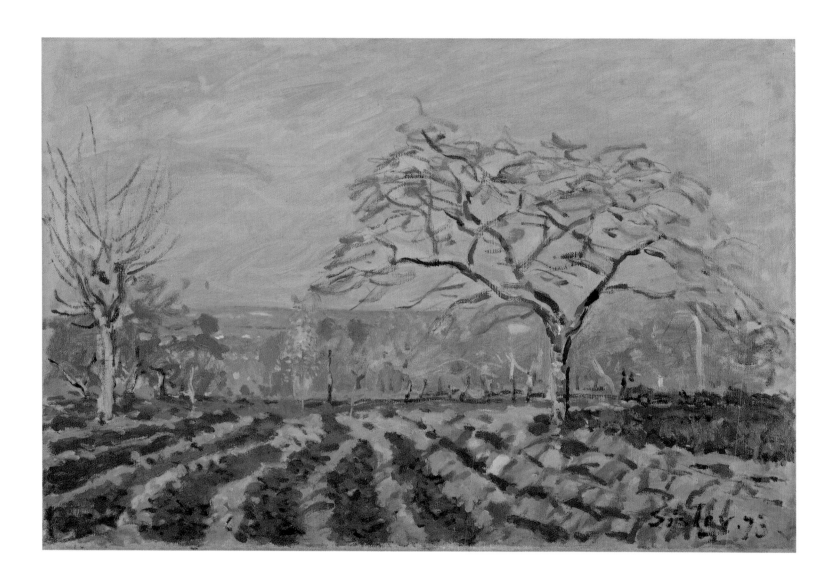

183
Berthe Morisot (1841–1895)
Peasant Girl Hanging Clothes to Dry, 1881
Oil on canvas, 46 × 67 cm

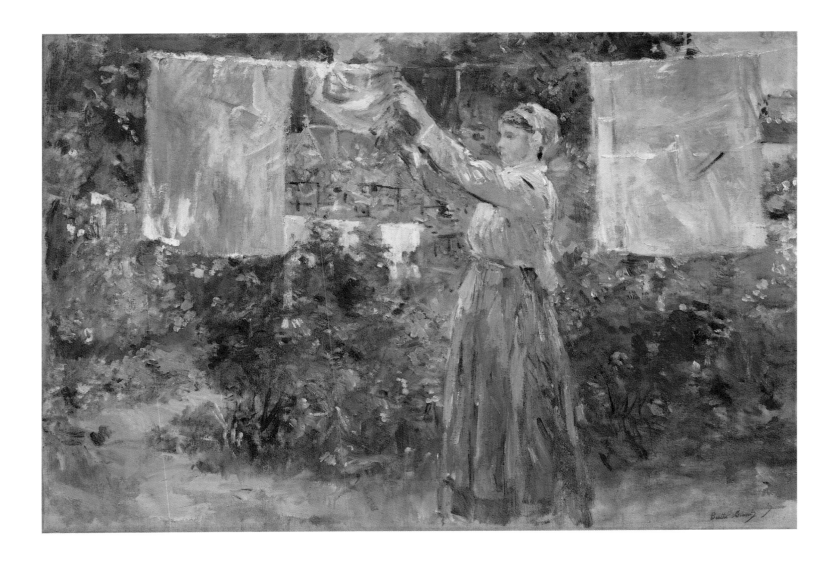

184
Claude Monet (1840–1926)
Shadows on the Sea. The Cliffs at Pourville, 1882
Oil on canvas, 57 × 80 cm

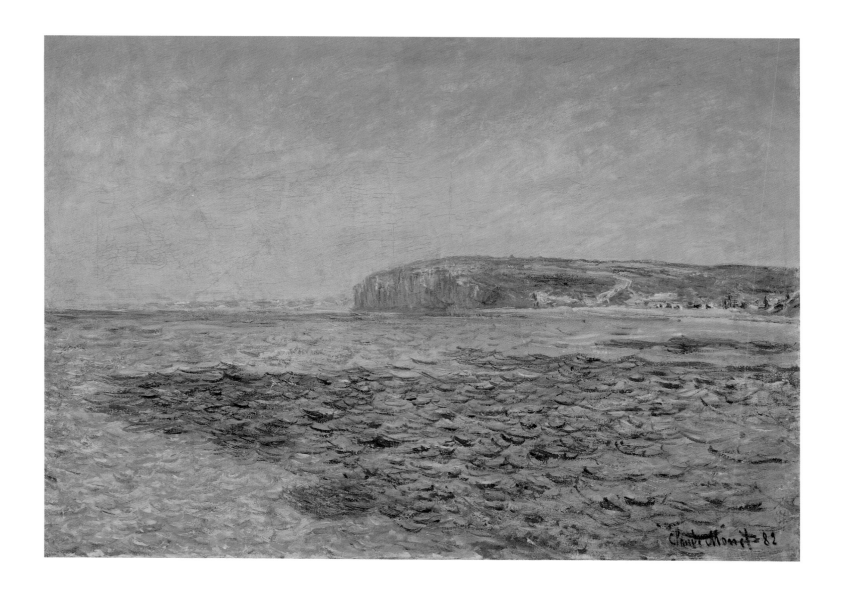

185
Claude Monet (1840–1926)
'Les Pyramides' at Port-Coton, Belle-Ile-en-Mer, 1886
Oil on canvas, 59.5 × 73 cm

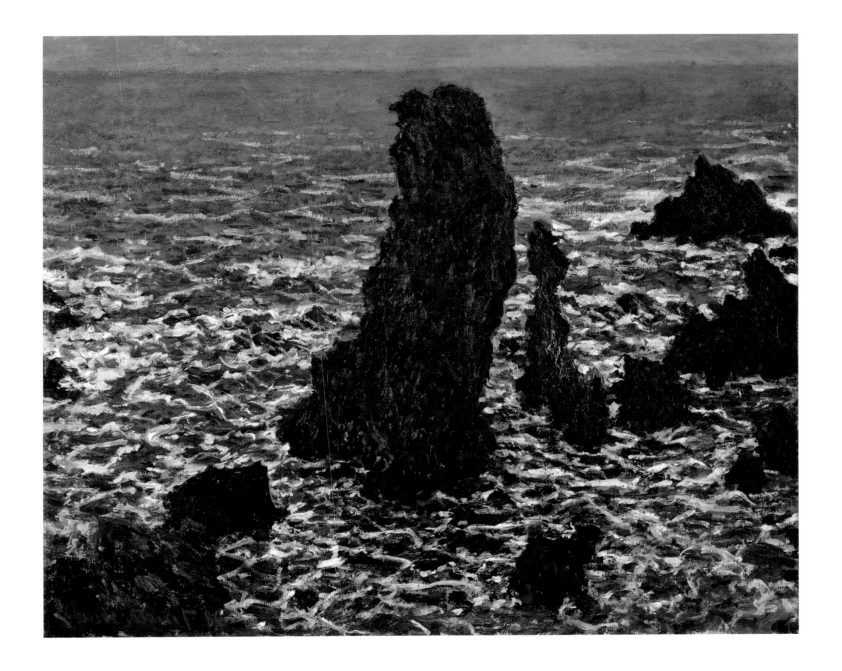

186
Paul Cézanne (1839–1906)
Self-portrait with a Bowler Hat,
c. 1883–4
Oil on canvas, 44.5 x 35.5 cm

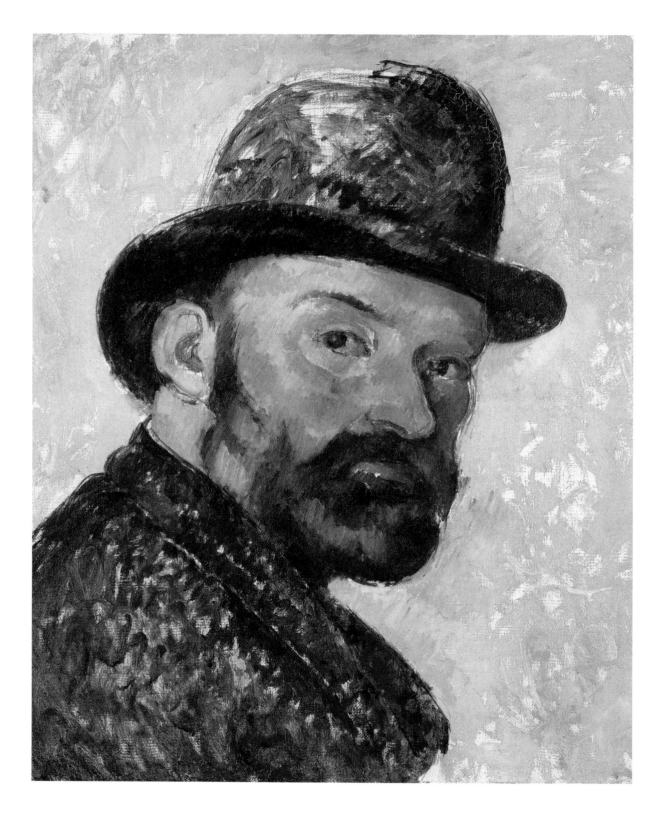

187
Camille Pissarro (1830–1903)
Portrait of Nini, 1884
Oil on canvas, 65.4 × 54.4 cm

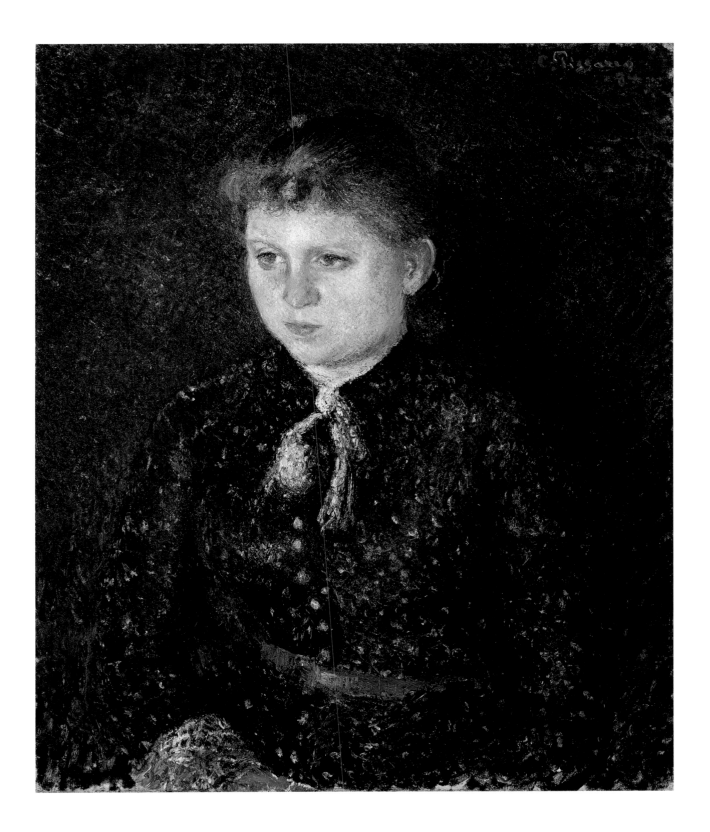

188
Vincent van Gogh (1853–1890)
Portrait of Julien Tanguy, 1887
Oil on canvas, 45.5 × 34 cm

189
Henri de Toulouse-Lautrec (1864–1901)
Portrait of Monsieur Delaporte in the
Jardin de Paris, 1893
Gouache on card, mounted on wood,
76 × 70 cm

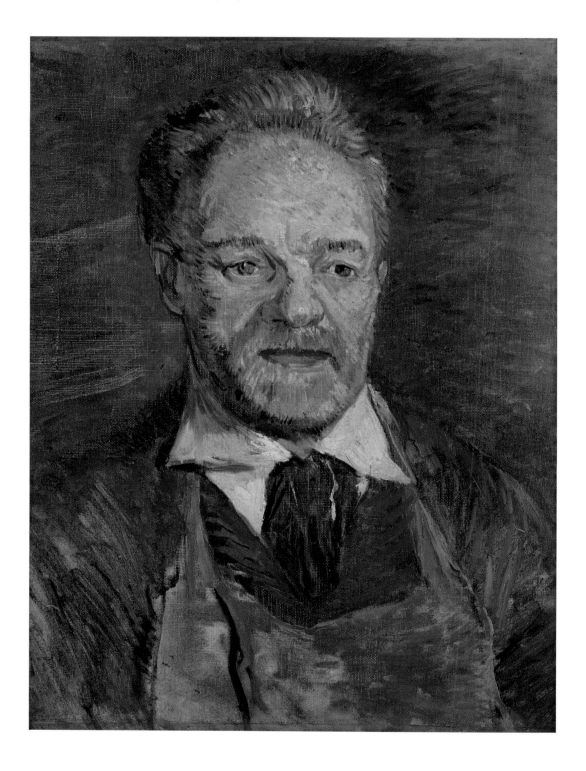

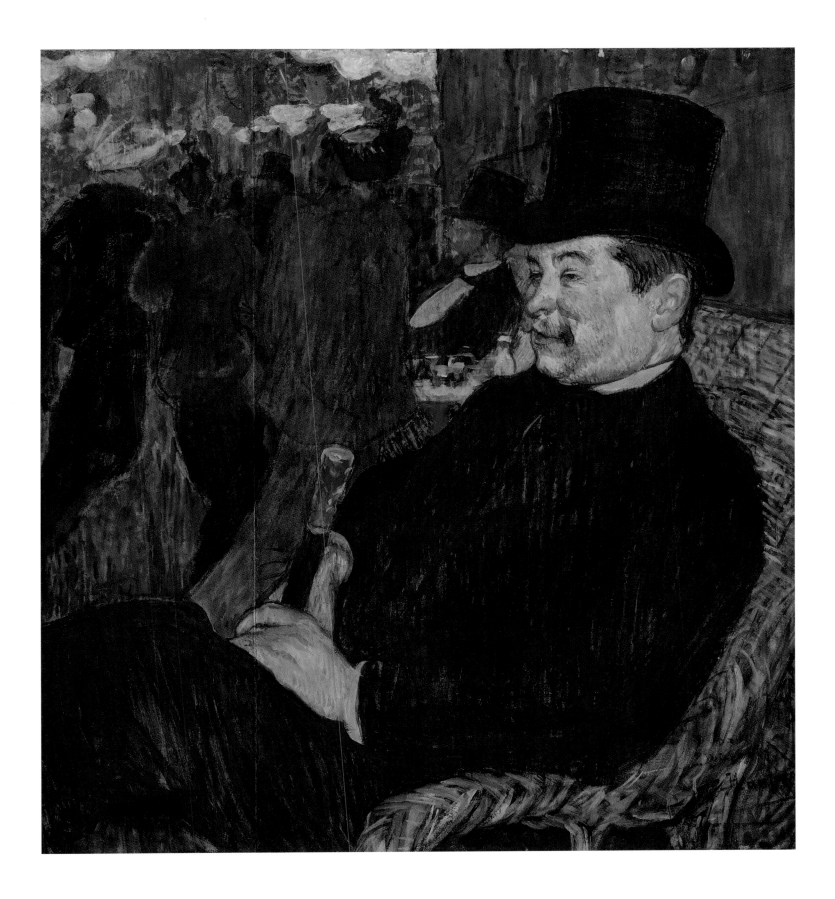

190
Auguste Rodin (1840–1917)
The Good Genius,
modelled 1900, carved 1907
Marble, H. 73.3 cm

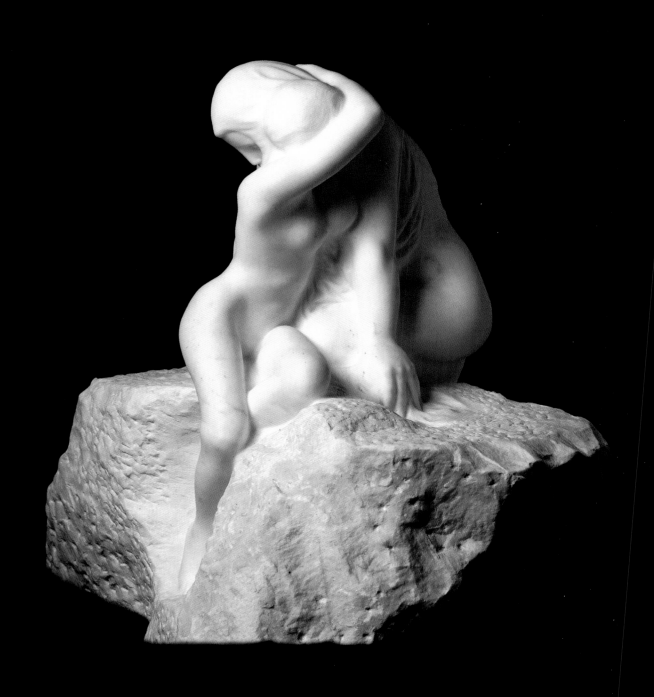

191
Auguste Rodin (1840–1917)
The Blessings,
modelled 1894, carved 1907–12
Marble, H. 90.5 cm

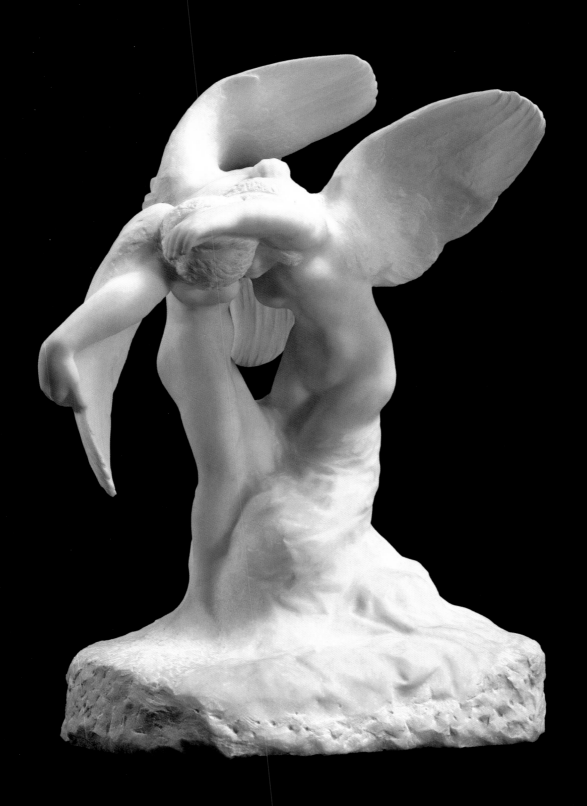

192
Auguste Rodin (1840–1917)
The Thinker,
modelled 1880, cast 1900–01
Bronze, H. 73.3 cm

193
Paul Gauguin (1848–1903)
Woman Sewing, 1880
Oil on canvas, 114.5 × 74.5 cm

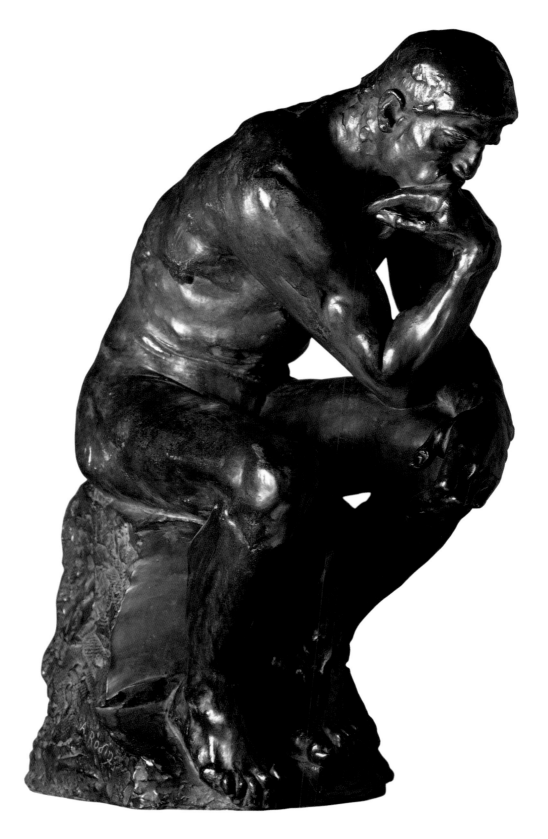

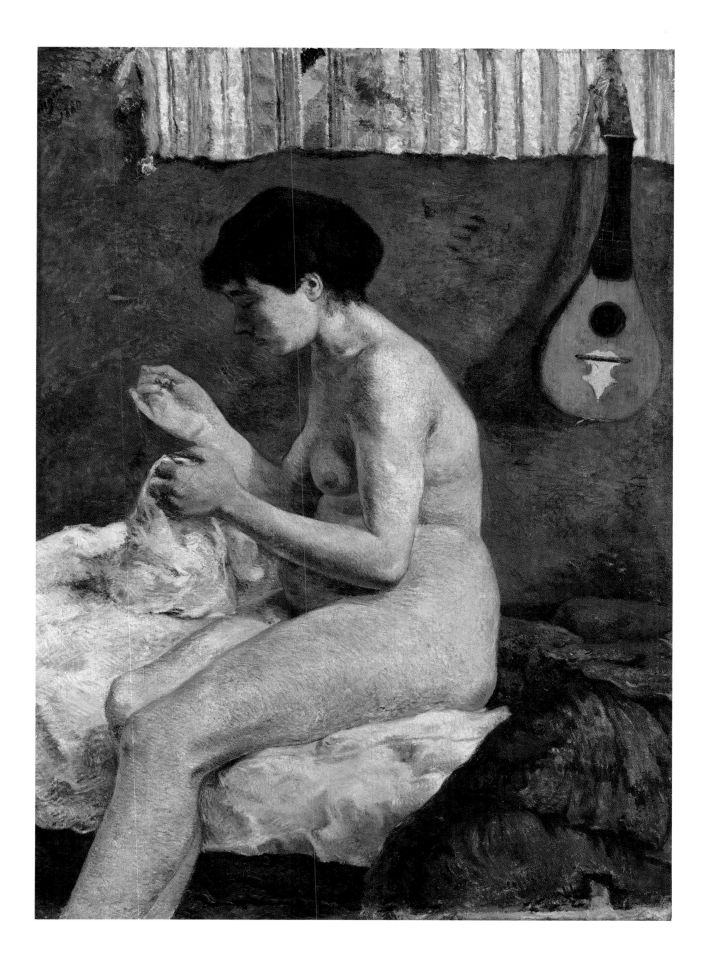

194
Paul Gauguin (1848–1903)
Skaters in Frederiksberg Park, 1884
Oil on canvas, 65 × 54 cm

195
Paul Gauguin (1848–1903)
The Queen's Mill, Østervold, 1885
Oil on canvas, 92.5 × 73.4 cm

196
Paul Gauguin (1848–1903)
Landscape near Pont-Aven,
Brittany, 1888
Oil on canvas, 90.5 × 71 cm

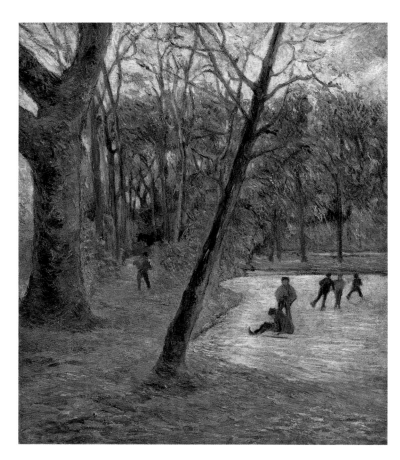

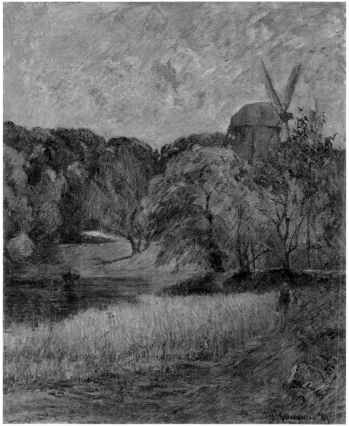

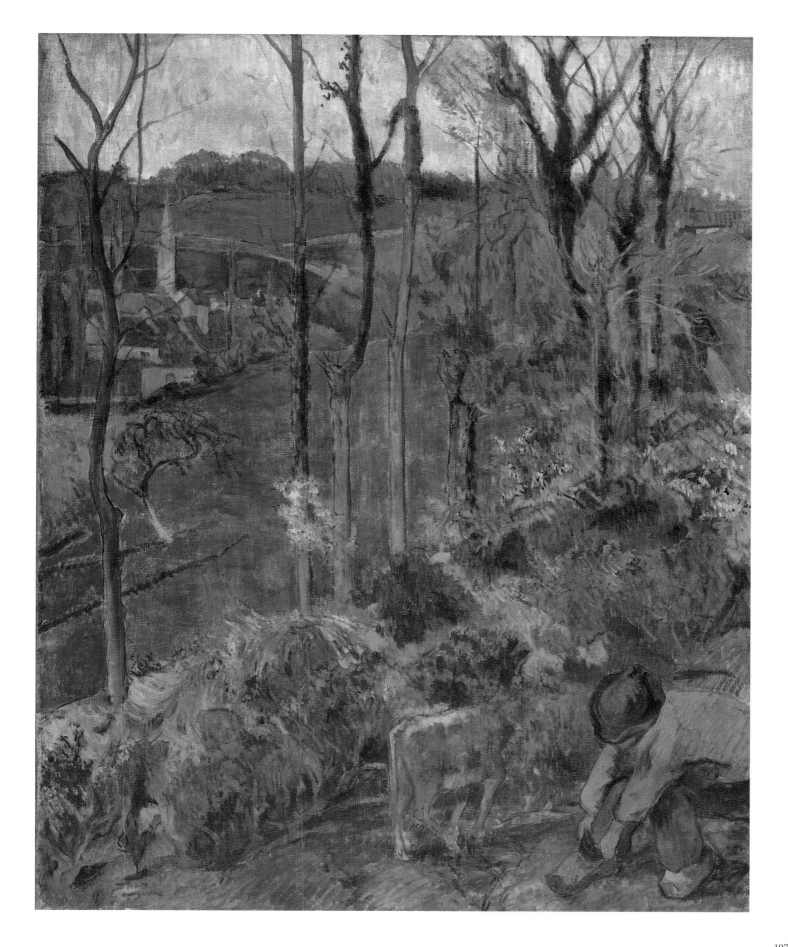

197
Paul Gauguin (1848–1903)
Breton Girl, 1889
Oil on canvas, 71.5 × 90.5 cm

198
Paul Gauguin (1848–1903)
Two Children, possibly 1889
Oil on canvas, 46 × 60 cm

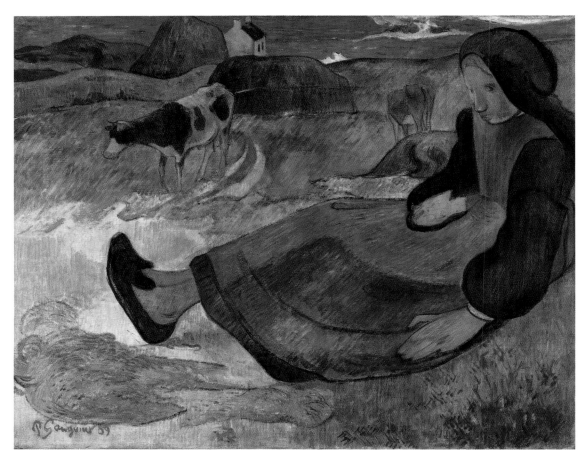

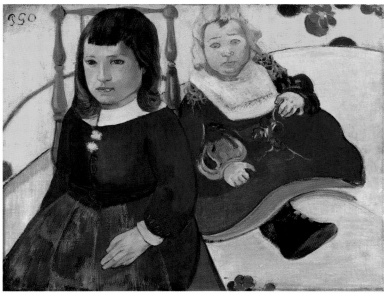

199
Paul Gauguin (1848–1903)
Two Reclining Tahitian Women, 1894
Oil on canvas, 60 × 98 cm

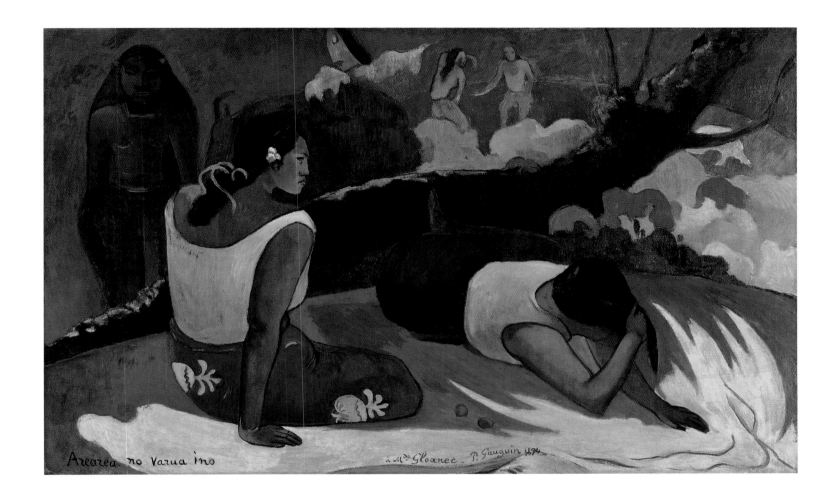

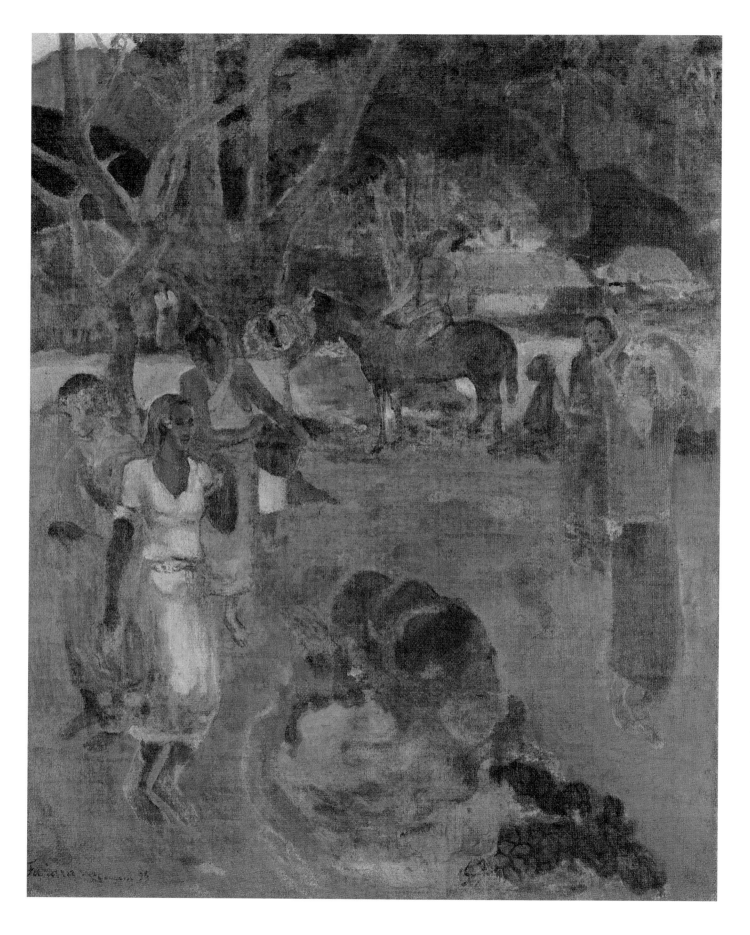

200
Paul Gauguin (1848–1903)
Tahitian Landscape with Nine Figures, 1898
Oil on sackcloth, 93 × 73 cm

201
Paul Gauguin (1848–1903)
La Chanteuse, 1880
Mahogany, plaster, paint and gilding,
53 cm (diameter) × 13 cm (depth)

202
Paul Gauguin (1848–1903)
Woman with Mango Fruits, possibly 1889
Polychrome wood-relief, 30 × 49 cm

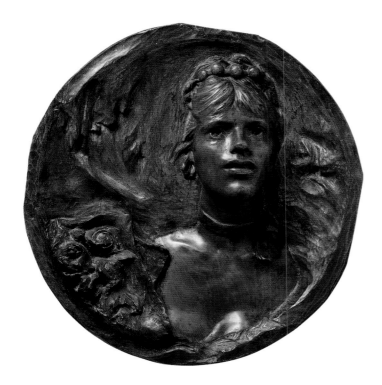

203
Paul Gauguin (1848–1903)
Double-vessel in unglazed Stoneware with Brittany Girl, Sheep and Geese, 1886–7
Unglazed stoneware decorated with coloured slip, H. 13.5 cm

204
Paul Gauguin (1848–1903)
Glazed Jug with Seated Shepherd Girl, Lamb and Goose, 1886–7
Glazed polychrome and gold stoneware, H. 18.5 cm

205
Paul Gauguin (1848–1903)
Double-vessel in glazed Stoneware,
1887–8
Glazed polychrome stoneware,
H. 19.5 cm

206
Paul Gauguin (1848–1903)
*Portrait Vase of a Woman with
a Snake Belt*, 1887–8
Unglazed stoneware, H. 26 cm

207
Constantin Meunier (1831–1905)
On the Way Home from the Mine,
undated but probably 1880s
Bronze, 59 × 82 cm

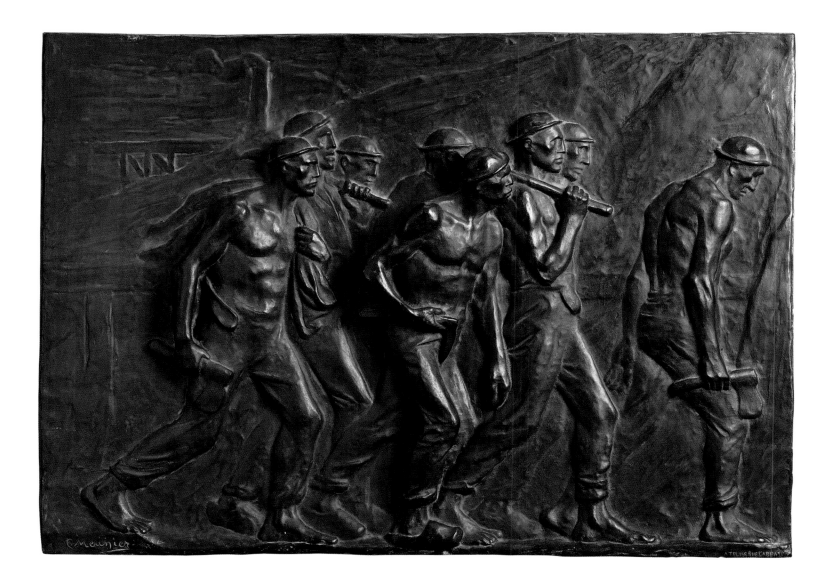

208
Constantin Meunier (1831–1905)
Suffering (The Martyr), 1887
Bronze, 63.5 × 68 × 35 cm

209
Aristide Maillol (1861–1944)
The Young Cyclist, 1907
Bronze, H. 98 cm

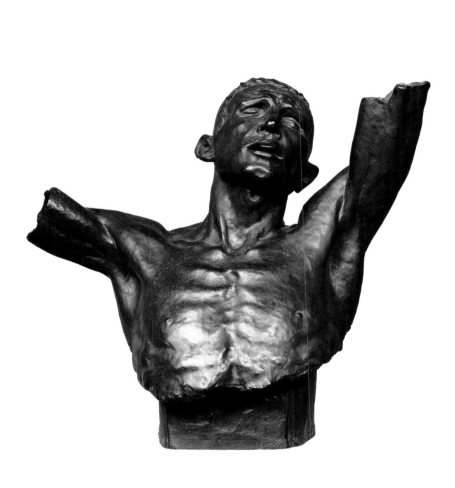

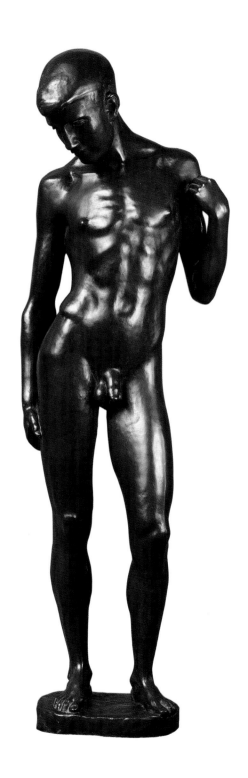

210
Paul Cézanne (1839–1906)
Women Bathing, c. 1900
Oil on canvas, 73 × 92 cm

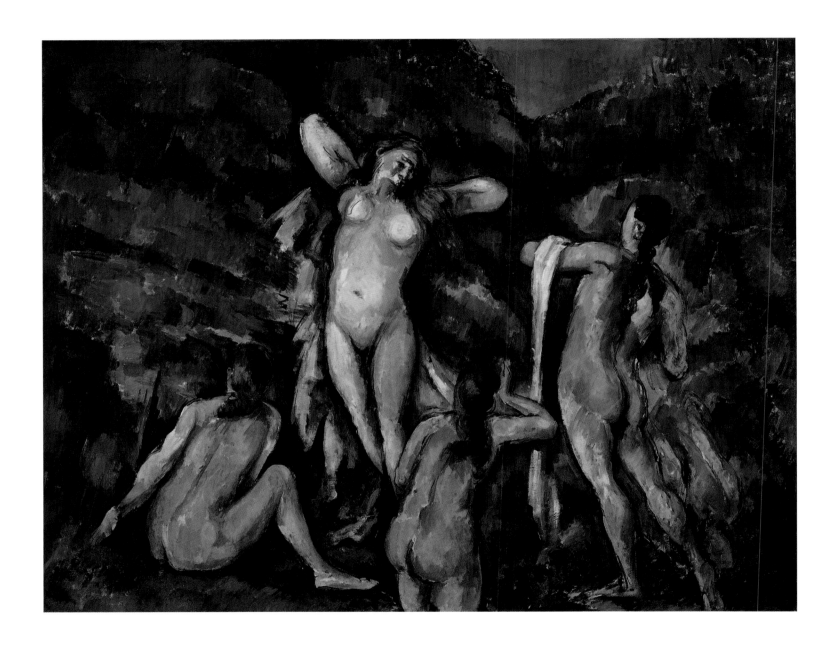

211
Ker-Xavier Roussel (1867–1944)
The Coronation of Venus, 1909
Oil on canvas, 34 × 54 cm

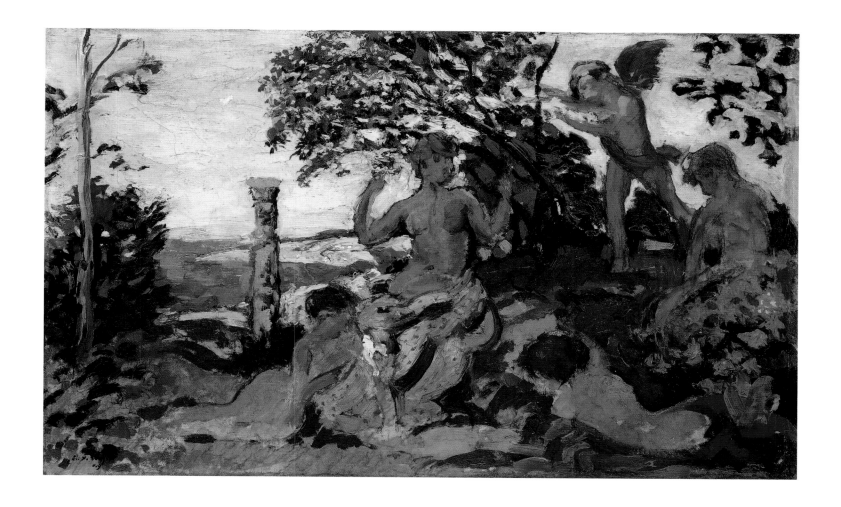

212
Henri Matisse (1869–1954)
Decorative Figure, 1908
Bronze, H. 73 cm

213
Pablo Picasso (1881–1973)
Woman Combing Her Hair,
modelled 1906, cast 1968
Bronze, H. 42.2 cm

214
Aristide Maillol (1861–1944)
Desire, modelled 1904, this version 1909
Terracotta, 115 × 106 cm

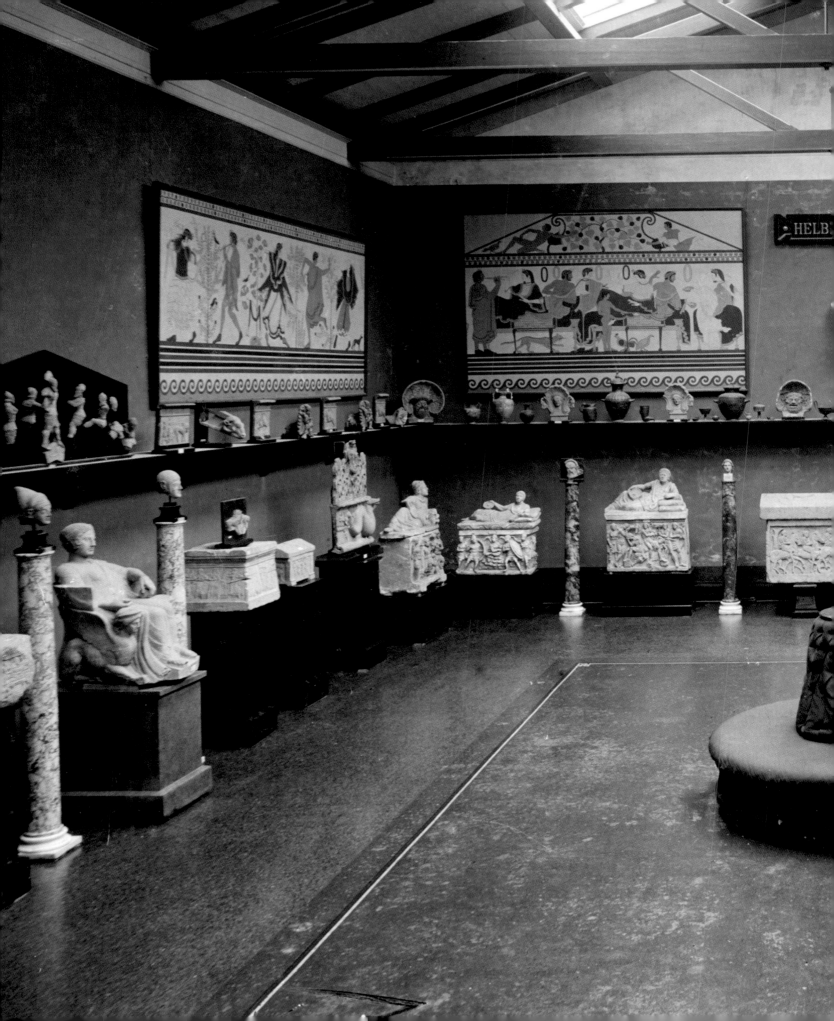

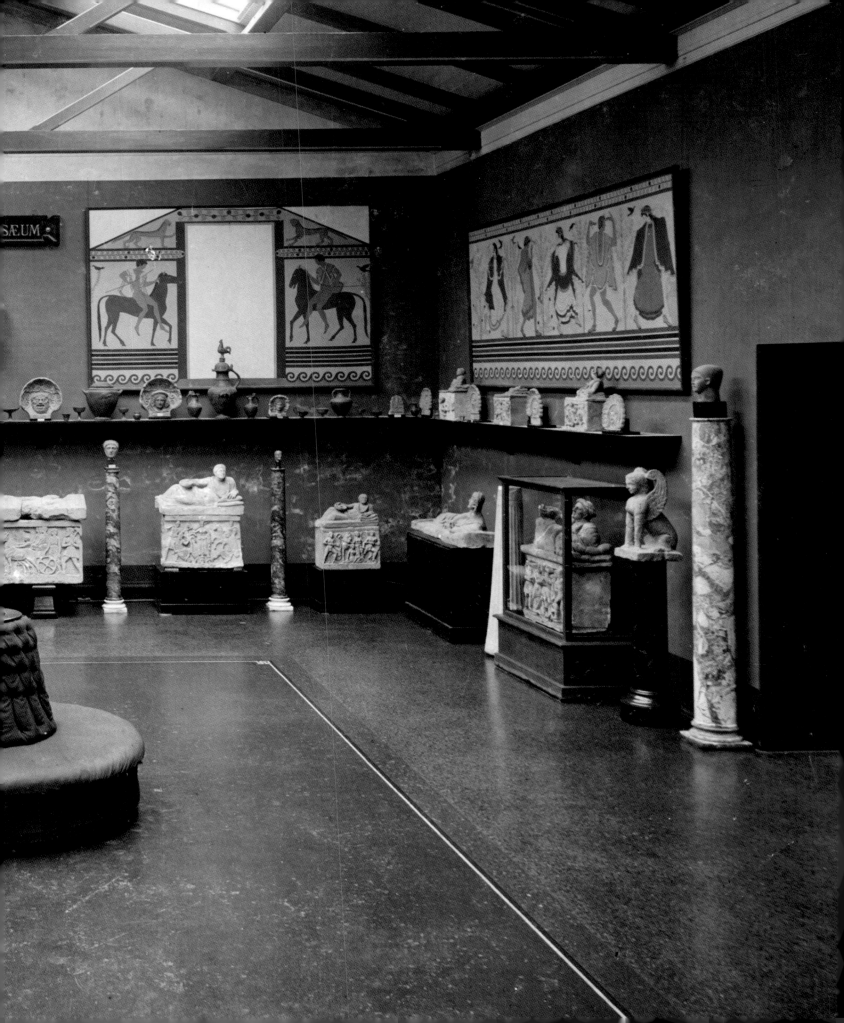

 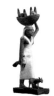 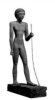 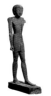

1

Hippopotamus, late Predynastic – Early Dynastic period, *c.* 3000 BC
Calcite, H. 16.5 cm
PROVENANCE: Find spot unknown. Collection of Friedrich Wilhelm von Bissing in 1909. Collection of Lunsingh Scheuerleer. Acquired by the Ny Carlsberg Foundation for the Glyptotek on the art market in 1934
SELECTED REFERENCES: Von Bissing 1909, pp. 128–9; Koefoed-Petersen 1939, pp. 53–64; Koefoed-Petersen 1950, pp. 7–8, no. 1, pl. 1–3; Jørgensen 1996, no. 1
ÆIN 1722

There exists a lively range of model fauna – including lions, monkeys, hippopotami, crocodiles, frogs and birds – that date from the beginning of Egypt's historical period, around 3000 BC. They are usually executed in a small format as amulets, sacrificial gifts, pieces for games or jewellery. Larger-format sculpture, such as this hippopotamus, was still rare at this time, however.

Although the find spot is unknown, it is likely that the statuette was made for a temple of a god who, according to Egyptian belief, manifested himself as a hippopotamus. The most likely candidate is Seth, God of Chaos.

The journey made by the statuette to Denmark was a long one. In 1909 the German Egyptologist Friedrich Wilhelm von Bissing (1873–1956) acquired it in Cairo for his own collection. Subsequently it became part of the Dutch industrialist Lunsingh Scheuerleer's private collection, from which the Ny Carlsberg Foundation acquired it for the Glyptotek in 1934. MJ

2

Pastoral scene from the mastaba of Ka-em-rehu at Sakkara, late 5th Dynasty, *c.* 2300 BC
Limestone, 70 × 141 × 14 cm
PROVENANCE: Acquired through the Egyptian Antiquities Service in 1911
SELECTED REFERENCES: Erman 1919, p. 30; Mogensen 1921, p. 5, fig. 4; Mogensen 1930, pp. 272–3, no. A654, pl. 88; Harpur 1987, p. 479, fig. 121; Jørgensen 1996, no. 20
ÆIN 1271

This vivid scene, part of a wall decorated in relief and originally painted in bright colours, shows two groups of cowherds, both in boats, leading a herd of oxen over the Nile or a canal. One of the cowherds catches sight of a crocodile approaching the oxen and warns his fellow herdsmen: 'Beware that *shy* coming blindly through the water!' His words are inscribed above the swimming oxen. It is not known what a *shy* is, but the context makes it clear that the herder uses the word as a euphemism for the inauspicious word 'crocodile', which he does not wish to utter.

In the damaged register above, men are shown catching fish in a net. The two scenes originally decorated a wall in the tomb of a high-ranking official, Ka-em-rehu, who lived during the reigns of Djedkare and Unas at the end of the 5th Dynasty, *c.* 2300 BC. MJ

3

Offering bearer, end of 6th Dynasty, *c.* 2150 BC
Painted wood, H. 40 cm
PROVENANCE: Probably from the Tomb of Hepikem at Meir. Acquired in Cairo in 1894
SELECTED REFERENCES: Jørgensen 1996, no. 35; The Eton statuette: Cambridge 1988, pp. 103–4, no. 90; New York 1999B, p. 13, no. 4
ÆIN 670

A woman is shown bringing offerings. In her basket are bread and jars of beer. She holds a bird in one hand, and drives a calf ahead of her. She wears a dress with shoulder straps and a scarf around her head, held in place with a headband. The original paintwork is almost perfectly preserved.

The statuette was acquired by Carl Jacobsen's Egyptologist, Valdemar Schmidt, from an art dealer in Cairo in 1894. It is almost certainly one of a pair originating from the tomb of the official Hepikem at the Middle Egyptian town of Meir. The other statuette is now at Eton College in the Egyptian collection bequeathed to the college by William Joseph Myers (1858–1899), an officer in the British Army.

According to Egyptian religion, the dead needed food and drink which were offered to them by the living or brought to the tombs by magical statuettes, like the one seen here. MJ

4

Meri-re-ha-ishtef as a middle-aged man, late 6th Dynasty, *c.* 2200–2150 BC
Wood, H. 65.5 cm
PROVENANCE: From Sedment. Acquired from W. M. F. Petrie's excavations in 1921
SELECTED REFERENCES: Petrie and Brunton 1924, pp. 2–3, pl. 9; Jørgensen 1996, no. 34; New York 1999, pp. 462–3, no. 189; Harvey 2001, pp. 208–9, no. A48
ÆIN 1560

One of the finest surviving examples of woodcarving from Ancient Egypt, this statuette of a man represents the 'Sole Associate and Lector Priest' Meri-re-ha-ishtef. He is portrayed in one of the poses used in Egyptian art for the depiction of gods, kings and noblemen: a stately posture with his left foot forward as though pausing in the middle of a step.

The statuette was found in the tomb of Meri-re-ha-ishtef at Sedment together with two other statuettes all portraying the same man, but at different stages of life: as young, middle-aged (seen here) and old. The English Egyptologist W. M. F. Petrie, who discovered the tomb in the winter of 1920–1, divided the statuettes between the British Museum (the young one), the Glyptotek (the middle-aged one) and the Egyptian Museum in Cairo (the old one).

Egyptian statues of nude adults are extremely rare, but a few exist from the end of the Old Kingdom, *c.* 2300–2150, probably reflecting changes in funerary beliefs. MJ

5

The official Hema, Transitional period between Old and Middle Kingdoms, *c.* 2100 BC
Painted wood, H. 112 cm
PROVENANCE: Probably from Meir. Acquired on the art market in 1958
SELECTED REFERENCES: Koefoed-Petersen 1962, pp. 7–8, fig. 2, pl. 6; Jørgensen 1996, no. 36; Harvey 2001, no. B22
ÆIN 1730

Dressed in a short-locked wig and a short kilt, Hema is portrayed in a pose typical for the depiction of noblemen, kings and gods: his left leg is advanced as though walking, but his vertical, symmetrical body, which shows no turn in either the hips or the shoulders, gives no other indication of movement. As usual in these cases it is an open question as to whether the person illustrated is actually walking or standing.

A sceptre was originally held in his right hand, while the left hand held a long staff which rested on the base in a small depression in front of the left foot. Here we also find an inscription identifying the man: 'Sole Assistant and Estate Manager Hema'.

Statues like this were placed in tombs where they were intended to furnish the *ka*, spirit, of the deceased with a solid body. MJ

Previous pages: The 'Helbig Museum' prior to 1906

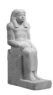
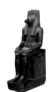

6

Man, probably reign of Sesostris II, *c.* 1897–1878 BC
Limestone, H. 22 cm
PROVENANCE: From Abydos. Acquired in 1926 from the Egypt Exploration Society
SELECTED REFERENCES: Frankfort 1926, pp. 143–4, pl. 21; Evers 1929, pl. 61; Koefoed-Petersen 1950, p. 15, no. 18, pl. 20; Jørgensen 1996, no. 63
ÆIN 1662

This statuette shows a nobleman, clad in a long wig and a long kilt, sitting on a high, almost throne-like chair. It is in a perfect state of preservation, but was never finished. Probably the sculptor discarded the statuette because the arms and the chair suffered damage before work reached its final stages.

The statuette was found in a poor man's tomb with no grave goods other than the statuette and a simple wooden coffin. Probably the poor man had been able to acquire the statuette only because the sculptor gave away the unfinished work for almost nothing.

A statuette like this was placed in the tomb in order to give the *ka*, spirit, of the deceased a solid, incorruptible body in which to dwell.

The tomb was discovered at the necropolis of Abydos by the Egypt Exploration Society in 1926 and donated to the Glyptotek in recognition of the Ny Carlsberg Foundation's financial support for the excavations. MJ

7

The god Anubis, reign of Amenophis III, *c.* 1403–1365 BC
Diorite, H. 158 cm
PROVENANCE: From the Temple of Luxor. Acquired at the auction of Raymond Sabatier's collection in Paris in 1890
SELECTED REFERENCES: Porter and Moss 1972, p. 287; Cleveland 1992, p. 215, fig. VII.2; Bryan 1997, p. 77; Jørgensen 1998, no. 27
ÆIN 33

This statue depicts the god Anubis as an enthroned man with the head of a jackal, a long wig and a short kilt. In his right hand he holds the symbol of life, or *ankh*. Anubis was protector of tombs, the patron of embalming, and guided the dead to the next world.

The inscriptions on the front of the throne are dedications by King Amenophis III to 'Anubis in the Temple of Luxor'.

The statue was one of Carl Jacobsen's earliest Egyptian acquisitions. He bought it with several other important sculptures when the art collection of the French diplomat Raymond Sabatier (1810–1879) was sold at auction in Paris in 1890. MJ

8

Head of the Young Amenemhat III, 12th Dynasty, reign of Amenemhat III, 1842–1795 BC
Greywacke, H. 46 cm
PROVENANCE: Find spot unknown. Acquired by Valdemar Schmidt from an art dealer in Cairo in 1894
SELECTED REFERENCES: Schmidt 1912, pl. 194; Jørgensen 1996, no. 68; Malek 1999, pp. 28–9; Munich 2000, pp. 127, 183, no. 53
ÆIN 924

King Amenemhet III was one of the most significant rulers in the history of ancient Egypt. His facial features are recorded on this head, which shows the king as a young man wearing the crown of Upper Egypt. In its complete form the crown was a symmetrical cone-shaped 'hat' but it is now damaged, as are the king's nose and ears.

The head belonged to an almost life-size statue of the king executed in greenish-black greywacke, a type of stone frequently used for sculpture in ancient Egypt.

Egyptian royal portraits are normally highly idealised, but during the reign of Sesostris III and that of his son, Amenemhet III, artists tended to put more emphasis on individuality and character, as can be seen here. The head was acquired in 1894 by Carl Jacobsen's Egyptologist, Valdemar Schmidt, and has since been the unqualified masterpiece of the Glyptotek's Egyptian collection. MJ

9

King Amenophis II, reign of Amenophis II, *c.* 1439–1413 BC
Diorite, H. 40 cm
PROVENANCE: Find spot unknown. Acquired by Carl Jacobsen in Egypt in 1909
SELECTED REFERENCES: Koefoed-Petersen 1950, p. 23, no. 34, pl. 37; Vandier 1958, p. 307; Jørgensen 1998, no. 16; Malek 1999, p. 94
ÆIN 1063

This head has been broken off a larger than life-size statue depicting a king. He is portrayed with the *nemes* headdress, the cobra diadem and the ceremonial chin-beard. The eyebrows and the outer corners of the eyes are marked with ceremonial, cosmetic lines.

The powerful, youthful features with a narrow mouth and large, open eyes are typical of portraits of Amenophis II.

The head is one of the many impressive sculptures which Carl Jacobsen himself bought during a visit to Egypt in 1909. MJ

10

Amun, probably from the reign of Tutankhamun, *c.* 1346–1337 BC
Diorite, H. 54 cm
PROVENANCE: Probably from the Temple of Karnak. Acquired in 1911 in Egypt.
SELECTED REFERENCES: Vandier 1958, p. 387; Porter and Moss 1972, p. 534; Jørgensen 1998, no. 60
ÆIN 1285

This head comes from a life-size statue of a man representing the god Amun in his customary attire: a tall crown of feathers, a braided chin-beard and a broad, ornamental collar. The top of the feathers has been broken off and the original inlaid eyes are missing. On the back pillar a fragmentary inscription includes some of Amun's appellations: '... the First of Karnak, Great of Repute, Great of Strength, Lord of Heaven, Lord of the Ennea ...'.

Amun or Amun-Re was a mighty creator, a solar, warrior and fertility god, who was worshipped in the great Temple of Karnak, from where this head probably originates.

Egyptian representations of gods were often given facial features based on idealised portraits of specific rulers. In this case the model was probably the boy king Tutankhamun who, after the heresy of his father, Akhenaten, reintroduced the worship of Amun. MJ

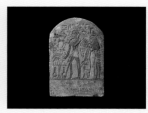

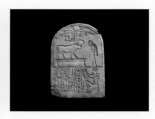

11

The stela of General Antef, Transitional period between Old and Middle Kingdoms, *c.* 2050 BC
Limestone, H. 172 cm
PROVENANCE: Probably from Thebes. Acquired for Bishop Frederik Münter's collection in Luxor in 1829. On loan to the Glyptotek from the Diocese of Copenhagen from 1908
SELECTED REFERENCES: Schmidt 1910, pp. 13–15, pl. 16; Lichtheim 1988, pp. 62–3; Jørgensen 1996, no. 47
ÆIN 963

This large *stela* depicts Antef, 'Head of the army in the entire land', twice. On the left he is shown inhaling the scent of a lotus, the flower associated with the creation of the world and the resurrection of the dead. In front of him an offering-table is set with bread, meat, vegetables and fruit. On the right he is seen again, now standing with his hands in a gesture signifying veneration of a god who, however, is not shown.

The inscription beneath the picture-field is a sequence of magic formulae, intended to aid and protect the general in the next world.

Shortly after Jean-François Champollion's decipherment of the hieroglyphs on the Rosetta Stone in 1822 Frederik Münter, a Danish bishop, decided to build up a collection of Egyptian texts. He had this and many other *stelae* brought from Egypt in 1829. The collection was transferred to the Glyptotek in 1908. MJ

12

The Polio stela, reign of Amenophis III, *c.* 1403–1365 BC
Limestone with original paintwork, H. 27 cm
PROVENANCE: Find spot unknown. Acquired in Egypt in the 1890s
SELECTED REFERENCES: Ranke 1932, pp. 412–18; Porter and Moss 1981, p. 871; Jørgensen 1998, no. 39
ÆIN 134

This round-topped limestone *stela* is decorated with sunken relief which has retained its original paintwork. It shows a scene in which a man, a woman and a boy stand at an offering-table. According to the inscriptions these figures are the doorkeeper Roma, his wife Imaya and her son, Ptah-em-heb, worshipping the goddess Astarte.

Roma holds out a small offering-stand with a bowl and a round loaf of bread. At the same time he pours a libation from a small flask over the offerings on the table in front of him. Between his arm and his chest he holds a long staff. His right leg is thin and crooked and his foot rests only on its toes. This deformity was probably caused by polio, and the *stela* is generally recognised as the oldest known representation of a polio victim.

Beneath the scene is an inscription in which Roma invokes Astarte for '... joy, prosperity and a decent burial'. MJ

13

Stela dedicated to Min, reign of Amenophis III, *c.* 1403–1365 BC
Limestone, H. 24 cm
PROVENANCE: From the Ptah Temple at Memphis. Acquired from excavations undertaken by W. M. F. Petrie in 1908
SELECTED REFERENCES: Petrie 1909, p. 8, pl. 16 (41); Porter and Moss 1981, p. 834; Jørgensen 1998, no. 38
ÆIN 1014

This small *stela* shows a woman making an offering to the ithyphallic fertility god Min, or Amun-Min, who stands in a formal, statue-like posture before her. The decoration is executed in low relief, which was probably originally painted in bright colours. Beneath the scene was an inscription in which the woman dedicated the *stela* to the god, but only traces of this remain.

The woman's transparent gown, the minutely detailed rendering of the folds of the skin under the navel, and the large, spindle-shaped eyes of both the woman and the god all date the work to the reign of Amenophis III.

The *stela* comes from the temple of Ptah in Memphis, where it was discovered in the course of W. M. F. Petrie's excavations in 1908. It was given to the Glyptotek in recognition of the Ny Carlsberg Foundation's financial support for Petrie's work. MJ

14

Stela dedicated to Mnevis, 19th Dynasty, *c.* 1305–1196 BC
Limestone, H. 36 cm
PROVENANCE: From Heliopolis. Acquired by Valdemar Schmidt in Egypt in 1894
SELECTED REFERENCES: Moursi 1987, pp. 228–30; Jørgensen 1998, no. 108
ÆIN 590

This *stela* shows the sacred Mnevis Bull and one of its worshippers. Between its horns the bull bears a crown in the form of a sun disc, and before the animal stands an offering-table with a libation jug and a bouquet of lotus flowers. The worshipper kneels with raised hands in honour of the bull. The text reads:

Giving praise to Mnevis,
Kissing the ground before the herald of Re,
The Great God, the Ruler of Heliopolis,
So that he might grant life, prosperity and health
To the ka of the laundryman in the House of Re, Ipiya.

The worshipper, Ipiya, has consecrated the *stela* to Mnevis in order to express his pious attitude to the sacred animal. In this way he hoped to make himself more deserving of the 'life, prosperity and health' given by the holy animal, which was considered an incarnation of the Sun God Re.

The *stela* was acquired by Carl Jacobsen's Egyptologist, Valdemar Schmidt, during one of his many visits to Egypt. MJ

15

Fragment of a relief showing King Akhenaten, reign of Akhenaten, *c.* 1365–1347 BC
Quartzite, H. 15 cm
PROVENANCE: From el-Amarna in Middle Egypt. Acquired from the Egypt Exploration Society in 1933
SELECTED REFERENCES: Pendlebury 1951, p. 19 (32/130), pl. 58; Jørgensen 1998, no. 45
ÆIN 1718

The subject of this scene was originally King Akhenaten making offerings to the Sun God Aten. Only a fragment, showing the king's face, neck, shoulders, arms and part of his crown, has survived.

Aten was originally depicted above the king's head as a solar disc with radiating beams, each terminating in a human hand. Some of the hands were reaching towards the offering, which the king held up towards the god. Other hands presented the king with the symbol of life, *ankh*, in return for his offering. Two *ankhs* and one of the god's hands are still visible in front of the king's head.

The fragment was part of a wall decoration in the Temple of Gematen, which Akhenaten erected for Aten in his capital el-Amarna. It was found by the Egypt Exploration Society in 1932–3 and given to the Glyptotek in recognition of the Ny Carlsberg Foundation's financial support for the society's excavations. MJ

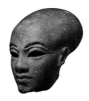
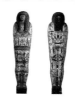
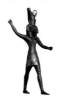
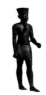
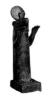

16

Princess, reign of Akhenaten,
c. 1365–1347 BC
Quartzite, H. 15 cm
PROVENANCE: Probably from
el-Amarna. Acquired from the
collection of Friedrich Wilhelm
von Bissing in 1927
SELECTED REFERENCES: Borchardt
1923, pp. 11–12, fig. 9; Koefoed-
Petersen 1950, p. 28, pl. 53–4;
Vandier 1958, p. 343; Jørgensen
1998, no. 46
ÆIN 1663

This head, with its strikingly
beautiful features, represents one
of the six daughters of King
Akhenaten and Queen Nefertiti,
possibly the eldest, Merit-aten.

The large back of the head has
prompted all kinds of speculation.
Some scholars used to believe
that the princess suffered from
hydrocephalus, while others have
suggested that her head was
deformed in infancy. It is,
however, most likely that the
head's shape is simply a case of
artistic exaggeration of a natural,
oval head shape.

Reddish-brown quartzite was
very widely used for sculpture
during the reign of Akhenaten.
The eyes originally had inlays of
various coloured stones or other
coloured materials.

The Glyptotek acquired the
head in 1927 from the private
collection belonging to the
famous German Egyptologist
Friedrich Wilhelm von Bissing. MJ

17

The Coffin of Kep-ha-ese,
c. 900–700 BC
Linen, glue and plaster, H. 160 cm
PROVENANCE: Find spot unknown.
Acquired through Julius Løytved
in Egypt in 1888
SELECTED REFERENCES: Ikram
and Dodson 1998, p. 236, fig. 312,
pl. 29; Jørgensen 2001, no. 6
ÆIN 298

This coffin was one of the first
Egyptian objects to arrive at the
Glyptotek. Carl Jacobsen acquired
it in 1888 through the Danish
Consul in Beirut, Julius Løytved,
who had connections with Egypt
through the German Egyptologist
Emile Brugsch.

The decoration is composed of
mythological scenes. On the chest
the Sun God Re is depicted as a
newborn child. On the back Re
appears once again, now in the
form of a scarab beetle, the
incarnation of the morning sun
and a symbol of creation. On the
thighs the falcon-headed Horus
restores his dead father, Osiris,
to life by presenting him with the
symbol of life, *ankh*. These scenes
of rebirth, creation and
resurrection were intended to
help the deceased into a new life.

The coffin is made of
cartonnage (linen, glue and
plaster). During the period
900–700 BC a cartonnage coffin
was often used as the immediate
container of a mummy. It was
then enclosed in one or more
coffins of more durable materials
such as wood, stone or metal. MJ

18

Seth, probably Ramesside Period,
c. 1300–1080 BC
Bronze and silver, H. 70 cm
PROVENANCE: Find spot unknown.
Collection of Gustave Posno.
Acquired by Carl Jacobsen from
the art dealer Jean-Henri
Hoffmann in Paris in 1893
SELECTED REFERENCES: Te Velde
1977, pp. 126–7 (n. 2), pl. 1; Porter
and Moss 1981, p. 870; Jørgensen
1998, no. 144
ÆIN 614

This statuette originally depicted
the god Seth as a man with the
head of a mythical beast. He wears
the double crown of Upper and
Lower Egypt and was probably
holding a club and a lance, or a
club and a shield.

In Egyptian mythology Seth
was the murderer of Osiris. In
addition he was the God of the
Desert, Foreign Lands and Chaos.
His cult reached its zenith under
the Ramesside kings, *c.* 1300–1080
BC. Subsequently Seth fell from
favour and statues of him were
destroyed or reworked into
representations of other deities.
In this case his appearance was
altered to that of a ram-headed
god, probably Khnum, by cutting
off Seth's original tall ears and
replacing them with the curved
horns of a ram.

The statuette once belonged
to Gustave Posno (*fl.* 1874–83), a
French collector of Egyptian art,
and was later acquired by Carl
Jacobsen in Paris from Jean-Henri
Hoffmann, an art dealer. MJ

19

Amun, probably 22nd Dynasty,
c. 900 BC
Bronze with silver inlays, H. 21 cm
PROVENANCE: Find spot unknown.
Acquired at auction from the
collection of Giovanni Datari in
Paris in 1912
SELECTED REFERENCES: Paris 1912,
p. 47, no. 404, pl. 46; Mogensen
1930, no. A128
ÆIN 1468

This statuette shows the god
Amun in his typical guise: as
a young man with a tall crown,
a pointed beard, a broad collar
and a short kilt. His crown was
originally the base of two tall
plumes, and in each hand he held
a sceptre. The material is bronze
with well-preserved inlays of
silver in the face, the beard, the
collar and the kilt. Under the feet
the statuette had a base which
was probably inscribed with a
formula invoking Amun to grant
'Life, Prosperity and Health' to
the man or woman who had
commissioned the statuette and
donated it to the god's temple.

The extremely fine metalwork
and the delicately made face
argue for a dating in the 22nd
Dynasty, *c.* 900 BC. MJ

20

Mongoose, probably 26th Dynasty,
664–525 BC
Bronze, H. 27 cm
PROVENANCE: Find spot unknown.
Date and place of acquisition
unknown
SELECTED REFERENCES: Mogensen
1930, no. A426
ÆIN 622

The Egyptian mongoose
(*ichneumon*) is able to kill snakes.
It was considered a protector of
the Sun God Re in the fight
against Apophis, the Serpent of
the Underworld who, if not killed
every night, would prevent the
sun rising at dawn.

This mongoose sits upright
on its hind legs with its forepaws
raised in a position that makes
it look like a pious Egyptian
worshipping his god. The idea is
that the mongoose is praising Re
as the god rises at dawn. The
association with Re is additionally
stressed by the crown, which is
composed of a sun disc and a
cobra. In Egyptian mythology
the cobra was an incarnation of
Tefnut, daughter of Re.

The statuette probably
contained a part of a mummified
mongoose and may have been
given as an *ex-voto* to a temple by
an Egyptian who wanted to assist
Re against his rival Apophis in the
underworld. MJ

 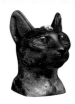 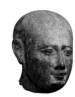 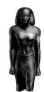

21

Ptah, probably 26th Dynasty, 664–525 BC
Egyptian faience, H. 23 cm
PROVENANCE: Find spot unknown. Acquired at auction in Paris from the collection of Giovanni Datari in 1912
SELECTED REFERENCES: Mogensen 1930, no. A141
ÆIN 1469

The statuette shows the god Ptah in his typical form: as a man with a skull cap, a square beard and a close-fitting garment. In his hands he originally bore a long sceptre, probably of metal. Egyptian faience, of which the statuette is made, consists mainly of fine quartz sand which was fired at a high temperature in a kiln. The fresh green colour is due to a glaze containing copper.

Ptah was one of the most important gods of Ancient Egypt, with his cult centre at Memphis. According to a myth, he created the world by conceiving the idea and uttering the 'creative word'. MJ

22

Bes, probably 26th Dynasty, 664–525 BC
Bronze, H. 14 cm
PROVENANCE: Find spot unknown. Acquired from the MacGregor Collection in London in 1922
SELECTED REFERENCES: London 1922, p. 166, no. 1270, pl. 22; Mogensen 1930, no. A180
ÆIN 1594

The statuette, which once belonged to the famous MacGregor Collection, shows the god Bes in one of his many forms: with a grotesque lion-like face, a dwarf-like male body, four arms, two pairs of wings and the back and tail of a bird. He wears a crown of tall plumes ornamented with sun discs and the heads of various animals: a cat, a crocodile, a lion, an oryx, a baboon, a falcon and a ram. In his four hands he holds snakes and flowers. His penis is erect, and cobras spring from his knees and ankles. Around his feet a snake bites its own tail.

Bes was a frightening warrior who fought against evil powers and protected both mortals and immortals. In his so-called 'pantheistic' form, shown here, he assimilated a large number of protective divinities and became an omnipotent solar god. MJ

23

Cat head, probably 26th Dynasty, 664–525 BC
Bronze, H. 13 cm
PROVENANCE: Find spot unknown. Acquired in Paris in 1920
SELECTED REFERENCES: Mogensen 1930, no. A394
ÆIN 1545

Mummified cats were presented as *ex-votos* to temples devoted to the worship of goddesses who, according to Egyptian belief, manifested themselves as cats or lions. Most important among these were Bastet and Sakhmet, who had their cult centres at Bubastis and Memphis respectively.

In many cases the mummies were enclosed in containers shaped like a sitting cat. This piece is the head from such a container. The hollow body containing the mummy may have been made of wood, while the head is of bronze with a scarab beetle of bone on the forehead. The scarab was a symbol of the Sun God Re in his morning incarnation, Kheper, and was probably placed on the head because Bastet, Sakhmet and the other feline goddesses were all considered various manifestations of Tefnut, daughter of Re. The original eyes were probably made of various coloured stones; the current ones are a modern glass restoration. The pierced ears were probably adorned with rings of gold. MJ

24

Man, probably third century BC
Limestone, H. 33 cm
PROVENANCE: Find spot unknown. Acquired in Cairo in 1911
SELECTED REFERENCES: Koefoed-Petersen 1950, no. 113; New York 1960, p. 128
ÆIN 1384

This head from a statue represents a man with a bald or shaven pate and fleshy, middle-aged features. Faint traces of original paintwork show that the skin was red while the pupils and irises were black. The work does not portray a specific individual, but represents an idealised type of man known from many other statues and statuettes from Egypt's Late Period (*c.* 700–300 BC) and Ptolemaic Era (*c.* 300–30 BC).

Decidedly unusual, however, is the great size of the head which was obviously once part of an over-life-size statue that must have represented an unusually important person. His name and titles were probably inscribed on the statue's back pillar and base, of which, however, nothing remains. MJ

25

Young man, third century BC
Diorite, H. 42 cm
PROVENANCE: Find spot unknown. Acquired by Carl Jacobsen in Athens in 1895
SELECTED REFERENCES: Koefoed-Petersen 1950, no. 125; Malek 1999, p. 767
ÆIN 925

The young man is portrayed in a stately posture with a straight back, arms hanging down at his sides and his left leg forward. He wears a long wig and a short kilt, but is otherwise naked. The whole of the original base has been broken off and is missing, together with the lower part of his legs and feet.

Hard, dark stone was especially favoured for statues in the Late Period (*c.* 700–300 BC) and the Ptolemaic Era (*c.* 300–30 BC), and the light, elegant style of the piece argues for a date in the third century BC.

In the Egyptian religion offerings of food and drink were regarded as essential for the well-being of the dead. A statuette like this was typically placed in a temple where, according to Egyptian belief, the god would share his offerings with the private individuals who had their monuments in his presence. MJ

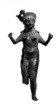
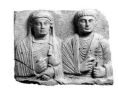

26

Aphrodite, first century AD
Bronze, H. 32 cm
PROVENANCE: Find spot unknown.
Acquired on the art market by
the Ny Carlsberg Foundation
in 1954 and donated to the
Glyptotek in 1956
SELECTED REFERENCES:
Unpublished
ÆIN 1725

The goddess Aphrodite appears
as a young, naked woman
standing with slightly bent knees
and raised hands. She wears a
broad wreath of leaves on her
head, heavy earrings and a collar
with rectangular pendants. Her
hair is fastened up behind her
head, and a thick corkscrew tress
descends over each shoulder.

The material is bronze except
for the eyes, which are made of
black and white stone. The
statuette has partly disintegrated
and lacks the nipples, parts of the
right leg and the base. In her
hands the goddess presumably
held attributes, maybe fruits, ears
of corn or musical instruments.

The find spot is not known, but
the statuette probably originates
from Egypt where similar
statuettes have been found and
where Aphrodite was assimilated
with Isis and other Egyptian
goddesses during the Roman era.
MJ

27

Bust of a couple, c. AD 150
Soft white limestone, H. 47 cm
PROVENANCE: Acquired through
Julius Løytved in Syria
SELECTED REFERENCES: Colledge
1976, pp. 247, 255; Ploug 1995, no.
30; Hvidberg-Hansen 1998, no. 30
IN 1026

The Palmyran funerary reliefs
from the first centuries AD were
made as cover slabs closing grave
niches, *loculi*, rows of burials
either in funerary towers or in
subterranean vaults, *hypogeia*.

In her left hand the woman
holds a spindle and a distaff,
while the man holds the deed
to the tomb, the *schedula* – the
common formula for these
representations. The inscription
between them is enigmatic, as
it is written in more than one
Aramaic script. It is impossible
to translate or interpret the
inscription, but it seems to be
ancient. Perhaps it represents a
reuse of the stone for practising
various Aramaic letters, or maybe
it is an ancient forgery. AMN

28

Bust of 'The Beauty of Palmyra',
AD 190–210
Hard white limestone with traces
of yellowish, red and black paint,
H. 55 cm
PROVENANCE: Acquired in Syria
through Harald Ingholt from
a private collection in 1929
SELECTED REFERENCES: Colledge
1976, pp. 71–2; Ploug 1995, no. 77
IN 2795

The gem of the Palmyran
collection is the colourful bust
of a woman of eastern
appearance. She wears a tunic,
cloak and turban, as well as an
abundance of golden jewellery:
diadem, earrings, head chains,
brooch, necklaces, bracelets,
armlets and finger rings.
Palmyran funerary sculpture is
normally not painted, and the
inlaid eyes are also unusual. The
inscription is missing. It has been
suggested that she originated in
India, and no doubt commercial
connections with India would
have brought Indian slaves and
merchants to Palmyra. AMN

29

Bust of Kaspâ, AD 150–70
Hard white limestone, H. 53 cm
PROVENANCE: Acquired through
Julius Løytved in Syria
SELECTED REFERENCES: Colledge
1976, p. 152 (n. 578), p. 261; Ploug
1995, no. 54; Hvidberg-Hansen
1998, no. 54
IN 1074

The young woman's complicated
coiffure is similar to that of the
Roman empress Faustina the
Elder, the wife of Antoninus Pius,
who died in AD 141. The later
dating of this piece reflects the
assumption that the fashion took
some time to reach the provinces.
The deceased woman appears to
be very young and no husband is
mentioned in the inscription,
suggesting that she died
unmarried. The inscription reads:
'Kaspâ, daughter of Timaios [?] [or
Tamiâs?]. Alas!' AMN

30

Bust of a man with a camel, c. 160 AD
Hard white limestone, H. 56 cm
PROVENANCE: Acquired through
Harald Ingholt in Hama, Syria
in 1937
SELECTED REFERENCES: Colledge
1976, p. 68 (n. 211), p. 142 (n. 525),
p. 250; Ploug 1995, no. 47;
Hvidberg-Hansen 1998, no. 47
IN 2833

Behind the human figure is the
front part of a laden camel. This
unknown Palmyran, whose name
inscription is missing, is unusual
in being accompanied by a camel.
Priests and occasionally soldiers
appear on these sculptures with
the attributes of their positions,
but civilians only rarely so. The
accompanying inscriptions do not
usually concern themselves with
the occupation of the deceased.
The camel here is probably
intended to indicate that the man
was a merchant, possibly one of
the organisers of the caravans on
the Silk Road. AMN

 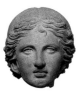

31

Head of a man, Cypro-Classical, fifth century BC
Limestone, H. 32 cm
PROVENANCE: Acquired by Carl Jacobsen from the art dealer Yanakopulos in 1911
SELECTED REFERENCES: Nielsen 1992, no. 12; Karageorghis et al. 2001, no. 37
IN 2538

The man portrayed, a votive from a Cypriot sanctuary, shows traces of colour: the pupils are black and red, the moustache red, the remainder of the beard black, and the hair and wreath red. The laurel wreath is very common in Cypriot sculpture, of which this is a characteristic example. The wreath may indicate that the man was an adherent of the god Apollo, whose symbol laurel was. The head would have belonged to a full-length statue. Similar examples have been found in a number of Cypriot sanctuaries. AMN

32

Head of a man, Hellenistic-Roman, second century BC
Limestone, H. 32 cm
PROVENANCE: Acquired on the art market in 1924
SELECTED REFERENCES: Connelly 1987, fig. 108; Nielsen 1992, no. 17; Karageorghis 2001, no. 42
IN 2746

This head, a votive from a Cypriot sanctuary, belonged to a cloaked statue, as is indicated by remnants of a cloak on the back of the neck. If a similar portrait found at the Cypriot sanctuary of Golgoi represents the same individual, then he must have been well known, or at least rich. AMN

33

Male votive head, fifth century BC
Terracotta, H. 25 cm
PROVENANCE: Allegedly from Città San Angelo. Acquired in Rome in 1896, through Wolfgang Helbig
SELECTED REFERENCES: Leipen 1989, p. 125, pl. 63, no. 2a–b; Moltesen and Nielsen 1996, no. 60
HIN 108

The well-modelled face was made in a hollow mould and joined to the back of the head and the neck. The face has been reworked to sharpen details and the short hair rendered in wavy lines from the top of the skull. The slight remains of white slip on the hair and face are probably primer, indicating that the head was once painted, the skin presumably in a reddish colour as was the rule for the representation of males. The back of the head and neck is covered by a thick layer of stucco, which may indicate that a cloak once covered the head. This was often the case with votive heads, which allude to the act of sacrifice in which the celebrant covered his head with a garment. JC

34

Male votive head, late fourth – early third century BC
Terracotta, H. 29.5 cm
PROVENANCE: Allegedly from a votive deposit at Castel di Decima in Latium, south of Rome. Acquired in Rome in 1909, through Wolfgang Helbig
SELECTED REFERENCES: Jovino 1965, p. 90 (n. 1); Moltesen and Nielsen 1996, no. 109
IN 2380

This head is moulded in two halves, the front and back separately, while the ears were worked by hand and then added. This technique reflects a mass production consistent with the growing demand at popular sanctuaries where votives were sold to visiting worshippers. In the most popular and important sanctuaries a great number of votives were accumulated over the years. At intervals the earlier ones were buried in pits within the sanctuary. Thus often hundreds or thousands of similar figures have been found in modern times.

The sanctuary from which this head derives is unknown, but cloaked men and veiled women are the most common type. Not only do the cloaks indicate persons of high rank, but as dedications they suggest the dress adopted in conducting sacrifices. The practice of sacrifice with heads covered was taken over by the Romans. JC

35

Female votive head, fourth – third centuries BC
Terracotta, H. 23 cm
PROVENANCE: Allegedly from a votive deposit at Castel di Decima in Latium, south of Rome. Acquired in Rome in 1909, through Wolfgang Helbig
SELECTED REFERENCES: Guaitoli et al. 1974, p. 61, fig. 13; Moltesen and Nielsen 1996, no. 117
IN 2379

The character of this female head reflects an obvious familiarity with Classical Greek sculpture. Apart from minor details the most striking difference from the models is the material: fired clay, *terracotta*, instead of marble. Remnants of paint – as on this head – reveal that the terracotta surface was originally covered with clay slip, on to which colours for hair and skin as well as details for eyes and lips were applied.

This head was created by skilled artisans in Central Italy who developed a refined method of producing this type of sculpture, using a fired clay technique based on earlier Etruscan traditions. A mould, formed on a model, probably in wax, was the point of departure. Using two moulds, one for the front and one for the back of a head, the same type could be reproduced in several copies. The same face could even be used for both male and female heads. Individual elements, such as details of hairstyle and headdress, determined the final result according to the customer's request.

This head might have been made for insertion in a statue. A veil or an elaborate hairstyle might have been applied on top of the skull. JC

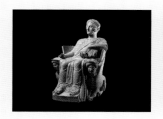

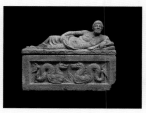

36

Enthroned woman, c. 450 BC
Stinkstone with faint traces of
colour, H. 100 cm
PROVENANCE: Allegedly found near
the Lago di Chiusi; eventually
included in the Collezioni
Quindici at Città della Pieve,
whence it was acquired for the
Ny Carlsberg Glyptotek in Rome
in 1891, through Wolfgang Helbig
SELECTED REFERENCES: Poulsen
1966, p. 38, no. H214; Cristofani
1975, p. 41, no. 10, pl. 26–8;
Cristofani 1991, fig. 7
HIN 77

The statue is completely hollow,
roughly cut inside and
bottomless; the head is worked
separately and inserted in the
neck hole.

In cases in which provenance
is known, this type of statue is
derived from chamber tombs,
containing the cremated remains
as well as the personal belongings
of the dead. For this reason they
have been interpreted as
monumental cinerary urns.
In the correspondence between
Helbig and Jacobsen the piece
is called 'a sepulchral statue of
Proserpina'. In Etrusco-Roman
mythology Proserpina (Greek
Persephone) is the wife of Pluto,
sovereign of the underworld,
though the identification is
uncertain.

A connection to the chthonic
world is emphasised by the
sphinxes, guarding the dead;
the pomegranate, symbolising
fertility and death, from its links
with the myth of Persephone;
and the feline skin of a leopard
or a panther, both attendant
animals of Dionysos, related to
the underworld as the god of
vegetation and, according to
some theories, resurrection. JC

37

*Sarcophagus with reclining male
on lid,* second century BC
Nenfro (tufa), sarcophagus
76 × 195 × 67 cm, lid H. 74 cm
PROVENANCE: Acquired in Orvieto
in 1912, through Paul Hartwig
SELECTED REFERENCES: Herbig
1952, p. 31, no. 49; Brendel 1978,
p. 325, fig. 247; Moltesen and
Nielsen 1996, no. 14
HIN 429

A middle-aged man reclines
comfortably on a couch, the lid of
his own coffin. The individualised
features may indicate that this is
a 'realistic' portrait. A signet ring
on his left hand suggests that he
is a man of rank. The sea monsters
on front of the coffin might refer
to creatures assisting the dead on
their last journey to the hereafter,
or they may merely be ornaments.
The sarcophagus was placed in
a chamber tomb belonging to
a family over several generations.
Ancestors were an important
element in Etruscan culture
and various Etruscan rituals were
concerned with the cult of the
dead, such as providing supplies
for the banquet supposedly
attended by these reclining
ancestors. Within and outside
the tomb regular ceremonies
were performed by the relatives
in order to honour the dead as
well as the gods in the
underworld.

Adjacent to the town of the
living each Etruscan city had a
'town of the dead', or *necropolis*.
Over the centuries the tombs
accumulated, initially laid out
in specific family groups and later
organised on a structured plan
just as in a real town. JC

**The Tomba delle Iscrizioni,
Tarquinia**

Much more is known about the
Etruscans from their tombs than
from their cities. This is due to the
fact that many of their tombs are
extremely well preserved, often
chamber tombs cut into the
volcanic bedrock. Particularly
notable examples were excavated
in necropoleis around the
Etruscan town of Tarquinia in the
nineteenth century. In some of
them the painted walls were
found still more or less intact.
Since then deep ploughing and
the use of fertilisers have seriously
damaged the paintings; some of
them have disappeared altogether.
The copies that Carl Jacobsen
commissioned, at great expense,
of the 28 painted tombs which
were known in his time are there-
fore an invaluable testimony to
one of the oldest groups of ancient
wall paintings known to us.

This tomb lies in Tarquinia and
was discovered in 1827. Since
1971, when tomb-robbers tried to
hack away pieces of the paintings,
it has been closed to public view.
The facsimiles were painted and
signed in 1900 by the Italian
painter Alessandro Colonelli,
probably an alias for Alessandro
Morani, Wolfgang Helbig's son-in-
law. The facsimiles were prepared
using a series of photographs
taken in the tomb, a set of
watercolour sketches at a scale of
1:20, and tracings of the contours.
From these materials facsimiles
at actual size were painted in the
studio, and checked against the
tomb.

The tomb was named after
the many inscriptions written
over the figures. These are in the
Etruscan language, written from
right to left, and give the names
of the participants. It dates to
c. 520 BC and depicts young
aristocrats participating in the
athletic and musical funeral
games of the deceased. The scenes
take place out of doors among
bushes and hanging wreaths. The
style is archaic, showing figures
with head and legs in profile and
chests front-on; very few details
are given. The colours were well
preserved at the time of copying,
with several red hues alongside
black and blue. MM

38

Alessandro Colonelli
*Facsimile of the left wall of the Tomba
delle Iscrizioni, Tarquinia,* 1900
Tempera on canvas, 178 × 477 cm
SELECTED REFERENCES: Poulsen
1922, pp. 14–16, fig. 7; Steingräber
1985, pp. 322–3; Moltesen and
Lehmann 1991, no. 78
HIN 169

A painted door is flanked on one
side by two boxers, a cloaked flute
player and two wrestlers. We
know that in Etruria flute players
often accompanied the games.
On the other side, two horsemen.
Inscriptions above the figures. MM

39

Alessandro Colonelli
*Facsimile of the right wall of the Tomba
delle Iscrizioni, Tarquinia,* 1900
Tempera on canvas, 174 × 483 cm
SELECTED REFERENCES: Steingräber
1985, pp. 322–3; Moltesen and
Lehmann 1991, no. 80
HIN 173

To the left of the painted door are
five *komasts*, men participating in
a lively procession and carrying
wreaths, drinking cups and a
large *crater* (mixing bowl) for
wine. To the right, a bench in the
foreground with some cushions
and behind it a man in a cloak
carrying wreaths and a servant
with branches preparing for the
feast. MM

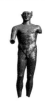
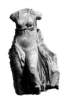
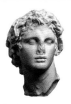

40–43

Four statuettes of mourning women,
early third century BC
Terracotta, H. 92 cm, 92 cm,
89 cm, 92 cm
PROVENANCE: Probably from a
tomb excavated in Canosa in
South Italy in 1895 with four
similar statuettes. Acquired in
Rome in 1912
SELECTED REFERENCES: Oliver 1968;
Fischer-Hansen 1992, nos 77–80;
Van Ommeren 1999, pp. 43–65,
nos 7–8, 19–20; Jeammet 2003,
nos 15–16, 41–42
HIN 419–22

The statuettes show women in
long garments with their hands
in gestures of mourning. Two
wear sleeveless *chitons* with a high
belt and shoes. Two wear a
himation arranged like a shawl
over the shoulders and falling
over the breast; they wear sandals.
Their hair is long and drawn back
either in a knot or plait.

Two of the women hold out
their hands in lament, a third
holds her hand under her cheek
lost in contemplation, while the
fourth holds her hands in front.
Originally eight such women
were placed in the tomb, perhaps
standing around the body, as was
the case in several other tombs.
The Hellenistic tombs in Canosa
had richly painted walls and were
furnished with grave-goods, such
as vases and jewellery.

The figures are hollow and have
a square vent-hole at the back;
they were cast in moulds and
afterwards details were made by
hand in wet clay. They were richly
painted and many traces of colour
remain in the hair and garments.
MM

44

The Rayet Head, c. 520 BC
Parian marble, H. 31 cm
PROVENANCE: Found near the
gasworks in Athens. Acquired
from the auction of Olivier Rayet
in Paris in 1879
SELECTED REFERENCES: Deyhle
1969, pp. 12–20; Schmidt 1969;
Johansen 1994B, no. 18; Bol 2000,
pp. 175, 207, 225, 232, 237, 242,
fig. 305; Brinkmann 2003, no. 233,
fig. 233 (1–3)
IN 418

This head, the first piece of
ancient sculpture acquired by
Carl Jacobsen, was originally part
of a full-length statue of a young
man, a *kouros*, typical of the Greek
Archaic period (seventh and sixth
centuries BC). The hair is short
with layers of individual locks.
On the conventional scheme of
development (which sees a
gradual progression towards
'naturalism'), the head is still
relatively block-like with large
eyes protruding, high
cheekbones, a broad chin and
the corners of the mouth turned
up in the so-called Archaic smile.
The ears are swollen, perhaps to
indicate that the subject was an
athlete, possibly a boxer.

The function of these *kouros*
statues is uncertain. Some may
have been placed as costly votives
in a sanctuary, but in this case
the find spot near the Kerameikos
burial grounds suggests that it
was a grave-marker for one of the
noble Athenian youths of the
period immediately before the
Pisistratid tyrants were expelled
from Athens (510 BC).

The nose is broken and there are
minor damages to the hair, ears
and left brow. Many traces of red
exist in the hair and eyes. MM

45

The Sciarra Bronze, 470–460 BC
Bronze, H. 102 cm
PROVENANCE: Allegedly found
on the Gianicolo in Rome in the
seventeenth century, then in
the Palazzo Barberini and in the
1830s in the Palazzo Sciarra.
Acquired from the Sciarra family
in 1892
SELECTED REFERENCES: Fischer-
Hansen 1992, no. 3; Bell 1996
IN 2235

This under-life-size statue shows
a young man standing stiffly with
his right hand stretched forward
holding an attribute, perhaps an
offering-bowl. His shoulders are
broad and his torso is flat, and
the lower body is slight. The eyes
were inlaid in another material
and are missing. The nipples, lips,
eyebrows and navel were inlaid
in a different alloy from the rest.
The work's style and workmanship
suggest that it was made in
southern Italy, and was probably
intended to stand in a sanctuary.

The statue had a notable
'afterlife'. When it stood in the
Palazzo Barberini it was used as
a lamp with candles inside
glowing through the eyeholes.
In the correspondence between
Helbig and Jacobsen concerning
the acquisition of the statue, it
was given the code name Emil.

Both feet, the left arm from
the shoulder, the right hand and
the upper part of the head are
missing. The mouth is damaged.
The seventeenth-century
restorations were removed in
1963. MM

46

Torso of a wind goddess, c. 400 BC
Pentelic marble, H. 98 cm
PROVENANCE: Allegedly found
in Hermione in the Argolid in
Greece. Acquired from Greece
in 1909
SELECTED REFERENCES: Moltesen
1995, no. 9
IN 2432

The head, arms, feet and a large
part of the garment are missing.
A young woman floats through
the air, the form of her body
underlined by her flowing
garments. The thin *chiton* that
she wears fastened on her left
shoulder has slid down under
her right breast and opens over
her right thigh. A belt is tied just
under her breasts and the thin
material is pressed against her
belly and thighs in what is known
as a 'wet-look' style. Her hair fell
in long locks over her shoulders.
With her left hand she held out
her large cloak so that it billowed
in the wind.

The figure must have served as
an *acroterion* (rooftop sculpture) of
a temple and probably represents
an *aura* or wind goddess. MM

47

Portrait of Alexander the Great,
third century BC
Marble, H. 34 cm
PROVENANCE: Allegedly found
in Alexandria, Egypt. Purchased
from the auction house
Hoffmann in Paris in 1894
SELECTED REFERENCES: Nielsen
1987; Smith 1988, p. 62; Johansen
1992, no. 24; Stewart 1993, p. 424,
fig. 84
IN 574

This portrait of the young king
Alexander the Great (356–323 BC)
is canonical: beardless, firm
features, a hairstyle with a quiff
of hair above the forehead (also
known as a 'cow-lick' or in Greek
an *anastolé*), a faraway look, and
a sharp turn of the head.
Stylistically the work matches
the idiom of the late Classical
sculptor, Lysippos, Alexander's
court sculptor. The co-operation
between Lysippos and Alexander
resulted in the creation of a new
concept in Greek portraiture:
a royal image conveying a
political message using specific
traits drawn from the real-life
features of the sitter, combined
with a certain idealisation. This
new style of portraiture coincided
with the breaking up of the old
'city state' society of Classical
Greece and the emergence of
superpowers headed by one
person. This aroused interest
in the single character, and in
the arts put greater emphasis on
portraits of famous, unique
individuals. AMN

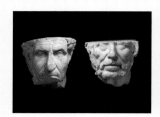 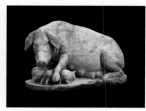 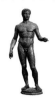 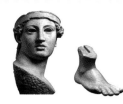 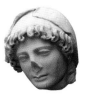

48

Double herm, first century BC
Marble, H. 17 cm
PROVENANCE: Acquired in Rome
from Francesco Martinetti in
1892, through Wolfgang Helbig
SELECTED REFERENCES: Hafner
1981, p. 135; Richter 1984, p. 191;
Johansen 1992, no. 54
IN 611

The heads were once separated,
but there is no doubt that they
originally formed a single piece.
Two elderly male heads are
portrayed on a double herm: that
is, two portraits placed on top of
a shared plain supporting shaft.
The bearded man has commonly
been identified as Seneca
(*c.* 5 BC – *c.* AD 65, the Roman
philosopher and tutor of the
emperor Nero), but may be the
Greek poet Hesiod of the seventh
century BC; the other may be the
Roman poet Virgil (70–19 BC).
There is no firm evidence to
corroborate these identifications.

Double herms were sometimes
used in ancient sculpture to 'pair'
portrait types, either for contrast
or juxtaposition. If we are dealing
here with Hesiod and Virgil, then
the point is presumably to reflect
on the separate (but interrelated)
Greek and Roman strands of
Classical culture: both poets
wrote on country life, Hesiod in
Greek, Virgil in Latin. AMN

49

Statue of the 'Laurentian Sow',
first – second century AD
Marble, 46 × 75 cm
PROVENANCE: Acquired from the
art dealer Simonetti in Rome in
1909
SELECTED REFERENCES: Moltesen
et al. 2002, no. 117
IN 2421

This well-nourished sow with
piglets may be read on two levels:
either as a bucolic scene of an
animal and her young or as an
episode from the mythology
surrounding the origin of Rome.
According to Virgil, a priest of
Apollo prophesied that the sight
of a white sow 'with a litter of
thirty young' would reveal to the
hero Aeneas where he should
found the city of Laurentium
(Lavinium) when he arrived in
Italy after the Trojan War. Aeneas
played a special role in the
propaganda of Augustus, the first
Roman emperor, since Augustus
claimed descent from Aeneas and
assumed the role of the second
founder of Rome.

The front part of the plinth
and the piglets are in a different
marble from the rest, perhaps
suggesting that they are a later
addition. The snout, forelegs and
ears have been restored in marble.
MM

50

Hercules, first century AD
Bronze, H. 125 cm, including
plinth
PROVENANCE: Allegedly found in
an ancient bronze-founder's
workshop on the Via Barberini in
Rome. Acquired from Francesco
Martinetti in 1891, through
Wolfgang Helbig
SELECTED REFERENCES: Lehmann
1946, pp. 53–62; Moltesen et al.
2002, no. 77; Copenhagen 2003B,
p. 424, no. 7.1
IN 456

Hercules stands with his head
turned to the left and with his left
arm stretched forward; the
position of the fingers show that
the hand once held a bow, with
the bent middle finger around an
arrow. His right arm hangs down
at his side and may have borne a
lion skin. Traces of a strap
diagonally over his chest show
that he once wore a quiver of
arrows on his back.

Although the work has been
thought to be an original Greek
bronze of the fourth century BC,
the profiled plinth and the finely
decorated base suggest that it is
more likely to be a Roman statue
in classicising style. Statues such
as this were occasionally used as
lamp holders, as evidenced by
similar pieces discovered (for
example at Pompeii) with lamps
hanging from their hands.

The statue was restored by
Francesco Martinetti. The right
eye is modern and the right
forearm and the neck have been
repaired with sheet bronze
fastened with rivets. MM

51

Head and foot of Dea Roma,
AD 150–200
Carrara marble, head H. 66 cm;
foot H. 28 cm; length of foot 37 cm
PROVENANCE: Found near Porta
Portese in Rome during the
construction of the Trastevere
railway station. Acquired in Rome
from Francesco Martinetti in 1887
SELECTED REFERENCES: Moltesen et
al. 2002, nos 18–19
IN 568–69

This colossal head and right foot
belong to an 'acrolithic' statue:
the exposed areas of flesh (face,
neck, arms and legs) were made
in marble; the clothed parts were
probably constructed as a wooden
skeleton covered in sheet bronze.
Large cuttings for clamps on the
back of the head and the flat
surface on top were meant for
fastening a large helmet, the
holes in the ears for metal
earrings. The eyes were inlaid in
another material, perhaps glass
or semi-precious stones. There is
some slight damage to the rim of
the helmet, and some chips are
missing from the edge of the leg.

The statue was a cult statue
of the personification of the city
of Rome, Dea Roma, represented
seated with her head turned
sharply towards her right, one
foot stretched forward, the other
back. Her attributes would have
included a shield and sword, and
a figure of Victory. Although we
know that the emperor Hadrian
built a temple dedicated to her
near the Forum, we have no
information concerning a temple
on the other side of the Tiber,
where this statue was found. MM

52

Head of Penelope, *c.* 460 BC;
copy second century AD
Marble, H. 25 cm
PROVENANCE: Acquired from
Palazzo Giustiniani in Rome in
1902
SELECTED REFERENCES: Ridgway
1970, pp. 65, 101, 103, 109, 113, fig.
104; Boardman 1985, p. 51, fig. 26;
Stähler 1990, p. 7 (n. 10); Moltesen
et al. 2002, no. 85
IN 1943

This work, known in a number
of copies, is conventionally seen
as a representation of Penelope,
the faithful wife of Odysseus,
patiently awaiting the return of
her husband from Troy (although
there is no evidence to support
this interpretation).

One of the marble versions was
discovered in the King's Palace at
Persepolis (in modern Iran),
where it had been buried during
the building's destruction by
Alexander the Great in 330 BC.
This work, now in Tehran, may
be dated to the middle of the fifth
century BC. Since this was below
ground from 330 BC until its
rediscovery in the modern
excavations, it cannot be the
model for later Roman copies.

A Classical version, maybe in
bronze, must have constituted the
model for the copyists, though
the relation between such a work
and the marble version in
Persepolis remains a mystery.
Equally puzzling is how the
marble ended up in Persepolis.
Did the Persians buy, inherit or
steal it from the Greeks, despite
their enmity? Why would the
Greeks have produced two
editions of the same sculpture
at a time when copying was not,
despite isolated examples, general
practice? The problems posed by
this piece have never been
resolved. AMN

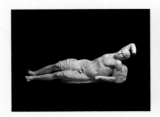
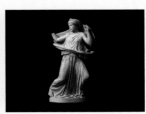
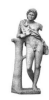
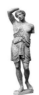

53

Statue group of Artemis and Iphigeneia, third – first century BC
Marble, H. 170 cm
PROVENANCE: Found in Rome at the Villa Spithoever, situated on the remains of the Gardens of Sallust. During the reign of Hadrian in the second century AD, the group was mounted on a base in a *nymphaeum* in the Gardens of Sallust, where it was presumably found *in situ* in 1886. Acquired in Rome in 1888
SELECTED REFERENCES: Ridgway 1990, p. 283; Nielsen and Østergaard 1997, no. 12; Moltesen 1998; Hartswick 2004, pp. 85–93
IN 481–82a

The group of two female torsos and a hind's head (not shown) has been interpreted as the goddess Artemis rescuing Iphigeneia from the sacrificial altar, and substituting her with a hind. The group depicts the moment of high drama when Agamemnon has pledged his daughter in sacrifice in return for a fair wind to Troy; but the goddess herself steps in to rescue Iphigeneia.

There is some doubt about whether this is a Greek original or a Roman copy. If it is a Roman copy, then it is a most meticulous work. Even though the details are not visible to the casual observer, the inner sides of the folds, for example, are fully worked, and the hems of the costume may be followed all the way round, even at the back where detail was not as visible. AMN

54

Statue of a dying Niobid, Greek original, 440–430 BC
Parian Lychnites marble, 62 × 165 cm
IN 472

55

Statue of a running Niobid, Greek original, 440–430 BC
Parian Lychnites marble, H. 140 cm, not including the modern plinth
IN 520

PROVENANCE: Both works probably found near the Villa Spithoever, in the former Gardens of Sallust, in 1886–7. Acquired in Rome from the German bookseller Josef Spithoever in 1888, through Wolfgang Helbig
SELECTED REFERENCES: La Rocca 1985, pp. 71–2; Berlin 1988, pp. 345–6; Moltesen et al. 1995, nos 1–2; Moltesen 1998, pp. 175–88; Hartswick 2004, pp. 93–104

Both these statues represent figures from the well-known legend of the Slaying of the Niobids. The story was popular throughout Antiquity. Niobe, a mortal woman, had six sons and six daughters. She boasted of her fecundity to Leto, who had only two children, Apollo and Artemis. They were, however, divine, and avenged their mother by killing all of Niobe's children with arrows. This story, with its array of the dead and dying, gave artists a unique opportunity to represent the human body in various poses, and the drama was commonly rendered in sculpture as well as vase painting, and no doubt also in monumental painting. Of these two figures, one is a running girl, not yet hit but protecting herself by drawing her cloak over her head, the other a youth, who is trying to extract an arrow from his back with the last of his strength.

The two figures come from a Classical Greek temple pediment brought to Rome in antiquity (a third Niobid, a girl now in the Museo Nazionale in Rome, has been assigned to the same pediment). Some have argued that the Classical Greek figures from the Temple of Apollo Sosianus in Rome also come from the same original Greek building. That has never been identified, but suggestions include a temple at Eretria (on the island of Euboea) or, on the basis of the style, somewhere in Magna Graecia (Greek Southern Italy). We know nothing of the figures' final display in the Gardens of Sallust. The subject matter suggests that the assemblage may have constituted a kind of lesson on moral failings and the ensuing divine punishment. AMN

56

Statue of a resting satyr, second-century AD Roman copy of a Greek original by Praxiteles, *c*. 340–330 BC
Marble, H. 180 cm
PROVENANCE: Allegedly from the Gardens of Sallust. Acquired in Rome in 1897, through Wolfgang Helbig from the major-domo at the Palazzo Piombino-Boncompagni, during the building of the stables for the present American Embassy, situated on the remains of the Gardens of Sallust
SELECTED REFERENCES: Schlörb 1979, pp. 352–63; Moltesen 1998; Moltesen et al. 2002, no. 92; Hartswick. 2004, p. 96
IN 474

The satyr, characterised as such by his pointed animal ears, tousled mane of hair and panther skin, was immensely popular in Rome. Satyrs were among the followers of Dionysos, living in the realm between the civilised and the uncivilised worlds. They formed an appropriate emblem for Roman villas and gardens, in which all manner of sculptural tableaux created the background for various kinds of exotic life.

This statue, one of the most popular statues in Rome ever, is known in more than 100 copies. The original may be that mentioned by Pliny (*Natural History*, XXXIV, lxix): the satyr 'which the Greeks call Periboëtos', or the very beautiful. AMN

57

Statue of a wounded Amazon, Roman copy, *c*. AD 150, of Greek original
Marble, H. 197 cm, including plinth
PROVENANCE: Possibly found in Cardinal Del Monte's vineyard, situated on the remains of the Gardens of Sallust. In Palazzo Barberini, for which it was acquired in 1628. Acquired by Jacobsen through Wolfgang Helbig from Palazzo Sciarra in Rome in 1897
SELECTED REFERENCES: Moltesen 1998; Berlin 2002, pp. 656–7; Moltesen et al. 2002, no. 60; Hartswick 2004, pp. 93–104
IN 1568

A representation of one of the mythical warrior-women, the Amazons. She is shown exposing her spear wound with drops of blood under her raised right arm, leaning on a column in exhaustion, while her *chiton* is dishevelled, the only indications that something is wrong in an otherwise Classical state of calm. There are restorations to the feet.

In Pliny's encyclopaedia (*Natural History*, XXXIV, liii), there is the story of a competition among the famous artists of the Classical period for creating a statue of a wounded Amazon for the Sanctuary of Artemis at Ephesus in Asia Minor. Polykleitos was the winner, Phidias came in second, third place was taken by Kresilas and fourth place by Phradmon. Roman copies of three different wounded Amazons have survived, of which this is one, but there is no consensus as to which was the work of which sculptor. In fact the story itself may be a myth invented to 'explain' the existence of the various Amazon statues. AMN

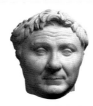

58

Torso of a 'Peplophoros',
first century BC
Large-grained Greek marble,
H. 156 cm
PROVENANCE: Presumably found
on the Villa Ludovisi grounds,
situated on the remains of the
Gardens of Sallust. Acquired in
Rome through the art dealer
Francesco Martinetti in 1893;
formerly in the Villa
Boncompagni Ludovisi
SELECTED REFERENCES: Moltesen
1998; Berlin 2002, pp. 656–7,
no. 524; Moltesen et al. 2002, no.
110; Hartswick 2004, pp. 93–104
IN 433

The woman is clad in a heavy
woollen garment, the *peplos*. The
right arm was lowered, the left
was bent forward, probably
holding an offering or attribute.
The head, which was separately
attached, was turned towards her
right. She is resting on her right
leg, with the folds of her garment
falling like the fluting of a Greek
column. This is a Roman work,
reproducing the early Classical
Greek 'severe style' from around
470–460 BC. Two similar statues
were found in the vicinity,
suggesting the presence of a
larger ensemble of *peplophoroi*
in the gardens like the one
discovered in the Villa dei Papiri
in Herculaneum. AMN

59

Statue of a hippopotamus, second
century AD
Rosso antico marble, H. 77 cm
PROVENANCE: Allegedly found in
the Gardens of Sallust. Acquired
from the Regnicoli Collection,
Tivoli, in 1895
SELECTED REFERENCES: Moltesen
1998; Moltesen et al. 2002, no. 118;
Hartswick 2004, p. 135
IN 1415

This hippopotamus was probably
a fountain figure, as is suggested
by a passage for water leading up
through the front leg and into the
open mouth.
 The statue of an animal
associated with Egypt was
presumably part of a Nilotic
landscape setting in the Gardens
of Sallust. Egyptian objects and
artistic style were popular,
especially after 31 BC when Egypt
fell to Rome after Augustus'
victory at Actium over Antony and
Cleopatra. Hippopotami were
known in Rome, occasionally
appearing in processions and
amphitheatre spectacles.
 There are restorations to the
ears, the right eye, the upper part
of the muzzle and the open jaws.
The eyes were originally inlaid in
some other material. AMN

60

Portrait of Pompey the Great, marble
copy from the AD 40s of a bronze
statue of 55 BC
Marble from Asia Minor, H. 25 cm
PROVENANCE: Allegedly found in
the 'Licinian Tomb' on the Via
Salaria in Rome in 1885. Acquired
from Michael Tyszkiewicz in
1887, through Wolfgang Helbig
SELECTED REFERENCES: Giuliani
1986, pp. 25–100; Johansen 1994,
no. 1; Fuchs 1999, pp. 131–5;
Kragelund, Moltesen and
Østergaard 2003, pp. 81–98, 113,
no. 24, fig. 57
IN 773

The portrait shows the Roman
general Gnaeus Pompeius Magnus
(106–48 BC), known as 'Pompey
the Great', a one-time ally and
later adversary of Julius Caesar.
It is identified through its
resemblance to images of Pompey
on contemporary or near-
contemporary Roman coins and
through a description of him in
the second-century AD biography
by Plutarch. This refers to a quiff
of hair on his forehead (also
known as a 'cow-lick' or in Greek
an *anastolé*), which he adopted in
imitation of Alexander the Great.
The quiff is clearly depicted in
this portrait. The hair over the
right ear has been reworked. MM

61

Portrait of a man, c. AD 160
Marble, H. 41 cm
PROVENANCE: Allegedly found in
the 'Licinian Tomb' on the Via
Salaria in Rome in 1885. Acquired
from Michael Tyszkiewicz in
1887, through Wolfgang Helbig
SELECTED REFERENCES: Johansen
1995B, no. 24; Kragelund,
Moltesen and Østergaard 2003,
pp. 81–98, 113, no. 37, fig. 70
IN 783

From a large shoulder bust, some
of which is missing. It represents
a mature man with a beard and
rather long wavy hair rendered
with drilled furrows, creating
striking light and shade. The
eyebrows are bushy and the pupils
are drilled out. The hair and beard
are reminiscent of those of the
emperor Antoninus Pius (AD
138–161); the sitter was
presumably a man of the Licinian
family from that time. MM

62

*Portrait bust of Lucius Verus as a
child*, c. AD 140–50
Marble, H. 47 cm
PROVENANCE: Allegedly found in
the 'Licinian Tomb' on the Via
Salaria in Rome in 1885. Acquired
from Michael Tyszkiewicz in
1887, through Wolfgang Helbig
SELECTED REFERENCES: Johansen
1995, no. 87; Kragelund, Moltesen
and Østergaard 2003, pp. 81–98,
114, no. 36, fig. 69
IN 787

This large shoulder bust is a
portrait of a young boy. There are
several versions of this type,
suggesting that the sitter was a
member of the imperial family.
He has been identified as Lucius
Aurelius Verus (AD 130–169), son
of Aelius Caesar, who was adopted
by Antoninus Pius in AD 138.
When Marcus Aurelius became
emperor in 161, Lucius Verus
became his co-regent. The reason
for the placement of his portrait
in the Licinian Tomb is not
known. MM

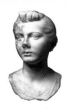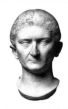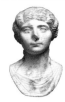

63

Portrait of a young woman, late second century AD
Marble, H. 37 cm
PROVENANCE: Allegedly found in the 'Licinian Tomb' on the Via Salaria in Rome in 1885. Acquired from Michael Tyszkiewicz in 1887, through Wolfgang Helbig
SELECTED REFERENCES: Johansen 1995B, no. 33; Kragelund, Moltesen and Østergaard 2003, pp. 81–98, 115, no. 38, fig. 71
IN 799

The woman's head is turned strongly to the right. Her hairstyle is complicated, with a large twisted strand along the side of the face and the back hair plaited over the whole back of the head. The surface of the face is polished to a sheen almost like porcelain. The eyes have incised irises and the pupils are drilled out. This feature in particular suggests that the portrait dates to the late second century. The second chamber of the Licinian Tomb, where this work was probably found, contained sarcophagi of the same period. The nose has been restored. The head was meant for insertion into a statue. MM

64

Portrait of a small boy, AD 40s
Parian marble, H. 24 cm
PROVENANCE: Allegedly found in the 'Licinian Tomb' on the Via Salaria in Rome in 1885. Acquired from Michael Tyszkiewicz in 1887, through Wolfgang Helbig
SELECTED REFERENCES: Boschung 1986, p. 257–87; Johansen 1994, no. 74; Kragelund, Moltesen and Østergaard 2003, pp. 81–98, 114, no. 30, fig. 63
IN 744

This portrait of a boy of no more than five or six years old captures well his short neck and chubby cheeks. The tip of the nose has been restored. MM

65

Portrait bust of a young woman, AD 40s
Parian marble, H. 38 cm
PROVENANCE: Allegedly found in the 'Licinian Tomb' on the Via Salaria in Rome in 1885. Acquired from Michael Tyszkiewicz in 1887, through Wolfgang Helbig
SELECTED REFERENCES: Boschung 1986, p. 266, figs 3–5; Johansen 1994, no. 71; Kragelund, Moltesen and Østergaard 2003, pp. 81–98, 114, no. 34, fig. 67
IN 738

This young woman's hairstyle is characteristic of the fashion of the 40s BC. The traces of her garment suggest that she is wearing the *stola*, the costume of the married women in Rome. Her identification is uncertain. MM

66

Portrait of a woman, AD 40s
Parian marble, H. 33.5 cm
PROVENANCE: Allegedly found in the 'Licinian Tomb' on the Via Salaria in Rome in 1885. Acquired from Michael Tyszkiewicz in 1887, through Wolfgang Helbig
SELECTED REFERENCES: Boschung 1986, p. 270, fig. 13; Johansen 1994, no. 78; Kragelund, Moltesen and Østergaard 2003, pp. 81–98, 113, no. 28, fig. 61
IN 741

This portrait depicts an elderly woman of austere appearance with a very simple hairstyle (her long hair is swept back and gathered at the nape of the neck with a plaited band). The nose has been restored, and the neck was intended for insertion into a larger bust or full-length statue. MM

67

Portrait of a woman, AD 40s
Parian marble, H. 38 cm
PROVENANCE: Allegedly found in the 'Licinian Tomb' on the Via Salaria in Rome in 1885. Acquired from Michael Tyszkiewicz in 1887, through Wolfgang Helbig
SELECTED REFERENCES: Johansen 1994, no. 77; Boschung 1986, p. 271; Kragelund, Moltesen and Østergaard 2003, pp. 81–98, 114, no. 29
IN 742

The sitter for this portrait is probably wearing the *stola*, showing her to be a married woman. Her hair is parted in the middle and lies in thick waves over the ears. It is gathered at the nape of the neck with three plaits wound around, and small curls lie along the sides of the neck. The bust has been restored on either side. MM

 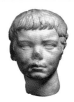 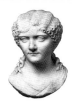 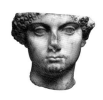 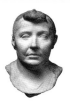

68

Portrait of a young woman, AD 40s
Parian marble, H. 39 cm
PROVENANCE: Allegedly found in
the 'Licinian Tomb' on the Via
Salaria in Rome in 1885. Acquired
from Michael Tyszkiewicz in
1887, through Wolfgang Helbig
SELECTED REFERENCES: Boschung
1986, p. 274, figs 22–3; Johansen
1994, no. 65; Kragelund, Moltesen
and Østergaard 2003, pp. 81–98,
114, no. 31
IN 751

The young woman has a
complicated hairstyle in which
the side hair lies in twisted rows
while the hair at the back is
gathered in a low chignon and
twisted side curls fall over the
shoulders. A row of small kiss
curls across the forehead are
in low relief. There is no firm
evidence for her identification.
One suggestion is that she
represents the great-
granddaughter of Pompey
the Great, Scribonia, who was
married to Marcus Licinius
Crassus Frugi Pontifex (see cat.
74). MM

69

*Portrait of a young man, perhaps
Pompeius Magnus*, AD 40s
Parian marble, H. 28 cm
PROVENANCE: Allegedly found in
the 'Licinian Tomb' on the Via
Salaria in Rome in 1885. Acquired
from Michael Tyszkiewicz in
1887, through Wolfgang Helbig
SELECTED REFERENCES: Boschung
1986, pp. 274–5, figs 18–21;
Johansen 1994, no. 73; Kragelund,
Moltesen and Østergaard 2003,
pp. 81–98, 113, no. 25, fig. 58
IN 735

A young man with a wrinkled
brow and puffy cheeks. Although
his hairstyle is similar to that of
several Julio-Claudian princes it
is not identical to any. He may
represent the unfortunate young
nobleman Gnaeus Pompeius
Magnus, who enjoyed a short-
lived moment of favour before his
father-in-law the emperor
Claudius put him to death. His
funerary altar was discovered in
the 'Licinian Tomb'. MM

70

Portrait of a young woman, AD 40s
Parian marble, H. 36 cm
PROVENANCE: Allegedly found in
the 'Licinian Tomb' on the Via
Salaria in Rome in 1885. Acquired
from Michael Tyszkiewicz in
1887, through Wolfgang Helbig
SELECTED REFERENCES: Boschung
1986, pp. 268–70, figs 10–12;
Johansen 1994, no. 76; Kragelund,
Moltesen and Østergaard 2003,
pp. 81–98, 114, no. 32, fig. 65. For
the restoration of the nose:
Moltesen 1991, pp. 271–9
IN 754

The young woman has a round
face and a fine coiffure with small
snail curls on either side of the
head. This hairstyle is commonly
associated with Agrippina, the
third wife of the emperor
Claudius. It has been suggested
that this portrait depicts
Agrippina's young cousin,
Claudia Antonia, the daughter of
Claudius, who was married to the
young Pompeius Magnus of the
Licinian family (see cat. 69). There
is, however, no firm evidence for
this.

There is nineteenth-century
restoration to the nose, with
marble taken from the back of
the bust (a practice used in other
Licinian portraits, such as cats
64, 73). MM

71

Portrait of a woman, AD 40s
Parian marble, H. 27 cm
PROVENANCE: Allegedly found in
the 'Licinian Tomb' on the Via
Salaria in Rome in 1885. Acquired
from Michael Tyszkiewicz in
1887, through Wolfgang Helbig
SELECTED REFERENCES: Boschung
1986, pp. 270–2, figs 14–16;
Johansen 1994, no. 40; Kragelund,
Moltesen and Østergaard 2003,
pp. 81–98, 113, no. 27, fig. 60
IN 747

This head was heavily restored
while in the possession of
Tyszkiewicz in Paris. It was
published in 1886 by Wolfgang
Helbig, who regarded it as a
portrait of the empress Livia in
old age. When, however, the
restorations were removed she
appeared much younger. The
similarity of her hairstyle to that
of the younger Agrippina,
Claudius' last wife, suggests that
she is a representation of one of
the women of the Licinian family
in the Claudian period. There are
traces of paint in the eyes. MM

72

Portrait bust of an elderly woman,
AD 40s
Parian marble, H. 34 cm
PROVENANCE: Allegedly found in
the 'Licinian Tomb' on the Via
Salaria in Rome in 1885. Acquired
from Michael Tyszkiewicz in
1887, through Wolfgang Helbig
SELECTED REFERENCES: Boschung
1986, p. 266, figs 6–7; Johansen
1994, no. 70; Kragelund, Moltesen
and Østergaard 2003, pp. 81–98,
114, no. 33, fig. 66
IN 736

A middle-aged woman, whose
hair is arranged in the *nodus*,
the knot over the forehead from
which runs a braid to the back
where all the hair is gathered in
a tight braided bun. This hairstyle
was worn by Roman women in
the 40s BC. The identification is
uncertain, but Pompeia the
daughter of Pompey has been
suggested. The nose tip has been
restored. MM

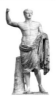

73

Portrait bust of a man, perhaps Marcus Licinius Crassus, AD 40s
Parian marble, H. 45 cm
PROVENANCE: Allegedly found in the 'Licinian Tomb' on the Via Salaria in Rome in 1885. Acquired from Michael Tyszkiewicz in 1887, through Wolfgang Helbig
SELECTED REFERENCES: Boschung 1986, pp. 276–82, figs 24–6; Giuliani 1986, pp. 233–8; Johansen 1994, no. 69; Mango 1999, p. 29; Kragelund, Moltesen and Østergaard 2003, pp. 81–98, 113, no. 26, fig. 59
IN 749

This portrait of a mature man exists in several versions, suggesting that he was a well-known person. It has been suggested that he is Marcus Licinius Crassus, consul of 70 and 55 BC and a one-time ally of Pompey and Julius Caesar, although there is no evidence to support this. The nose has been restored, and there has been some damage to the ears. MM

74

Portrait of a man, AD 40s
Parian marble, H. 24 cm
PROVENANCE: Allegedly found in the 'Licinian Tomb' on the Via Salaria in Rome in 1885. Acquired in 1891 from an engineer from Aquila who had worked at the Via Salaria, through Wolfgang Helbig
SELECTED REFERENCES: Boschung 1986, p. 272, fig. 17; Johansen 1994, no. 75; Kragelund, Moltesen and Østergaard 2003, pp. 81–98, 113, no. 39, fig. 72
IN 734

This head was acquired after the other portraits but had allegedly been found in 1885 in the Licinian Tomb.

The style of the short hair, with its straight, slightly inturned fringe, is typical of the period of the emperor Claudius (AD 41–54). It has been suggested that this portrait represents Marcus Licinius Crassus Frugi Pontifex, one of the most significant members of the family, perhaps the man who built and adorned the family tomb before he was murdered in AD 47, together with his wife and his son, young Pompeius Magnus. There is, however, no firm evidence for this identification. MM

75

Portrait bust of a young woman, AD 40s
Parian marble, H. 44 cm
PROVENANCE: Allegedly found in the 'Licinian Tomb' on the Via Salaria in Rome in 1885. Acquired from Michael Tyszkiewicz in 1887, through Wolfgang Helbig
SELECTED REFERENCES: Boschung 1986, pp. 265–6, figs 1–2; Johansen 1994, no. 72; Kragelund, Moltesen and Østergaard 2003, pp. 81–98, 114, no. 35, fig. 68
IN 737

A young woman, wearing a *stola* (the dress of a Roman married woman); her hair is arranged in a knot (or *nodus*). Her identity is uncertain. MM

76

Torso of Drusus the Younger (?), AD 20–50
Parian marble, H. 182 cm
PROVENANCE: From Nemi (?). Acquired in 1896. Ludwig Pollak later stated that it had come from Prince Orsini in Nemi
SELECTED REFERENCES: Johansen 1994, no. 49; Moltesen 1997, p. 139, no. 18
IN 1657

The statue type is very similar to that of Tiberius (cat. 77), and it has been suggested that this statue was one of three placed in the apsidal room designated 'exedra g' in the sanctuary. The theory is that the work may have represented Drusus (*c.* 14 BC – AD 23), the son and heir of Tiberius, and that the group was erected posthumously by Tiberius' successor, Caligula. He built the two floating palaces which were recovered from Lake Nemi in 1929–32. The left leg and foot have been restored, and the head and right arm are missing. MM

77

Statue of Tiberius, AD 20–50
Torso Carrara marble; lower body Parian marble, H. 212 cm
PROVENANCE: Found in exedra g in the central portico of the Sanctuary of Diana, Nemi, in 1885. Acquired in Nemi from Prince Orsini in 1891
SELECTED REFERENCES: Johansen 1994, no. 48; Moltesen 1997, pp. 138–9, no. 16
IN 709

The portrait shows the emperor in middle age, wearing only a cloak draped around his lower body. In his right hand he held a staff or sceptre. This pose is also characteristic of the god Jupiter, which (along with the bare feet typical of divine images) suggests an intended comparison between the emperor and the gods. The hairstyle is typical of Tiberius. The support and lower legs have been restored. The right arm was in several pieces, and the left hand is missing. Traces of red paint remain in the folds of the cloak. MM

78

Statue of Fundilia Rufa, AD 20–50
Carrara marble, H. 178 cm
PROVENANCE: Found in room A,
position H, of the central portico
of the Sanctuary of Diana, Nemi,
in 1887. Acquired from Prince
Orsini in Nemi in 1891
SELECTED REFERENCES: Johansen
1994, no. 80; Moltesen 1997,
p. 141, no. 20. The portrait herm
from Nottingham: p. 142, no. 21
IN 708

This is a portrait of a woman
firmly identified as Fundilia Rufa.
On the travertine plinth an
inscription reads FUNDILIAE C.F.
PATRONAE ('to his patron Fundilia,
the daughter of Gaius'). This
indicates that the statue was
erected to her by her former slave
('patron' is the technical term for
the ex-master or ex-mistress of a
freed slave). A portrait herm of
Fundilia from this room (now in
the Castle Museum, Nottingham)
commemorates her as FUNDILIA
C.F. RUFA PATRONA DOCTI ('Fundilia
Rufa, the daughter of Gaius, the
patron of Doctus'). This makes
clear that she had been the owner
of Doctus (cat. 79), whom she
freed.

This draped statue type is
common in female portraits.
The hairstyle, however, is very
unusual, with two partings along
the crown of the head where the
long hair is combed into two
braids forming a loop on either
side of the head and finally a knot
on the very top of the head, for
which there is a cutting. The same
hairstyle is found on the other
portrait of Fundilia from the
same room. The woman is middle-
aged and has high cheekbones
and a very narrow nose; a very
distinctive physiognomy. MM

79

Statue of Fundilius Doctus, AD 20–50
Dokimian marble, H. 183 cm
PROVENANCE: Found in room A,
position I, in the central portico
of the Sanctuary of Diana, Nemi,
in 1887. Acquired from the art
dealer Simonetti in Rome in 1888
SELECTED REFERENCES: Johansen
1994, no. 79; Moltesen 1997,
pp. 142–3, no. 22
IN 707

An elderly, short-haired man
is standing wearing a tunic and,
over it, a large toga which is
elegantly draped around him.
On his feet are soft leather boots,
calcei equestris (so called as they
were worn by wealthy men of the
equestrian rank). By his side is a
box for book scrolls (*capsa*), and
between his feet is a ribbon that
perhaps held a scroll together.

On the *capsa* and on the base
of the statue is the inscription:
C. FUNDILIUS DOCTUS APOLLINIS
PARASITUS ('Gaius Fundilius
Doctus, companion of Apollo').
This shows that Fundilius Doctus
was an actor, 'companion of
Apollo' being a common way to
refer to a member of a company
of players under the patronage of
the god Apollo. From the portrait
herm of Fundilia (Castle Museum,
Nottingham) we know that
Doctus was the former slave of
Fundilia and it is likely that he
set up both the statue of himself
and those of his former mistress
in her honour. The excellent
quality of the workmanship and
the expensive marble suggest that
he was extremely wealthy, as we
know that some of the most
popular Roman actors and mime
performers could become.

The right lower arm and left
hand were attached and are
missing. The head with part of the
left shoulder has been broken. MM

80

Portrait of a mature woman,
AD 20–50
Carrara marble, H. 31 cm
PROVENANCE: Found in room
A in the central portico of the
Sanctuary of Diana, Nemi, in
1887. Acquired from Prince Orsini
in Nemi in 1891
SELECTED REFERENCES: Johansen
1994, no. 82; Moltesen 1997,
p. 145, no. 27, p.146, no. 29
IN 761

The woman is of middle age,
with a strong face and high
cheekbones. Her hair is swept
back and held by a narrow braid
around the head. The head was
probably originally mounted on
a herm (found in Lord Savile's
excavations in the portico) that
now belongs to the Castle
Museum, Nottingham (N 830).

The herm bears the inscription
LICINIAE CHRYSARIONI M. BOLANUS
CANUSAEUS H.C.D.N.S. This clearly
shows that the sculpture was
erected by Marcus Bolanus from
Canosa (in South Italy) to Licinia
Chrysarion. The meaning of the
abbreviation H.C.D.N.S. is
uncertain. It may be short for
'honoris causa Dianae Nemorensi
sacrum' ('in her honour, sacred to
Diana of Nemi'). The Greek name
Chrysarion has been taken to
suggest that the woman was a
former slave. MM

81

Portrait herm of Aninius Rufus,
AD 20–50
Parian marble, H. 40 cm; herm
in *bardiglio*, H. 110 cm
PROVENANCE: Found in room A,
position G of the Sanctuary of
Diana, Nemi, in 1887. Acquired
from Prince Orsini in Nemi in
1891
SELECTED REFERENCES: Johansen
1994, no. 84; Moltesen 1997,
p. 143, no. 23
IN 1437

The bust represents a middle-aged
man with short hair. The large
neck piece is set into a herm
which carries the inscription
L.ANINIO.L.F.RUFO.Q.ARICIAE PRIMA
UXOR ('His wife Prima [set this up]
to Lucius Aninius Rufus, son of
Lucius, *quaestor* of Aricia'). This
shows that the portrait
commemorates Lucius Aninius
Rufus, a local magistrate (*quaestor*)
of Aricia. His final name
(*cognomen*), Rufus, may well
indicate that he was a relative of
Fundilia Rufa. A large chip from
the forehead has been reattached.
MM

82

Portrait herm of Staia Quinta,
AD 20–50
Parian marble, H. 44 cm; herm in
bardiglio, H. 100 cm
PROVENANCE: The herm shaft was
found in room A, position L of the
Sanctuary of Diana, Nemi, in
1885. Acquired from Prince Orsini
in Nemi in 1891
SELECTED REFERENCES: Johansen
1994, no. 86; Moltesen 1997,
pp. 143–4, no. 24
IN 1435

The young woman has a large
shoulder bust with part of her
elegant garment fastened on
the right shoulder with a button,
but revealing the left. She has
an elegant and complicated
hairstyle. The hair is parted in
the middle, falls in short curls at
the sides but is long at the back
where it is combed into two braids
fastened with a small bow. The
portrait is set in a herm with an
inscription, naming the woman:
STAIA. L. L. QUINTA ('Staia Quinta,
the ex-slave of Lucius'). It is
possible that she had been the
slave of Lucius Aninius Rufus
(cat. 81), but this identification
is uncertain. Staia Quinta was
probably a person of some
importance, at least locally, as
there was another inscription
with her name found in the
sanctuary.

The lower part of the herm has
been restored. Many traces of red
colour exist in the hair, especially
on the left side. MM

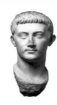
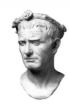

83

Portrait herm of Hostius Capito, AD 20–50
Parian marble, H. 32 cm; herm in *bardiglio*, H. 112 cm
PROVENANCE: Herm shaft found in room A, position M in the central portico of the Sanctuary of Diana, Nemi, in 1885. Acquired from Prince Orsini in Nemi in 1891
SELECTED REFERENCES: Johansen 1994, no. 85; Moltesen 1997, p. 144, no. 25
IN 1436

A mature man with very short hair is characterised by his close-set eyes and straight brows. On the herm an inscription identifies him as Q.HOSTIUS.Q.F.CAPITO. RHETOR ('Quintus Hostius Capito, son of Quintus, *rhetor*'). A *rhetor* was a teacher of oratory and rhetoric. The back part of the head has been reattached. The herm has been restored. MM

84

Portrait of a young woman, AD 20–50
Parian marble, H. 42 cm
PROVENANCE: Found in room A in the central portico of the Sanctuary of Diana, Nemi, in 1887. Acquired from Prince Orsini in Nemi in 1891
SELECTED REFERENCES: Johansen 1994, no. 83; Moltesen 1997, p. 138, no. 16
IN 759

The young woman has strong cheeks and close-set eyes. She has a complicated hairstyle: the hair at the back is twisted in a 'melon' coiffure; a long braid of hair is twisted right round her head, its end tucked in over her temple. The great care taken in rendering the hair is reminiscent of the portrait of Staia Quinta (cat. 82). Two fragments of the bust have been reattached; presumably it was meant for insertion into a herm. MM

85

Portrait of Germanicus (?), AD 20–50
Dokimian marble, H. 41 cm
PROVENANCE: Perhaps from exedra g in the northern portico of the Sanctuary of Diana, Nemi. Acquired in Nemi from Prince Orsini in 1891
SELECTED REFERENCES: Johansen 1994, no. 52; Moltesen 1997, p. 139, no. 17
IN 760

This portrait, the neck of which is cut for insertion into a body, probably depicts Germanicus (15 BC – AD 19), the nephew of Tiberius, whom Tiberius had adopted as his heir at the same time as his own adoption by Augustus in AD 4. The statue was probably placed in one of three niches in exedra g, where the statue of Tiberius would have been placed between his two designated heirs. Germanicus did not survive to become emperor but died in suspicious circumstances in AD 19. MM

86

Portrait of a man wearing a wreath, AD 20–50
Parian marble, H. 40 cm
PROVENANCE: Found in room A of the central portico of the Sanctuary of Diana, Nemi, in 1887. Acquired from Prince Orsini in Nemi in 1891
SELECTED REFERENCES: Johansen 1994, no. 81; Moltesen 1997, p. 145, no. 28
IN 1438

A middle-aged man with a wrinkled forehead and furrowed cheeks. His hair is short with a fringe reminiscent of one of the styles of the emperor Augustus. Around his head is a wreath, a circlet apparently covered by a ribbon with five rosettes attached. This 'floral crown' was used as a prize in competitions both in sports and in musical games; it could also be worn by the person sponsoring the games. As both actors and rhetoricians could participate in games this victor might also belong to the world of the stage.

The narrowness of the neck piece might suggest that the head was inserted into a draped statue. MM

87

Marble vase, first century BC
Marble from Asia Minor, H. 86 cm
PROVENANCE: Found in a room in the central portico of the Sanctuary of Diana, Nemi, in 1895. Acquired from Prince Orsini in Nemi in 1896
SELECTED REFERENCES: Moltesen et al. 1996, no. 91; Bilde 1997, figs 3–5 (before the restorations were removed); Moltesen 1997, pp. 130–1, no. 4
IN 1518

The vase has an ovoid body; the lid, neck, handles, foot and plinth are missing. The shape of the vase is similar to that of Hellenistic Panathenaic vases from Athens (given as prizes in the Panathenaic games). The shoulder and belly are decorated in relief. On the shoulder is an acanthus garland with flowers and tendrils. The main decoration on either side shows a horseman controlling a second, unmounted horse. He is represented as a satyr on one side, and on the other as a child (or Cupid). Between the two is a tall goalpost (or *meta*). Under the handle is a lap-counter made of wooden posts and a beam. It has three egg-shaped beads raised and four lowered, meaning that there are three more laps to go. In this race a jockey, *desultor*, jumps from one horse to another. This is thought originally to have been a military practice in which a soldier could jump to a fresh horse without dismounting; in later times it became part of the circus games. In this vase the race is transposed as a metaphor into a Dionysiac setting in which a satyr chases a child or Cupid. The scene is probably the earliest representation of the lap-counter with egg-shaped beads in the circus.

Above is the inscription CHIO (on one side) and DD ('Dono Dedit') on the other, meaning 'Chio gave this as a gift'. The vase was one of eight dedicated at the sanctuary by a man named Chio. MM

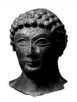

88

Marble vase, first century BC
Marble, H. 94 cm
PROVENANCE: Found in a room
in the central portico of the
Sanctuary of Diana, Nemi, in
1895. Acquired from Prince Orsini
in Nemi in 1896
SELECTED REFERENCES: Moltesen
and Nielsen 1996, no. 92; Bilde
1997, figs 6–7; Moltesen 1997,
pp. 131–2, no. 5
IN 1519

This vase, which lacks one handle
and part of the foot, has an ovoid
body and rests on a low foot.
The shape is similar to that of
Hellenistic Panathenaic vases
from Athens (given as prizes in
the Panathenaic games). The
shoulder and the lid are
decorated with a tongue pattern,
as is the neck. The shoulder and
belly of the vase are decorated in
relief. On the shoulder is an
acanthus garland with flowers
and tendrils, with vine leaves in
low relief under the handles.
The main decoration on the belly
shows on either side two satyrs
fighting over a wine *krater*, each
trying to push the other away. The
motif of opposing satyrs flanking
a *krater* is known from terracotta
plaques and neo-attic marble
reliefs.

Above is the inscription CHIO
(on one side) and DD ('Dono
Dedit') on the other, meaning
'Chio gave this as a gift'. The vase
is one of eight dedicated at the
sanctuary by a man named Chio.
MM

89

The Ariccia Head, *c.* 480 BC
Bronze, H. 21.5 cm
PROVENANCE: Allegedly found in
Ariccia in 1789–91. Acquired from
the collection of Cardinal A.
Despuig in Mallorca in 1898
SELECTED REFERENCES: Riis 1966,
pp. 67–75, figs 4 a–d; LIMC II 1984,
Artemis/Diana, no. 110; Moltesen
1997, pp. 95–100, 128, no. 1
IN 1624

This head is under life size and
belonged to a statue of a woman.
The style is late archaic with large
open eyes, originally with an inlay
in other material, the
characteristic 'archaic smile' and
three rows of curls around the
face. It has been suggested that
the head belongs to an early cult
image of Diana. The face has been
compared to representations on
silver coins minted by Publius
Accoleius Lariscolus in 43 BC
which are believed to represent
such an ancient image of the
goddess. Yet, as there was no
temple at that period where such
a cult statue could be housed, this
statue is more likely to have been
a costly votive gift to Diana either
in Nemi or in a sanctuary in
Ariccia, the city to which the
sanctuary at Nemi belonged. MM

90

Head of the goddess Diana, *c.* 100 BC
Parian marble, H. 54 cm
PROVENANCE: Found in room
F in the central portico of the
Sanctuary of Diana, Nemi, in
1895. Acquired from Prince Orsini
in Nemi in 1896
SELECTED REFERENCES: Bilde 1995,
pp. 195–9, figs 3–6; Moltesen and
Nielsen 1996, no. 90; Moltesen
1997, p. 129, no. 2, pp. 197–8
IN 1517

The head represents a young
woman in a Classical style, her
head turned to her right. The
head was part of a composite or
'acrolithic' statue in which the
exposed flesh (arms, legs and face)
was in marble, while the body
was probably made as a wooden
skeleton with clothes in bronze
or another material. Three heads
of such statues have been found
in Nemi.

The statue probably represented
Diana in hunting costume,
wearing a short *chiton*, leather
boots and a baldric with a quiver
on her back. There are several
attachment surfaces on the back
of the head. A piece of the hair on
the right side is separately
attached, as were originally other
parts of the hair. MM

91

Anakreon, second century AD
Thasian marble, H. 206 cm,
including plinth
PROVENANCE: Found at the Villa
of Bruttius Praesens at Monte
Calvo in the Sabine Hills in 1835.
Acquired from the Villa Borghese
in Rome in 1891
SELECTED REFERENCES: Richter
1984, fig. 48, pp. 83–6; Johansen
1992, no. 1; Brusini 2001, pp.
178–93, figs 91–101; Koortbojian
2002, pp. 179–80
IN 491

A middle-aged man stands
supported by a tree trunk. His
eyes were inlaid. His mouth is
open as he sings while playing
the lyre originally held in his
left hand. He wears only a cloak
round his shoulder and his
penis is 'infibulated' (or tied up),
a practice common in ancient
Greece for athletes and
performers. He is identified as
Anakreon, a sixth-century BC lyric
poet from Asia Minor, by his
resemblance to a surviving bust
in Rome, inscribed with this
poet's name.

In Greek vase-painting
Anakreon is usually represented
as an Oriental in long, flowing
garments and a turban. Here,
however, he is shown as a Greek
model in heroic nudity. This
statue is a Roman copy, probably
of a bronze statue placed on the
Acropolis of Athens in *c.* 440 BC.
MM

92

Melpomene, muse of tragedy,
second century AD
White marble, H. 178 cm,
including plinth
PROVENANCE: Found at the Villa
of Bruttius Praesens at Monte
Calvo in the Sabine Hills in 1829.
Acquired from the Villa Borghese
in Rome in 1897
SELECTED REFERENCES: Brusini
2001, pp. 103–9, figs 31–5;
Moltesen et al. 2002, no. 28
IN 1565

The young woman is dressed in
a long-sleeved *chiton* and a *peplos*
with a high-waisted belt; round
her shoulder is a cloak. Her pose
is awkward, with her left leg
supported on a rock at her side.
In her left hand she holds a sword
and in her right a large theatrical
mask bearing the face of Hercules
surrounded by the lion skin. This
identifies her as Melpomene,
muse of tragedy. Around her head
is a vine with large leaves and
bunches of grapes, a reference
to Dionysos, god of wine and the
theatre.

The statue's nose, lips and cheek
have been restored in marble; the
lower part of the neck, areas of
the garment, right shoulder and
hand, part of the mask, left lower
arm and hand with most of the
sword, the lower part of the figure
and part of the back have all been
restored in plaster. The right arm
and drapery have been broken
and reattached. MM

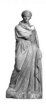
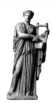
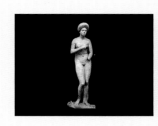
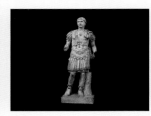
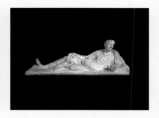

93

Polyhymnia, muse of dancing, second
century AD
White marble, H. 179 cm,
including plinth
PROVENANCE: Found at the Villa of
Bruttius Praesens at Monte Calvo
in the Sabine Hills in 1829.
Acquired from the Villa Borghese
in Rome in 1897
SELECTED REFERENCES: Brusini
2001, pp. 113–14, figs 42–5;
Moltesen et al. 2002, no. 31
IN 1547

The young woman is wrapped in
a large cloak which she holds up
to her left shoulder. She wears a
wreath of flowers around her hair,
long tresses falling down her
back. Her right leg is slightly bent
at the knee and the diagonal folds
of the cloak give the figure a
torsion, suggesting movement.
She holds no particular attribute;
the movement identifies her as
Polyhymnia, muse of dancing.
 The statue's nose, lips, chin,
right ear, most of the hair on
the sides and back, the right hand
and part of the drapery have been
restored in plaster. MM

94

Erato, muse of lyric poetry, second
century AD
White marble, H. 182 cm,
including plinth
PROVENANCE: Found at the Villa
of Bruttius Praesens at Monte
Calvo in the Sabine Hills in 1829.
Acquired from the Villa Borghese
in Rome in 1897
SELECTED REFERENCES: Brusini
2001, pp. 109–12, figs 36–41;
Moltesen et al. 2002, no. 32
IN 1566

The young woman wears a short-
sleeved *chiton*, the *peplos* and a
very large cloak draped around
her right side and back. Traces on
the statue indicate that she was
holding an instrument, probably
the smaller and lighter lyre rather
than the heavier *kithara* restored
here. Her right hand holds the
plektron, with which she plucks
the strings.
 The left arm with the *kithara*,
the fold hanging beneath it, the
right lower arm, nose, lips and
chin have all been restored in
plaster. The right hand is original.
MM

95

Statue of a mature woman as Venus,
AD 90–100
Marble, H. 191 cm
PROVENANCE: Allegedly found in a
villa at Fratocchie, south of Rome.
Acquired from Casa Vitali at
Marino in the Alban Hills in 1891
SELECTED REFERENCES: Wrede
1981, pp. 307–8, no. 292; Johansen
1995, no. 14; D'Ambra 1996;
Stewart 2004, pp. 51–4
IN 711

The statue shows a mature Roman
lady with the body of the type
known as the Capitoline Venus
(after a famous statue in Rome).
Her nakedness is both emphasised
and partly concealed by the
distinctive position of her hands.
By her side stood her child, Cupid
(only his feet are preserved), with
wings and perhaps a bow and
arrow. The face is that of an
austere-looking woman with
the complicated hairstyle
characteristic of women of the
Flavian period (AD 69–96); the hair
around the forehead forms a
honeycomb of small curls,
probably a wig; at the back it is
plaited in many thin braids.
The most striking feature of the
statue is the discrepancy between
the young naked body and the
mature face. The statue was
probably placed in a tomb
situated along the Via Appia. MM

96

Statue of Trajan in armour,
AD 110–17
Marble, H. 200 cm
PROVENANCE: Unknown. Acquired
from the Villa Barberini at Castel
Gandolfo in 1897
SELECTED REFERENCES: Stemmer
1978, p. 113, pl. 76 (1–2); Johansen
1995, no. 34
IN 1584

The emperor Trajan (AD 98–117)
is portrayed as a military
commander with tunic, leather
doublet and breastplate with a
mantle loosely thrown over the
left shoulder. The breastplate
bears two heraldic griffins on
either side of a candelabrum;
above is a head of the gorgon
Medusa (as on the mythical
breastplate of the goddess
Athena). On his right shoulder
strap is the thunderbolt of
Jupiter; on the flaps at the bottom
of the breastplate are animal
heads, masks and rosettes in
relief. The legs, feet and support
are modern restorations. MM

97

Kline monument: reclining man,
Rome, *c.* AD 100–150
Thasian marble, 63 × 175 × 66 cm
PROVENANCE: From the Villa Pacca.
Found in Ostia in 1831–4.
Acquired in 1885
SELECTED REFERENCES: Wrede
1977; Koch 1993, p. 24; Østergaard
1996, no. 27
IN 846

A man reclines, a cup in his left
hand, a wreath of flowers in his
right; his weight compresses the
thin mattress on which he lies.
Funerary monuments depicting
the deceased on a couch, so-called
kline monuments, appeared
during the first century AD. They
stood inside tombs and mausolea,
where they were placed
freestanding on the floor, in
niches or on simple sarcophagi
with lids. Their often modest size
and irregular shape show that
they cannot themselves have
formed sarcophagus lids.
Inscriptions indicate that this
type of monument was favoured
by wealthy ex-slaves.
 Kline monuments are probably
of Etruscan origin. The deceased
is shown participating in the
funeral feast, and might have
been thought to participate
'actively' when offerings were
poured into his cup.
 The muzzle of the dog has been
restored, and there is some
modern working over of the
surface. JSØ

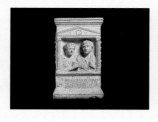

98

Sarcophagus with Roman shipping,
late third century AD
Marble with many traces of
red, blue and green paint,
52 × 178 × 85 cm
PROVENANCE: Said to be from
Ostia. Acquired from the Villa
Borghese in 1895
SELECTED REFERENCES: Crumlin-
Pedersen and Vinner 1986, p. 177;
Østergaard 1996, no. 33
Østergaard 1997; Ensoli and
La Rocca 2000, p. 480, no. 99
(Marina Sapelli)
IN 1299

Of the few known sarcophagi
with maritime motifs, this is
the most detailed. The location
of the find makes it likely that
the setting is the harbour of
Rome, Portus, just north of Ostia,
the famous lighthouse of which
had square and cylindrical storeys
as seen on the relief. The
sarcophagus may have been
commissioned for a ship-owner.
Perhaps he is the man overboard
below the central ship, the victim
of an accident at sea?

The three merchant vessels are
all of different types, the one in
the middle being the earliest
known representation of a sprit
rig. The oarsmen control the two
steering oars by means of
extensions attached to the tiller
bars. According to maritime
experts, the two ships on the
right are manoeuvring to avoid
collision in the narrow harbour
entrance.

The extensive drilling of the
faces and hair is typical of the
style of the late third century. JSØ

99

*Sarcophagus with the wedding feast
of Dionysos and Ariadne,* end of the
second century AD
Marble, 68 × 222 × 83 cm; lid relief
H. 31 cm
PROVENANCE: Found in 1775 in the
Vigna Casali on the Via Appia,
Rome, inside the Porta San
Sebastiano. Acquired from the
Casali Collection in Rome in 1883
SELECTED REFERENCES: Østergaard
1996, no. 42; Koch 1998, pp.
100–01, pl. 46 (1–5), p. 105 (J. S.
Østergaard); Turcan 1999, p. 106,
fig. 121; Zanker and Ewald 2004,
pp. 309–12
IN 843

Apart from some breaks and
insignificant damage, this work's
state of preservation is superb.
Many minute traces remain of the
original polychromy.

Subjects connected with
Dionysos, god of wine, are among
the most popular on Roman
sarcophagi, expressing as they do
the prospect of a blessed existence
in the afterlife. Here, Dionysos
and Ariadne have just witnessed
a contest between Cupid and an
old satyr, surrounded by the usual
entourage of satyrs and maenads,
as well as by the god Hermes.
The party continues on the lid.

Of the sarcophagi to have
come down to us, the 'Casali
Sarcophagus' is considered one of
the masterpieces. Compositional
skill and virtuoso carving
combine to bring out the very
spirit of the style of the late
second century AD. The work's
almost Rococo flamboyance and
delicacy were particularly
congenial to the taste of the late
eighteenth century and brought
the piece instant renown when it
was discovered in 1775. JSØ

100

*A child's sarcophagus with the legend
of Jonah, c.* AD 300
Marble, 40 × 124 × 42 cm
PROVENANCE: Said to have been
found near the Porta Angelica,
Rome. Acquired in Rome in 1889
SELECTED REFERENCES: Huskinson
1996, p. 69, no. 10.2; Østergaard
1996, no. 67; Koch 1998, p. 100, pl.
45 (1–4), p. 105 (J. S. Østergaard);
Koch 2000, pp. 17, 23, 76, 228, 230,
233, 240, fig. 11
IN 857

This sarcophagus was originally
assembled from two halves of
different blocks of marble
(though of similar type). Apart
from minor breaks, the front is
well preserved. The surface has
been worked with a rasp and is
only partly polished.

The story of the prophet Jonah
is told in three episodes. God
commanded him to preach in
Nineveh, but when Jonah fled
aboard ship God sent a howling
gale, represented on the upper
left by two winged wind-gods
blowing on shells. On the vessel
below, Jonah persuaded the crew
to throw him overboard, beardless
and naked, to calm the storm.
A *ketos*, a dragon-like sea monster
in Greek and Roman mythology
interpreted as a whale in more
recent accounts, swallowed him
and spewed him back on land.

The Jonah legend appeared on
sarcophagi in the late third
century and went on to become
extremely popular in the fourth.
It is the most widely used biblical
theme in Early Christian art. JSØ

101

Funerary altar, Rome, *c.* AD 130
Marble, 90 × 55 × 43 cm
PROVENANCE: Found before 1697.
Palazzo Sciarra, Rome. Acquired
in 1890
SELECTED REFERENCES: Kleiner
1987, p. 180 f., no. 56; Østergaard
1996, no. 13
IN 861

The pediment on top of the altar
is lost. There are traces of red
paint in the inscription and the
mouth of the dog. The front of the
funerary altar shows a half-length
double portrait of a couple with
clasped hands: a gesture that
indicates their legally married
state. The inscription records that
Julia Heuresis and Sulpicius
Clytus erected the memorial to
'Julia Saturnina, daughter of
Gaius, and to Gaius Sulpicius
Clytus, and to the memory of Julia
Musaris'; the two figures depicted
are Julia Saturnina and Gaius
Sulpicius Clytus.

To the left of the inscription is
the figure of a chained dog, a
frequently used symbol of fidelity.
The sides of the altar show a tree,
its fruit eaten by birds while a
young boy attempts to climb up.
The meaning of this is not
entirely clear, although the snake
on the left side may be a symbol
of the underworld. The dating is
based on the hairstyles of the
couple: the man's typical of the
reign of the emperor Trajan (AD
98–117), the woman's slightly
later (probably from the reign
of Hadrian, 117–138). JSØ

102

Cinerary altar, AD 100–150
Marble, 105 × 62 × 30 cm
PROVENANCE: Found in the Vigna
Casali near the Porta San
Sebastiano in Rome in 1775.
Acquired from Saturnino
Innocenti in Rome in 1884
SELECTED REFERENCES: Boschung
1987, p. 99, no. 694; Østergaard
1996, no. 15
IN 860

This urn, the surface of which has
been vigorously cleaned, is in the
form of an altar, with a cavity for
the ashes under its lid (hence
'cinerary altar'). On the front an
inscription records that the altar
was dedicated by Marcus
Cornelius Hymnus and Cornelia
Corinthias to the memory of their
'very devoted and deserving
daughter', Cornelia Cleopatra,
who died at the age of twenty.
The dead girl is portrayed asleep,
as a scantily clad nymph, her hair
arranged according to the
elaborate fashion of the period.

The front corners carry a head
of Zeus Ammon, showing the
bearded god with ram's horns.
Below the heads are eagles, the
birds of Zeus, their wings
outspread. Unusually, the sides
of the urn are decorated with a
type of parakeet well known from
Hellenistic times and onwards as
a pet of the social élite.

On the sides, the lower edge of
the lid has been drilled through;
the drilling continues into the
raised edge round the top of the
chest. Perhaps this was to permit
the insertion of a metal rod as a
precaution against tomb-robbery.
JSØ

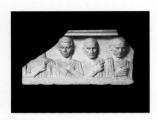

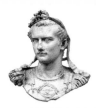
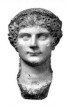

103

Funerary portrait relief, end of the
first century BC
Marble, 63 × 127 × 23 cm
PROVENANCE: Acquired in Rome
in 1893, through the mediation
of Wolfgang Helbig
SELECTED REFERENCES: Kockel
1993, p. 151, no. 16; Johansen
1994, no. 119
IN 762

Reliefs such as this were set into
the façades of family tomb
buildings of the first century BC,
at Rome, in Latium and further
south. An accompanying
inscription, now lost, gave the
names of the family members
represented. Surviving
inscriptions reveal that this kind
of relief was almost exclusively
commissioned by freed slaves.
This was a class with strong social
aspirations. They are often
depicted in a manner almost
more Roman than the Romans
themselves, dressed as citizens
(the men in the Roman toga) and
portrayed in the severely realistic
style typical also of élite Roman
portraiture, especially of the early
to mid-first century BC. JSØ

104

Portrait of a Roman lady, end of the
first century BC
Marble, H. 39 cm
PROVENANCE: Acquired from the
collection of Michael Tyszkiewicz
in Paris in 1887, through
Wolfgang Helbig
SELECTED REFERENCES: Poulsen
1973, no. 102; Kockel 1993, p. 215
(n. 4); Johansen 1994, no. 105;
Legrottaglie 1999, p. 62 (n. 2)
IN 729

The strong, lined features with
wide mouth and relatively small
eyes convey a marked
individualism in this portrait. An
apparently ruthless realism and a
severity of expression characterise
much Late Republican and Early
Imperial portraiture (second –
first centuries BC). The hairstyle
of this piece suggests a date in the
reign of the emperor Augustus.
From a centre parting, the wispy
hair flows around the head to be
gathered in a bun at the back,
with loose locks falling down
along the neck.
 The head was probably inset
into a full-length portrait statue
which may once have stood in a
family tomb. JSØ

105

Portrait of the emperor Caligula,
AD 37–41
Parian marble, H. 51 cm
PROVENANCE: Allegedly found
during construction of the Tiber
embankments. Acquired in Rome
in 1896, through the mediation
of Ludwig Pollak
SELECTED REFERENCES: Giuliano
1986, p. 44, no. II, 14; Johansen
1994, no. 55; Krierer 1995, p. 75,
pl. 21; Meyer 2000, p. 88 (n. 303),
fig. 175
IN 1453

A section of the oak wreath
(separately carved and inserted)
is lost. Iron dowels have been used
to reassemble the shattered right
shoulder and attach part of the
occiput. Many surfaces have been
cleaned.
 Of the surviving large-scale
portraits of Caligula (AD 12–41),
this is the only example to show
this notorious emperor in a
military guise. He wears a
breastplate (showing the head
of the gorgon Medusa) and the
oak wreath, the *corona civica* (civic
crown), an honour awarded for
saving the life of a Roman citizen
in battle. The deep-set eyes, the
broad forehead and the sunken
temples are consistent with
ancient written descriptions of
the emperor, but his reported
baldness has been repressed.
After Caligula's assassination, the
Senate decreed that his portraits
should be dragged through the
streets of Rome and thrown into
the Tiber, the fate accorded to
executed criminals. To this we
may owe the survival of this
marvellous bust. JSØ

106

*Portrait of Agrippina the Younger,
wife of the emperor Claudius*,
AD 41–54
Marble, H. 36 cm
PROVENANCE: Acquired in Rome
in 1890
SELECTED REFERENCES: Johansen
1994, no. 63; Mannsperger 1998,
p. 48 (n. 301), fig. 37; Wood 1999,
p. 299 (n. 137), p. 300 (n. 138)
IN 755

Agrippina (d. AD 59), sister of the
emperor Caligula, was married to
her uncle the emperor Claudius
in the year AD 49. She is portrayed
with the intricately curly coiffure
fashionable in Claudian times.
Her facial features are clearly
reminiscent of those of her
brother, not least the protruding
upper lip.
 Agrippina ensured that
Claudius adopted her own son
Nero by a previous marriage.
Later, when he came to power,
Nero arranged his mother's
death.
 The facial surfaces have been
heavily cleaned, but the state of
preservation is otherwise
exceptionally good. The
remaining discoloration on the
hair is due to calcite deposits. JSØ

107

Portrait of a young man, AD 160–170
Marble, H. 70 cm
PROVENANCE: Reportedly found on
the Aventine Hill in Rome in the
ruins of a large residence, along
with 500 newly struck gold coins
bearing the portrait of Lucius
Verus. Acquired in Rome in 1893
through the mediation of
Wolfgang Helbig
SELECTED REFERENCES: Johansen
1995, no. 91
IN 789

This portrait is remarkable in
several respects. Not only is it
wonderfully preserved but it is
also of exquisite workmanship
and of unusual size, the bust
reaching almost to the navel. The
long hair and beard as well as the
Greek cloak suggest two possible
interpretations. This portrait may
be of a young, Greek intellectual,
or a Roman displaying his
Philhellenism in a manner much
in vogue from the time of the
emperor Hadrian onwards. JSØ

 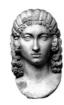 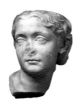 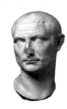

108
Portrait of the emperor Caracalla,
c. 212 AD
Marble, H. 35 cm
PROVENANCE: Acquired in Rome
from the art dealer Jandolo (son
of the art dealer Augusto Jandolo)
in 1906, through the mediation
of Wolfgang Helbig
SELECTED REFERENCES: Nodelman
1965, pp. 186, 198; Wiggers and
Wegner 1971, p. 65; Johansen
1995B, no. 9
IN 2028

This type of Caracalla portrait
strongly resembles portraits of
the emperor found on coins
introduced in AD 212, the year in
which he liquidated his brother
Geta to become sole ruler of the
Empire (212–217). The head, made
to be inserted into a bust or a full-
length statue, is inclined to the
right but turns towards the left,
the direction of the emperor's
stern gaze under the knitted
brows. The dynamic, threatening
pose echoes the words of his
contemporary, the historian Dio
Cassius: 'He always wanted to look
formidable, wild and fierce.' JSØ

109
Portrait of a Roman woman,
c. 220 AD
Marble, H. 45 cm
PROVENANCE: Acquired from Eliseo
Borghi in Rome in 1892, through
the mediation of Wolfgang Helbig
SELECTED REFERENCES: Johansen
1995B, no. 20; de Kersauson 1996,
p. 406; Wood 1999, pp. 52–3, pl.
XII, fig. 16; Bartman 2001, p. 18
(n. 90), fig. 14
IN 825

The unusually large format, the
carving and the elaborate coiffure
make it likely that the subject of
this portrait is a member of the
imperial élite at the time of the
Severan dynasty, probably during
the reign of the emperor Elagabal
(218–222). It has been suggested
that it represents Elagabal's
mother, Julia Soaemias.
 The tip of the nose has been
repaired in marble. The head
was inserted into a larger or full-
length statue. The pupil, iris and
eyebrows are emphasised (as
commonly from the late second
century on) by carving. JSØ

110
Bust of a Roman lady, c. 240 AD
Marble, H. 33 cm
PROVENANCE: Acquired from Eliseo
Borghi in Rome in 1894, through
Wolfgang Helbig
SELECTED REFERENCES: Johansen
1995B, no. 22; Wood 1999, pp. 76,
99, pl. XXX, fig. 42
IN 792

Despite the damage, the high
quality of this portrait is clear.
The subject has not been
identified with any certainty.
The lively pose of the head is
highly unusual. The crown of the
head was made separately and
attached. JSØ

111
Portrait of a Roman, middle of the
third century AD
Marble, H. 35 cm
PROVENANCE: Acquired from Felix
Feuardent in Paris in 1890
SELECTED REFERENCES: Wegner
1979, p. 88; Johansen 1995B,
no. 49
IN 833

The period from AD 230 to 280
is often known as that of the
'Soldier Emperors', during which
almost 40 emperors made more
or less successful bids for imperial
power. The decisive factor was the
attitude of the legions towards
the candidate, many of whom
therefore had a military
background. There have been
many attempts to understand
the portraits of this period: some
have seen them as a reflection of
a (claimed) return to Republican
styles and values; others see in
them the sombre uncertainty of
an epoch of crisis. The closely
shaven hair and beards
characteristic of the period's male
portraits – as seen in this work –
may reflect this. The neck of this
portrait has been formed for
insertion into a full-length statue
or bust. JSØ

112
Christoffer Wilhelm Eckersberg
(1783–1853)
View of the Via Sacra, Rome, 1814
Oil on canvas, 28 × 33 cm
Unsigned
PROVENANCE: Donated by the
Ny Carlsberg Foundation in 1946
SELECTED REFERENCES:
Copenhagen 1983, no. 21;
Nørregård-Nielsen 1995, no. 12;
Copenhagen 1996, p. 117, fig. 68;
Paris 2001, p. 319, no. 196
MIN 2611

Eckersberg became the first
Danish plein-air painter, and
a leading figure among Danish
Golden Age artists. After studying
in Paris under Jacques-Louis
David, he travelled in 1813 to
Rome, ostensibly to study from
the Antique and the great masters
of the Renaissance. However, he
turned his attention to prospects
of the city and surrounding
landscape, making rapid oil
sketches directly in front of the
motif.
 This ravishing view shows the
ruins of the Temple of Antoninus
and Faustina. Although its
entrance façade was most often
portrayed, the temple is here
shown from the side, thus
allowing the interest in outline
and perspective encouraged by
Eckersberg's friend Thorvaldsen
to come to the fore by permitting
concentration on the depth of
the composition by means of the
foreshortened columns. All
elements are of equal value, and
the play of light and shadow on
the temple wall has been given
special value. TB-M

113

Constantin Hansen (1804–1880)
View of the Forum Romanum in Rome,
1837
Oil on canvas, 34 × 46 cm
Signed lower left: *C.H. Rom 1837*
PROVENANCE: Pietro Krohn.
Acquired by the Ny Carlsberg
Foundation in 1930; on loan to
the Statens Museum for Kunst;
returned to the Glyptotek in 1933
SELECTED REFERENCES: Stockholm
1963, p. 46; Nørregård-Nielsen
1982, p. 108; Copenhagen 1991,
no. 41; Nørregård-Nielsen 1995,
no. 37
MIN 1883

At the beginning of the
nineteenth century, cattle and
sheep still grazed on the grounds
of the Forum in Rome: young
shepherds leading their herds
on the vast green area were a
common sight. By 1835, when
Constantin Hansen, a pupil of
Eckersberg, returned to the city,
excavations of the Forum were
underway.

Hansen's painting gives an
impression of the Forum's past
and present functions. In the
middle foreground two beasts,
apparently oxen, belong with
the cart on the left, which reflects
the cluster of carts gathered
under the trees awaiting the
rubble from the newly excavated
site beyond. Thus he seems to be
suggesting the changes taking
place in the site, rather than
referring to its bucolic past. The
lush foliage of the trees to the
right is a stark contrast to the
predominantly sunburnt and
dry colours of the ruins and the
ground. Hansen has summarised
the various phases of Rome's
history through the different
styles of architecture, unifying
them under a clear blue summer
sky. Eckersberg had painted the
same view some twenty years
earlier. As a token of his close
dependence on his teacher,
Hansen has chosen the same
viewpoint for the scene as that
adopted by his master, which he
had most likely seen in his studio
in Copenhagen. TB-M

114

Jørgen Roed (1808–1888)
Casa Cenci, presumably 1840
Oil on canvas, 29 × 37 cm
Signed: *J.R.*
PROVENANCE: Acquired by Carl
Jacobsen before 1885
SELECTED REFERENCES: Voss 1968,
p. 168 f.; Copenhagen 1978, no. 65;
Christensen 1991, p. 90, no. 22;
Nørregård-Nielsen 1995, no. 99
MIN 930

Young painters visiting Rome
were as impressed by the
Renaissance and its revival of
the Classical past almost as much
as by the great monuments of
Antiquity. The Casa Cenci, or the
Casino di Pineto, near the
Borghese Gardens, was reputedly
associated with Raphael and
hence accorded the status of an
artistic shrine.

Jørgen Roed arrived in Rome
in 1837. As is characteristic with
oil sketches done in front of the
subject, the light has been
carefully observed. The shadows
of the house and the wall
surrounding the garden are long
and the sunlight is warm, and
a related drawing dated '14 May
1840' confirms the study's
execution on a golden afternoon
in early summer. Most Golden Age
studies of the Casa Cenci adopt
a similar approach. This study
served as the model for a more
carefully executed version of the
same subject (private collection).
TB-M

115

Fritz Petzholdt (1805–1838)
The Campagna Outside Rome, c. 1832
Oil on paper on canvas, 23 × 27 cm
Unsigned
PROVENANCE: Acquired in 1992
SELECTED REFERENCES: Nørregård-
Nielsen 1995, no. 97
MIN 3270

Fritz Petzholdt was primarily
a landscape painter who went
frequently to the Roman
Campagna to execute small oil
studies that recorded both the
physical characteristics of a
specific location and the
particular light effects of a certain
time of day and season. Rapidly
executed, this study captures
details within the landscape such
as the mountain ridge on the
horizon, which is pale and blue
against the shimmering lemon
colour of the sky, and the warmer,
ochre-yellow middle ground with
its swiftly sketched hillside and
vegetation. Petzholdt has adopted
a high viewpoint, which endows
this small sketch with a certain
sense of drama.

His study is similar in approach
and treatment to Jean-Baptiste-
Camille Corot's near-contemporary
Italian landscape studies, such as
*Landscape from the Region around
Civita Castellana with a View towards
Monte Soratte* (cat. 152). However,
although the treatment of light
and colour is similar, Corot's
approach is sometimes more
considered. TB-M

116

Martinus Rørbye (1803–1848)
*Michelangelo's Cypresses in the
Monastery in the Baths of Diocletian*,
1841
Oil on canvas, 55 × 37 cm
Inscribed: *M.R. Roma 1841*
PROVENANCE: Sold at the auction
in 1849 of the artist's personal
effects after his death. Acquired
in 1978
SELECTED REFERENCES:
Copenhagen 1981, no. 93;
Nørregård-Nielsen 1984, p. 42 ff.;
Nørregård-Nielsen 1995, no. 105;
Paris 2001, p. 343, no. 212
MIN 3106

Martinus Rørbye was not very
fond of Rome. However, he visited
the city on a number of occasions.
On his second journey to Italy, in
1839–41, he made a number of
studies for use in larger works
created later in the studio. Among
them is this study of cypresses,
three large and one smaller, in
the grounds of the Baths of
Diocletian, which by this date had
been converted into a Carthusian
Monastery. Three of the cypresses
are old, monumental and
overwhelming, and had allegedly
been planted by Michelangelo.

Rørbye has not only captured
the impressive magnificence of
the trees but has also given a very
detailed botanical account. By
presenting the viewer with dry,
evergreen foliage he reveals the
trees' inner structure. The size
and age of the trees are set in
contrast to the diminutive figure
of the Carthusian monk, possibly
suggesting the grandeur of nature
and the short span of human life.
TB-M

117

Constantin Hansen (1804–1880)
*The Bay of Naples with Vesuvius in the
Background*, 1839/40
Oil on paper on canvas, 20 × 28 cm
Unsigned
PROVENANCE: Acquired in 1992
SELECTED REFERENCES: Nørregård-
Nielsen 1995, no. 40
MIN 3272

Danish painters were attracted
not only to Rome but also to
locations further south, such
as Naples and Capri, where the
Antique coexisted with colourful
manifestations of local
contemporary culture. In the
autumn of 1839 Constantin
Hansen joined his friend Christen
Købke (see cat. 118) in an artist's
colony on the coast near the
island of Capri. Købke encouraged
Hansen to make a sequence
of beautiful small-scale sketches
in oils.

Particularly eye-catching is the
cloth that provides shade to the
family of a fisherman. Its warm
orange colour is intensified by
the calm, pale blue water in the
background. The water divides
the composition into three parts.
In the background Vesuvius can
be seen faintly through the heat
haze. Smoke rises from the crater
as an indication of the constant
threat that nature imposes on the
people living in the volcano's
shadow. TB-M

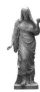

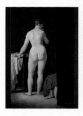

118

Christen Købke (1810–1848)
Path Leading Up from the Marina Piccola on the Island of Capri, c. 1839
Oil on paper, 23 × 24 cm
Unsigned
PROVENANCE: Donated by the Ny Carlsberg Foundation in 1992
SELECTED REFERENCES: Fonsmark 1983, fig. 5; Nørregård-Nielsen 1995, no. 68
MIN 3268

The characteristic fishing boats symbolise the continuity of human existence on Capri in this oil sketch, which was probably made in 1839. The location is one of the island's few natural harbours, the Marina Piccola ('small harbour'), which lies beside the Rock of the Sirens. Its association with Classical mythology and its contemporary activity made it an icon for Romantic attempts to express the timelessness of Mediterranean life, unchanged since Antiquity. The boats and the lifestyle of the local fishermen were thought to have been unchanged for at least two millennia.

Købke had been introduced to the subject shortly before his departure for Italy through copying a scene of the Marina Piccola by Fritz Petzholdt in the collection of the Danish sculptor Hermann Ernst Freund. The romantic idea of Capri appealed to Købke. He painted several sketches from its picturesque landing places, visiting in the autumn of 1839 with Constantin Hansen. In this painting, the fishermen have finished their work, the day is drawing to a close, the boats have been beached and the fishing nets have been set out to dry in the sun. TB-M

119

Martinus Rørbye (1803–1848)
Greeks Fetching Water from the Well at the Tower of the Winds in Athens, 1836
Oil on canvas, 30 × 41.5 cm
Unsigned
PROVENANCE: Acquired in 1977
SELECTED REFERENCES: Copenhagen 1981, no. 100; Nørregård-Nielsen 1995, no. 104
MIN 3100

Unlike earlier generations of artists and architects, who had seen Athens solely in terms of its ancient and glorious past, Rørbye, when he visited the city as part of a tour of Greece and Turkey made in 1835–6, sought to reflect the impact of the collapse of Ottoman domination and the establishment of a new Greek nation following the Greek War of Independence.

Rørbye's visual record is both picturesque and topographic. In *Greeks Fetching Water from the Well at the Tower of the Winds in Athens* he has carefully noticed every small detail of the scene: the simple houses still marked by the War of Independence, the Tower of the Winds with its figures in relief, and the new, independent Greek population in their national costume, working, resting and talking. In a single picture, he has summarised the city's ancient history as the cradle of democracy and expressed his hopes for the future of a modern and newly liberated Greece. TB-M

120

H. W. Bissen (1798–1868)
Flower Girl, 1828–9; modelled 1828–9, carved 1829–31
Marble, H. 120 cm
Not inscribed
PROVENANCE: King Frederik VII of Denmark; Countess Danner; Danner auction, 19 June 1874; J. W. Heymann; Heymann auction 25 February 1886; acquired by Carl Jacobsen
SELECTED REFERENCES: Rostrup 1945, p. 128, no. 47; Christensen 1995, no. 7
MIN 3

Throughout the 1880s Carl Jacobsen was acquiring sculpture by the pupils and successors of Bertel Thorvaldsen. Among these H. W. Bissen was a favourite, with almost 400 works by him eventually entering the collection. The *Flower Girl,* originally commissioned in around 1828 by HM Crown Prince Frederik, was among the very first he bought.

The term 'Danish Golden Age' is normally applied to painting, but many of its characteristics are present in the sculpture of the era: a penchant for quiet, everyday motifs emerges, gradually supplanting the heroic, idealised figures inspired by Greek and Roman prototypes that marked Thorvaldsen's neoclassical work. In this early work, Bissen has chosen to represent 'a girl in the first bloom of youth, playfully holding some flowers, her very being tender and loving', as the sculptor later wrote. FF

121

Jens Adolph Jerichau (1816–1883)
Penelope, 1843
Marble, H. 182 cm
Not inscribed
PROVENANCE: Commissioned by August Abendroth, Hamburg; O. Berckefeldt, Copenhagen; purchased from the Berckefeldt heirs by Carl Jacobsen in 1901
SELECTED REFERENCES: Bøgh 1884, pp. 147, 159; Michaëlis 1906, pp. 21, 37–8; Rostrup 1945, pp. 254–8; Munk 1995, no. 155
MIN 366

During her long wait for the return of her husband Ulysses, Penelope promised that she would consider suitors only once her tapestry was complete. Each night she unpicked her day's work to hold them at bay (Homer, *Odyssey,* XIX, 124–64).

In Jerichau's sculpture, Penelope is represented as a young woman of classical beauty. She holds a ball of wool in one hand and does not reveal the suffering caused by her uncertainty about her husband's fate.

The work was modelled during the artist's Roman sojourn (1838–49). It derives its draped pose from Roman sculptures, notably the so-called *Pudicitia* (Vatican Museums, Rome), which Jerichau recorded in his notebook several times (Ny Carlsberg Glyptotek, MIN 2797), with its *contrapposto* pose and simple basic shape. However, his meticulous modelling of the details adds a virtuoso touch and introduces a note of greater realism, in keeping with Danish neoclassical sculpture of the generation succeeding Thorvaldsen. The carving of the marble, undertaken solely with the chisel, is particularly striking: it both reveals and emphasises the body of the young woman and the textures of her drapery, and gives a freshness and light to the marble itself. TB-M

122

Christoffer Wilhelm Eckersberg (1783–1853)
Nude Study, 1833
Oil on zinc, 34.5 × 24.5 cm
Unsigned
PROVENANCE: Donated by the Ny Carlsberg Foundation in 2002
SELECTED REFERENCES: Copenhagen 1994, p. 86 ff., no. 35; Copenhagen 1996, p. 173, fig. 106; Friborg 2002B, p. 103 ff., fig. 5
MIN 3580

In June 1833, a session took place in Professor Eckersberg's studio at the Royal Academy in Copenhagen in which some of his most talented former students participated. The result was a series of individual studies made from the same model. The Glyptotek owns four of these studies (by Martinus Rørbye, Christen Købke, Constantin Hansen and Wilhelm Marstrand respectively), as well as this more finished version made by Eckersberg himself.

The professor reworked his painting after the session. Compared to the sketchy works of his pupils, the *Nude Study* is a complete painting, in which the model has been given an imaginary setting. In keeping with his other finished nude studies (see cat. 124), Eckersberg gives the work a sexual dimension. The woman is scrutinised by a hidden voyeur, whose presence has just been noticed by the model herself. By the use of an elegant painterly trick, Eckersberg has placed us as beholders in the darker room behind her, in turn making voyeurs of us by means of the green velvet curtain and a door frame, set parallel to the picture plane. The whole composition stresses the fact that any spectator here is trespassing. TB-M

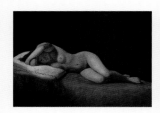 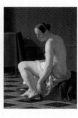

123
Constantin Hansen (1804–1880)
Resting Model, 1839
Oil on canvas, 40 × 55 cm
Signed: *Const. H. Rom 1839.*
PROVENANCE: Sold to the painter
Thorvald Niss at the auction of
Hansen's personal effects held
after his death. Bought by the
Ny Carlsberg Foundation, and
donated to the Glyptotek in 1928
SELECTED REFERENCES:
Copenhagen 1978, no. 33;
Bramsen 1990, p. 151;
Copenhagen 1991, no. 66;
Nørregård-Nielsen 1995, no. 38
MIN 1882

Far from Copenhagen's petty
constraints of bourgeois morality,
some of the young Danish artists
in Rome led a less than virtuous
private life. Roman mistresses,
often models, and illegitimate
children, were not unusual.

This model was painted by
Constantin Hansen in Rome in
1839. Although her identity is
unknown, her pose is rarely found
in Danish Golden Age painting.
The girl frames her face with her
arms, exposing the heavy curves
of her breasts and torso to create
an image that is both bold and
erotic. Even in shadow, her look is
direct; she is indeed a temptress
and challenges the beholder.

Given that the work remained
in the artist's studio until his
death it may have recorded an
emotional involvement between
model and artist. Although a
private record, its signature,
location and date suggest that it
might have served as a personal
memento. TB-M

124
Christoffer Wilhelm Eckersberg
(1783–1853)
*Naked Woman Putting on Her
Slippers*, 1843
Oil on canvas, 65.5 × 46 cm
Signed: *E. 1843*
PROVENANCE: Donated by the
Ny Carlsberg Foundation in 1942
SELECTED REFERENCES: Århus 1983,
no. 106; Copenhagen 1994, p. 128 ff.,
no. 59; Nørregård-Nielsen 1995,
no. 24, Washington 2003, no. 50
MIN 2062

In *Naked Woman Putting on Her
Slippers* C. W. Eckersberg
presented a radical departure in
Danish painting: the study of the
female nude in her environment.
The model is placed in a
contemporary everyday interior,
since the setting, possibly a
bedroom, was considered quite
risqué within the strict moral
code of the first half of the
nineteenth century. No artist
would normally have had access
to his model's bedroom. However,
Eckersberg's nude studies appear
to have been made for a small
group of connoisseurs whose
tastes were somewhat voyeuristic.
The woman's gesture is
superficially mundane: she is
simply putting on her slippers.
However, the focus concentrated
on the act imbues it with
innuendo, whether explicitly
referring to the woman dressing
after a sexual encounter or
implicitly presenting a tantalising
suggestion of the act as yet
unfulfilled. TB-M

125
Wilhelm Marstrand (1810–1873)
*Study of an Italian Woman and
a Sleeping Child*, 1841
Oil on paper, 29 × 44 cm
Signed: *Marstrand 1841*
PROVENANCE: Acquired in 1988
SELECTED REFERENCES: Nivaa 1992,
no. 55; Nørregård-Nielsen 1995,
no. 88
MIN 3241

Wilhelm Marstrand's sketch is a
recollection of the artist's sojourn
in Italy. Executed in Munich,
where Marstrand spent the New
Year of 1840/1, it is a memory
of what seems to have been a
pleasant stay. The woman
cleaning vegetables and her
sleeping child in a wicker cradle
beside her are portrayed with
great solicitude and, seemingly,
not a little longing for Italy.

The study is one of many of this
type so common among the
Golden Age painters, who often
combined several sketches on one
sheet. Marstrand might even have
brought a roughly pencilled
sketch from life with him from
Italy, and spent some of his time
in Munich meticulously
elaborating the scene and 'filling
in' the colour. He has managed to
combine painterly analysis with
genre study, and even though
mother and child have been
compositionally separated, the
impression of motherly love and
tenderness remains. FF

126
Jens Juel (1745–1802)
*Elisabeth Henriette Bruun de
Neergaard and Her Eldest Son,
Henrik*, possibly 1799 or 1800
Oil on canvas, 63.5 × 48.5 cm
Unsigned
PROVENANCE: Donated by the
Ny Carlsberg Foundation 1936 to
replace an inferior replica
acquired by Carl Jacobsen in 1894
SELECTED REFERENCES: Colding et
al. 1972, fig. 165; Poulsen 1991,
no. 775. Nørregård-Nielsen, 1995,
no. 51; Heiberg 2003, p. 114
MIN 898

Trained in Hamburg, Munich
and Copenhagen, Jens Juel was
a brilliant portrait painter who
received commissions from the
Danish royal family and nobility.

This portrait of Elisabeth
Henriette Bruun de Neergaard
and her eldest son, Henrik, is
conceived as a personification
of motherhood. Mrs Bruun de
Neergaard's arms form a
protective frame around the little
boy, and her mild appearance
signifies maternal protection.
Henrik represents childhood as a
carefree time, when children can
prepare for the duties of adult life
by role-playing: the whip in his
hand is still just a toy, but
identifies him as a master of the
house in the making.

The composition of this portrait
owes much to neoclassical ideals,
not least in setting the sitters
within a narrow picture plane
as if in a Classical bas-relief.
The pose of mother and child,
however, owes much to
Renaissance Madonna and Child
prototypes. The portrait mirrors
the bourgeois ideals of the time:
on one side, the mild woman, and
on the other, the active and
energetic man-to-be. TB-M

127
Constantin Hansen (1804–1880)
A Hunter Shows a Little Girl His Bag,
1832
Oil on canvas, 44.5 × 34 cm
Inscribed: *CH 1832*
PROVENANCE: Raffled off by the
Kunstforeningen (Copenhagen
Fine Arts Society) in 1832.
Donated by the Ny Carlsberg
Foundation in 1932
SELECTED REFERENCES: Colding
et al. 1972, p. 366 ff.; Copenhagen
1991, p. 158, no. 27; Nørregård-
Nielsen 1995, no. 35
MIN 1856

For both landscape and genre
painting of the Danish Golden
Age, Dutch seventeenth-century
art provided an important model.
This influence can be well
observed in this genre scene of
a hunter displaying his bag after
a day's shoot.

The subject was conceived
during one of Constantin
Hansen's visits to the home of
the parents of his friend and
colleague Jørgen Roed. As with
Dutch genre painting, Hansen's
work goes beyond basic
description. Roed shows his little
sister a dead magpie. The
situation makes the girl
uncomfortable and she anxiously
grabs the knee of her brother
while confronted with the dead
bird. Other compositional
elements placed in juxtaposition
to the two figures extend the
meaning of the work to suggest
male and female spheres, and
the fragile security of the home.
While some knitting lies on the
sofa next to Roed's sister and an
easel stands behind him, in the
foreground another hunter is at
work: the cat playing with a ball
of yarn suggests that the idyll of a
calm domestic interior might not
be as safe and homely as first
assumed. TB-M

.

128
Wilhelm Bendz (1804–1832)
A Smoking Party, 1827–8
Oil on canvas, 98.5 × 85 cm
Unsigned
PROVENANCE: Donated by the Ny
Carlsberg Foundation in 1930
SELECTED REFERENCES: Nykjær
1991, p. 87; Monrad 1989, p. 76 ff.;
Nørregård-Nielsen 1995, no. 4;
Copenhagen 1996B, no. 34
MIN 1881

Wilhelm Bendz died on his first
Italian tour, at Vicenza, at the age
of 28. During his short career,
which ended before he had even
finished his studies, his talent had
attracted much attention.
Dazzling technical skill marked
his work, as is obvious in this
painting.
 The work is an example of an
important type of painting within
the art of the Danish Golden Age,
namely scenes from everyday life,
or genre scenes. Here Bendz
invites the beholder to an evening
party in a students' lodgings
during which the company smoke
and enjoy music. The focus of the
composition is the dark,
rectangular card which has been
held up to a lamp in order to cast
a sequence of interesting,
complex shadows within the
room. Further perspective tricks
are introduced by the mirror on
the wall, which appears to reflect
the hangings of the bed in the
right foreground. Bendz has
enjoyed playing with such details,
and includes himself in the party:
he is the figure, head in profile, on
the left of the table. TB-M

129
Jens Juel (1745–1802)
*Landscape with Aurora Borealis, with
Middelfart Church in the Background:
'Attempt to Paint the
Aurora Borealis'*, possibly 1790s
Oil on canvas, 31.2 × 39.5 cm
Unsigned
PROVENANCE: Donated by the Ny
Carlsberg Foundation in 1936
SELECTED REFERENCES: London
1972, p. 23 f., Ill. iv; Copenhagen
1991B, p. 20 f., fig. 15, no. 60;
Poulsen 1991, no. 721; Nørregård-
Nielsen 1995, no. 54
MIN 1936

Although primarily a portrait
painter, Jens Juel executed some
60 landscapes. These appear to
have been private works, their
motifs inspired by the artist's
childhood home on the island of
Funen or by the area to the north
of Copenhagen.
 Nocturnal landscapes are rare
in Danish art. However, the night-
time setting allows Juel to create
a work that both reflects the
contemporary interest in
nocturnal phenomena, such as
the aurora borealis, and –
through the juxtaposition of the
tiny gatekeeper, the silhouette of
the church beyond and the vast
sky – reminds the spectator of
man's insignificance within the
universe. The sensitive
representation of the sky predicts
later developments in European
Romantic painting. TB-M

130
Christen Købke (1810–1848)
The North Gate of the Citadel, 1834
Oil on canvas, 79 × 93 cm
Signed: *C. Købke 1834*
PROVENANCE: Commissioned by
the Kunstforeningen
(Copenhagen Fine Arts Society)
in 1834. Acquired at the society's
raffle of December 1834 by Mr
Gamst, Copenhagen. Acquired
by Carl Jacobsen in 1887
SELECTED REFERENCES:
Copenhagen 1981B, no. 21; Los
Angeles 1993, p. 39 f.; Wivel 1993,
pl. 8; Nørregård-Nielsen 1995,
no. 60; Copenhagen 1996, p. 210,
fig. 136, no. 79
MIN 909

This work is one of the finest
examples of Danish Golden Age
painting. Købke's picture shows
the north gate in the
fortifications of Copenhagen
facing the Øresund, the stretch
of water that separates Denmark
from Sweden. It was a site with
which he was very familiar: his
father had been master baker to
the garrison until 1833 (see cat.
132), and the family had been
housed inside the military
complex.
 Købke never felt entirely
comfortable with large
compositions and struggled with
the work for months. He built up
the composition through a study
in oil and a large number of
drawings of details, such as the
brickwork in the gateposts.
Everything is dazzlingly clear,
with each detail captured. Købke
has caught the light of high
summer and the half-shadows,
and recorded a blissful day for
posterity. The boy in the white
trousers is his pupil, Lorenz
Frölich (1820–1908). FF

131
Christen Købke (1810–1848)
Two Tall Poplars, c. 1836
Oil on paper, 29 × 15.5 cm
Unsigned
PROVENANCE: Acquired in 1980
SELECTED REFERENCES: Nørregård-
Nielsen 1995, no. 61; Copenhagen
1996, p. 266, fig. 180, no. 102a
MIN 3115

Christen Købke undertook
extensive studies in pencil and
in oil on paper or canvas of both
Copenhagen and the surrounding
landscape as preparatory studies
for finished works such as *The
North Gate of the Citadel* (cat. 130).
Poplars, the only trees planted by
the city of Copenhagen, became a
hallmark of views of the city from
the early nineteenth century. The
two poplar trees shown here have
been studied for their response to
the weather conditions: the wind
and the gathering clouds in the
pale grey sky. With these few
details, Købke gives a clear
impression of the changeable
Danish weather. TB-M

132
Christen Købke (1810–1848)
*View of the Yard Beside the Bakery
in the Citadel*, c. 1832
Oil on canvas, 33 × 24 cm
Unsigned
PROVENANCE: Acquired by the
artist's brother-in-law, the
medallist F. C. Krohn, at the
auction of Købke's personal
effects held in March 1848 after
his death (oil painting no. 8).
On Krohn's death it was passed to
his son, Mario Krohn. Sold at the
auction of Mario Krohn's personal
effects held in 1937 after his
death. Donated by the Ny
Carlsberg Foundation in 1959
SELECTED REFERENCES:
Gunnarsson 1989, p. 117;
Nørregård-Nielsen 1991, p. 65;
Wivel 1993, pl. 5; Nørregård-
Nielsen 1995, no. 58; Copenhagen
1996, p. 137, fig. 80, no. 48
MIN 2812

In the early 1830s Christen Købke
painted a number of views made
within Copenhagen's citadel,
where he grew up as the son of
the garrison's master baker. The
ramparts and alleys of the citadel
became his playground. This
work, showing one of his father's
two bakeries within the citadel,
appears to be imbued with
memories of a happy childhood,
and is devoid of any reference to
the military function of the site.
TB-M

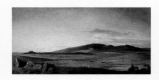 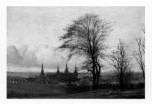 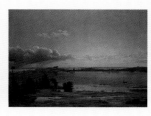

133
Johan Thomas Lundbye
(1818–1848)
Zealand Landscape, 1840
Oil on canvas, 61 × 124 cm
Signed with monogram and
dated: *1840*
PROVENANCE: Acquired by Carl
Jacobsen in 1897
SELECTED REFERENCES: Madsen
1931, fig. 1; Madsen 1949, no. 79;
Nørregård-Nielsen 1986, no.11;
Nørregård-Nielsen 1995, no. 76
MIN 912

Zealand Landscape is one of the
most important works in
Lundbye's oeuvre. The subject is
from the western part of Zealand,
an area that Lundbye often visited
and with which he had a family
association. He painted it
frequently, finding a number of
his best motifs there.
 The landscape explicitly reflects
both Lundbye's love of the Danish
landscape and his personal
interest in visiting it. As in his
other landscapes (see cat. 135), he
manipulates the existing
landscape yet retains sufficient
topographic detail to allow
specific identification. Such detail
includes the Lammefjord on the
right, the Kattegat coast in the
distance on the left, and the
gentle slopes of Vejrhøj Hill in the
background. The topography is
punctuated by an ancient burial
mound on the top of the Vejrhøj,
the remains of a stone hut circle
in the foreground and Dragsholm
Manor in the distance on the left
– the last not shown as it was in
the early nineteenth century but
as it appeared in the Middle Ages,
when it had been built as a brick
castle. It is thus that Lundbye's
landscapes made an important
contribution to the idealisation
of Denmark, central to the Danish
national Romantic movement,
which called for Danish views
with spectacular, historically
charged monuments and
memorials. Denmark had to be
shown as a beautiful country with
a glorious and long history of its
own. TB-M

134
Christen Købke (1810–1848)
*Autumn Landscape. Frederiksborg
Castle in the Middle Distance*, 1837–8
Oil on canvas, 25.5 × 35.5 cm
Unsigned
PROVENANCE: Belonged to the
artist's son, Peter Købke. Acquired
in 1990
SELECTED REFERENCES:
Copenhagen 1991B, no. 106;
Nørregård-Nielsen 1991, p. 96 ff.;
Nørregård-Nielsen 1995, no. 66;
Copenhagen 1996, p. 279 f., fig.
191, no. 131
MIN 3244

The seventeenth-century royal
castle of Frederiksborg, built by
King Christian IV in 1602–15,
became a symbol of the Danish
national Romantic movement.
It held a special place within
Købke's oeuvre, not least through
personal association, since his
family had a house in the nearby
town of Hillerød. He painted the
building from many angles early
in the 1830s and often returned to
it in the course of his short career
as a painter. The castle itself is
located in the middle distance, its
four spires, including that of the
Audience House (see cat. 136), set
against the drifting clouds caught
by the light of the setting sun.
 This masterly late picture is
characterised by its melancholy,
a mood rarely found in Danish
Golden Age painting. Nature is
fading and autumn will soon be
replaced by winter. Købke was
religious, but a non-conformist.
His reading was made up of
psalms, almanacs and some of the
religious-philosophical musings
of the era's Danish clergy. This is
thought to have influenced his
painting significantly in its late
phase. The colour scheme is
reddish, and the leafless trees
in the foreground are frail
silhouettes against the cold
winter sky. It might be conceived
of as a melancholic farewell to a
much loved motif: Købke never
painted Frederiksborg Castle
again. TB-M

135
Johan Thomas Lundbye
(1818–1848)
Landscape at Arresø [Lake Arre], 1838
Oil on canvas, 64 × 86.5 cm
Unsigned
PROVENANCE: Once belonged to
the artist's brother, Colonel
C. C. Lundbye, who was Minister
of Defence. Donated by the Ny
Carlsberg Foundation in 1966
SELECTED REFERENCES:
Gunnarsson 1989, p. 149;
Nørregård-Nielsen 1995, no. 71;
Odense 2003, p. 35
MIN 2856

Johan Thomas Lundbye's
paintings are often marked by his
melancholic disposition, which
sets them apart from the
optimistic and sunny landscapes
produced by other Danish Golden
Age painters. This work was made
when the artist was barely twenty
years old. He was very well
acquainted with the subject,
which was the view from his
parents' garden in Frederiksværk,
some 65 km to the north-west of
Copenhagen.
 Lundbye preferred to represent
the wide, open countryside. The
landscape near Lake Arre spreads
out in an idyllic scene with a
shepherdess, a fisherman and the
then most Danish of all birds, the
stork, in its nest. But the
representation is not wholly
realist: Lundbye arranged the
details in such a way as to portray
Danish nationality and show the
characteristics of the country's
landscape at its best and through
time, lowering the tongue of land
in the middle ground to make
visible the ancient spires and
towers of Frederiksborg Castle
on the horizon. He also made sure
to select two typically Danish
figures – the peasant girl and the
fisherman – and clad them in
national dress, in order to
complete this vision of the nation.
Lundbye's work exemplifies a
gathering impetus in Danish
painting at this time, towards
idealist tampering with the motif.
This type of landscape painting
has its theoretical origin in the
ideological soil of the national
Romantic movement. TB-M

136
Peter Christian Skovgaard
(1817–1875)
View from Frederiksborg Castle, 1842
Oil on canvas, 34 × 59 cm
Unsigned
PROVENANCE: Donated by the
Ny Carlsberg Foundation in 1984
SELECTED REFERENCES: Bramsen
1938, p. 20; Nørregård-Nielsen
1995, no. 109
MIN 3216

At the beginning of the 1840s
the painters Peter Christian
Skovgaard and Johan Thomas
Lundbye worked side by side in
the northern parts of Zealand.
Their subjects included historic
buildings in their landscape
settings. On one of these field
trips Skovgaard returned to one
of the most popular motifs of that
time, namely Frederiksborg
Castle, a seventeenth-century
royal palace. In the work shown
here, a preliminary study for a
larger, finished painting (1842;
Ordrupgaard Museum),
Skovgaard has not depicted the
castle as such but merely the
rooftop of the Audience House
and the passage connecting it to
the main buildings. Behind the
castle lie the royal forests and the
luxuriant landscape of the area.
The high viewpoint suggests its
status as a sketch, since it breaks
with the contemporary
conventions of landscape
painting. Despite this, the
composition is perfectly balanced,
the monumental architecture
of the castle acting as a vertical
counterweight to the dominant
horizontals of water, meadow and
forest beyond. TB-M

137
Martinus Rørbye (1803–1848)
*Vester Egede Church with Gisselfelt
Monastery in the Background*, 1832
Oil on canvas, 23.7 × 34.2 cm
Dated: *1832*
PROVENANCE: Sold at the auction
of the artist's personal effects
in 1849 after his death. Acquired
in 1989
SELECTED REFERENCES:
Copenhagen 1981, no. 27; Munk
1993C, p. 5 ff.; Nørregård-Nielsen
1995, no. 102
MIN 3249

In the summer of 1832, Martinus
Rørbye was staying at the home
of his future in-laws in the village
of Vester Egede in the south of
Zealand. Here he undertook an
extensive campaign of pencil
studies and some oil paintings,
recording the many picturesque
motifs that the area had to offer.
 The study captures the houses
of Vester Egede with the Zealand
landscape behind. Beyond the
church in the centre lies
Gisselfeld Monastery, set within
woodland. Only the church tower
rising above the thatched roofs of
the village breaks the dominant
horizontal structure of land and
sky. Its red tiled roof is echoed in
the roof of the monastery.
 Landscape paintings
celebrating uniquely Danish
scenes and light effects, as in
this scene showing Danish high
summer, mark an important
aspect of the art of the Danish
Golden Age, which is also found
in the work of Lundbye (see cats
133, 135), Skovgaard (see cat. 136)
and Købke (see cat. 130). TB-M

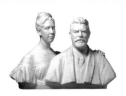

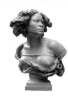

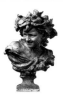

138
Ludvig Brandstrup (1861–1935)
Carl and Ottilia Jacobsen ('The Double Bust'), carved 1906
Marble, H. 76 cm
Not inscribed
PROVENANCE: Commissioned by Carl Jacobsen in 1903
SELECTED REFERENCES: Bencard and Friborg 1995, no. 32
MIN 279

Brandstrup was one of the most popular Danish portrait sculptors of his day. Eschewing excessive interpretations, he sought to capture the physical and psychological likeness of his sitters. As the Jacobsens' 'family sculptor', he received many commissions throughout the 1890s.

'The Double Bust' makes specific reference to the Antique Roman double portrait type, which was used to convey devotion and unity between man and wife. Commissioned in 1903, the year of Ottilia's death at the age of 49, it was completed three years later and thus became a work in which life and death meet. Brandstrup first sculpted a portrait bust of Ottilia in 1895. There is a striking difference between that work and this posthumous one, in which the eyes have no pupils and practically no iris. These 'empty' eyes make the bust an ideal portrait of the late Ottilia. She is a powerful figure *d'outre-tombe*, a patron saint of her widowed husband, her hand resting lightly on his shoulder, offering him support, guidance and blessing. FF

139
Peder Severin Krøyer (1851–1909)
An Evening at the Ny Carlsberg, 1888
Oil on canvas, 145 × 174 cm
Signed lower left: *S. Krøyer. 88.*
PROVENANCE: Ordered by Carl Jacobsen in 1888. Deposited at the Carlsberg Museum, Valby in 1897
SELECTED REFERENCES: Fonsmark et al. 1999, pp. 14–15, fig. 3
MIN 903

In February 1888 Carl Jacobsen wrote to the French sculptors Henri Chapu and Jean Gautherin, asking if they would pose for a painting which would record the sculptors' visit to the original Glyptotek in Valby in 1885.

In the resulting work, Chapu and Gautherin are shown talking to Carl Jacobsen flanked by other male guests, who include artists and leaders of contemporary Danish cultural life, all of them emblematic of Carl Jacobsen's importance as a collector and patron of the arts. Jacobsen's wife Ottilia is seated on the *paté* in a black dress, and the three children in the right corner are Alf, Theodora and little Beatrice. Carl and Ottilia Jacobsen tragically lost four of their eight children in infancy or very early youth: Beatrice, shown here, had died on 31 January 1888, and Krøyer must have worked from photographs for her portrait. Alf, the eldest son, was to die in 1890, at the age of ten. The painting summarises the position of Carl Jacobsen and his family as key players in Danish cultural activities. TB-M

140
Jean-Baptiste Carpeaux (1827–1875)
Negress, modelled 1868, carved 1869
Marble, H. 67 cm
Inscribed on the front of the socle: *POURQUOI NAITRE ESCLAVE* [Why born a slave] and on the right side of the socle: *JBTE Carpeaux 1869*
PROVENANCE: Eugénie Plantié, Caen. Purchased from same by the Ny Carlsberg Foundation in 1911 and donated to the Glyptotek the same year
SELECTED REFERENCES: Paris 1975; Wagner 1986, pp. 262–5; Williamstown 1989; Munk 1993B, no. 66
MIN 1671

This bust is a preparatory study for a bronze fountain commissioned to represent the four continents by the Observatory in Paris. It was executed between 1867 and 1872 and erected in the Jardins de Luxembourg. Created to personify the continent of Africa, the *Negress* represented the native African struggle to break the bonds of slavery. To establish its immediate recognition, Carpeaux undertook precise ethnographic studies so he could create convincing African physiognomy.

The bust was originally modelled in 1868. A marble version was shown at the Paris Salon of 1869, the year in which this version (also in marble) was made. The pose suggest that the negress's hands have been bound behind her by the rope that cuts across her breasts. However, in keeping with the inscription 'Why born a slave', the head is turned in noble defiance of her condition. Carpeaux treated the exotic, piquant motif with a feeling for both decoration and statuary exuberance. Consequently the work encapsulates both political outrage and the kind of prurient seduction frequently found in 'orientalist' work of this period. SMS

141
Jean-Baptiste Carpeaux (1827–1875)
Neapolitan Fisher Lad, modelled 1856 (signed 1857), reproduced 1873
Terracotta, H. 84 cm, including socle
Inscribed on the base at right: *JBte Carpeaux. 1857* and on the back: *PROPRIETE CARPEAUX* [impressed stamp]
PROVENANCE: Amélie Carpeaux, Paris. Purchased from same by the Ny Carlsberg Foundation in 1908 and donated to the Glyptotek the same year
SELECTED REFERENCES: Kocks 1981, pp. 61–7; Wagner 1976, pp. 144–50; Williamstown 1989, nos 1–2; Munk 1993B, no. 50
MIN 1437

The Carpeaux collection came relatively late to the Glyptotek. In 1907–8, the main part of what now numbers a collection of 52 works (45 sculptures and 7 works on paper) was purchased from or generously donated by Carpeaux's widow, Mme Amélie Carpeaux. After her death in 1908 an additional group of works was acquired from the estate and from Carpeaux's daughter, Louise Clément-Carpeaux. In 1913 and as late as 1962, the museum once again had the opportunity to acquire works directly from the family; as in the previous cases this was made possible with the financial support of the Ny Carlsberg Foundation.

This work was modelled in Rome, where Carpeaux was a pensioner at the Institute de France (Villa Medici), having won the Prix de Rome in 1854. It was cast in bronze and shown at the Paris Salon in 1859. This variant is one of many made in a variety of materials.

Neapolitan fisher boys were a popular subject for artist travellers in the nineteenth century. They were not shown at work but rather as the embodiment of carefree youth playing with one of nature's creatures or wonders. In Carpeaux's version, the object of attention is a conch shell: the boy smiles as he listens to its maritime echo.

Despite his admiration for the work of Michelangelo in the late 1850s, Carpeaux has moved towards an impression of greater naturalism in the representation of the boy. He here introduces the distinctive smile for the first time. TB-M

142
Jean-Baptiste Carpeaux (1827–1875)
Laughing Boy with Vines in His Hair, 1860s
Patinated plaster, original model, H. 56 cm, including socle
Inscribed on right-hand side of socle: *JBte Carpeaux*
PROVENANCE: Amélie Carpeaux, Paris. Purchased from same by the Ny Carlsberg Foundation in 1908 and donated to the Glyptotek the same year
SELECTED REFERENCES: Kocks 1981, p. 63; Calais 1982, p. 31; Munk 1993B, no. 51
MIN 1418

One of an important group of original plasters left in Carpeaux's studio on his death in 1875 and acquired from the artist's widow, Amélie, on her death in 1908 (see also cats 143–6), this piece has all the immediacy of direct modelling. The distinctive smile is a striking feature of Carpeaux's allegorical figures (see also cats 143, 144), and had been established as a characteristic of his work in *Neapolitan Fisher Lad* (cat. 141). In *Laughing Boy with Vines in his Hair* Carpeaux has crossed the thin line between idealisation and reality: the boy is grinning and his teeth are showing, yet the vine leaves and grapes in his hair are the attributes of Bacchus, the god of wine, or his followers, bacchantes. Indeed, in this piece Carpeaux uses the attributes and smile to suggest a state of *joie de vivre*, and to epitomize the powers of art, song and mirth. TB-M

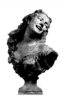

143

Jean-Baptiste Carpeaux
(1827–1875)
Bacchante with Roses, c. 1872
Patinated plaster, original model,
H. 63 cm, including socle
Inscribed on right side of socle:
JBte Carpeaux
PROVENANCE: Amélie Carpeaux,
Paris. Purchased from same by the
Ny Carlsberg Foundation 1908
and donated to the Glyptotek the
same year
SELECTED REFERENCES: Clément-
Carpeaux 1934, p. 357;
Williamstown 1989, no. 26; Munk
1993B, no. 88
MIN 1412

This bust is a reworked version
of a dancing bacchante from
Carpeaux's major decorative
group sculpture, *The Dance*,
commissioned by the state in 1865
as one of the groups of sculpture
to decorate the façade of the new
opera house designed by Charles
Garnier (see also cat. 145); the
original plaster was completed in
1868. When unveiled in July 1869,
the nakedness of the figures and
the apparent gay abandon of their
poses caused an outrage which
threatened to lead to the nude's
removal. It was spared by the
outbreak of the Franco-Prussian
War the following year.

The model for the bacchante
from which *Bacchante with Roses*
was derived was the actress Mlle
Miette, of the Théâtre du Palais-
Royal. In the original work she is
placed to the left of the winged
Genius of Dance. TB-M

144

Jean-Baptiste Carpeaux
(1827–1875)
Spring, c. 1870
Patinated plaster, original model,
H. 59 cm, including socle
Inscribed on the edge of the
shoulder truncation on the right:
JBte Carpeaux
PROVENANCE: Louise Clément-
Carpeaux, Paris. Purchased from
same by the Ny Carlsberg
Foundation in 1908 and donated
to the Glyptotek the same year
SELECTED REFERENCES:
Williamstown 1989, nos 11–12;
Munk 1993B, no. 81
MIN 1413

Carpeaux frequently reproduced
for commercial purposes busts
derived from his larger, highly
acclaimed decorative works. He
either copied them as they were
or modified them to create more
convincing independent pieces.

The bust of *Spring* is a reworked
version of the head of Flora in
The Triumph of Flora, a sculpture
commissioned by the emperor
Napoleon III in 1865 to decorate
the south façade of the recently
completed south wing of the
Louvre, which came to be named
the 'Pavillon de Flore'. In this
version, made in around 1870,
Flora is represented as the
allegory of spring. Unlike her full-
length original, she is no longer
undressed but has been draped in
a thin cloth to cover her bosom.
She is crowned and emblazoned
with garlands of leaves and
flowers. Represented as a happy
young girl, she also signifies
youth. TB-M

145

Jean-Baptiste Carpeaux
(1827–1875)
Portrait Bust of Charles Garnier, 1869
Patinated plaster, original model,
H. 68 cm, including socle
Unsigned
PROVENANCE: Amélie Carpeaux,
Paris. Purchased from same by the
Ny Carlsberg Foundation in 1908
and donated to the Glyptotek the
same year
SELECTED REFERENCES: Clément-
Carpeaux 1934, p. 267; Janson
1985, p. 147; Williamstown 1989,
no. 32; Munk 1993B, no. 75
MIN 1415

Charles Garnier (1825–1898) won
the competition in 1860 to design
the new Paris opera house. Its
façade was unveiled in 1869,
complete with Carpeaux's highly
controversial *Dance* (see cat. 143),
although the building was not
completed until six years later.
This portrait bust was probably
executed around the time of the
façade's unveiling. Carpeaux and
Garnier, who had been friends
since childhood, were at this time
at the peak of their careers.

The expression of the sitter
suggests a man engrossed in
creative thought. The nostrils
quiver and the eyes seem
unfocused. The sketchy execution
of the piece matches brilliantly
the concept of a 'portrait of the
artist'. The writer Théophile
Gautier noted of the bronze
version of the bust, when it was
exhibited at the Salon of 1869,
that is was 'more alive than life'.
Garnier wears an artist's loosely
tied neck scarf and a jacket which
is nonchalantly draped around
his upper body, a modern
paraphrase of the Baroque bust
tradition. TB-M

146

Jean-Baptiste Carpeaux
(1827–1875)
Portrait Bust of Mrs Turner, 1871
Patinated plaster, original model,
H. 85 cm, including socle
Inscribed on right side of socle:
JBte Carpeaux
PROVENANCE: Vente Atelier J.-B.
Carpeaux, 30 May 1913, lot 56.
Purchased there by the Ny
Carlsberg Foundation and
donated to the Glyptotek the
same year
SELECTED REFERENCES: Clément-
Carpeaux 1934, p. 339; Munk
1993B, no. 86
MIN 1746

Carpeaux was an eclectic *par
excellence* in terms of his stylistic
sources. He was inspired by
such great periods of art as the
Renaissance and the Baroque.
His portrait busts are frequently
modelled on the French
seventeenth-century portrait
tradition, especially as seen in
portraits created within the circle
of Louis XIV's court. Yet, Carpeaux
also had to convey a contemporary
likeness. Hence, especially in his
female portraits, he provides
detail in the rendering of hair,
clothes and accessories. Moreover,
in the portrait bust of Mrs Turner,
by stressing the sumptuous dress
Carpeaux solves the problem of
the difficult and abrupt lower cut-
off of the torso, 'à la Fiorentino'.
The dress not only characterises
Mrs Turner as a distinguished and
stylish woman but also completes
the bust in the most elegant way.

Little is known of Mr and Mrs
Turner. Carpeaux met them
during his exile in London in
1871 in the wake of the Franco-
Prussian War and the Paris
Commune. Both husband and
wife sat for the artist. TB-M

147

Eugène Delaplanche (1836–1891)
Music, modelled 1877, carved 1878
Marble, ivory, horsehair and gut,
H. 174 cm
Inscribed: *Delaplanche 1878*
PROVENANCE: Purchased from
the artist by Carl Jacobsen 1878
SELECTED REFERENCES: *Meddelelser
fra Ny Carlsberg Glyptotek*, 35 (1978),
pp. 18–27; Paris 1995; Fonsmark et
al. 1999, no. 54; Søndergaard 2000
MIN 507

Music was originally made to
embellish Garnier's Opéra de
Paris. It presents a synthesis
between meticulously observed
reality – in the form of the violin
string with gut, and the ivory bow
complete with actual horsehair –
and the idealised female form,
whose pose owes much to
Renaissance prototypes, notably
Raphael's figure of St Cecilia.
When the plaster original was
exhibited at the Paris Salon of
1877 critics were perplexed, but
generally approving.

Carl Jacobsen saw the marble
version at the Salon of 1878,
where it made a deep impression
on him and became the first piece
of French sculpture he bought.
In a Danish periodical, *Ude og
Hjemme*, Jacobsen used *Music* to
encapsulate his admiration for
France as a country where art is
revered and placed at the service
of the public, not merely the rich
private patron: 'You sing,
exquisite girl ... of a land where
Art is honoured by great and
small, where it is not regarded
merely as a luxury for the rich,
[but] where state and city vie with
each other to honour it and thus
bring honour on themselves.' SMS

148

Antonin Mercié (1845–1916)
Gloria Victis (Honour to the Vanquished), modelled 1874, cast 1905
Bronze, H. 309 cm
Inscribed: *A.Mercié*; on the edge of the base: *Gloria Victis* (Founder's mark): *Fondu à cire perdue par L.GASNE. Paris.L'ORIGINAL APPARTIENT A LA VILLE DE PARIS)*
PROVENANCE: Commissioned by Carl Jacobsen *c.* 1901–2, cast in 1905, acquired in 1906. Lent to the convalescent home 'Lysglimt' in Gilleleje in 1927. Returned to the Ny Carlsberg Glyptotek in 2000
SELECTED REFERENCES: Wennberg 1978; Paris 1989; Fonsmark et al. 1999, no. 102; Søndergaard 2000
MIN 1336

The public success of *Gloria Victis* at the Salon of 1874 established Mercié's reputation and laid the basis for a highly successful career. The work commemorates those Frenchmen who had fallen during the Franco-Prussian War (1870–1). Given that the war was a military as well as a psychological defeat for the French nation, Mercié has sought, by placing the dead soldier within the arms of the winged figure of Fame, to transform defeat into heroic sacrifice. Following its enthusiastic reception at the Salon, bronze casts of the work were set up all over France.

The group echoes various styles in European sculpture: from the measured elegance of the Renaissance to a Baroque dynamic in the composition. The work is a typical example of the eclecticism that was in vogue in Salon sculpture of the period. SMS

149

Jacques-Louis David (1748–1825)
Portrait of the Comte de Turenne, 1816
Oil on canvas, 112 × 87 cm
Signed on the base to the right: *L. David 1816. Bruxelles*
PROVENANCE: Comte de Turenne. E. Kraemer. Wilhelm Hansen, Ordrupgaard, (1918). Purchased by the Ny Carlsberg Foundation at the Hansen sale in 1923 and donated to the Glyptotek the same year
SELECTED REFERENCES: Wildenstein 1973; de Nanteuil 1985; Paris 1989B; Friborg 1994, no. 39
MIN 1900

This portrait of Comte Henri-Amédée-Mercure de Turenne (1776–1852) belongs to the late period of David's oeuvre, when his painting technique was marked by an exaggeratedly steely neoclassicism. It bears witness to turbulent events. Following the fall of Napoleon in 1815, the revolutionary turned Napoleonic court painter was forced to flee France. He spent the last ten years of his life in exile in Brussels, where he met several compatriots in similar circumstances, among them the Comte de Turenne, one of Napoleon's officers.

David painted the count's portrait twice. In the first version, also made in 1816, he was shown in the uniform of a colonel (Sterling and Francine Clark Art Institute, Massachusetts). In the second version, shown here, the sitter appears in more civilian attire, although he still sports his officer's frock coat and his military decorations. The count's identity and Brussels address are indicated on the envelope that sits on the table, and David's signature reinforces the reference to location. Turenne was allowed to return to France in 1817; he was received back into the higher nobility in 1831. SMS

150

Paul Delaroche (1797–1856)
The Statesman and Historian Guizot, *c.* 1839
Oil on canvas, 53 × 45 cm
Not inscribed
PROVENANCE: Purchased by A. P. Weis for Carl Jacobsen in Cologne in 1878
SELECTED REFERENCES: Ziff 1977, pp. 190 ff., 287; Friborg 1994, no. 52
MIN 963

This painting was acquired when Jacobsen was on his first 'shopping spree' in Europe in 1878. A. P. Weis, one of his long-standing friends and advisers in both business and museum ventures, secured it for him in Cologne. The reason for its purchase is not entirely clear, however. Delaroche was primarily known for his flamboyant history paintings, such as *The Execution of Lady Jane Grey* (1834; National Gallery, London).

It was perhaps Jacobsen's love of portraits that played a role in the choice of this work, which depicts one of the leading politicians of the July Monarchy, François-Pierre Guizot (1787–1874). Delaroche knew Guizot slightly. Shortly after taking up portraiture, in 1837, he was commissioned to paint a three-quarter-length portrait (Brocard Collection, Paris), which Jacobsen may have known from an engraving. This second, smaller version captures the austere personality of Guizot. He was often the butt of caricaturists, including Daumier and Busquet, the latter depicting him in the role of the executioner in a pastiche of Delaroche's *Lady Jane Grey* painting. FF

151

Emile-Auguste Carolus-Duran (1837–1917)
Portrait of a Little Girl in Spanish Costume, 1870
Oil on canvas, 41 × 39 cm
Signed top right: *Carolus-Duran 9 Janvier 1870*
PROVENANCE: Acquired by Carl Jacobsen in 1889
SELECTED REFERENCES: Rostrup 1977, no. 895; Friborg 1994, no. 4; Lille 2003, no. 23B
MIN 968

At the time when the young Carolus-Duran started his career, the contemporary enthusiasm in France for all things Spanish had reached its zenith. In 1866, following the example of a number of fellow artists, most notably Manet, Carolus-Duran embarked upon a study trip to Spain. The trip left a deep impression and a lasting admiration for the Spanish master Velázquez, as can be detected in a number of his paintings.

In *Portrait of a Little Girl in Spanish Costume* Carolus-Duran has drawn inspiration from Velázquez in terms of his limited, tonal palette and rich application of paint; the work might even be seen as a contemporary meditation upon his masterpiece *Las Meninas* (Prado, Madrid). Thus Carolus-Duran could at once permit Velázquez to add lustre to his portrait of a young girl while at the same time paying homage to him as one of the great masters in the history of art. In portraits of his fellow artists, by contrast, Carolus-Duran chose a more realistic style. In this way, the different sources of inspiration acted as a painterly repertoire from which the artist could make his own selection. SMS

152

Jean-Baptiste-Camille Corot (1796–1875)
Landscape from the Region around Civita Castellana with a View towards Monte Soratte, 1827
Oil on paper on canvas, 22.5 × 34.5 cm
Signed bottom right: *COROT*
PROVENANCE: Bonnemaison. Vente Bonnemaison, 29 April 1896, lot 12. Ebstein. Alfred Daber, Paris. Purchased from the latter by the Ny Carlsberg Foundation in 1960 and donated to the Glyptotek the same year
SELECTED REFERENCES: Robaut and Moreau-Nélaton 1905, p. 170; Rostrup 1960, pp. 20–6; Galassi 1991, pp. 184–5; Friborg 1994, no. 7
MIN 2816

During his Italian stay of 1825–8, Corot twice visited Civita Castellana in the Roman Campagna: in May–June 1826 and again in September 1827. In this study, probably made in front of the subject, the Monte Soratte forms the cool bluish background to the landscape in front of which the town's fortifications, La Rocca, are easily recognised.

The composition is a type known from notable predecessors in French art such as Claude Lorrain and, in this case especially, Nicolas Poussin. From a slightly elevated viewpoint, the landscape spreads out in a perfectly harmonised composition. Dense shadows and darker areas in the foliage contrast with an otherwise warm and sunlit landscape. The study has brilliant clarity and a luminosity that is characteristic of the works from Corot's early years, especially the plein-air paintings executed in Italy. Corot has focused on the overall atmospheric impression of the warm, sunlit landscape, an approach rarely seen in contemporary Danish studies by, for example, C. W. Eckersberg (see cat. 112), Christen Købke (see cat. 118) and Fritz Petzholdt (see cat. 115), to whom the rendering of details played a more important role. TB-M

153

Théodore Rousseau (1812–1867)
*Landscape from the Auvergne /
Landscape from the Region of Lake
Geneva*, 1829/30
Oil on paper, 27 × 42.2 cm
Signed: *Th. R.*
PROVENANCE: J. Guérin, Paris.
Donated by the Ny Carlsberg
Foundation in 1908
SELECTED REFERENCES: Friborg
1994, no. 73
MIN 1392

The verso of this study is inscribed
'View in the area of Lake Geneva'.
However, it could also have been
made in the area of the Puy de
Dôme, looking across to the valley
of Clermont-Ferrand. Its scale and
medium (oil on paper) indicate
that it was a study made in front
of the subject.

Rousseau used a special easel for
stretching the paper very tightly
when he did his open air studies,
and this landscape is laid out
generously with the open expanse
of the valley in focus. A Roman
ruin functions as a perfect
repoussoir in the front left, and the
transparent cool blue horizon, set
against the brownish foreground,
increases the feeling of distance.
The young painter has captured
the atmosphere of a warm day in
the open landscape by applying
the oil in an almost watercolour-
like transparency.

The consistent division of the
landscape into horizontal planes
became a significant feature in
Rousseau's mature work, and this
sketch is a forerunner of his
rigidly divided later paintings.
In the present work, the bright
light spreading from the centre
of the painting seems to soften
the horizontal lines. TB-M

154

Jean-Baptiste-Camille Corot
(1796–1875)
*Wooded Landscape from Mas-Bilier
near Limoges*, possibly around 1850
Oil on canvas, 34 × 52 cm
Signed bottom left: *COROT*
PROVENANCE: Gift from Corot to
M. Faulte du Puyparlier, who left
it in his will to his cousin Jules
Lacroix, Limoges. A. Robaut, Paris.
Vente Robaut, 18 December 1907,
lot 7. Purchased at the Vente
Robaut by Carl Jacobsen
SELECTED REFERENCES: Robaut and
Moreau-Nélaton 1905, p. 843;
Petersen 1920, pp. 116–17; Madsen
1920, pp. 52–4; Friborg 1994, no. 8
MIN 1391

Corot stayed in Mas-Bilier on five
occasions between 1850 and 1864.
Given the freshness of its palette
and the apparent naturalism of
its subject, this finished
landscape was probably made
during his first visit. In this
woodland scene, the play of light
and shadow in the treetops and
on the forest floor serve as the
primary motif. The forest floor is
dense and soft and clings around
the uneven ground of the
clearing. Only in a few places do
the sunbeams pass through the
thick foliage, notably along the
path on the right, when touches
of lighter colour are used to
suggest the depth of recession
in the composition.

Carl Jacobsen purchased several
works by Corot for the Glyptotek.
In keeping with his taste for
French sculpture, Jacobsen's
acquisitions of French landscape
painting tended towards the
finished, academic style rather
than studies made in front of the
subject (see cat. 153). This part of
the French collection has been
added to over the years and now
gives a representative account of
Corot's oeuvre. TB-M

155

Jean-Baptiste-Camille Corot
(1796–1875)
Landscape with Harvesters, c. 1850
Oil on canvas, 34 × 47 cm
Signed below left: *COROT*
PROVENANCE: Henri Hecht, Paris.
Vente Hecht, 8 June 1891, lot 2.
Wilhelm Hansen, Ordrupgaard.
Purchased by the Ny Carlsberg
Foundation at the Hansen sale in
1923 and donated to the
Glyptotek in 1932
SELECTED REFERENCES: Robaut and
Moreau-Nélaton 1905, p. 809;
Madsen 1920, p. 59; Asmussen
1993, no. 8; Friborg 1994, no. 9
MIN 1893

In this modest-scaled but finished
landscape, made for the
commercial market, the
specifying of location is
subordinated to the desire to
express through a harvest scene
the unity of Man and Nature.
Harvesters work against a rich
field of corn set against a tranquil,
inhabited landscape and lit from
an overarching sky studded with
clouds. Corot has created a
harmonious, atmospheric
impression of human labour.
The tonality of the painting is
carefully controlled, informed
by the intensity of a uniform light
source. To avoid a monotonous
tonal atmosphere, Corot has
caught the harvesters' shirts in
patches of sunlight and has given
the two women red and blue
kerchiefs, tiny details that
punctuate and enliven the
composition. TB-M

156

Jean-Francois Millet (1814–1875)
Death and the Wood Cutter, 1858–9
Oil on canvas, 77.5 × 98.5 cm
Signed bottom right: *J.F. Millet*
PROVENANCE: Laurent-Richard,
Paris. Purchased by Carl Jacobsen
in 1878
SELECTED REFERENCES: Moreau-
Nélaton 1921, pp. 46, 63 ff.;
Pollock 1977, p. 19 f.; Van Tilborgh
et al. 1988, p. 18; Friborg 1994,
no. 66
MIN 972

In 1878 Carl Jacobsen acquired
Millet's masterpiece *Death and the
Wood Cutter*. While in Paris to visit
the Salon Jacobsen also attended
an auction, from which he bought
this work. It was his first
acquisition of a French painting
and thus became the core of the
French nineteenth-century
collection.

Given his taste for the symbolic
and morally uplifting powers
of art, Jacobsen must have
responded to the picture's
subject, an illustration of one of
La Fontaine's fables. Although
the fable deals with the universal
theme of how old age inevitably
leads to death, the mid-
nineteenth-century
interpretation given to it by Millet
turns it into a comment on the
inevitable fate of the struggling
rural poor. The stark
personification of Death
combined with a generalised
portrayal of the peasant and his
rural environment makes the
scene both timely and universal.
TB-M

157

Théodore Rousseau (1812–1867)
Thunderstorm over Mont Blanc,
1834, 1863–7
Oil on canvas, 143 × 240 cm
Signed bottom left: *Th. R.*
PROVENANCE: Vente Rousseau,
1868, no. 10. Bonnet. A. Roux,
1914. Donated by the Ny Carlsberg
Foundation in 1919
SELECTED REFERENCES: Dorbec
1910, p. 104; Huyghe 1976, p. 338;
Friborg 1992, p. 112 ff.; Friborg
1994, no. 74
MIN 1783

The Jura Mountains in the eastern
part of France provided a range
of rugged, sublime subjects for
landscape painters in the middle
of the nineteenth century. While
Courbet was primarily concerned
to capture the distinct geology of
the region, Rousseau sought an
altogether more sublime record
of the rough landscape. Detail
was excluded in order to convey
an overall impression of the
magnificence and thrill of
mountain and weather effects.

The Romantic idea of 'the
sublime' – which derived its
source from eighteenth-century
aestheticism, the philosopher
Edmund Burke (1729–1787) and
the English Romantic landscape
tradition – connotes a sensation
of awe and dread when faced with
monumental natural effects of
height and depth. These natural
elements are all present in
Rousseau's rendering of the
overwhelming landscape in
which the spectator is
precariously suspended above
a yawning chasm, with a
thunderstorm passing over
Mont Blanc in the distance.
The monumentality and deep
perspective of the composition,
together with the elimination
of any reference to a human
presence, emphasises the
insignificance of humanity when
confronted with the awesome
powers of nature.

Rousseau laid out the
composition in 1834; he reworked
it from 1863 until his death in
1867, when it remained
unfinished. TB-M

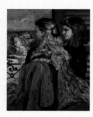

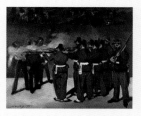

158
Gustave Courbet (1819–1877)
Landscape with Trees, c. 1856
Oil on canvas, 88 × 115 cm
Signed bottom left: *G. Courbet*
PROVENANCE: Collection Henri
Hecht, Paris. Galerie
Thannhauser, Paris. Purchased
by the Ny Carlsberg Foundation
in 1927 and donated to the
Glyptotek in 1932
SELECTED REFERENCES: Rostrup
1931, pp. 113–22; de Forges 1962,
p. 56; Fernier 1977, p. 198; Friborg
1994, no. 21
MIN 1897

The location of this landscape
by Courbet is uncommon in his
oeuvre. In contrast to his near-
contemporaries, the landscape
painters of the Barbizon School,
Gustave did not make regular
visits to the Forest of
Fontainebleau, south-east of Paris.
Instead, he preferred the
mountainous regions of eastern
France and Switzerland. However,
in both its composition – the
concentration on a specific group
of trees – and the thickly worked
technique, the painting is similar
to his other landscapes. He
'botanises': we are not presented
with an overall idea of the
Fontainebleau forest landscape
but with a careful exposition
of the relationship of three great
trees to the rock-strewn land
below. Here, Courbet's purpose
was above all to present the
material structure of the ground
and of the imposing tree trunks.
The painting is obviously a studio
work based on studies from an
excursion. TB-M

159
Gustave Courbet (1819–1877)
Self-portrait, 1850–3
Oil on canvas, 71.5 × 59 cm
Unsigned
PROVENANCE: Wilhelm Hansen,
Ordrupgaard, (1916). Purchased
by the Ny Carlsberg Foundation
at the Hansen sale in 1923 and
donated to the Glyptotek the
same year
SELECTED REFERENCES: Asmussen
1993, no. 43; Friborg 1994, no. 20
MIN 1896

Courbet was an artist who, like
Rembrandt, subjected his own
image to regular scrutiny in a
sequence of self-portraits,
especially in the period between
around 1840 and 1855. While
those of the 1840s tended to
present the artist in a role, such
as a cello player or a madman,
this one, dating from the early
1850s, shows him as a simple
man in shirtsleeves, set against
a generalised landscape. In so
doing, Courbet is possibly
identifying himself as a man
of the people, in this case the
peasant stock of his native
Ornans, consistent with his
socialist convictions.
 The low viewpoint endows
the artist with a certain
monumentality, which
communicates a sense of the
nobility and pride of the peasant.
SMS

160
Gustave Courbet (1819–1877)
*Three Young Englishwomen by a
Window, 1865*
Oil on canvas, 92.2 × 72.5 cm
Signed bottom right: *G. Courbet*
PROVENANCE: E. Baudry. Prince
de Wagram. Maczell de Nemes,
Budapest. Herzog. Purchased for
the Glyptotek by the Ny Carlsberg
Foundation at the Exhibition of
French Art at the Statens Museum
for Kunst, Copenhagen in 1914
SELECTED REFERENCES: New York
1988, p. 168 ff.; Friborg 1994, no.
22; Bajou 2003, p. 338
MIN 1750

This work, ostensibly a study of
the three daughters of the English
wallpaper manufacturer John
Gerald Potter (1829–1980), is
effectively a study in hair. It was
made in Trouville in 1865, when
Courbet was engaged in other
works that celebrated the beauty
and sensuousness of female hair
(such as *Portrait of Jo, the Beautiful
Irish Girl*, 1865; Nationalmuseum,
Stockholm).
 The work was not a
commissioned portrait. In the
summer of 1865 Courbet had met
the three girls, Julia, Grace and
Rose, in the studio of his friend,
Alfred Stevens (1817–1875).
Courbet was fascinated, and
executed his own version of the
three girls. He arranged them as a
narrow picture plane, which gives
the composition a decorative, two-
dimensional effect in which the
dominant colour and texture of
the hair of the three girls becomes
the central feature.
 John Potter refused to buy the
picture. After its eventual sale,
a later owner, possibly Maczell
de Nemes, painted over the girl
and the dog on the left, perhaps
because he took issue with
Courbet's representation of space.
FF

161
Edouard Manet (1832–1883)
The Absinthe Drinker, 1859
Oil on canvas, 180.5 × 105.6 cm
Signed, right: *Manet*
PROVENANCE: Sold by the artist
to Durand-Ruel in 1872. Jean-
Baptiste Faure, Paris. Bought
at Faure's auction in 1906, by
Durand-Ruel. Bought at the
Exhibition of French Art at the
Statens Museum for Kunst,
Copenhagen in 1914, no. 127,
by the Ny Carlsberg Foundation.
Donated to the Glyptotek in 1917
SELECTED REFERENCES: Lajer-
Burchart 1985; Fonsmark 1987;
Munk 1993, no. 18
MIN 1778

This is one of Manet's first
paintings of modern-life subjects.
Although the model is thought
to have been a certain Collardet,
the painting is not a portrait but
the representation of a type, a
figure who lives on the margins
of society, excluded by the
modernisation of Paris under
the Second Empire. The work was
rejected by the Salon of 1859,
on the grounds of both subject
matter and technique. Manet had
deliberately eschewed a smooth
academic method of painting in
favour of a looser approach and a
very narrow colour range. In this
regard Manet was paying homage
to the great seventeenth-century
Spanish painter Velázquez,
adopting both the pose and the
palette of the latter's four great
paintings of 'Philosophers' (Prado,
Madrid).
 The canvas was extended some
time between 1867 and 1872,
when the absinthe glass and the
bottle were added, possibly as an
allusion to the poem 'Le Vin des
chiffonniers' (The Ragpickers'
Wine) by Manet's friend the poet
and critic Charles Baudelaire
(1821–1867). SMS

162
Edouard Manet (1832–1883)
*The Execution of the Emperor
Maximilian, 1867*
Oil on canvas, 48 × 58 cm
Signed lower left: *Manet 1867*
PROVENANCE: Gift from Manet
to Méry Laurent, Paris. Victor
Margueritte, Paris. Montaignac,
Paris. Bernheim-Jeune, Paris,
1906. Denys Cochin, Paris, 1909.
Durand-Ruel, Paris, 1910. Bought
at the Exhibition of French Art
at the Statens Museum for Kunst,
Copenhagen in 1914, no. 129, by
the Statens Museum for Kunst.
Deposited with the Glyptotek
in 1915
SELECTED REFERENCES: Fonsmark
1984; London 1992; Munk 1993,
no. 19; Madrid 2004, no. 79
MIN-smk 3270

Napoleon III of France was
instrumental in Archduke
Maximilian of Austria being
installed as Emperor of Mexico
in 1864, shored up by French
troops and capital. In March 1867,
however, France withdrew its
troops. Two months later the
emperor was taken prisoner and
on 19 June 1867 he was executed
by Republican insurgents.
 The event has profound
repercussions in France. Manet
was deeply affected, creating
a group of works based on
newspaper accounts and prints
illustrating the execution. He also
had recourse to Goya's politically
loaded painting, *The Third of May,
1808* (*c.* 1814; Prado, Madrid), which
he had seen on a recent visit to
Madrid. There are three complete
versions (this one; one in the
Museum of Fine Arts, Boston; and
one in the Kunsthalle, Mannheim)
and four fragments surviving from
a fourth, large-scale version which
Manet cut up (National Gallery,
London). All date from 1867. The
original version may be that in
Boston, since it shows the soldiers
still in Mexican uniform. Given
the traces of a squared-up grid, the
depiction of the soldiers in French
uniform, and the scale of the work,
the Ny Carlsberg version probably
served as a sketch for the finished,
larger version now in Mannheim.
 The fact that Manet chose to
dress the soldiers in French
uniform transformed the meaning
of the work into one in which the
French were seen as having
betrayed the Mexican cause; as
such it served as a critique of the
politics of the Second Empire. SMS

163

Edouard Manet (1832–1883)
Mademoiselle Isabelle Lemonnier,
c. 1879–82
Oil on canvas, 86.5 × 63.5 cm
Unsigned
PROVENANCE: Estate of the artist.
Thos. Agnew, London, (1902). Lord
Grimthorpe, London. Auction of
the Grimthorpe estate, Christie's,
London, 12 May 1906. Alphonse
Kann, Paris. Wilhelm Hansen,
Ordrupgaard, 1918. Bought by the
Ny Carlsberg Foundation in 1923
and donated to the Glyptotek the
same year
SELECTED REFERENCES: Munk 1993,
no. 20
MIN 1912

In the years 1879–82 Manet
painted six portraits of Isabelle
Lemonnier (1857–1926). She was
the daughter of a jeweller and the
sister of Marguerite Charpentier
(1848–1904), the wife of the
successful publisher Georges
Charpentier (1846–1905).
Charpentier published works by
naturalist writers and the avant-
garde periodical *La Vie Moderne*,
and made the offices of the latter
available from 1880 for one-man
exhibitions by, amongst others,
Manet and the Impressionists.
Manet probably met Isabelle
Lemonnier at her sister's salon
attended by avant-garde artists
and writers.

In this portrait Manet has
shown Mlle Lemonnier wearing
her coat, as if she has just come in
from the street. The sketchy
treatment underlines the casual
mood. As a hint to the modern life
of Paris as it could be encountered
on the boulevards, Isabelle may
represent the modern *parisienne*.
SMS

Edgar Degas, sculptures

On Degas's death in 1917, around
150 wax models were found in his
studio. These sculptures can be
classed into five groups: horses,
dancers, women at their toilette
or bathing, three portraits and
one relief (his only essay in that
genre). Started as early as the
1860s, these small-scale
sculptures were made for Degas's
own use: with the exception of
the *Little Ballet Dancer Aged Fourteen
Years*, shown in 1881 at the sixth
Impressionist exhibition, none
was intended for public
exhibition. Rather, the wax
models offered a way to gain
deeper understanding of the
figures in his paintings. As Degas
remarked: 'The only reason I
made wax figures of animals and
people was for my own
satisfaction, not to relax from
painting and drawing but to give
the paintings and drawings more
expressiveness, more intensity
and more life. They are exercises
meant to get me started;
documents, no more. Nothing
was done with sale in mind'
(interview with Thiébault-Sisson,
printed in *Le Temps*, 1921).

In 1919, 72 of the wax models
were cast in bronze by the bronze-
founder Adrien Hébrard; they
were displayed in his gallery in
1921. The following year an
edition of 22 complete sets was
made, 20 of which were marked
with the letters 'A–T'. The Ny
Carlsberg Glyptotek owns a
complete set, 'R', which was
donated in 1949 by the Ny
Carlsberg Foundation. *The
Schoolgirl* (cat. 164), which was
only cast in an edition of 20,
in 1956, was donated in 1957.

The dates of the original
sculptures are uncertain. Dates
given here are those given by John
Rewald and Charles W. Millard
respectively. SMS

164

Edgar Degas (1834–1917)
The Schoolgirl, 1879
Bronze, 27.5 × 12 × 15 cm
Inscribed on base, centre right:
Degas, and on base, back left:
founder's mark and *3/20*
PROVENANCE: Donated by the
Ny Carlsberg Foundation in 1957
SELECTED REFERENCES: Munk 1993,
no. 101; Czestochowski and
Pingeot 2002, no. 74
MIN 2799

165

Edgar Degas (1834–1917)
*Nude Study for the Little Ballet Dancer
Aged Fourteen Years, c.* 1878–80
Bronze, 72 × 34 × 28 cm
Inscribed on base, front right:
Degas, and on base, back left:
founder's mark. On edge: *56/R*
Original model: red wax with
brown spots (National Gallery
of Art, Washington DC)
PROVENANCE: Donated by the Ny
Carlsberg Foundation in 1949
SELECTED REFERENCES: Munk 1993,
no. 82; Czestochowski and
Pingeot 2002, no. 56
MIN 2650

166

Edgar Degas (1834–1917)
Dancers Practising in the Foyer,
c. 1875–1900
Oil on canvas, 71 × 88 cm
Atelier stamp lower right
PROVENANCE: Vente Atelier Degas,
I, 6–8 May 1918, lot 46. Galerie
Georges Petit, Paris. Trotti, Paris.
Wilhelm Hansen, Ordrupgaard,
1918. Bought by the Ny Carlsberg
Foundation from the Hansen sale
in 1923 and donated to the
Glyptotek in 1932
SELECTED REFERENCES: Munk 1993,
no. 2; Detroit 2003, pp. 83–6
MIN 1903

Around 1873 Degas began to work
on what was to become a veritable
cycle of paintings representing
the ballet classroom. At least
eight of them, including this one,
seem to be set in the same lofty
room with tall round-topped
windows along one side. The
present work, however, was
among several that Degas
repainted during the 1890s. The
original 1870s version is thought
to have included five dancers, all
of them to one side of the three
columns, leaving the rest of the
composition unpopulated. In
reworking the composition Degas
eliminated one dancer, whose
presence is still slightly visible to
the far left of the canvas, and
added a further three in the right-
hand section. The reworking also
led to some stylistic changes:
typically for Degas's late work,
the brushwork has become bolder
and the colours stronger.

Degas regularly included two
or three variants of the classroom
theme in each Impressionist
exhibition from 1874 to 1879.
Dancers Practising in the Foyer might
have featured at the Impressionist
exhibition of 1876. SMS

167

Edgar Degas (1834–1917)
Dancer Putting on Her Stocking,
1896–1911
Bronze, 46 × 19 × 33 cm
Inscribed on base, left of left foot:
Degas, and on base behind left
foot: founder's mark and *29/R*
Original model: brown wax
(National Gallery of Art,
Washington DC)
PROVENANCE: Donated by the
Ny Carlsberg Foundation in 1949
SELECTED REFERENCES: Munk 1993,
no. 59; Czestochowski and
Pingeot 2002, no. 29
MIN 2687

168

Edgar Degas (1834–1917)
Grande Arabesque, 1882–95 /
1885–90
Bronze, 45 × 28 × 54 cm
Inscribed on base, back left: *Degas*,
and at the right leg: founder's
mark and *60/R*
Original model: beeswax and
paraffin wax (Musée d'Orsay,
Paris)
PROVENANCE: Donated by the
Ny Carlsberg Foundation in 1949
SELECTED REFERENCES: Munk 1993,
no. 53; Czestochowski and
Pingeot 2002, no. 60
MIN 2670

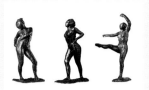 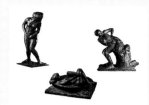 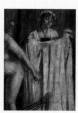 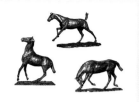

169

Edgar Degas (1834–1917)
Dancer Fastening the String of Her Tights, 1882–95 / 1885–90
Bronze, 42.5 × 21.5 × 15 cm
Inscribed on base, back left: *Degas*, and on base, back right: founder's mark and *33/R*
Original model: brownish-yellow wax (National Gallery of Art, Washington DC)
PROVENANCE: Donated by the Ny Carlsberg Foundation in 1949
SELECTED REFERENCES: Munk 1993, no. 60; Czestochowski and Pingeot 2002, no. 33
MIN 2659

170

Edgar Degas (1834–1917)
Dancer at Rest, Hands Behind Her Back, Right Leg Forward, 1882–95 / 1881–5
Bronze, 44.5 × 14 × 25.5 cm
Inscribed on base, back left: *Degas*, founder's mark and *63/R*
Original model: green wax and plastilina (National Gallery of Art, Washington DC)
PROVENANCE: Donated by the Ny Carlsberg Foundation in 1949
SELECTED REFERENCES: Munk 1993, no. 69; Czestochowski and Pingeot 2002, no. 63
MIN 2653

171

Fourth Position Front, on the Left Leg, 1883–8 / 1896–1911
Bronze, 40.5 × 28 × 25 cm
Inscribed on the base at left leg: *Degas*, and on base, back right: founder's mark and *6/R*
Original model: brown wax (Musée d'Orsay, Paris)
PROVENANCE: Donated by the Ny Carlsberg Foundation in 1949
SELECTED REFERENCES: Munk 1993, no. 54; Czestochowski and Pingeot 2002, no. 6
MIN 2686

172

Edgar Degas (1834–1917)
Woman Taken Unawares, 1896–1911
Bronze, 40.3 × 28 × 19 cm
Inscribed on base, front right: *Degas*, and on back left: founder's mark and *42/R*
Original model: yellowish-brown wax (National Gallery of Art, Washington DC)
PROVENANCE: Donated by the Ny Carlsberg Foundation in 1949
SELECTED REFERENCES: Munk 1993, no. 89; Czestochowski and Pingeot 2002, no. 42
MIN 2685

173

Edgar Degas (1834–1917)
The Tub, 1888–9
Bronze, 24 × 42 × 47 cm
Inscribed on base, back left: *Degas*, and on base, back right: founder's mark and *26/R*
Original model: figure, reddish-brown wax; tub, lead; water, plaster (National Gallery of Art, Washington DC)
PROVENANCE: Donated by the Ny Carlsberg Foundation in 1949
SELECTED REFERENCES: Munk 1993, no. 84; Czestochowski and Pingeot 2002, no. 26
MIN 2658

174

Edgar Degas (1834–1917)
Seated Woman Wiping Her Left Side, 1896–1911 / 1900–10
Bronze, 35 × 24 × 35 cm
Inscribed on base, left: *Degas*, and on base, front right: founder's mark and *46/R*
Original model: red wax (National Gallery of Art, Washington DC)
PROVENANCE: Donated by the Ny Carlsberg Foundation in 1949
SELECTED REFERENCES: Munk 1993, no. 87; Czestochowski and Pingeot 2002, no. 46
MIN 2700

175

Edgar Degas (1834–1917)
Toilette after the Bath, 1888–9
Pastel on paper, 77.5 × 53.5 cm
Atelier stamp lower left
PROVENANCE: Vente Atelier Degas, I, 6–8 May 1918, lot 197. Lazare Weiller, Paris. L. Benatow, Paris. Donated by the Ny Carlsberg Foundation in 1951
SELECTED REFERENCES: Rostrup 1952; Munk 1993, no. 5
MIN 2724

Although this work depicts a genre scene, it might also be a portrait in disguise. The features of the servant probably represent the famous actress, Gabrielle Réjane (1857–1920), who played the title role of a servant maid in the play *Germinie Lacerteux* by Edmond de Goncourt, which opened at the Théâtre de l'Odéon in Paris on 19 December 1888. If so, the pastel must date from around 1888–9 and as such comes towards the end of the group of monumental pastel works showing nude women in various stages of bathing that Degas had embarked upon at the beginning of that decade.

The bold composition of the work, with the figure of the bathing woman arbitrarily pushed partially out of the composition on the left, is evidence of Degas's inspiration from Japanese woodcuts, much admired by artists in the Impressionist circle. By narrowing the picture space Degas managed to intensify the relation between work and beholder and create a stronger sense of intimacy in the scene, in which the viewer is cast in the role of voyeur. SMS

176

Edgar Degas (1834–1917)
Rearing Horse, 1865–81 / end 1880s / 1888–90
Bronze, 30.5 × 19.5 × 24 cm
Inscribed on base, back left: *Degas*, and on base, front left: founder's mark and *4/R*
Original model: red wax (National Gallery of Art, Washington DC)
PROVENANCE: Donated by the Ny Carlsberg Foundation in 1949
SELECTED REFERENCES: Munk 1993, no. 108; Czestochowski and Pingeot 2002, no. 4
MIN 2646

177

Edgar Degas (1834–1917)
Horse Galloping with the Off Fore Leading, 1865–81 / 1881–90
Bronze, 30 × 21 × 44 cm
Inscribed on base at left hind leg: *Degas*, and on base, front left: founder's mark and *47/R*
Original model: brown wax (National Gallery of Art, Washington DC)
PROVENANCE: Donated by the Ny Carlsberg Foundation in 1949
SELECTED REFERENCES: Munk 1993, no. 105; Czestochowski and Pingeot 2002, no. 47
MIN 2639

178

Edgar Degas (1834–1917)
Horse with Head Lowered, 1865–90
Bronze, 19 × 8 × 28 cm
Inscribed on base, centre back: *Degas*, and on base behind right hind leg: founder's mark and *22/R*
Original model: brown wax (National Gallery of Art, Washington DC)
PROVENANCE: Donated by the Ny Carlsberg Foundation in 1949
SELECTED REFERENCES: Munk 1993, no. 110; Czestochowski and Pingeot 2002, no. 22
MIN 2645

179

Edgar Degas (1834–1917)
Village Street, Saint-Valéry-sur-Somme, c. 1896–8
Oil on canvas, 67.5 × 81 cm
Atelier stamp lower right
PROVENANCE: Vente Atelier Degas, II, 13 December 1918, lot 44. Clausen, Paris. C. J. Becker, Copenhagen, gift to the Royal Museum of Fine Arts, 1941. Deposited with the Glyptotek in 1945
SELECTED REFERENCES: New York 1988B, no. 355; Kendall 1993, pp. 257–9; Munk 1993, no. 4
MIN-smk 4324

Landscapes play a very special part in Degas's oeuvre, from the backdrops of his early racecourse pictures to the sequence of paintings made of the village of Saint-Valéry-sur-Somme on the Channel coast, his last essays in the genre. The work shown here was made in the studio, based on plein-air sketches in charcoal and pastel and, perhaps, on photographs, Degas being a keen practitioner in that medium. It is enigmatic in its representation of a banal, nondescript village street, devoid of any human presence or narrative content. Here, the artist seems to have been exploring the relationship between perspective, mass and colour, grappling late in life with the basic components of a picture. It is possible that Degas might have been inspired by Cézanne's similar struggle to express the essential structure of a given landscape. Degas collected paintings by the Provençal master, most being acquired between 1895 and 1898. Degas's late landscapes might be seen in that context. FF

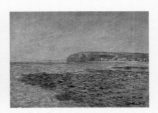

180
Claude Monet (1840–1926)
Windmill and Boats near Zaandam, Holland, 1871
Oil on canvas, 48 × 73.5 cm
Signed lower right: *72 Claude Monet*
PROVENANCE: Jean-Baptiste Faure, Paris, *c.* 1883. Durand-Ruel, Paris, 1907. Henckel, Germany. Hermann Stoll, Zurich. Alfred Schwabacher, New York. Sotheby's, London, 2 December 1970, lot 13. Sotheby's, London, 2 December 1986, lot 17. Bought by the Ny Carlsberg Foundation and donated to the Glyptotek the same year
SELECTED REFERENCES: Wildenstein 1974, no. 177; Amsterdam 1986, no. 20; Nørregård-Nielsen 1987; Munk 1993, no. 23; Søndergaard 2002
MIN 3233

Monet spent the summer of 1871 in Holland on his way back to France from an 'exile' in London precipitated by the Franco-Prussian War and the Commune. Settling in Zaandam, 12 km outside Amsterdam, he made 24 paintings of which three, including this one, depict the windmill, Het Oosterkattegat and the open expanse of water at Vorzaan and Ij. On his return to France his mentor, Boudin, wrote: 'Monet has returned from Holland with a series of magnificent pictures. He will undoubtedly come to play a leading role in our movement.'
 Monet's brushwork in this early work is inspired by Manet, whom he had met in 1866 and whom he greatly admired. The picture appears to be an essay on the old and the new. In the left foreground stands an old windmill, set amongst natural vegetation and complemented by traditional sailing vessels. On the distant horizon to the right appears the silhouette of a more modern, industrial area. The drifting smoke from the chimneys in the distance might be read as a sign of the new epoch. In this regard, the painting presages the extensive investigation of the intrusion of modern industry into an older France undertaken by Monet in the subsequent four years at Argenteuil, on the River Seine. SMS

181
Alfred Sisley (1839–1899)
Inundation: The Ferry of the Ile du Bac, 1872
Oil on canvas, 45 × 60 cm
Signed lower left: *Sisley.72.*
PROVENANCE: Durand-Ruel, Paris, 1873. François Depeaux, Rouen. Vente Depeaux, Galerie Georges Petit, Paris, 31 May 1906, lot 58. Bernheim-Jeune, Paris. Prince de Wagram, Paris. Alfred Strölin, Paris. Levesque & Cie, Paris. Purchased by the Ny Carlsberg Foundation at the Exhibition of French Art, Statens Museum for Kunst, Copenhagen, 1914, no. 197, and donated to the Glyptotek the same year
SELECTED REFERENCES: Daulte 1959, no. 21; London 1993, no. 16; Munk 1993, no. 40; Lyon 2003, no. 28
MIN 1752

Sisley probably moved to Louveciennes, a village above the River Seine to the north-west of Paris, in the winter of 1871–2. Already a member of the nascent Impressionist group, he set about visually mapping the village and its environs. The picture shown here is one of a sequence of four works made in the nearby river port of Port-Marly, recording floods created when the Seine burst its banks in early spring 1872. The rapid, often thinly loaded brush strokes occasionally leave areas of untouched canvas visible, giving the painting a suggestion of the unfinished. This makes it a typical example of Impressionist painting, with its apparently sketch-like, spontaneous record of a fleeting moment in time. The composition is in fact carefully constructed: the tree and the telegraph pole divide the picture into sections, and the spectator's gaze is drawn into the picture by the ferry cable which links Port-Marly to the Ile du Bac. It is possible that the compositional precedents of Japanese woodcuts might have influenced the work. The painting was hailed by some critics when it was shown at the first Impressionist exhibition held in April 1874. SMS

182
Alfred Sisley (1839–1899)
The Furrows, 1873
Oil on canvas, 45.5 × 64.5 cm
Signed lower right: *Sisley.73*
PROVENANCE: Bernheim-Jeune, Paris. Prince de Wagram, Paris. Barbazanges, Paris. Levesque & Cie, Paris. Bought by the Ny Carlsberg Foundation at the Exhibition of French Art at the Statens Museum for Kunst, Copenhagen, 1914, no. 199, and donated to the Glyptotek the same year
SELECTED REFERENCES: Daulte 1959, no. 65; Rostrup 1977, no. 941; Munk 1993, no. 41
MIN 1763

Unlike most of his Impressionist colleagues, Sisley did not reject the use of mid-tone colours in his painting. This is evident in *The Furrows*, which was painted in the region of Louveciennes, where Sisley lived from 1871/2 to 1874. The furrows take pride of place in this composition, which is as daring as such works as *Champs de blé* (1872; Kunsthalle, Hamburg) and *Les Champs* (1874; Leeds City Art Gallery) in which the dramatic perspectival plunge into depth in the composition has been achieved by direct confrontation with ingeniously organised components of the landscape (in this case the furrows in the ploughed field). The scene has been delicately rendered in Sisley's characteristic muted palette, an aspect of his art that inspired contemporary critics to comment upon the poetry in his rendering of the natural scene. SMS

183
Berthe Morisot (1841–1895)
Peasant Girl Hanging Clothes to Dry, 1881
Oil on canvas, 46 × 67 cm
Atelier stamp (twice) lower right: *Berthe Morisot*
PROVENANCE: Mme Pompé, Paris. Bought from same by the Ny Carlsberg Foundation in 1950, and donated to the Glyptotek the same year
SELECTED REFERENCES: Munk 1993, no. 29; Claret, Montalant and Rouart 1997, no. 106; Lille 2002, no. 54
MIN 2715

In the summer of 1881 Berthe Morisot and her husband Eugène Manet, the brother of Edouard Manet, rented a house in Bougival. Here she painted the same peasant girl twice: once seated on the grass and once hanging washing out to dry. The latter subject belonged to the conventional repertoire of contemporary genre scenes and invites comparison with the personal subjects undertaken by Morisot's fellow Impressionist, Camille Pissarro. Morisot's treatment is devoid of any anecdotal narrative; the straightforward representation of this everyday activity is the pretext for a bold composition and highly original feather-like brushwork based on a fine sense of colour. This painting was one of nine works shown by Morisot at the seventh Impressionist exhibition in 1882. SMS

184
Claude Monet (1840–1926)
Shadows on the Sea. The Cliffs at Pourville, 1882
Oil on canvas, 57 × 80 cm
Signed lower right: *Claude Monet 82*
PROVENANCE: Durand-Ruel, Paris, 1882 (?). Georges Petit, Paris, 1883. Prince de Wagram, Paris. Levesque & Cie, Paris. Bought at the Exhibition of French Art at the Statens Museum for Kunst, Copenhagen, 1914, no. 148, by the Ny Carlsberg Foundation and donated to the Glyptotek the same year
SELECTED REFERENCES: Wildenstein 1979, no. 792; Munk 1993, no. 24
MIN 1753

This painting was executed during Monet's sojourn in Pourville from mid-July to the beginning of October, 1882. Monet had returned to the Normandy coast in 1879 after some ten years' absence, in part as a source for fresh subject matter and renewed creative inspiration. The long shadow cast over the water is of the steep cliffs at Varengeville. The view is towards the east; in the background are the houses of Pourville and the cliffs of Amont, beyond which lies the port of Dieppe.
 Throughout his career Monet was fascinated by light reflected on water. This painting reveals Monet's fully developed Impressionist technique where shadows, reflections and movement are rendered in a series of short brush strokes in pure, unmixed pigments. This work was probably the first by Monet to enter a Danish public collection. SMS

185
Claude Monet (1840–1926)
'Les Pyramides' at Port-Coton,
Belle-Ile-en-Mer, 1886
Oil on canvas, 59.5 × 73 cm
Signed lower left: *Claude Monet 86*
PROVENANCE: Serge Schoukin,
Paris. Durand-Ruel, Paris, 1898.
Fayet, Paris, 1902. Bernheim-
Jeune, Paris, 1905. Rosenberg,
Paris, 1905. Professor J. C. Bock,
Copenhagen, (1948). Mr and Mrs
Erik Meyer, Copenhagen, (1960).
Mrs A. Meyer, Copenhagen.
Bought from the last by the Ny
Carlsberg Foundation in 1961,
and donated to the Glyptotek the
same year
SELECTED REFERENCES:
Wildenstein 1979, no. 1086;
Boston 1989, pp. 29–31; Delouche
1992; Munk 1993, no. 26
MIN 2820

Monet's search for new subject
matter during the 1880s took him
not only to the Normandy coast
(see cat. 184) but also further
afield to the Mediterranean coast
and to Brittany. He visited Belle-
Ile-en-Mer, an island off the south
coast of Brittany, in September
1886. Here he created a sequence
of paintings of the rocky coastline
of this rugged, granite island,
under weather conditions
ranging from sunlit calm to
stormy tempests.
 This painting, showing the
famous rocks 'Les Pyramides' near
Port-Coton, exemplifies Monet's
increasing tendency to render
light and form through dense
touches of colour. He challenges
the traditional relationship
between figure and ground as
well as the laws of perspective,
and makes the rocks stand out as
individual sculptural entities.
These dark structures are set off
by the green and white of the sea.
Reality and abstraction alternate
in the heavy-textured but vibrant
light that is so characteristic of
Monet's painting after 1880. SMS

186
Paul Cézanne (1839–1906)
Self-portrait with a Bowler Hat,
c. 1883–4
Oil on canvas, 44.5 × 35.5 cm
Unsigned
PROVENANCE: Stéphan Bourgeois
Gallery, New York. Auction Mr X.
Collection (Coll. Leonardus
Nardus?). Auction F. Müller,
Amsterdam, 19 June 1917.
Wilhelm Hansen, Ordrupgaard,
1917. Bought by the Ny Carlsberg
Foundation from the Hansen sale
in 1923 and donated to the
Glyptotek in 1932
SELECTED REFERENCES: Munk and
Olesen 1993, no. 13; Rewald 1996,
vol. 1, no. 584; Kitschen 1998,
p. 122; Vienna 2000
MIN 1892

Between 1858 and 1902 Cézanne
painted his self-portrait at least
23 times. Around the middle of
the 1860s he introduced a
characteristic pose with himself
looking back over his shoulder at
the beholder, a pose which he
used in seven self-portraits,
including the one shown here.
 Cézanne directs a penetrating
gaze towards the viewer but
somehow still manages to
maintain a distance that belies
the intensity of his portrait
presence. The paint has been
applied with the artist's
characteristic diagonal
brushwork, which constructs the
analysis of the essential volumes
of visage, coat and hat. The sense
of a dialogue between finished
and unfinished, characteristic of
Cézanne's later work, is conveyed
by the irregular build-up of the
paint surface. It is a work that is
sketchy in patches, most visibly so
where the canvas is left exposed.
The existence of a more finished
version of this portrait (1885–6;
private collection, Switzerland)
raises the question of whether
the portrait on view here might
be a study for the more finished
version. However, no definitive
evidence has yet been able to
document such a relationship.
SMS

187
Camille Pissarro (1830–1903)
Portrait of Nini, 1884
Oil on canvas, 65.4 × 54.4 cm
Signed lower right: *C. Pissarro 84*
PROVENANCE: Art dealer Richard
Nathanson, London. Donated by
the Ny Carlsberg Foundation in
2002
SELECTED REFERENCES: Pissarro
and Venturi 1939, no. 654
MIN 3579.

Pissarro painted portraits
throughout his career, his sitters
tending to be members of his
family. This one depicts Eugénie
Estruc (1863–1930), nicknamed
Nini, the niece of Pissarro's wife.
Pissarro did Nini's portrait several
times, beginning with a pastel in
1877. In 1883 she again became
the subject of his portraits. This
resulted in a full-figure portrait in
an outdoor setting (Pissarro and
Venturi 1939, no. 653), the portrait
seen here, and a portrait without
date, probably 1884 (Pissarro and
Venturi 1939, no. 1391).
 The portrait seen here was
painted during the Christmas
period of 1883–4. The artist
appears to have been fairly happy
with the result. On 28 December
1883 he wrote to his son Lucien
in London: 'Nini is here. I have
begun to paint her portrait ...
I show her a bit sulky beneath
her fair, curly hair tied with a
marvellous cherry-coloured bow
and set against an intense, deep-
blue background. The blue can
be seen all the way to London!
I struggled like hell to get it right.'
By capturing directly Nini's
character Pissarro managed to
avoid the sentimentalism that he
noted in contemporary portraits
and which caused him to treat the
genre with great circumspection.
Nini also appears in some of
Pissarro's market scenes such as
The Butcher (1883; Tate, on long-
term loan to the National Gallery,
London), where she modelled for
the central figure. SMS

188
Vincent van Gogh (1853–1890)
Portrait of Julien Tanguy, 1887
Oil on canvas, 45.5 × 34 cm
Inscribed upper left: *Tanguy.*
Signed lower left: *Vincent. Janvier 87*
PROVENANCE: Julien Tanguy,
Auvers. Dr Keller, Paris. Druet,
Paris, 1910. Bernheim-Jeune, Paris,
1911. Octave Mirbeau, Paris. Vente
Mirbeau, Durand-Ruel, Paris, 24
February 1919, lot 19. Wilhelm
Hansen, Ordrupgaard, 1919.
Purchased by the Ny Carlsberg
Foundation and donated to the
Glyptotek in 1923
SELECTED REFERENCES: Hulsker
1980, no. 944; New York 1986,
p. 75; Paris 1988, p. 18, fig. 13;
Asmussen 1993, no. 155; Munk
and Olesen 1993, no. 53
MIN 1908

'The thing I hope to achieve is to
paint a good portrait', Vincent
van Gogh simply stated in the
summer or autumn of 1887. By
then he had already painted a
number of portraits of the artists
and other people who inhabited
Montmartre, where he lived with
his brother Theo from spring 1886
to February 1888.
 This portrait is one of at least
three portraits of Julien François
Tanguy (1825–1894), a Breton
colour-merchant who kept a shop
at 22 rue Clancel which was
patronised by, amongst others,
Van Gogh, Paul Gauguin, Paul
Cézanne and Emile Bernard.
Unlike the other portraits of
Tanguy, made around one year
later, with their full-frontal poses,
brilliant palette and associational
objects such as Japanese prints,
the sober, brownish tonality of
this earlier portrait is reminiscent
of Van Gogh's sombre Dutch-
period paintings made prior to his
move to Paris in 1886. However,
the broken handling of the
brushwork, especially in the
realisation of the face, points to
Van Gogh's adoption initially
of Impressionist techniques, in
1886, prior to his brief conversion
to a variant of Seurat's Neo-
Impressionism by the summer
of 1887. The work is thus a
transitional one, lying between
two very different stylistic periods
in Vincent van Gogh's oeuvre.
TB-M

189
Henri de Toulouse-Lautrec
(1864–1901)
*Portrait of Monsieur Delaporte in
the Jardin de Paris,* 1893
Gouache on card, mounted on
wood, 76 × 70 cm
Signed lower right: *pour/L.
Delaporte/HTLautrec*
PROVENANCE: Léon Delaporte,
Paris. La Societé des Amis du
Luxembourg, which in 1905
twice offered it to the Musée du
Luxembourg; the Conseil des
Beaux-Arts refused the offer.
Auguste Pellerin, Paris. Bernheim-
Jeune, Paris, 1909. Alexandre
Nathanson, Paris. Wilhelm
Hansen, Ordrupgaard, 1916.
Bought by the Ny Carlsberg
Foundation at the Hansen sale
in 1923 and donated to the
Glyptotek in 1932
SELECTED REFERENCES: Dortu 1971,
p. 464 (cf p. 432); London 1980,
no. 222; London 1992B, no. 36;
Asmussen 1993, no. 135; Munk
and Olesen 1993, no. 63
MIN 1911

The Jardin de Paris, a café-concert
on the Champs Elysées, opened in
the spring of 1893. With opening
hours beyond those of such
popular establishments as
Montmartre's Moulin Rouge, it
provided the possibility of further
late-night entertainment.
 Léon Delaporte, the director
of the advertising firm Delaporte
and Chetard, which produced
posters for the Variétés, was a
habitué of the establishment.
Placed as a monumental figure
in the foreground plane, his
figure frames a similar, seated
gentleman and a glimpse of the
brightly lit interior beyond.
The woman dressed in purple,
sporting a blue hat set on a pile
of red hair, is the popular variety
artist Jane Avril. Toulouse-Lautrec
has employed accessories, such as
the gas lamps and the glimpse
of lilting figures, to extend the
meaning of the portrait:
Delaporte was not only a guest,
but his business and fortune
depended on the life of these
dazzling entertainment
establishments. TB-M

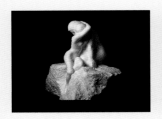 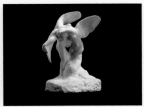 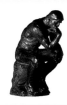 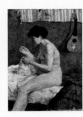

190
Auguste Rodin (1840–1917)
The Good Genius, modelled 1900, carved 1907
Marble, H. 73.3 cm
Inscribed on the right side of the base, beneath the figures' hands: *A. Rodin*
PROVENANCE: Purchased by Carl Jacobsen from Rodin in October 1907; sent to Copenhagen in January 1908. Donated by the Ny Carlsberg Foundation
SELECTED REFERENCES: Tancock 1976, nos 56, 315; London 1986, no. 179; Fonsmark 1988, no. 31; Fonsmark et al. 1999, no. 144
MIN 1398

This work is the result of Rodin's highly original and modern working process. In the wake of his experiment while working on *The Burghers of Calais*, Rodin tried out different compositions using individual body parts cast in plaster, in different figural assemblages. *The Good Genius* was the result of a similar process: individual female figures that had been modelled earlier – the kneeling figure of Isis and the figure of a young girl – were brought together to create a new sculptural group. In adapting the two, Rodin found that he had to increase the length of the torso of Isis, a procedure that he achieved by adding another torso. Isis thus has a double pair of breasts. Rodin tried to suppress any traces of this anatomical anomaly on both of the two known marble versions (the other is in the Fundación Thyssen-Bornemisza, Madrid). When Carl Jacobsen ordered the work from Rodin in 1907 he specifically asked for the shape of one of the breasts to be more clearly defined. SMS

191
Auguste Rodin (1840–1917)
The Blessings, modelled 1894, carved 1907–12
Marble, H. 90.5 cm
Inscribed on the right side of the base: *A. Rodin 1912*
PROVENANCE: Ordered by Carl Jacobsen from Rodin in October 1907; delivered in July 1912. Donated by the Ny Carlsberg Foundation
SELECTED REFERENCES: Cladel 1908; Paris 1987; Fonsmark 1988, no. 29; Fonsmark et al. 1999, no. 142
MIN 1717

The idea for *The Blessings* originated in Rodin's work between 1894 and 1899 on a monument extolling labour. Entitled *The Tower*, the monument was to include two 'winged genii' at the top, pouring blessings on the workers below. It was never completed, however, and instead Rodin transformed *The Blessings* into a work in its own right. The marble version shown here was ordered from Rodin by Carl Jacobsen in 1907. It is one of three or possibly four marble versions. Upon receipt of the sculpture in 1912, Carl Jacobsen was somewhat disappointed by the lack of detail in the marble when compared with a plaster version that he had seen in a photograph. This led to a dispute between Jacobsen and Rodin, who referred resentfully to his Scandinavian patron as a 'Mephistopheles'. Rodin gave Jacobsen the choice of returning the work or accepting the group as it was. Jacobsen took the latter course. SMS

192
Auguste Rodin (1840–1917)
The Thinker, modelled 1880, cast 1900–01
Bronze, H. 73.3 cm
Inscribed on the left side of the base at the bottom: *A. Rodin*
PROVENANCE: Commissioned from the artist by Carl Jacobsen, October 1900; shipped to Copenhagen in June 1901
SELECTED REFERENCES: Rilke 1951, pp. 61–2; Elsen 1985, passim; Fonsmark 1988, no. 4; Fonsmark et al. 1999, no. 117
MIN 605

The Thinker was originally conceived by Rodin in the context of his monumental, multi-figured work, *The Gates of Hell*. Intended for a projected museum of decorative arts in Paris it was a project which occupied him until his death in 1917. *The Thinker* was intended as the figure at the centre of the tympanum above two doors. Here he occupies the seat of judgement, in keeping with the central figure placed above the west door in French medieval cathedrals, an important source of inspiration for Rodin. In 1880 Rodin developed the figure as a free-standing sculpture, inspired by the works of both Michelangelo and Carpeaux (see cats 140–6).
The Thinker was exhibited for the first time in Copenhagen in 1888, where a small plaster version featured in the great French art exhibition organized by Carl Jacobsen. Although Jacobsen was interested in the work at that time, it was not until his visit to the large Rodin retrospective exhibition held in Paris at the Pavillon d'Alma in 1900 that he took the decision to order this bronze version. The work was cast during Rodin's lifetime, and the quality of the bronze and the richness of its patination are the result of the sculptor's direct involvement with its realisation in that medium. SMS

193
Paul Gauguin (1848–1903)
Woman Sewing, 1880
Oil on canvas, 114.5 × 74.5 cm
Signed upper right: *Gauguin 1880*
PROVENANCE: Mette Gauguin, Copenhagen. Th. Philipsen, Copenhagen, (1892). Bequeathed by the latter to the Statens Museum for Kunst, Copenhagen, 1920. Deposited with the Glyptotek in 1922
SELECTED REFERENCES: Bodelsen 1966, p. 34; Rewald 1973, p. 452; San Francisco 1986, pp. 344–5; Washington 1988, pp. 21–3; Munk and Olesen 1993, no. 22; Wildenstein 2001, pp. 72–4; Friborg 2004, no. 4
MIN-smk 3453

Woman Sewing is a key early work by Gauguin, signalling the scope of his ambitions as an artist. The depiction of a nude woman sewing is devoid of both erotic and idealising undertones. As though she were part of a still-life, Gauguin has given her the same status as the other elements of this interior. The figure is rendered in somewhat feathery brush strokes, echoing lessons learnt from Camille Pissarro but applied in such a way that the figure takes on a monumental quality comparable to the nudes of Cézanne.
The public found the work provocative on its first appearance, at the sixth Impressionist exhibition in 1881. The critics were displeased with the way in which Gauguin had conflated the traditional nude study with a scene from everyday life. The author and critic J. K. Huysmans was, however, very positive: '... among the artists of today nobody has presented such a powerful impression of reality'. The painting can be seen as Gauguin's tribute to one of his favourite painters, J. A. D. Ingres, to whose *Valpinçon Bather* of 1808 (Louvre, Paris) it alludes. FF

194
Paul Gauguin (1848–1903)
Skaters in Frederiksberg Park, 1884
Oil on canvas, 65 × 54 cm
Unsigned
PROVENANCE: Mette Gauguin, Copenhagen. Emil Gauguin, Copenhagen. Knoedler, New York. Chester H. Johnson, Chicago. Sotheby's, New York, 16 November 1983, lot 33. Purchased there by the Ny Carlsberg Foundation and donated to the Glyptotek in 1984
SELECTED REFERENCES: Copenhagen 1985, pp. 33–5; Munk and Olesen 1993, no. 31; Wildenstein 2001, no. 161; Copenhagen 2003, p. 137; Friborg 2004, no. 13
MIN 3213

In November 1884, the Gauguin family moved to Denmark. Paul Gauguin hoped that the change of location would be the beginning of happier times for Mette, the children and himself. In a letter of *c.* 1 December 1884 to Camille Pissarro he describes Copenhagen as 'very picturesque', wintry cold and full of possible motifs waiting to be painted.
Immediately upon his arrival in Copenhagen Gauguin embarked upon an active campaign to paint the city. Here he records skaters on the lake in the gardens of Frederiksberg Castle. The main focus of the picture, however, is the colours and shapes of the tree trunks and the forest floor. The skaters emphasise the coldness of the scene and help balance the composition.
Technically the painting echoes important experiences in France prior to Gauguin's departure: the feathery brushwork recalls in particular that of Pissarro, while the introduction of stabs of brighter colours into the otherwise drab winter tonality recalls Gauguin's experimentation with hints of less 'naturalistic' colour in his Rouen paintings of 1884. This was a line of investigation that he was to push further over the subsequent three years. TB-M

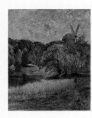

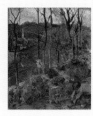

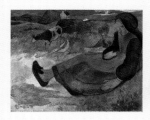

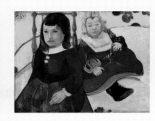

195

Paul Gauguin (1848–1903)
The Queen's Mill, Østervold, 1885
Oil on canvas, 92.5 × 73.4 cm
Signed lower right: *P.Gauguin 85*
PROVENANCE: Victor Høffding,
Copenhagen, 1893. Svend
Bramsen, Copenhagen. Purchased
by the Ny Carlsberg Foundation in
1931 and donated to the Glyptotek
in 1932
SELECTED REFERENCES:
Copenhagen 1984, p. 65; Munk
and Olesen 1993, no. 35;
Wildenstein 2001, no. 141;
Copenhagen 2003, p. 146, no. 28;
Friborg 2004, no. 17
MIN 1850

Although his disappearance from
Paris in late 1884 physically
distanced Gauguin from the
Impressionist group, he was not
bereft of their inspiration. He had
brought with him to Denmark his
already extensive collection of
Impressionist paintings and
during the winter of 1884–5 he
used these as inspiration for
paintings executed in an attic
room in the apartment, to which
he had been relegated.

With the arrival of spring,
Gauguin set out to paint in the
parks of Copenhagen. Having
moved in April 1885 to Nørregade
51, he frequented the nearby park
of Østre Anlæg, where the last
of Copenhagen's old windmills,
the Queen's Mill, stood upon the
city ramparts. (The mill was
demolished in 1895.) In his
painting of the Queen's Mill,
Gauguin declares a stylistic debt
to both Cézanne and Pissarro. The
technique of the former clearly
underlies the parallel brush
strokes used to build up the
volumes in creating parts of the
foliage of the trees, while the
latter is echoed in the rushes and
the range of greens used along
the edge of the lake. The motif of
the man walking on the path to
the right was taken from a pastel
by Pissarro made in 1880, and
then in Gauguin's collection
(*Landscape near Pontoise. Peasant
Walking Along a Path*), now in the
Glyptotek. TB-M

196

Paul Gauguin (1848–1903)
Landscape near Pont-Aven, Brittany,
1888
Oil on canvas, 90.5 × 71 cm
Signed lower left: *P.Gauguin 88*
PROVENANCE: Nelly Ericksen,
Copenhagen. Statens Museum
for Kunst, Copenhagen, 1912.
Deposited with the Glyptotek
in 1915
SELECTED REFERENCES: Delouche
1986, p. 54; Thomson 1987, pp.
57–8; Munk and Olesen 1993, no.
38; Wildenstein 2001, no. 258;
Friborg 2004, no. 20
MIN-smk 3142

Gauguin was attracted to the
untainted rural life of Brittany.
Both the distinct granite
landscapes and the Breton
peasants found their way into
his paintings. Left relatively
untouched by industrialisation
and the modernisation of the
French economy, the Bretons
pursued a life imbued with Celtic
tradition, profound Catholicism,
and an apparent primitivism
demonstrated in their language,
traditions, superstitions and
national costume. Gauguin saw
Brittany as a perfect place in
which to escape from the strains
of modern life and society. In a
letter of *c.* September 1888, he
describes the marvellous sound
of the wooden clogs on granite
ground, to him a deep timbre
which resonated of the place and
its history.

On the surface, *Landscape near
Pont-Aven, Brittany* presents a view
of the village and its rural
surroundings as the backdrop to
a shepherd who is adjusting his
clogs at the lower right of the
composition, watched by a
curious calf. On a more complex
level, the adoption of perspectival
recessional points, separated by
the diagonal line of bank and
trees, both harks back to the split
composition of Gauguin's Rouen
landscapes of 1885 and presages
the dramatic negation of
naturalism achieved later in the
summer of 1888 in a painting
such as *Vision after the Sermon*
(National Gallery of Scotland,
Edinburgh).

Gauguin returned to Brittany
in January 1888, after his sojourn
in Panama and Martinique. He
was already familiar with Pont-
Aven, the village seen through the
trees in the background of this
work, having stayed there initially
from June to October 1886. TB-M

197

Paul Gauguin (1848–1903)
Breton Girl, 1889
Oil on canvas, 71.5 × 90.5 cm
Signed lower left: *P.Gauguin 89*
PROVENANCE: Mogens Ballin,
Copenhagen, (1893). Christian
Tetzen-Lund, Copenhagen. Helge
Jacobsen, Copenhagen. Donated
by Helge Jacobsen in 1927
SELECTED REFERENCES:
Copenhagen 1984, pp. 76–8; Munk
and Olesen 1993, no. 40; Paris
1995, no. 32; Wildenstein 1964,
no. 344; Friborg 2004, no. 22
MIN 1827

During his third sojourn in
Brittany Gauguin shunned the
artist's colony of Pont-Aven,
choosing rather to settle in the
remote village of Le Pouldu. Here
the landscape was wilder than
that to be found around Pont-
Aven, and the culture even
further removed from
civilisation. In a letter of October
1889 to Vincent van Gogh,
Gauguin referred to the wildness
and the non-European aspects of
the peasants at Le Pouldu. His
treatment of the subject of a
Breton cow girl, made at Le
Pouldu, seeks to convey these
characteristics.

The portrait gives an impression
of the landscape at the Atlantic
coast, but compared to the
technique used in his *Landscape
near Pont-Aven, Brittany* from the
previous year (cat. 196) Gauguin
has changed his painterly
expression. The elements of the
landscape as well as the girl, the
beasts and the house on the edge
are now clearly defined by a
contour. The compositional
perspective and the proportions
of the elements have changed as
well. The girl seems enormous
compared to the cows in the
background. Gauguin is gradually
dissolving the naturalistic
perception of space. TB-M

198

Paul Gauguin (1848–1903)
Two Children, possibly 1889
Oil on canvas
46 × 60 cm
Signed upper left: *P Go*
PROVENANCE: Bernheim, Paris.
Paul Rosenberg, Paris. Goupil,
London. Helge Jacobsen,
Copenhagen, (1921). Donated by
Helge Jacobsen in 1927
SELECTED REFERENCES: Bodelsen
1966, p. 38; Pickvance 1970, p. 31;
Munk and Olesen 1993, no. 44;
Friborg 2004, no. 26
MIN 1833

The identity of the two,
presumably Breton, children in
Gauguin's picture is unknown,
as is its exact date of execution.
Given the strength of the colours
and the strict outline of each
form, the picture was almost
certainly painted after Gauguin's
stay with Vincent van Gogh in
Arles in the autumn of 1888,
where Gauguin came increasingly
to recognise the importance of
pure colours, especially the warm
yellow used in this painting.
However, the existence of a study
related to this work in a
sketchbook that includes material
from his first visit to Tahiti
(1891–4) has led to the painting
being ascribed to Gauguin's
Breton sojourn of 1894–5.

The clarity of outline and the
illogical description of space
signals a major development from
Gauguin's initial exercises in
pictorial symbolism made in the
summer of 1888. TB-M

199

Paul Gauguin (1848–1903)
Two Reclining Tahitian Women, 1894
Oil on canvas, 60 × 98 cm
Inscribed and signed lower centre:
à Md. Gloanec P. Gauguin 1894 and
inscribed lower left: *Arearea no
varua ino*
PROVENANCE: Donated by Helge
Jacobsen in 1927
SELECTED REFERENCES: Amishai-
Maisels 1985, pp. 378–80;
Washington 1988, pp. 276–7;
Munk and Olesen 1993, no. 49;
Paris 1995, no. 39; Wildenstein
2001, no. 514; Friborg 2004, no. 31
MIN 1832

Gauguin left France in 1891 in
search of a society untouched by
western civilisation. He arrived in
Tahiti where he was to pass two
periods of time, 1891–4 and 1896–
1901 (see cat . 200). Gauguin was
drawn to the beauty of Tahitian
women. Often placed in non-
natural or dream landscapes,
they came to represent the ideal
woman untainted by fashion or
artifice, set within an evocation
of nature in its unsullied form or
within landscapes that hold in
their detail an extended symbolic
meaning.

Here the composition has been
divided by a diagonally placed tree
trunk, which separates the two
women from a secondary plane
populated by unworldly figures: to
the left sits a statue of the goddess
of life, Hina, and in the upper
carton is a blue mask of what
might be a symbol of death.
Beyond, two figures are fighting or
dancing. Given the presence of the
two red fruits placed between the
women in the foreground, possibly
a symbol of temptation, the
meaning of the painting may lie in
a struggle between life and death,
in which the inscription, translated
loosely as 'the amusement of the
evil spirit', suggests that temptation
lies in waiting to convey the women
either towards death, or, if
shunned, towards eternal life.

Gauguin regularly attached
Tahitian phrases to his paintings.
Since he was untutored in Tahitian,
they tend to be hybrids from
anthropological texts or his own
personal interpretation. In
addition, given that the Tahitian
religion and its imagery had been
virtually eradicated by French
Catholic missionaries, the
appending of such texts reinforced
the archaic, primitivising
meaning of the work. TB-M

200

Paul Gauguin (1848–1903)
Tahitian Landscape with Nine Figures, 1898
Oil on sackcloth, 93 × 73 cm
Signed lower left: *Faiara. P. Gauguin 98*
PROVENANCE: Possibly Ambroise Vollard, Paris. Wladyslaw Slewinski, Paris. Helge Jacobsen, Copenhagen, 1914–15. Donated by Helge Jacobsen in 1927
SELECTED REFERENCES: Segalen 1950, p. 209; Rostrup 1956, p. 161; Danielsson 1967, p. 230; Munk and Olesen 1993, no. 50; Wildenstein 2001, no. 575; Friborg 2004, no. 32
MIN 1834

Gauguin returned to Tahiti after a brief sojourn in France from 1894 to 1896. During the following two years he painted a series of landscapes with figures, in which the compositions range from the highly stylised, non-naturalistic interpretation of nature, as seen in the monumental *Where Do We Come From? What Are We? Where Are We Going To?* (1897; Museum of Fine Arts, Boston), to more legible transcriptions, as in the painting shown here. However, given the distinct outlining of figures and landscape elements, the use of flat colour infill, the absence of any aerial or linear perspective, and the appending of the inscription 'Faiara', derived form the Tahitian verb 'to wake up', the intention is to read the work as a symbol of regeneration. This may explain the presence of the woman on the right seemingly eating some fruit, the couple embracing on the far left, and the dark area in the foreground, which may denote a spring.

The present landscape is painted on a roughly woven and apparently unprimed piece of canvas, probably sackcloth. It may well be a work described by Gauguin's friend and unofficial art agent, Daniel de Monfreid, in a letter of November 1888. It was not, however, included in the exhibition of eight Tahitian works shown at the Galerie Vollard, Paris in that year. TB-M

201

Paul Gauguin (1848–1903)
La Chanteuse, 1880
Mahogany, plaster, paint and gilding, 53 cm (diameter) × 13 cm (depth)
Signed lower centre: *P. Gauguin 1880*
PROVENANCE: Mette Gauguin, Copenhagen. Oda Nielsen, Copenhagen. Kay Nielsen, USA. Galerie Kornfeld, Bern, auction 192, 1986, lot 164. Purchased there by the Ny Carlsberg Foundation and donated to the Glyptotek the same year
SELECTED REFERENCES: Bodelsen 1967, p. 225; San Francisco 1986; Fonsmark 1987B; Washington 1988, pp. 23–5; Munk and Olesen 1993, no. 23; Friborg 2004, no. 5
MIN 3230

La Chanteuse is one of Gauguin's earliest sculptures in wood. As such it demonstrates his mastery of a new medium, to which he was probably introduced by the sculptor Jules-Erneste Bouillot (active *c*. 1877–1889), Gauguin's landlord from 1877. *La Chanteuse* is Gauguin's first serious attempt both to combine a variety of materials and to treat sculpture as polychrome art. This may, however, have been the result of necessity: the bouquet of roses on the lower left required delicate carving in the hard wood, and Gauguin may have resorted to the plaster purely to ensure a recognisable representation of the flowers. The figure of the singer, *La Chanteuse*, is thought to be Valéry Roumi (d. 1886), who performed on the stages of Paris's café-cabarets, places of entertainment frequented by the Impressionists, notably Degas. Gauguin has captured her at the moment she receives the applause of her audience. The distant expression on her face, however, might suggest that Gauguin has sought to convey the singer's state of mind rather than render a realistic impression of her response to her audience. As such, the work prefigures the symbolism found in Gauguin's later works. *La Chanteuse*, together with another sculpture, *Woman Walking (The Little Parisienne)*, and *Woman Sewing* (cat. 193), was shown at the sixth Impressionist exhibition of 1881. SMS

202

Paul Gauguin (1848–1903)
Woman with Mango Fruits, possibly 1889
Polychrome wood-relief, 30 × 49 cm
Signed: *Martinique Gauguin*
PROVENANCE: Tyge Møller, Paris. Helge Jacobsen, Copenhagen. Donated by the Ny Carlsberg Foundation in 1919
SELECTED REFERENCES: Gray 1963, no. 60; Amishai-Maisels 1985, pp. 145–6; Munk and Olesen 1993, no. 42; Friborg 2004, no. 24
MIN 1781

Following a disastrous stage working on the construction of the Panama Canal, Gauguin escaped to the French colony of Martinique in June 1887. He stayed there until November, his imagination fired by the exotic nature of its landscape, flora and fauna. Although this bas-relief is inscribed 'Martinique Gauguin', he almost certainly carved it two years later during his third sojourn in Brittany, in conjunction with a group of woodcarvings that sought to combine in imagery symbols of the exotic and his own personal ideas and emotions.

The symbolic language employed here contains many references to the Fall of Man, set within a non-Western context. A woman picking a mango from a tree is surrounded by animals – a goat and two monkeys – and what seem to be spirits in the shape of two heads appearing from each side of the relief. Traditionally, monkeys symbolise lust and in the light of the Eve-like presentation of the woman the motif seems to be dealing with temptation and sexuality in this tropical Garden of Eden.

This relief is one of three such pieces in Helge Jacobsen's large collection of works by Gauguin which were given to the Ny Carlsberg Glyptotek. TB-M

203

Paul Gauguin (1848–1903)
Double-vessel in unglazed Stoneware with Brittany Girl, Sheep and Geese, 1886–87
Unglazed stoneware decorated with coloured slip, H. 13.5 cm
Signed on the cornet, above the sheep: *P Go*
PROVENANCE: Ambroise Vollard, Paris. Jacques Ullmann. Acquired by the Ny Carlsberg Foundation in 1995 and donated to the Glyptotek in 1996
SELECTED REFERENCES: Gray 1963, no. 28; Bodelsen 1964, no. 12, fig. 31; Fonsmark 1996, no. 4; Friborg 2004, no. 37
MIN 3548

Having been able to develop an interest in ceramics – from French regional ware to Italian, Spanish-Moorish and oriental wares – in the collection of his guardian, the banker Gustave Arosa, it was an invitation from Félix Bracquemond on the strength of work exhibited at the eighth and final Impressionist exhibition in 1886, that appears to have sparked Gauguin's determination to work in this medium. On his return from Brittany in November 1886 he began to work in the atelier of the experimental ceramicist Ernest Chaplet. Over the following nine years he was to create some 150 pieces, some 50 of which have survived, in four specific periods: winter 1886–7, winter 1887–8, winter 1889–90 and 1893–5.

Gauguin's approach to his ceramics was singular. He regarded them as sculptures, and saw a close cross-relationship between them and his two-dimensional work. The piece shown here, one of 55 such pieces, was made in the first ceramic campaign. Innovative in its design, which is strictly non-functional, it includes decorative elements derived from works in other media. The pose of the Breton shepherdess is taken from two drawings and the painting *The Breton Shepherdess* (1886; Laing City Art Gallery, Newcastle); she had also appeared in one of Gauguin's earliest ceramics, a *jardinière*. The boy combing his hair, also on the lid, is derived from Gauguin's wood bas-relief, *La Toilette* (private collection), made in 1882, exhibited at the final Impressionist exhibition of 1886 and owned, at that time, by Camille Pissarro. TB-M

204

Paul Gauguin (1848–1903)
Glazed Jug with Seated Shepherd Girl, Lamb and Goose, 1886–7
Glazed polychrome and gold stoneware, H. 18.5 cm
Signed to the left of the left handle: *P Go* [with gold] and scored on the bottom of the base: *47*
PROVENANCE: Ambroise Vollard, Paris. Jacques Ullmann. Acquired by the Ny Carlsberg Foundation in 1995 and donated to the Glyptotek in 1996
SELECTED REFERENCES: Gray 1963, no. 25; Bodelsen 1964, p. 23, no. 8; Fonsmark 1996, no. 3; Friborg 2004, no. 36
MIN 3547

Although the initial campaign of ceramics in the winter of 1886–7 was engaged primarily with unglazed stoneware, occasionally finished with small elements of glaze (see cat. 203), there is a small group of glazed wares that are as experimental and radical in their efforts as were the shapes modelled by Gauguin. In this piece, which derives its figurative elements from his Breton sojourn, the richness of the coloration owes as much to the articulation of such elements as the body of the Breton shepherdess as from the density and variety of the polychrome glaze. Gauguin had already attempted to work with such glazes in a vase (the *Brussels Vase*, 1886–7; Musées royaux des Beaux-Arts de Belgique, Brussels), one of the earliest pieces made in the atelier of Ernest Chaplet (see cat. 203), but the inspiration for such a technique may have come directly from the master ceramicist himself.

In this medium Gauguin challenged conventional thinking: the function of the objects almost disappears in the crowd of subtle motifs. While these motifs are drawn from his paintings of the same period, they have been detached from their original context. Gauguin was even more experimental in clay than in oil – perhaps because ceramics did not have the same status as paintings. TB-M

205

Paul Gauguin (1848–1903)
Double-vessel in glazed Stoneware,
1887–8
Glazed polychrome stoneware,
H. 19.5 cm
Unsigned
PROVENANCE: Ambroise Vollard,
Paris. Jacques Ullmann, Paris.
Acquired by the Ny Carlsberg
Foundation in 1995 and donated
to the Glyptotek in 1996
SELECTED REFERENCES: Gray 1963,
no. 10; Bodelsen 1964, p. 95, nos
33, 41, 46, figs 47, 65, 75;
Fonsmark 1996, no. 12; Friborg
2004, no. 45
MIN 3556

Following his first experiments
in the medium (see cat. 203),
Gauguin's second campaign of
ceramics took place in the winter
of 1887–8, after his return from
Martinique and prior to his
departure for his second sojourn
in Brittany. Gauguin set a
premium on his ceramic works,
not least because of their
significance as an art form in
primitive cultures. Most of the
pieces were modelled by hand,
without the use of a potter's
wheel, as can be seen here
particularly in the two handles.
The resulting creations were
small, extraordinary sculptures,
each one unique, and devoid of
function beyond their aesthetic
expression.
 While Gauguin 'borrowed'
pictorial elements for his ceramic
pieces from his drawings and
paintings, he also included these
items in his two-dimensional
work. The ceramic shown here
was added to the right-hand
side of the composition *Flowers
on a Commode* (1886; private
collection), a dissonant, primitive
note within an otherwise
conventional Impressionist
still-life. TB-M

206

Paul Gauguin (1848–1903)
*Portrait Vase of a Woman with a
Snake Belt*, 1887–8
Unglazed stoneware, H. 26 cm
Signed: *P Gauguin/56*
PROVENANCE: Ambroise Vollard,
Paris. Jacques Ullmann, Paris.
Acquired by the Ny Carlsberg
Foundation in 1995 and donated
to the Glyptotek in 1996
SELECTED REFERENCES: Gray 1963,
no. 49; Bodelsen 1964, pp. 55–6,
63, 66, 98, no. 31, figs 43–4, 46–8,
50–2; Fonsmark 1996, no. 8;
Friborg 2004, no. 41
MIN 3552

This portrait, probably of the wife
of Gauguin's good friend Emile
Schuffenecker, practically
emerges from the vase form. Mme
Schuffenecker's oriental look has
been accentuated, and around
her waist she wears a snake belt.
At the end of 1887 Gauguin lived
at the Schuffenecker home where
he did a number of portraits of
the family members, several as
decoration on his ceramics.
 This ceramic work is as much
a sculpted symbolic portrait bust
in the guise of a caryatid as a
supposedly utilitarian object.
Given the ascribed identification
of the figure out of which this cast
has been created, it is assumed
that the piece was made after
Gauguin's return from
Martinique in November 1887.
It thus belongs to his second
ceramics campaign. Within the
same period, Gauguin also
modelled vases representing one
of the Schuffenecker daughters,
Jeanne, and the family's wet
nurse.
 The decoration of the buckle
of Mme Schuffenecker's belt with
a snake's head makes referral to
woman the temptress, a theme
that Gauguin returned to
consistently throughout his
oeuvre. This identification of
Mme Schuffenecker with Eve was
reiterated in another 'portrait-
vase', made two years later, in
which the snake appears as a
winding ribbon in the sitter's
hair. The break that took place
between Gauguin and
Schuffenecker in 1891 may have
been caused by Gauguin's
fascination with, and possible
advances towards, Mme
Schuffenecker. TB-M

207

Constantin Meunier (1831–1905)
On the Way Home from the Mine,
undated but probably 1880s
Bronze, 59 × 82 cm
Signed: *C. Meunier*
PROVENANCE: Acquired by Carl
Jacobsen in 1908 and donated by
the Ny Carlsberg Foundation the
same year
SELECTED REFERENCES: Friborg
1997, no. 28
MIN 1493

This relief, based upon a painting
by Meunier made in the 1870s,
was intended to form part of the
decoration of the plinth to a large-
scale monument to Work which
had been commissioned from the
Belgian artist by the city of
Louvain. The monument was
never realised.
 A group of miners have finished
work and are now on their way
home, some physically tired and
others still able to straighten their
backs and carry their picks with
strength and pride. Meunier's
sincerity in honouring the worker
appealed to Carl Jacobsen, who
insisted that the relief should
come to Copenhagen. Jacobsen
acquired several other figures
from the monument. They pay
tribute to both enterprise and art,
two of the very cornerstones of
Carl Jacobsen's life. Today, some
of these monuments can be seen
in the garden surrounding the
Glyptotek. TB-M

208

Constantin Meunier (1831–1905)
Suffering (The Martyr), 1887
Bronze, 63.5 × 68 × 35 cm
Signed: *C. Meunier*
PROVENANCE: Acquired from the
artist by Carl Jacobsen in 1901
SELECTED REFERENCES: Friborg
1997, no. 30; Hamburg 1998, no. 8
MIN 462

An unscheduled visit by Jacobsen
in November 1901 to Constantin
Meunier in Brussels ignited an
enthusiasm for the Belgian
sculptor's oeuvre which led to
the creation of a major holding
of his work. Jacobsen bought
seven works, including this one,
all on the subject of the worker,
his suffering and stolid
endurance under harsh working
conditions. When the sculptures
arrived in Copenhagen the
following spring, Jacobsen put
them on display in his brewery,
and chose 1 May, the
International Workers' Day, for
the event. Meunier wrote to him:
'I am very glad … to hear about
your idea of showing them to your
workers, that most interesting
class in our modern society –
their judgement is often more
valuable than that of a certain
prosperous class whose
appreciation of art is narrowed by
academic and antiquated ideals.'
Jacobsen saw Meunier's workers
as contemporary versions of the
heroes of Antiquity: part of a
monument to our own time.
In 1908 Jacobsen arranged a
Meunier exhibition in
Copenhagen from which he
bought most of the sculptures
on display, bringing his holdings
of the sculptor's work to a total
of 48. FF

209

Aristide Maillol (1861–1944)
The Young Cyclist, 1907
Bronze, H. 98 cm
Signed with monogram: *M 4/4*.
Founder's mark: *Alexis. Rudier.
Fondeur. Paris.*
PROVENANCE: Donated by the Ny
Carlsberg Foundation in 1954
SELECTED REFERENCES: Rostrup
1955, pp. 24–5; Harboe 1994,
no. 44; Lausanne 1996, pp. 57–8,
no. 57
MIN 2762

The origins of *The Young Cyclist*
lie in Maillol's new-found
appreciation of Classical art, in
this case the standing nude figure
striking the traditional pose of
the *contrapposto*. Nevertheless,
the work has been freed from
any literary or mythological
references. In the gentle lines
of the slender figure, Maillol has
tried to make all the shapes of the
body fuse into a whole. The figure
is built up on the Classical notion
of form, where the contours are
clearly defined; the slim body,
however, sharply differentiates
the youth from the idealised
figures of boys of Antiquity.
Rather, in this respect *The Young
Cyclist* echoes the male youths
of the Renaissance sculptor
Donatello. The work was given
its title because Maillol's model
came to the sittings on a bicycle.
SMS

210
Paul Cézanne (1839–1906)
Women Bathing, c. 1900
Oil on canvas, 73 × 92 cm
Unsigned
PROVENANCE: Ambroise Vollard,
Paris. Alexander Lewin, Guben.
Mrs Alix Kurz, New York.
Marianne Feilchenfeldt, Zurich.
Purchased from Marianne
Feilchenfeldt by the Ny Carlsberg
Foundation in 1956 and donated
to the Glyptotek the same year
SELECTED REFERENCES: Munk and
Olesen 1993, no. 14; Rewald 1996,
vol. I, no. 667
MIN 2790

Cézanne sought in his art, be it
landscape, still-life, portraits or
bather subjects, to 'make
something enduring out of
Impressionism; like the art in
museums'. This work shows him
addressing the classical, timeless
subject of the nude, a subject
which had held his attention
from the beginning of his career
in the 1860s.
 The carefully arranged figures
in this painting provide a stable
composition, increasingly
found in Cézanne's nude bather
subjects of the 1880s and 1890s.
To achieve this it would appear
that he eliminated a smaller,
crouched bather on the right
of the composition, partially
superimposing upon it the
larger, standing figure who
counterbalances the nude bather
seen full-frontally with arms
raised behind her head. The
analysis of the essential structure
of figures and landscape behind
has been expressed through the
build-up of Cézanne's
characteristic directional brush
stroke. The resultant effect of
interlocking faceted surfaces
provided the inspiration for
Cubism. Indeed, Picasso
'borrowed' the central female
figure, using the same pose in his
'manifesto' painting *Les Demoiselles
d'Avignon* (1907; Museum of
Modern Art, New York). Cézanne
had thus become a guideline and
inspiration for modern painting.
The critics, however, were not to
catch up until some ten years
after Cézanne's death, when they
had become familiar with the
idiom of Cubism. SMS

211
Ker-Xavier Roussel (1867–1944)
The Coronation of Venus, 1909
Oil on canvas, 34 × 54 cm
Signed lower left: *K.X. Roussel./0.9*
PROVENANCE: Valdemar Kleis,
Copenhagen. Helge Jacobsen,
Copenhagen, c. 1911. Donated by
Helge Jacobsen in 1927
SELECTED REFERENCES: Munk and
Olesen 1993, no. 56
MIN 1838

On the threshold of the twentieth
century, certain artists – such as
Ker-Xavier Roussel – who in the
1890s had been members of the
avant-garde group of second-
generation pictorial symbolists,
the Nabis, felt that the demand
of the symbolist programme for
constant innovation was
unsustainable. Roussel, like
his fellow Nabi, Maurice Denis,
returned to a model of absolute
and unchanging beauty: the
Antique.
 The scene takes place in an
idyllic, harmonious landscape,
Arcadia. Roussel has emphasised
the Classical location by the
inclusion of a pillar on the left,
a device intended to convince
the viewer of the sublimity of
the surroundings and hide the
resemblance to a coastal
landscape on the Côte d'Azur.
Venus is seated in the warm
sunlight under a flowering tree,
surrounded by lazy nymphs,
fauns and Cupid, who is about to
place the garland crown on the
head of the love goddess. TB-M

212
Henri Matisse (1869–1954)
Decorative Figure, 1908
Bronze, H. 73 cm
Signed: *HM 9*
PROVENANCE: Donated by the
Ny Carlsberg Foundation in 1954
SELECTED REFERENCES: Rostrup
1955; Elsen 1971, p. 87; New York
1992, p. 180; Harboe 1994, no. 48;
Duthuit 1997, no. 41
MIN 2756

This title draws attention to what
was a prime concern for Matisse:
form as ornamentation. The
figure is not standing erect in the
manner of a Classical statue, but
has stepped down from her plinth
and is posing nonchalantly for the
beholder. As a result, the square
shape of the plinth counteracts
the flowing lines of the body to
form a decorative whole. The
figure has thus become an ironic
commentary on the Classical
sculptural tradition – and a
debate on the relationship
between the work of art and its
support: where does art begin,
and where does it end? SMS

213
Pablo Picasso (1881–1973)
Woman Combing Her Hair,
modelled 1906, cast 1968
Bronze, H. 42.2 cm
Inscribed on the base: *5/10*.
Founder's mark: *Cire perdu
C. Valsuani*
PROVENANCE: Private collection,
Paris. Acquired by the Ny
Carlsberg Foundation in 1999 and
donated to the Glyptotek in 2002
SELECTED REFERENCES: Warncke
and Walther 1991, p. 143; London
1994, pp. 41 f., fig. 2; Spies 2000,
pp. 32–3, fig. 7
MIN 3582

Picasso explored the female nude
in both painting and sculpture
from early in his career. He
excluded any psychological
interpretation of his figures,
focusing rather on the female
nude as pure form.
 Unlike most of Picasso's three-
dimensional work of the early
twentieth century, *Woman
Combing Her Hair* is intended to be
seen from the front, evidenced
by the fact that the back of the
sculpture remains open and
unformed. It is a transitional
piece in which Picasso experiments
with the constraints of a single
viewpoint (as in a painting or
bas-relief) and the need to give
complete information of the
figure as seen in the round. It is
this dilemma which is finally
worked out in the Cubism of 1907
onwards. In *Woman Combing Her
Hair* Picasso scratched the
features of the woman's face on
the surface of the sculpture, thus
literally working in both two and
three dimensions. TB-M

214
Aristide Maillol (1861–1944)
Desire, modelled 1904, this version
1909
Terracotta, 115 × 106 cm
Signed lower left: *Aristide Maillol*.
PROVENANCE: Commissioned by
Carl Jacobsen in 1907
SELECTED REFERENCES: Harboe
1994, no. 43; Berlin 1996, pp. 45–6;
Lausanne 1996, pp. 45–7, 101,
no. 56
MIN 1558

The commission in 1907 for this
work by Maillol, originally
modelled in 1904, is ample
evidence of Jacobsen's
considerable breadth of taste:
during the period between its
commission and delivery (in
1909), Jacobsen also bought Salon
sculpture, Japanese statues and
a replica of *The Three Graces* by
Antonio Canova for his Glyptotek.
 Jacobsen first saw the relief at
the Salon of 1907 and fell for it,
not least because of its kinship
with figurative metopes on
ancient Greek temples. The work
balances delicately between relief
and sculpture in the round. *Desire*
has a decidedly architectural
flavour, and the two figures seem
by their stance to form the frame
he has set around them. The
position of the legs on each of the
two figures makes the group
unfold symmetrically, like a
plant, from a point of departure
on the base-line of the relief.
However Classical it may seem, its
built-in erotic naturalism clearly
betokens Modernism. FF

215
Johannes Hoffmann (1844–1920)
Wolfgang Helbig, 1891
Marble, H. 68 cm
Inscribed: *J.Hoffmann, Rom
MDCCCXCI den XIV Januar*, and on
the herm shaft: WOLFGANG HELBIG
PROVENANCE: Commissioned by
Carl Jacobsen in 1889
SELECTED REFERENCES: Bencard
and Friborg 1995, no. 61
MIN 1348

According to contemporary
accounts, the German
archaeologist and academic
Wolfgang Helbig (1839–1915) was
a distinct character, blessed with
both talent and diplomatic guile.
He was a highly valued brother-
in-arms for Carl Jacobsen the
collector. Together, they amassed
a total of 955 antiquities between
the time of their first contact
in 1887 and the collector's death
in 1914. Helbig's primary
contribution to the Glyptotek was
the establishment of the Etruscan
collection, the significance of
which led to that part of the
museum being named 'The
Helbig Museum'.
 The bust of the archaeologist
is one of the finest portraits by
the Danish sculptor Johannes
Hoffmann. It presents a true and
vivacious rendering of his friend.
FF

216
Ludvig Brandstrup (1861–1935)
Valdemar Schmidt, 1916
Marble, H. 76 cm
Inscribed at the back: *L.Br. 1916*
PROVENANCE: Acquired by the
Ny Carlsberg Foundation from
the artist in 1917
SELECTED REFERENCES: Bencard
and Friborg 1995, no. 37
IN 1777

The Egyptologist Professor
Valdemar Schmidt (1836–1925)
was one of the main architects
of the Glyptotek's Egyptian
collection. Carl Jacobsen provided
the Danish scholar with a
purchase grant in 1892, when
the Glyptotek was still housed at
the Carlsberg Brewery grounds
in Valby. From that date, Schmidt
was his regular expert on
Egyptian and Assyrian subjects.
Schmidt carried on giving
lectures and guided tours of the
Glyptotek up to his death at the
age of 89. The acquisition of this
work in 1917 by the Ny Carlsberg
Foundation served as a tribute to
his distinction as both a scholar
and curator. FF

Glossary

acrolithic
Statue with marble extremities (face, hands, feet) attached to a wooden skeletal core, which is often itself clothed with drapery
acroterion
Statue or carved finial on the apex, or at the lower angles, of a pediment

baldric
A belt for a sword or other piece of equipment, worn over one shoulder and reaching down to the opposite hip

capsa
A box for book scrolls
chiton
A tunic worn in ancient Greece
cinerary urn
An urn for holding ashes of the dead after cremation
cognomen
An extra personal name given to an ancient Roman citizen, often passed down from father to son

desultor
A type of acrobatic horseman, literally in Latin 'one who leaps off'
diadem
A jewelled crown or headband worn as a symbol of sovereignty
distaff
A stick or spindle on to which wool or flax is wound for spinning
dowel
A peg of wood or metal used for holding together components of a sculpture

exedra
Semi-circular or rectangular recess
ex-voto
An offering given in order to fulfil a vow

faience
Glazed ceramic ware, in particular decorative tin-glazed earthenware of the type which includes delftware and maiolica

herm
A portrait placed on top of a plain supporting shaft
himation
An outer garment worn by the ancient Greeks
hypogeia
Subterranean vaults which function as underground tombs or temples

ithyphallic
Having an erect penis, particularly referring to a statue

ka
In ancient Egypt, the supposed spiritual part of an individual human being or god, which survived (with the soul) after death and could reside in a statue of the person
ketos
A dragon-like sea monster in Greek and Roman mythology, interpreted as a whale in more recent accounts
kithara
A Greek musical instrument of the lyre family
komast
A performer of the komos, a dance that accompanied Greek drinking parties

loculus
Grave niche

maenad
In ancient Greece a female follower of Dionysos, traditionally associated with divine possession and frenzied rites
mastaba
An ancient Egyptian tomb consisting of an underground burial chamber with rooms above it (at ground level) to store offerings
meta
The turning post for chariots in the Roman circus
metope
A square space between triglyphs in a Doric frieze

necropolis
A cemetery (literally 'city of the dead'), especially a large one belonging to an ancient settlement
nemes
A pharaonic headcloth
nilotic
Of or relating to the River Nile or to the Nile region of Africa
nodus
A knot in the hair over the forehead from which runs a braid to the back where all the hair is gathered in a tight, braided bun

occiput
The back of the head or skull, a direct borrowing of the Latin word for the part of the head opposite the front

peplos
A woollen garment, tied with a belt, worn by women in ancient Greece
porta finta
A false (*trompe l'œil*) door

quaestor
A political official in the city of Rome (often concerned with finance); or a local town official

repoussoir
A figure or object in the foreground of a picture (and usually at the side) used to give depth to the principal scene or episode, focusing the viewer's attention on the subject of the work

schedula
The deed to the tomb
stela
An upright stone slab or column typically bearing a commemorative inscription or relief design, often serving as a gravestone
stola
The costume of married women in Rome

travertine
White or light-coloured calcareous rock deposited from mineral springs, particularly at Tivoli, used in building
tufa
Soft porous rock formed from the deposits of springs rich in lime, used for building and sometimes for sculpture
tympanum
The space enclosed between the lintel or a doorway and an arch over it

Bibliography

AMISHAI-MAISELS 1985: Ziva Amishai-Maisels, *Gauguin's Religious Themes*, New York and London, 1985

AMSTERDAM 1986: *Monet in Holland*, exh. cat., Rijksmuseum Vincent van Gogh, Amsterdam, 1986

ASMUSSEN 1993: Marianne W. Asmussen, *Wilhelm Hansen's Original French Collection at Ordrupgaard*, Copenhagen, 1993

ÅRHUS 1983: *C. W. Eckersberg*, Lise Funder and Claus Hagedorn-Olsen (eds), exh. cat., Aarhus Kunstmuseum, Århus, 1983

BAJOU 2003: Valérie Bajou, *Courbet*, Paris, 2003

BARTMAN 2001: Elisabeth Bartman, 'Hair and the Artifice of Roman Female Adornment', *American Journal of Archaeology*, 105 (2001), pp. 1–25

BELL 1996: Malcolm Bell, 'Il canto del chorentes. Un bronzo Greco dal Gianicolo' in *Janiculum – Gianicolo. Storia, topographia, monumenti, leggende dall´antichitá al Rinascimento*, Rome, 1996 , pp. 77–99

BENCARD AND FRIBORG 1995: Ernst Jonas Bencard and Flemming Friborg, *Ny Carlsberg Glyptotek Catalogue: Danish Sculpture around 1900*, Copenhagen, 1995

BERLIN 1988: *Kaiser Augustus und die verlorene Republik*, exh. cat.,Martin-Gropius-Bau, Berlin, 1998

BERLIN 1996: *Aristide Maillol*, exh. cat., Georg-Kolbe Museum, Berlin, Musée cantonal des Beaux-Arts, Lausanne, Gerhard Marcks-Museum, Bremen and Städtische Kunsthalle, Mannheim, 1996

BERLIN 2002: *Die griechische Klassik. Idee oder Wirklichkeit*, exh. cat., Martin-Gropius-Bau, Berlin 2002

BERNER 1980: M.-L. Berner, 'Den kongelige Afstøbningssamlings historie', *Kunst og Museum*, special issue, 1 (1980)

BILDE 1995: Pia Guldager Bilde, 'The Sanctuary of Diana Nemorensis: The Late Republican Acrolithic Cult Statues', *Acta Archaeologica*, 66 (1995), pp. 191–218

BILDE 1997: Pia Guldager Bilde, 'CHIO D(ONUM) D(EDIT): Eight Marble Vases from the Sanctuary of Diana Nemorensis', *Analecta Romana Instituti Danici*, 24 (1997), pp. 53–81

BOARDMAN 1985: John Boardman, *Greek Sculpture: The Classical Period*, London,1985

BODELSEN 1964: Merete Bodelsen, *Gauguin's Ceramics. A Study in the Development of His Art*, London, 1964

BODELSEN 1966: Merete Bodelsen, 'The Wildenstein-Cogniat Catalogue', *Burlington Magazine*, 108 (January 1966), pp. 27–41

BODELSEN 1967: Merete Bodelsen, 'Gauguin Studies', *Burlington Magazine*, 109 (April 1967), pp. 217–22

BØGH 1884: Nicolaj Bøgh, *Erindringer af og om Jens Adolph Jerichau*, Copenhagen, 1884

BOL 2000: Peter Cornelius Bol (ed.), *Die Geschichte der griechischen Bildhauerkunst. I: Frühgriechische Plastik*, 2000

BORCHARDT 1923: Ludwig Borchardt, *Ausgrabungen der Deutschen Orientgesellschaft in Tell-Amarna, III: Porträts der Königin Nofret-ete*, Leipzig, 1923

BOSCHUNG 1986: Dietrich Boschung, 'Überlegungen zum Liciniergrab', *Jahrbuch des deutschen archäologischen Instituts*, 101 (1986), pp. 257–87

BOSCHUNG 1987: Dietrich Boschung, *Antike Grabaltäre aus den Nekropolen Roms*, Bern, 1987

BOSTON 1989: *Monet in the'90s. The Series Paintings*, Paul Hayes Tucker, exh. cat., The Museum of Fine Arts, Boston, Art Institute of Chicago, and Royal Academy of Fine Arts, London, 1989

BRAMSEN 1938: Henrik Bramsen, *Malerier af P. C. Skovgaard*, Copenhagen, 1938

BRAMSEN 1990: Henrik Bramsen, *Kunst i enevældens sidste hundrede år*, Copenhagen, 1990

BRANDT ET AL. 2000: J. Rasmus Brandt et al. (eds), *Nemi – Status Quo, Recent Research at Nemi and the Sanctuary of Diana. Occasional Papers of the Nordic Institutes in Rome*, I, 2000

BRENDEL 1978: Otto Brendel, *Etruscan Art*, Kingsport, Tenn., 1978

BRINKMANN 2003: Vinzenz Brinkmann, *Die Polychromie der archaischen und frühklassischen Skulptur*, Munich, 2003

BRUSINI 2001: Serena Brusini, 'La decorazione scultorea della villa romana di Monte Calvo', *Rivista dell'Istituto Nazionale d'Archeologia e Storia dell'Arte*, 55 (2001), Rome, 2001

BRYAN 1997: Betsy M. Bryan, 'The Statue Program for the Mortuary Temple of Amenophis III', in *The Temple in Ancient Egypt*, Stephen Quirke (ed.), London, 1997

CALAIS 1982: *De Carpeaux à Matisse*, Françoise Maison, Anne Pingeot and Dominique Viéville, exh. cat., Musée des Beaux-Arts, Calais, 1982

CAMBRIDGE 1988: *Pharaohs and Mortals. Egyptian Art in the Middle Kingdom*, Janine Bourriau, exh. cat., Fitzwilliam Museum, Cambridge, 1988

CHRISTENSEN 1991: Charlotte Christensen, 'Jørgen Roed og Raphael', in *På sporet af Jørgen Roed. Italien 1837–1841*, Jens Peter Munk (ed.), exh. cat, Ny Carlsberg Glyptotek, Copenhagen, 1991

CHRISTENSEN 1995: Charlotte Christensen, *Ny Carlsberg Glyptotek Catalogue: H. W. Bissen Sculptures*, I, Copenhagen, 1995

CIMA AND LA ROCCA 1998: Maddalena Cima and Eugenio La Rocca (eds), 'HORTI ROMANI', *Bullettino della Commissione Archeologica Comunale di Roma*, Supplementi, 6 (1998)

CLADEL 1908: Judith Cladel, *Auguste Rodin, l'œuvre et l'homme*, Brussels, 1908

CLARET, MONTALANT AND ROUART 1977: Alain Claret, Delphine Montalant and Yves Rouart, *Berthe Morisot, 1841–1895. Catalogue raisonné de l'œuvre peint*, Montolivet, 1997

CLÉMENT-CARPEAUX 1934: Louise Clément-Carpeaux, *La Vérité sur l'œuvre et la vie de J.-B. Carpeaux (1827–1875)*, I, Paris, 1934

CLEVELAND 1992: *Egypt's Dazzling Sun. Amenophis III and his World*, Arielle P. Kozloff, Betsy M. Bryan and Lawrence M. Berman (eds), exh. cat., The Cleveland Museum of Art, Cleveland, Ohio, 1992

COLDING ET AL. 1972: Torben Holck Colding, Vagn Poulsen, Henrik Bramsen and Torben Balslev Jørgensen, *Akademiet og guldalderen 1750–1850. Dansk Kunsthistorie*, III, Copenhagen, 1972

COLLEDGE 1976: Malcolm A. R. Colledge, *The Art of Palmyra*, London, 1976

CONNELLY 1987: Joan Breton Connelly, *Votive Sculpture of Hellenistic Cyprus*, Nicosia, 1987

COPENHAGEN 1978: *Danske malere i Rom i det 19. århundrede*, Harald Peter Olsen, exh. cat., Statens Museum for Kunst, Copenhagen, and Palazzo Braschi, Rome, 1977–8

COPENHAGEN 1981: *Martinus Rørbye*, Dyveke Helsted, Eva Henschen, Bjarne Jørnæs and Torben Melander, exh. cat., Thorvaldsens Museum, Copenhagen, 1981

COPENHAGEN 1981B: *Købke og Kastellet*, Hans Edvard Nørregård-Nielsen, exh. cat., Ny Carlsberg Glyptotek, Copenhagen, 1981

COPENHAGEN 1983: *C. W. Eckersberg i Rom*, Dyveke Helsted, Eva Henschen and Bjarne Jørnæs (eds), exh. cat., Thorvaldsens Museum, Copenhagen, 1983

COPENHAGEN 1984: *Gauguin and van Gogh in Copenhagen in 1893*, Merete Bodelsen, exh. cat., Ordrupgaard, Copenhagen, 1984

COPENHAGEN 1985: *Gauguin og Danmark*, Anne-Birgitte Fonsmark, exh. cat., Ny Carlsberg Glyptotek, Copenhagen, 1985

COPENHAGEN 1991: *Constantin Hansen 1804–1880*, Bjarne Jørnæs and Stig Miss (eds), exh. cat., Thorvaldsens Museum, Copenhagen, and Aarhus Kunstmuseum, Århus, 1991

COPENHAGEN 1991B: *Caspar David Friedrich og Danmark*, Kasper Monrad and Colin J. Bailey, exh. cat., Statens Museum for Kunst, Copenhagen, 1991

COPENHAGEN 1994: *Den nøgne guldalder*, Annette Johansen, Emma Salling and Marianne Saabye, exh. cat., Den Hirschsprungske Samling, Copenhagen, 1994

COPENHAGEN 1996: *Christen Købke 1810–1848*, Kasper Monrad and Hans Edvard Nørregård-Nielsen (eds), exh. cat., Statens Museum for Kunst, Copenhagen, 1996

COPENHAGEN 1996B: *Wilhelm Bendz 1804–1832: Et ungt kunstnerliv*, Marianne Saabye et al., exh. cat., Den Hirschsprungske Samling, Copenhagen, 1996

COPENHAGEN 2003: *Impressionismen og Norden*, Torsten Gunnarsson, Per Hedström, Peter Nørgaard Larsen et al., exh. cat., Statens Museum for Kunst, Copenhagen, 2003

COPENHAGEN 2003B: *The Spoils of Victory. The North in the Shadow of the Roman Empire*, Lars Jørgensen et al. (eds), exh. cat., Nationalmuseet, Copenhagen, 2003

CRISTOFANI 1975: Mauro Cristofani, *Statue-cinerario chiusine di età classica*, Spoleto, 1975

CRISTOFANI 1991: Mauro Cristofani, 'Chimereide', *Prospettiva*, 61 (1991), pp. 2–5

CRUMLIN-PEDERSEN AND VINNER 1986: Ole Crumlin-Pedersen and Max Vinner, *Sailing in the Past*, Roskilde, 1986

CZESTOCHOWSKI AND PINGEOT 2002: Joseph S. Czestochowski and Anne Pingeot, *Degas Sculptures. Catalogue Raisonné of the Bronzes*, Memphis, 2002

D'AMBRA 1996: E. D'Ambra, 'The Calculus of Venus. Nude Portraits of Roman Matrons', in N. Boymel Kampen (ed.), *Sexuality in Ancient Art. Near East, Egypt, Greece, and Italy*, Cambridge, 1996, pp. 219–32

DANIELSSON 1967: Bengt Danielsson, 'Gauguin's Tahitian Titles', *Burlington Magazine*, 109 (April 1967), pp. 228–33

DAULTE 1959: Alfred Daulte, *Alfred Sisley. Catalogue raisonné de l'oeuvre peint.* Lausanne, 1959

DE FORGES 1962: Marie-Thérèse de Forges, *Barbizon*, Brussels, 1962

DE KERSAUSON 1996: Kate de Kersauson, *Musée du Louvre: Catalogue des portraits romains*, II, Paris, 1996

DE NANTEUIL 1985: Luc de Nanteuil, *Jacques-Louis David*, New York, 1985

DELOUCHE 1986: Denise Delouche (ed.), *Pont-Aven et ses peintres à propos d'un centenaire*, Rennes, 1986

DELOUCHE 1992: Denise Delouche, *Monet à Belle-Île*, Le Chasse-Marée, 1992

DETROIT 2003: *Degas and the Dance*, Jill DeVonyar and Richard Kendall, exh. cat., Detroit Institute of Arts and Philadelphia Museum of Art, 2002–3

DEYHLE 1969: Wolfgang Deyhle, 'Meisterfragen der archaischen Plastik Attikas', *Mitteilungen des Deutschen Archäologischen Instituts (Athenische Abteilung)*, 84 (1969), pp. 1–64

DI MINO 1981: M. R. di Mino, 'Terracotte architettoniche dalla zona del monumento di Vittorio Emanuele', *Archeologia Laziale*, 4 (1981), pp. 119–25

DORBEC 1910: Prosper Dorbec, *Th. Rousseau*, Paris, 1910

DORTU 1971: M. G. Dortu, *Toulouse-Lautrec et son œuvre*, II, New York, 1971

DUTHUIT 1997: Claude Duthuit, *Henry Matisse. Catalogue raisonné de l'œuvre sculpté*, Paris, 1997

ELSEN 1971: Alfred Elsen, *The Sculpture of Henri Matisse*, New York, 1971

ELSEN 1985: Albert E. Elsen, *Rodin's Thinker and the Dilemmas of Modern Public Sculpture*, New Haven and London, 1985

EMILIANI 1996: Andrea Emiliani, *Leggi, bandi e provvedimenti per la tutela dei Beni Artistici e Culturali negli antichi stati italiani 1571–1860*, Bologna, 1996

ENSOLI AND LA ROCCA 2000: Serena Ensoli and Eugenio La Rocca (eds), *Aurea Roma. Dalla città pagana alla città cristiana*, Rome, 2000

ERMAN 1919: Adolf Erman, *Reden, Rufe und Lieder auf Gräberbildern des alten Reiches*, Berlin, 1919

EVERS 1929: Hans Gerhard Evers, *Staat aus dem Stein*, Munich, 1929

FERNIER 1977: Robert Fernier, *La Vie et l'œuvre de Gustave Courbet*, I, Lausanne and Paris, 1977

FISCHER-HANSEN 1992: Tobias Fischer-Hansen, *Ny Carlsberg Glyptotek Catalogue: Campania, South Italy and Sicily*, Copenhagen, 1992

FONSMARK 1983: Anne-Birgitte Fonsmark, 'Købke på Capri', *Meddelelser fra Ny Carlsberg Glyptotek*, 39 (1983), pp. 76–98

FONSMARK 1984: Anne-Birgitte Fonsmark, 'Kejser Maximilians henrettelse. Om skitsen i Ny Carlsberg Glyptotek', *Meddelelser fra Ny Carlsberg Glyptotek*, 40 (1984), pp. 63–84

FONSMARK 1987: Anne-Birgitte Fonsmark, 'The Absinthe drinker – and Manet's Picture-Making', *Hafnia*, 11 (1987), pp. 76–92

FONSMARK 1987B: 'Paul Gauguin. To nyerhvervelser fra hans tidlige år', *Meddelelser fra Ny Carlsberg Glyptotek*, 43, (1987), pp. 29–44

FONSMARK 1988: Anne-Birgitte Fonsmark, *Rodin: La Collection du brasseur Carl Jacobsen à la Glyptothèque Ny Carlsberg – et œuvres apparentées*, Copenhagen, 1988

FONSMARK 1996: Anne-Birgitte Fonsmark, *Ny Carlsberg Glyptotek Catalogue: Gauguin Ceramics*, Copenhagen,1996

FONSMARK ET AL. 1999: Anne-Birgitte Fonsmark, Emmanuelle Héran and Sidsel Maria Søndergaard, *Ny Carlsberg Glyptotek Catalogue: French Sculpture*, II, Copenhagen, 1999

FRANKFORT 1926: Henri Frankfort, 'A Masterpiece of Early Middle Kingdom Sculpture', *The Journal of Egyptian Archaeology*, 12 (1926), pp. 143–4

FRIBORG 1992: Flemming Friborg, 'Théodore Rousseau og det sublime', *Meddelelser fra Ny Carlsberg Glyptotek*, 48 (1992), pp. 112–29

FRIBORG 1994: Flemming Friborg, *Ny Carlsberg Glyptotek Catalogue: French Painting in the Nineteenth Century*, Copenhagen, 1994

FRIBORG 1997: Flemming Friborg, *Ny Carlsberg Glyptotek Catalogue: European Sculpture*, Copenhagen, 1997

FRIBORG 2002B: Flemming Friborg, 'Perler: En modelseance i juni 1833', in *Gaveregn*, Anne Marie Nielsen (ed.), Ny Carlsberg Glyptotek, Copenhagen, 2002

FRIBORG 2004: Flemming Friborg, *Gauguin: An Essay*, Copenhagen, 2004

FUCHS 1999: Michaela Fuchs, 'Hoffnungsträger der *res publica*. Zur Authentizität des Pompeius, Typus Kopenhagen 597', in Hans von Steuben (ed.), *Antike Porträts zum Gedächtnis von Helga von Heintze*, Möhnesee, 1999

GALASSI 1991: Peter Galassi, *Corot in Italy. Open Air Painting and the Classical Landscape Tradition*, New Haven and London, 1991

GIULIANI 1986: Luca Giuliani, *Bildnis und Botschaft. Hermeneutische Untersuchungen zur Bildniskunst der römischen Republik*, Frankfurt am Main, 1986

GIULIANO 1986: Antonio Giuliano (ed.), *Museo nazionale romano: Le sculture. I, 6: I marmi Ludovisi disperse*, Rome, 1986

GLAMANN 1995: Kristof Glamann, *Beer and Marble*, Copenhagen, 1995

GRAY 1963: Christopher Gray, *Sculpture and Ceramics of Paul Gauguin*, Baltimore, 1963

GREGOROVIUS 1911: Ferdinand Gregorovius, *The Roman Journals, 1852–1874*, F. Althaus (ed.), trans. Mrs Gustavus W. Hamilton, London, 1911

GUAITOLI ET AL. 1974: Marcello Guaitoli et al., 'Contributi per une carta archeologica del territorio di Castel di Decima', in *Ricognizione archeologica e documentazione cartografica (QuadIstTopUniRom)*, 6, Rome, 1974

GUARDUCCI 1980: Margherita Guarducci, 'La cosiddetta Fibula Prenestina: antiquari, eruditi e falsari nella Roma dell'ottocento', *Atti dell'Accademia Nazionale dei Lincei (Classe di Scienze morali etc)*, Memorie, ser. 8, 24 (1980), pp. 415–569

GUARDUCCI 1984: Margherita Guarducci, 'La cosiddetta Fibula Prenestina: elementi nuovi', *Atti dell'Accademia Nazionale dei Lincei (Classe di Scienze morali etc)*, Memorie, ser. 8, 28 (1984), pp. 127–77

GULDAN 1988: M. Guldan, *Die Tagebücher von Ludwig Pollak. Kennerschaft und Kunsthandel in Rom 1893–1934*, Vienna, 1988

GUNNARSSON 1989: Torsten Gunnarsson, *Friluftsmåleri före friluftsmåleriet*, Uppsala, 1989

HAFNER 1981: German Hafner, *Prominente der Antike*, Düsseldorf and Vienna, 1981

HAMBURG 1998: *Constantin Meunier*, exh. cat., Ernst Barlach Haus, Hamburg, 1998

HARBOE 1994: Julie Harboe, *Ny Carlsberg Glyptotek Catalogue: European Art in the Twentieth Century*, Copenhagen, 1994

HARPUR 1987: Yvonne Harpur, *Decorations in Egyptian Tombs of the Old Kingdom*, London, 1987

HARTSWICK 2004: Kim J. Hartswick, *The Gardens of Sallust: A Changing Landscape*, Austin, Tex., 2004

HARVEY 2001: Julia Harvey, *Wooden Statues of the Old Kingdom*. Egyptological Memoirs, II, Geerd Haayer (ed.), Leiden, 2001

HEIBERG 2003: Steffen Heiberg, *Danske portrætter*, Copenhagen, 2003

HELBIG 1891: Wolfgang Helbig, *Führer durch die öffentlichen Sammlungen klassischer Alterthümer in Rom*, Leipzig, 1891; 4th edition, 1963–72; English edition, 1895

HERBIG 1952: Reinhard Herbig, *Die jungetruskischen Steinsarkophage. Die antiken Sarkophagreliefs*, 7, Berlin, 1952

HULSKER 1980: Jan Hulsker, *The Complete van Gogh. Paintings, Drawings, Sketches*, Oxford, 1980

HUSKINSON 1996: Janet Huskinson, *Roman Children's Sarcophagi. Their Decoration and Social Significance*, Oxford, 1996

HUYGHE 1976: René Huyghe, *La relève de l'imaginaire. Réalisme, Romantisme*, Paris, 1976

HVIDBERG-HANSEN 1998: F. O. Hvidberg-Hansen, *The Palmyran Inscriptions*, Copenhagen, 1998

IKRAM AND DODSON 1998: Salima Ikram and Aidan Dodson, *The Mummy in Ancient Egypt. Equipping the Dead for Eternity*, London, 1998

JACOBSEN 1878: Carl Jacobsen, 'La Musique', *Ude og Hjemme* 65/1 (1878), p. 142ff.

JANSON 1985: Horst Woldemar Janson, *Nineteenth-Century Sculpture*, London, 1985

JEAMMET 2003: Violaine Jeammet, 'Quelques particularités de la production des pleureuses canosines en terre cuite', *Revue Archeologique*, 2 (2003), pp. 255–92

JOHANSEN 1992: Flemming Johansen, *Ny Carlsberg Glyptotek Catalogue: Greek Portraits*, Copenhagen, 1992

JOHANSEN 1994: Flemming Johansen, *Ny Carlsberg Glyptotek Catalogue: Roman Portraits*, I, Copenhagen, 1994

JOHANSEN 1994B: Flemming Johansen, *Ny Carlsberg Glyptotek Catalogue: Greece in the Archaic Period*, Copenhagen, 1994

JOHANSEN 1995: Flemming Johansen, *Ny Carlsberg Glyptotek Catalogue: Roman Portraits*, II, Copenhagen, 1995

JOHANSEN 1995B: Flemming Johansen, *Ny Carlsberg Glyptotek Catalogue: Roman Portraits*, III, Copenhagen, 1995

JØRGENSEN 1996: Mogens Jørgensen, *Ny Carlsberg Glyptotek Catalogue: Egypt*, I: *3000–1550 BC*, Copenhagen, 1996

JØRGENSEN 1998: Mogens Jørgensen, *Ny Carlsberg Glyptotek Catalogue: Egypt*, II: *1550–1080 BC*, Copenhagen, 1998

JØRGENSEN 2001: Mogens Jørgensen, *Ny Carlsberg Glyptotek Catalogue: Egypt*, III: *Coffins, Mummy Adornments and Mummies from the Third Intermediate, Late, Ptolemaic and Roman Periods*, Copenhagen, 2001

JOVINO 1965: Maria Bonghi Jovino, *Capua Preromana. Terrecotte votive. Catalogo del Museo Provinciale Campano*, I, Rome and Florence, 1965

KARAGEORGHIS ET AL. 2001: V. Karageorghis et al., *Ancient Cypriote Art in Copenhagen. The Collections of the National Museum of Denmark and the Ny Carlsberg Glyptotek*, Nicosia, 2001

KENDALL 1993: Richard Kendall, *Degas Landscapes*, New Haven, 1993

KITSCHEN 1998: Friederike Kitschen, 'Cézannes Hüte. Zu einigen Selbstporträts von Paul Cézanne', *Pantheon*, 56 (1998)

KLEINER 1987: Diana E. E. Kleiner, *Roman Imperial Funerary Altars with Portraits*, Rome, 1987

KOCH 1993: Guntram Koch, *Sarkophage der römischen Kaiserzeit*, Darmstadt, 1993

KOCH 1998: Guntram Koch (ed.), *Sarkophag-Studien. Akten des Symposiums '125 Jahre Sarkophag Corpus' Marburg 1995*, Mainz am Rhein, 1998

KOCH 2000: Guntram Koch, *Frühchristliche Sarkophage*, Munich, 2000

KOCKEL 1993: Valentin Kockel, *Porträtreliefs stadtrömischer Grabbauten*, Mainz am Rhein, 1993

KOCKS 1981: Dirk Kocks, *Jean-Baptiste Carpeaux. Rezeption und Originalität*, Sankt Augustin, 1981

KOEFOED-PETERSEN 1939: Otto Koefoed-Petersen, 'Un hippopotame de l'Egypte archaïque', *From the Collections of the Ny Carlsberg Glyptotek*, II, Copenhagen, 1939, pp. 52–64

KOEFOED-PETERSEN 1950: Otto Koefoed-Petersen, *Publications de la Glyptothèque Ny Carlsberg*, III: *Catalogue des statues et statuettes égyptiennes*, Copenhagen, 1950

KOEFOED-PETERSEN 1962: Otto Koefoed-Petersen, *Egyptian Sculpture in the Ny Carlsberg Glyptothek*, Copenhagen, 1962

KOORTBOJIAN 2002: Michael Koortbojian, 'Forms of Attention', in E. K. Gazda (ed.), *The Ancient Art of Emulation. Studies in artistic originality and tradition from the present to classical antiquity*, Ann Arbor, Mich., 2002, pp. 173–204

KRAGELUND, MOLTESEN AND ØSTERGAARD 2003: Patrick Kragelund, Mette Moltesen and Jan Stubbe Østergaard, 'The Licinian Tomb: Fact or Fiction?', *Meddelelser fra Ny Carlsberg Glyptotek*, new series, 6 (2003)

KRIERER 1995: Karl R. Krierer, *Sieg und Niederlage*, Vienna, 1995

LAJER-BURCHART 1985: Ewa Lajer-Burchart, 'Modernity and the Condition of Disguise. Manet's Absinthe Drinker', *Art Journal*, 45 (1985), pp. 18–26

LANCIANI 1887: Rodolfo Lanciani, 'Notes from Rome', *Athenaeum*, 3137 (1887), p. 790; reprinted in Rodolfo Lanciani, *Notes from Rome*, Tony Cubberley (ed.), London, 1988

LANCIANI 1888: Rodolfo Lanciani, *Ancient Rome in the Light of Recent Discoveries*, London, 1888

LA ROCCA 1985: E. La Rocca, *Amazzonomachia: le sculture frontonali del tempio di Apollo Sosiano*, Rome, 1985

LAUSANNE 1996: *Aristide Maillol*, Ursel Berger and Jörg Zutter (eds), Georg Kolbe Museum, Berlin, and Musée des Beaux-Arts, Lausanne, 1996

LEGROTTAGLIE 1999: Giuseppina Legrottaglie, *Ritratti e statue iconiche di età romana nel museo civico di Lucera*, Bari, 1999

LEHMANN 1946: P. Lehmann, *Statues on Coins of Southern Italy and Sicily*, New York, 1946

LEIPEN 1989: Neda Leipen, 'A New Etruscan Marble', in *Festschrift Jale Inan Armagani*, 2 vols, N. Basgelen and M. Lugai (eds), Istanbul, 1989

LICHTHEIM 1988: Miriam Lichtheim, *Ancient Egyptian Autobiographies chiefly of the Middle Kingdom*, Göttingen, 1988

LILLE 2002: *Berthe Morisot 1841–1895*, Sylvie Patry, Hugues Wilhelm and Sylvie Patin, exh. cat., Palais des Beaux-Arts, Lille, and Fondation Pierre Gianadda, Martigny, 2002

LILLE 2003: *Carolus-Duran, 1837–1917*, Annie Scottez-De Wambrechies et al., exh. cat., Palais des Beaux-Arts, Lille, and Musée des Augustins, Toulouse, 2003

LIMC II 1984: *Lexicon Iconographicum Mythologiae Classicae*, II, Zurich and Munich, 1984

LONDON 1922: *Catalogue of the MacGregor Collection of Egyptian Antiquities*, Percy E. Newberry (ed.), auction catalogue, Sotheby, Wilkinson & Hodge, London, 1922

LONDON 1972: *Caspar David Friedrich 1774–1840*, William Vaughan, Helmut Börsch-Supan and Hans Joachim Neidhardt, exh. cat., The Tate Gallery, London, 1972

LONDON 1980: *Cross-Currents in European Painting*, John House and MaryAnne Stevens (eds), exh. cat., Royal Academy of Arts, London, 1979–80

LONDON 1986: *Rodin: Sculpture and Drawings*, exh. cat., Hayward Gallery, London, 1986

LONDON 1992: *Manet: The Execution of Maximilian. Painting, Politics and Censorship*, Juliet Wilson-Bareau, exh. cat., National Gallery, London, 1992

LONDON 1992B: *Toulouse-Lautrec*, Caroline Laroche (ed.), exh. cat., Hayward Gallery, London, and Galeries nationales du Grand Palais, Paris, 1991–2

LONDON 1993: *Alfred Sisley*, MaryAnne Stevens (ed.), exh. cat., Royal Academy of Arts, London, Musée d'Orsay, Paris, and The Walters Art Gallery, Baltimore, 1992–3

LONDON 1994: *Picasso: Sculptor/Painter*, Elizabeth Cowling and John Golding, Tate Gallery, London, 1994

LOS ANGELES 1993: *The Golden Age of Danish Painting*, Kasper Monrad (ed.), exh. cat., Los Angeles County Museum of Art, Los Angeles, and Metropolitan Museum of Art, New York, 1993

LYON 2003: *Alfred Sisley. Poète de l'impressionisme*, Anne Dumas, MaryAnne Stevens, Vincent Pomarède, exh. cat., Musée des Beaux-Arts, Lyon, 2002–3

MADRID 2004: *Manet en el Prado*, M. B. Mena Marquéz (ed.), exh. cat., Museo Nacional del Prado, Madrid, 2003–4

MADSEN 1920: Karl Madsen, *Corot og hans billeder i nordisk Eie*, Copenhagen, 1920

MADSEN 1931: Karl Madsen, *Malerier af Johan Thomas Lundbye*, Copenhagen, 1931

MADSEN 1949: Karl Madsen, *Johan Thomas Lundbye*, Copenhagen, 1949

MALEK 1999: Jaromir Malek, *Topographical Bibliography of Ancient Egyptian Hieroglyphic Texts, Statues, Reliefs and Paintings*, VIII: *Objects of Provenance Not Known*, Oxford, 1999

MANGO 1999: Elena Mango, 'Calvus et senex. Überlegungen zu einem Porträt in der archäologischen Sammlung', in *Drei Bildnisse*, Zurich, 1999

MANNSPERGER 1998: Marion Mannsperger, *Kunstfrisur und Frisurenkunst*, Bonn, 1998

MEYER 2000: Hugo Meyer, *Prunkkameen und Staatsdenkmäler römischer Kaiser*, Munich, 2000

MICHAËLIS 1906: Sophus Michaëlis, *Billedhuggeren J. A. Jerichau*, Copenhagen, 1906

MOATTI 1993: Claude Moatti, *The Search for Ancient Rome*, London, 1993

MOGENSEN 1921: Maria Mogensen, *Le Mastaba Egyptien de la Glyptothèque Ny Carlsberg*, Copenhagen, 1921

MOGENSEN 1930: Maria Mogensen, *La Glyptothèque Ny Carlsberg: La Collection égyptienne*, Copenhagen, 1930

MOLTESEN 1987: Mette Moltesen, *Wolfgang Helbig, brygger Jacobsens agent i Rom 1887–1914*, Copenhagen, 1987

MOLTESEN 1987B: Mette Moltesen, 'From the Princely Collections of the Borghese Family to the Glyptotek of Carl Jacobsen', *Analecta Romana Instituti Danici*, 16 (1987), pp. 188–203

MOLTESEN 1990: Mette Moltesen, 'Brewer Carl Jacobsen's Thoughts on Ancient Sculpture and its Communication', *Acta Hyperborea*, 2 (1990), pp. 251–65

MOLTESEN 1990B: Mette Moltesen, 'Una nota sul Trono Ludovisi e sul Trono Boston: La "Connection" Danese', *Bollettino d'Arte*, 64 (1990), pp. 27–46

MOLTESEN 1991: Mette Moltesen, 'Neue Nasen, neue Namen', *Archäologische Anzeiger* (1991)

MOLTESEN 1995: Mette Moltesen, *Ny Carlsberg Glyptotek Catalogue: Greece in the Classical Period*, Copenhagen, 1995

MOLTESEN 1997: Mette Moltesen (ed.), *I Dianas hellige lund. Fund fra en helligdom i Nemi*, Copenhagen, 1997 (Danish and English text)

MOLTESEN 1998: Mette Moltesen, 'The Sculptures from the Horti Sallustiani in the Ny Carlsberg Glyptotek', in Cima and La Rocca 1998, pp. 175–88

MOLTESEN AND LEHMANN 1991: Mette Moltesen and Cornelia Weber Lehmann, *Ny Carlsberg Glyptotek Catalogue: Copies of Etruscan Tomb Paintings*, Copenhagen, 1991

MOLTESEN AND NIELSEN 1996: Mette Moltesen and Marjatta Nielsen, *Ny Carlsberg Glyptotek Catalogue: Etruria and Central Italy*, Copenhagen, 1996

MOLTESEN ET AL. 2002: Mette Moltesen et al., *Ny Carlsberg Glyptotek Catalogue: Imperial Rome*, II, Copenhagen, 2002

MONRAD 1989: Kasper Monrad, *Hverdagsbilleder*, Copenhagen, 1989

MOREAU-NÉLATON 1921: Alfred Moreau-Nélaton, *J.-F. Millet*, II, Paris, 1921

MOURSI 1987: Mohamed Moursi, 'Corpus der Mnevis-Stelen und Untersuchungen zum Kult der Mnevis-Stiere in Heliopolis', *Studien zur Altägyptischen Kultur*, 14 (1987), pp. 224–37

MUNICH 2000: *Ägypten 2000 v.Chr., Die Geburt des Individuums*, Dietrich Wildung (ed.), exh. cat., Staatliche Sammlung Ägyptischer Kunst, Munich,

and Ägyptisches Museum und Papyrussammlung, Staatliche Museen zu Berlin, Berlin, 2000

MUNK 1993: Jens Peter Munk, *Ny Carlsberg Glyptotek Catalogue: French Impressionism*, Copenhagen, 1993

MUNK 1993B: Jens Peter Munk, *Ny Carlsberg Glyptotek Catalogue: French Sculpture*, I, Copenhagen, 1993

MUNK 1993C: Jens Peter Munk, '"Den følende Beskuer" Rørbyes rejse til Sydsjælland sommeren 1832', *Meddelelser fra Ny Carlsberg Glyptotek*, 49 (1993), pp. 5–36

MUNK 1995: Jens Peter Munk, *Ny Carlsberg Glyptotek Catalogue: Danish Sculpture 1694–1889*, Copenhagen, 1995

MUNK AND OLESEN 1993: Jens Peter Munk and Kirsten Olesen, *Ny Carlsberg Glyptotek Catalogue: Post-Impressionism*, Copenhagen, 1993

NEW YORK 1960: *Egyptian Sculpture of the Late Period*, compiled by Bernard V. Bothmer in collaboration with Herman de Meulenaere and Hans Wolfgang Müller, Elizabeth Riefstahl (ed.), exh. cat., The Brooklyn Museum, New York, 1960

NEW YORK 1986: *Van Gogh in Saint-Rémy and Auvers*, Ronald Pickvance (ed.), exh. cat., The Metropolitan Museum of Art, New York, 1986

NEW YORK 1988: *Courbet Reconsidered*, Sarah France and Linda Nochlin (eds), exh. cat., The Brooklyn Museum, New York, and The Minneapolis Institute of Arts, Minneapolis, 1988–9

NEW YORK 1988B: *Degas*, Valérie Bajou (ed.), exh. cat., The Metropolitan Museum of Art, New York, and National Gallery of Canada, Ottawa, 1988

NEW YORK 1992: *Henri Matisse: A Retrospective*, John Elderfield, exh. cat., The Museum of Modern Art, New York, 1992

NEW YORK 1999: *Egyptian Art in the Age of the Pyramids*, John P. O'Neill (ed.), exh. cat., The Metropolitan Museum of Art, New York, 1999

NEW YORK 1999B: *Egyptian Art at Eton College. Selections from the Myers Museum*, Stephen Spurr, Nicholas Reeves and Stephen Quirke, exh. cat., The Metropolitan Museum of Art, New York, and Eton College, 1999

NIELSEN 1987: Anne Marie Nielsen, '"fecit et Alexandrum Magnum multis operibus." Alexander the Great and Lysippos', *Acta Archaeologica*, 58 (1987), pp. 151–70

NIELSEN 1992: Anne Marie Nielsen, *Ny Carlsberg Glyptotek Catalogue: The Cypriot Collection*, Copenhagen, 1992

NIELSEN AND ØSTERGAARD 1997: Anne Marie Nielsen and Jan Stubbe Østergaard, *Ny Carlsberg Glyptotek Catalogue: Hellenism*, Copenhagen, 1997

NIVAA 1992: *Nivaagaard viser Marstrand*, Gitte Valentiner (ed.), exh. cat., Nivaagaard, Nivaa, 1992

NODELMAN 1965: S. A. Nodelman, *Severan Imperial Portraiture AD 193–217*, Ann Arbor, Mich., 1965

NØRREGÅRD-NIELSEN 1982: Hans Edvard Nørregård-Nielsen, 'Om de danske kunstnere i Rom', in *Rom er et fortryllet bur*, Tue Ritzau and Karen Ascani (eds), Copenhagen, 1982

NØRREGÅRD-NIELSEN 1984: Hans Edvard Nørregård-Nielsen, 'Evergreens', *Meddelelser fra Ny Carlsberg Glyptotek*, 40 (1984), pp. 31–62

NØRREGÅRD-NIELSEN 1986: Hans Edvard Nørregård-Nielsen, *Danske Kyster*, Copenhagen, 1986

NØRREGÅRD-NIELSEN 1987: Hans Edvard Nørregård-Nielsen, 'Monet i Holland', *Meddelelser fra Ny Carlsberg Glyptotek*, 43 (1987), pp. 5–28

NØRREGÅRD-NIELSEN 1991: Hans Edvard Nørregård-Nielsen, *Undervejs med Christen Købke*, Copenhagen, 1991

NØRREGÅRD-NIELSEN 1995: Hans Edvard Nørregård-Nielsen, *Ny Carlsberg Glyptotek Catalogue: Danish Painting of the Golden Age*, Copenhagen, 1995

NOTTINGHAM 1983: *Mysteries of Diana. The Antiquities from Nemi in Nottingham Museums*, exh. cat., Castle Museum, Nottingham, 1983

NYKJÆR 1991: Mogens Nykjær, *Kundskabens billeder*, Copenhagen, 1991

ODENSE 2003: *Himlens spejl: Skyer og vejrlig i danske maleri 1770–1880*, Gertrud Hvidberg-Hansen (ed.), exh. cat., Fyns Kunstmuseum, Odense, and Storstrøms Kunstmuseum, Maribo, 2002–3

OLIVER 1968: A. Oliver, 'The Reconstruction of two Apulian Tomb Groups', *Antike Kunst*, Beiheft, 5 (1968)

ØSTERGAARD 1996: Jan Stubbe Østergaard, *Ny Carlsberg Glyptotek Catalogue: Imperial Rome*, I, Copenhagen, 1996

ØSTERGAARD 1997: Jan Stubbe Østergaard, 'Navigare necesse est! – en romersk sarkofag med skibsfart', *Meddelelser fra Ny Carlsberg Glyptotek*, 53 (1997), pp. 80–101 (English summary)

PARIS 1912: *Collections de Feu M. Jean P. Lambros d'Athènes et de M. Giovanni Dattari du Caire, Antiquités égyptiennes, grecques et romaines*, auction catalogue, Hôtel Drouot, Paris, 17–19 June 1912

PARIS 1975: *Sur les traces de Jean-Baptiste Carpeaux*, exh. cat, Galeries nationales du Grand Palais, Paris, 1975

PARIS 1987: *Marbres de Rodin*, Nicole Barbier, exh. cat., Musée Rodin, Paris, 1987

PARIS 1988: *Van Gogh à Paris*, Françoise Cachin, Bogomila Welsh-Ovcharov and Monsigue Nonne, exh. cat., Musée d'Orsay, Paris, 1988

PARIS 1989: *Quand Paris dansait avec Marianne (1879–1889)*, exh. cat., Musée du Petit Palais, Paris, 1989

PARIS 1989B: *Jacques-Louis David 1748–1825*, Antoine Schnapper and Arlette Sérullaz, exh. cat., Musée du Louvre, Paris, 1989–90

PARIS 1995: *Manet, Gauguin, Rodin … Chefs-d'œuvre de la Ny Carlsberg Glyptotek de Copenhague*, Anne-Birgitte Fonsmark et al., exh. cat., Musée d'Orsay et Réunion des musées nationaux, Paris, 1995

PARIS 2001: *Paysages d'Italie : les peintres du plein air 1780–1830*, Anna Ottani Cavina (ed.), exh. cat., Galeries nationales du Grand Palais, Paris, 2001

PENDLEBURY 1951: John Devitt Stringfellow Pendlebury, *The City of Akhenaten*, III, London, 1951

PETERSEN 1920: Carl V. Petersen, 'Fransk Landskabsmaleri. Camille Corot: "Mas-Bilier og La Rochelle"', in *Fra Ny Carlsberg Glyptoteks Samlinger*, I, 1920

PETRIE 1909: William Matthew Flinders Petrie, *British School of Archaeology in Egypt and Egyptian Research Account, Fourteenth Year, 1908: Memphis*, I, London, 1909

PETRIE AND BRUNTON 1924: William Matthew Flinders Petrie and Guy Brunton, *British School of Archaeology in Egypt and Egyptian Research Account, Twenty-seventh Year, 1921: Sedment*, I, London, 1924

PICKVANCE 1970: Robert Pickvance, *The Drawings of Gauguin*, London, 1970

PISSARRO AND VENTURI 1939: Ludovic-Rodo Pissarro and Lionello Venturi, *Camille Pissaro. Son art et son œuvre*, 2 vols, Paris, 1939

PLOUG 1995: Gunhild Ploug, *Ny Carlsberg Glyptotek Catalogue: Palmyrene Sculptures*, Copenhagen, 1995

POLLOCK 1977: Griselda Pollock, *Millet*, London, 1977

PORTER AND MOSS 1972: Bertha Porter and Rosalind L. B. Moss, *Topographical Bibliography of Ancient Egyptian Hieroglyphic Texts, Statues, Reliefs and Paintings*, II: *Theben Temples*, Oxford, 1972

PORTER AND MOSS 1981: Bertha Porter and Rosalind L. B. Moss, *Topographical Bibliography of Ancient Egyptian Hieroglyphic Texts, Statues, Reliefs and Paintings*, III: *Memphis*, Part 2: *Saqqara to Dashur*, Oxford, 1981

POULSEN 1922: Frederik Poulsen, *Etruscan Tomb Painting*, Oxford, 1922

POULSEN 1966: Vagn Poulsen, *Ny Carlsberg Glyptotek: Den etruskiske Samling*, Copenhagen, 1966

POULSEN 1973: Vagn Poulsen, *Les portraits romains*, I, Copenhagen, 1973

POULSEN 1991: Ellen Poulsen, *Jens Juel*, Copenhagen, 1991

QUILICI 1983: Lorenzo Quilici, 'La tutela archeologica nei piani regolatori e nella legislazione', in Sartorio and Quilici 1983, pp. 48–74

RAMIERI 1983: Anna Maria Ramieri, 'L'archeologia in Roma capitale: le scoperte, i metodi e gli studi', in Sartorio and Quilici 1983, pp. 18–29

RANKE 1932: Hermann Ranke, 'Ishtar als Heilgöttin in Ägypten', in *Studies Presented to Francis Llewellyn Griffith*, Stephen R. K. Glanville (ed.), Oxford, 1932

REWALD 1973: John Rewald, *The History of Impressionism*, London, 1973

REWALD 1996: John Rewald, with Walter Feilchenfeld and Jayne Warman, *The Paintings of Paul Cézanne. A Catalogue Raisonné*, 2 vols, New York, 1996

RICHTER 1984: Gisela M. A. Richter, *The Portraits of the Greeks*, abridged and revised by R. R. R. Smith, Oxford, 1984

RIDGWAY 1970: Brunhilde Sismondo Ridgway, *The Severe Style*, Princeton, N.J., 1970

RIDGWAY 1990: Brunhilde Sismondo Ridgway, *Hellenistic Sculpture*, I, Bristol, 1990

RIIS 1966: Poul Jørgen Riis, 'The Cult Image of Diana Nemorensis', *Acta Archaeologica*, 37 (1966)

RILKE 1951: Rainer Maria Rilke, *Die Briefe an Rodin*, Hamburg, 1951

ROBAUT AND MORAU-NÉLATON 1905: Alfred Robaut and Etienne Morau-Nélaton, *L'œuvre de Corot*, II, Paris, 1905

ROME 1990: *Il tesoro di via Alessandrina*, exh. cat., Castel Sant'Angelo, Rome, 1990

ROSTRUP 1931: Haavard Rostrup, *From the Collections of the Ny Carlsberg Glyptotek*, Copenhagen, 1931

ROSTRUP 1945: Haavard Rostrup, *The Sculptor H. W. Bissen 1798–1868*, I, Copenhagen, 1945

ROSTRUP 1952: Haavard Rostrup, 'To pasteller af Degas', *Meddelelser fra Ny Carlsberg Glyptotek*, 9 (1952), pp. 24–42

ROSTRUP 1955: Haavard Rostrup, 'De moderne Samlingers Vœxt 1950–54', *Meddelelser fra Ny Carlsberg Glyptotek*, 12 (1955), pp. 12–54

ROSTRUP 1956: Haavard Rostrup, 'Gauguin et le Danemark', *Gazette des Beaux-Arts*, 47 (January – April 1956), pp. 63–82

ROSTRUP 1960: Haavard Rostrup, 'Den guddommelige Corot', *Meddelelser fra Ny Carlsberg Glyptotek*, 17 (1960), pp. 19–36

ROSTRUP 1977: Haavard Rostrup, 'Degas og Réjane', *Meddelelser fra Ny Carlsberg Glyptotek*, 34 (1977), pp. 7–12

SAN FRANCISCO 1986: *The New Painting. Impressionism 1874–1886*, Charles S. Moffet (ed.), exh. cat., Fine Arts Museums of San Francisco, San Francisco, and National Gallery of Art, Washington, D.C., 1986

SARTORIO AND QUILICI 1983: Giuseppina Pisani Sartorio and Lorenzo Quilici (eds), *L'archeologia in Roma Capitale tra sterro e scavo*, Rome, 1983

SCHLÖRB 1979: Barbara Vierneisel Schlörb, *Klassische Skulpturen des 5. und 4. Jahrhunderts v.Chr. Glyptothek München. Katalog der Skulpturen*, II, Munich, 1979

SCHMIDT 1910: Valdemar Schmidt, *Museum Münterianum*, Brussels, 1910

SCHMIDT 1912: Valdemar Schmidt, 'Monuments égyptiens', in *La Glyptothèque Ny-Carlsberg*, Paul Arndt (ed.), Munich, 1912

SCHMIDT 1969: Gerhard Schmidt, 'Kopf Rayet und Torso vom Piräischen Tor', *Mitteilungen des Deutschen Archaologischen Instituts (Athenische Abteilung)*, 84 (1969), pp. 65–75

SEGALEN 1950: Victor Segalen (ed.), *Lettres de Gauguin à Daniel de Monfreid*, Paris, 1950,

SMITH 1988: R. R. R. Smith, *Hellenistic Royal Portraits*, Oxford, 1988

SØNDERGAARD 2000: Sidsel Maria Søndergaard, 'When Tradition Becomes Modern', in *Gloria Victis: Victors and Vanquished in French Art 1848–1910*, Flemming Friborg (ed.), exh. cat., Ny Carlsberg Glyptotek, Copenhagen, 2000

SØNDERGAARD 2002: Sidsel Maria Søndergaard, 'Det springende punkt – om et maleri af Monet', in *Gaveregn*, Anne Marie Nielsen (ed.), Copenhagen, 2002

SPIES 2000: Werner Spies, *Picasso: The Sculptures*, Ostfildern and Stuttgart, 2000

STÄHLER 1990: Klaus Stähler, 'Die Freiheit in Persepolis? Zum Statuentypus der sogenannten Penelope', *Boreas*, 13 (1990)

STEINGRÄBER 1985: Stephan Steingräber, *Etruskische Wandmalerei*, Stuttgart, 1985

STEMMER 1978: Klaus Stemmer, 'Untersuchungen zur Typologie, Chronologie und Ikonographie der Panzerstatue', *Archäologische Forschungen*, 4 (1978)

STEWART 1993: Andrew F. Stewart, *Faces of Power. Alexander's Image and Hellenistic Politics*, Berkeley and Los Angeles, 1993

STEWART 2004: P. Stewart, *Statues in Roman Society: Representation and Response*, Oxford, 2004

STOCKHOLM 1963: *Guldåldern i dansk Konst*, Bo Lindwall (ed.), exh. cat., Nationalmuseum, Stockholm, 1963

TANCOCK 1976: John L. Tancock, *The Sculpture of Auguste Rodin. The Collection of the Rodin Museum, Philadelphia*, Philadelphia, 1976

TE VELDE 1977: Herman Te Velde, *Seth: God of Confusion*, Probleme der Ägyptologie, 6, Wolgang Helck (ed.), Leiden, 1977

THOMSON 1987: Belinda Thomson, *Gauguin*, London, 1987

TURCAN 1999: Robert Turcan, *Messages d'outre-tombe. L'Iconographie des sarcophages romains*, Paris, 1999

TYSZKIEWICZ 1898: Michael Tyszkiewicz, *Memories of an Old Collector*, London, 1898

VAN KEUREN 2003: F. van Keuren, 'Unpublished documents shed new light on the Licinian Tomb, discovered in 1884–1885, Rome', *MAAR (Memoirs of the American Academy at Rome)*, 48 (2003), pp. 53–139

VAN OMMEREN 1999: F. van der Wielen van Ommeren, '"Orantes" canosines, in *Genève et l'Italie, Mélanges de la Societé genevoise d'etudes italiennes*, Geneva, 1999

VAN TILBORGH ET AL. 1988: Louis van Tilborgh, Sjraar van Heughten and Philip Conisbee, *Van Gogh and Millet*, Zwolle and Amsterdam, 1988

VANDIER 1958: Jacques Vandier, *Manuel d'archéologie égyptienne*, III, Paris, 1958

VIENNA 2000: *Cézanne: Finished – Unfinished*, Felix Baumann et al. (eds), exh. cat., Kunstforum, Vienna, and Kunsthaus, Zurich, 2000

VON BISSING 1909: Friedrich Wilhelm Freiherr von Bissing, 'Altägyptische Nilpferd-Statuetten', *Münchner Jahrbuch der bildenden Kunst*, 1909, pp. 127–31

VOSS 1968: Knud Voss, *Guldalderens Malerkunst*, Copenhagen, 1968

WAGNER 1986: Anne Middleton Wagner, *Jean-Baptiste Carpeaux: Sculptor of the Second Empire*, New Haven and London, 1986

WARNCKE AND WALTHER 1991: Carsten-Peter Warncke and Ingo F. Walther, *Pablo Picasso 1881–1973*, I, Cologne, 1991

WASHINGTON 1988: *The Art of Paul Gauguin*, Richard Brettell (ed.), exh. cat., National Gallery of Art, Washington, 1988

WASHINGTON 2003: *Christopher Wilhelm Eckersberg 1783–1853*, Philip Conisbee, Kasper Monrad and Lene Bøgh Rønberg, exh. cat., National Gallery of Art, Washington, D.C., 2003

WEGNER 1979: Max Wegner, *Gordianus III bis Carinus*, Berlin, 1979

WENNBERG 1978: Bo Wennberg, *French and Scandinavian Sculpture in the Nineteenth Century. A Study of Trends and Innovations*, Stockholm and Atlantic Highlands, N.J., 1978

WIGGERS AND WEGNER 1971: H. B. Wiggers and Max Wegner, *Caracalla bis Balbinus*, Berlin, 1971

WILDENSTEIN 1964: Georges Wildenstein, *Gauguin*, Paris, 1964

WILDENSTEIN 1973: Daniel Wildenstein, *Louis David. Documents complémentaires au Catalogue de l'œuvre*, Paris, 1973

WILDENSTEIN 1974: Daniel Wildenstein, *Claude Monet. Biographie et catalogue raisonné*, I, Lausanne and Paris, 1974

WILDENSTEIN 1979 : Daniel Wildenstein, *Claude Monet. Biographie et catalogue raisonné*, II, Lausanne and Paris, 1979

WILDENSTEIN 2001: Daniel Wildenstein, *Gauguin. Premier itinéraire d'un sauvage. Catalogue de l'œuvre peint (1873–1888)*, Paris, 2001

WILLIAMSTOWN 1989: *A Romance with Realism. The Art of Jean-Baptiste Carpeaux*, Jennifer Gordon Lovett , exh. cat., Sterling and Francine Clark Art Institute, Williamstown, and Bowdoin College Museum of Art, Brunswick, 1989

WIVEL 1993: Mikael Wivel, *Christen Købke*, Copenhagen, 1993

WOOD 1999: Susan E. Wood, *Imperial Women. A Study in Public Images 40 BC–68 AD*, Leiden, 1999

WREDE 1977: Henning Wrede, 'Stadtrömische Monumente, Urnen und Sarkophage des Klinen typus in den beiden ersten Jahrhunderten nach Christus', *Archäologischer Anzeiger*, (1977), pp. 395–431

WREDE 1981: Henning Wrede, *Consecratio in Formam Deorum*, Mainz am Rhein 1981

ZANKER AND EWALD: P. Zanker and B. C. Ewald, *Mit Mythen leben: Die Bilderwelt der römischen Sarkophage*, Munich, 2004

ZEVI 1990: Fausto Zevi, 'Lanciani e Roma', in Rodolfo Lanciani, *Storia degli scavi di Roma*, I, Rome, 1990, pp. 1–8

ZIFF 1977: N. D. Ziff, *Paul Delaroche: A Study in Nineteenth Century French Painting*, New York, 1977

Index